U0136766

中国出土壁画全集

徐光冀／主编

科学出版社

北　京

版 权 声 明

本书所有内容，包括文字内容（中英文）、图片内容、版面设计、内容分类以及其他任何本书信息，均受《中华人民共和国著作权法》保护，为相关权利人专属所有。未经本书相关权利人特别授权，任何人不得转载、复制、重制、改动或利用本书内容，否则我们将依法追究法律责任。特此声明！

图书在版编目（CIP）数据

中国出土壁画全集／徐光冀主编.—北京：科学出版社，2011
ISBN 978-7-03-030720-0

Ⅰ．①中... Ⅱ．①徐... Ⅲ．①墓室壁画-美术考古-中国-图集
Ⅳ．①K879.412

中国版本图书馆CIP数据核字（2011）第058079号

审图号：GS（2011）76号

责任编辑：闫向东／封面设计：黄华斌　陈　敬
责任印制：赵德静

科学出版社出版
北京东黄城根北街16号
邮政编码：100717
http://www.sciencep.com

北京天时彩色印刷有限公司印刷
科学出版社发行　各地新华书店经销

*

2012年1月第 一 版　　开本：889×1194　1/16
2012年1月第一次印刷　　印张：160
印数：1-2 000　　字数：1280 000

定价：3980.00元
（如有印装质量问题，我社负责调换）

THE COMPLETE COLLECTION OF MURALS UNEARTHED IN CHINA

Xu Guangji

Science Press

Beijing

Science Press

16 Donghuangchenggen North Street, Beijing,

P.R.China, 100717

Copyright 2011, Science Press and Beijing Institute of Jade Culture

ISBN 978–7–03–030720–0

All rights reserved. No part of this publication may be reproduced, stored in a retrieval system, or transmitted, in any form or by any means, electronic, mechanical, photocopying, recording or otherwise, without the proper permission in writing of Science Press. Enquiries concerning reproduction in other countries should be sent to the Editorial Department of Archaeology, Science Press, at the address above.

《中国出土壁画全集》编委会

总 策 划　柳建尧

总 顾 问　宿　白

执行策划　向安全　于　明

顾　　问　（按姓氏笔画为序）

马宝杰　王　辉　王　巍　王卫东　王奇志　王炜林　石金鸣　包东波
毕　华　刘　旭　孙新民　李向东　李陈奇　李小宁　杨　泓　杨惠福
吴志跃　何　冰　邹后曦　宋大川　宋玉彬　宋建忠　张松林　张建林
陈永志　罗　丰　金旭东　金维诺　哈比布　郑同修　侯一民　徐苹芳
高大伦　塔　拉　韩立森　焦南峰　樊昌生

主　　编　徐光冀

副 主 编　汤　池　信立祥（常务）　朱岩石　秦大树

编　　委　（以姓氏笔画为序）

于志勇　马　昇　王　辉　王进先　王奇志　尹申平　孔德铭　史家珍
成建正　朱　亮　朱岩石　伊弟利斯·阿不都热苏勒　刘　宁　刘　斌　刘俊喜
刘善沂　汤　池　孙建华　孙新民　李　非　李　铭　李百勤　李陈奇
李振光　杨　波　杨　琮　杨惠福　杨德聪　谷德平　邹后曦　宋大川
张　蕴　张玉忠　张松林　罗　丰　岳　起　金旭东　郑同修　孟华平
赵评春　信立祥　俞达瓦　姚蔚玲　秦大树　徐光冀　高大伦　郭永利
黄道钦　曹　凯　商彤流　塔　拉　董　峰　韩立森　程林泉　傅佳欣
蔡全法　樊昌生

英文翻译　丁晓雷　赵永红　李梅田

编 辑 组　闫向东　孙　莉　宋小军　张亚娜　王光明　海　宁　李　茜　刘　能
雷　英　曹明明　郝莎莎　王　钰　吴书雷　樊　鑫　范雯静

凡　例

1. 《中国出土壁画全集》为"中国出土文物大系"之组成部分。

2. 全书共10册。出土壁画资料丰富的省区单独成册，或为上、下册；其余省、自治区、直辖市根据地域相近或所收数量多寡，编为3册。

3. 本书所选资料，均由各省、自治区、直辖市的文博、考古机构提供。选入的资料兼顾了壁画所属时代、壁画内容及分布区域。所收资料截至2009年。

4. 全书设前言、中国出土壁画分布示意图、中国出土壁画分布地点及时代一览表。每册有概述。

5. 关于图像的编辑排序、定名、时代、尺寸、图像说明：

编辑排序： 图像排序时，以朝代先后为序；同一朝代中纪年明确的资料置于前面，无纪年的资料置于后面。

定　　名： 每幅图像除有明确榜题外，均根据内容定名。如是局部图像，则在原图名后加"（局部）"；如是同一图像的不同部分，则在图名后加"（一）（二）（三）……"；临摹图像均注明"摹本"。

时　　代： 先写朝代名称，再写公元纪年。

尺　　寸： 单位为厘米。大部分表述壁画尺寸，少数表述具体物像尺寸，个别资料缺失的标明"尺寸不详"。

图像说明： 包括墓向、位置、内容描述。个别未介绍墓向、位置者，因原始资料缺乏。

6. 本全集按照《中华人民共和国行政区划简册·2008》的排序编排卷册。卷册顺序优先排列单独成册的，多省市区合卷的图像资料亦按照地图排序编排。编委会的排序也按照图像排序编定。

<div align="right">《中国出土壁画全集》编委会</div>

中国出土壁画全集

— ◆ 8 ◆ —

辽宁 吉林 黑龙江
LIAONING JILIN HEILONGJIANG

辽 宁
主 编：刘 宁
Edited by Liu Ning

吉 林
主 编：金旭东 副主编：傅佳欣 谷德平 董 峰
Edited by Jin Xudong, Fu Jiaxin, Gu Deping, Dong Feng

黑龙江
主 编：李陈奇 副主编：赵评春
Edited by Li Chenqi, Zhao Pingchun

科学出版社
Science Press

辽宁编委会名单

参编人员（以姓氏笔画为序）

万雄飞　孙国龙　都惜青　陶　亮　梁振晶　温科学

辽宁参编单位

辽宁省博物馆　　　　　　　　　　辽阳市文化局
辽宁省文物考古研究所　　　　　　朝阳市博物馆

吉林编委会名单

参编人员（以姓氏笔画为序）

林世香　赵　昕

吉林参编单位

吉林省文物考古研究所　　　　　　集安市文物局

黑龙江编委会名单

编　委

李陈奇　赵评春　盖立新　赵哲夫

参编人员

赵评春

黑龙江参编单位

黑龙江省文物考古研究所

辽宁、吉林、黑龙江地区出土壁画概述

刘　宁　傅佳欣　赵评春　盖立新

一、辽宁地区

辽宁省保存着中国迄今所知最古老的出土壁画遗物，那就是1983年在凌源、建平两县交界处牛河梁女神庙遗址出土的壁画残块，或用赭红色画出勾连纹图案，或用赭红间黄白色彩描绘三角纹图案，属距今五千多年前红山文化后期遗物[1]。

辽宁地区古代墓葬壁画，最早见于大连、辽阳两地的东汉时期壁画墓，此外，还有辽阳地区的汉魏壁画墓群、辽西朝阳地区三燕时期的几座壁画墓，同一时期的高句丽壁画墓主要发现于桓仁地区。大量的是辽代壁画墓，金元时期壁画墓的考古发现相对较少。

最为重要的东汉壁画墓是1931年在大连营城子发掘的东汉前期壁画墓[2]。这是一座砖筑多室墓，墓砖朝向墓室内的一面，印有红、黄、白彩绘的连球和方格纹；壁画内容丰富，主室门洞旁及后壁绘有怪兽、门吏、祥云、瑞鸟、卷草，及祝祷墓主人升天图。画面以墨线勾勒并施以红彩，构图简洁，笔调生动，具有较高的艺术造诣。

辽阳在秦汉以后是辽东郡治襄平城的所在地，东汉末年，公孙度据此统治辽东、辽西两郡，直至魏明帝景初二年（238年）公孙渊被司马懿讨灭为止，这里一直是公孙氏等望族属地。由于公孙氏的割据，此地未受到战乱的侵扰，这一带东汉晚期到西晋的壁画墓在继承传统的基础上继续发展。

辽阳地区东汉魏晋壁画墓主要发现在今辽阳城北郊和东南郊，已发表资料的墓葬有20余座，主要有1918年发掘的迎水寺墓[3]、20世纪40年代初清理的南林子墓[4]，1943年发现的北园1号墓[5]，1944年发现的棒台子1号墓[6]，1951年发现的三道壕第四窑场墓（车骑墓）[7]、1953年发现的令支令张氏墓[8]，1955年发掘的三道壕1、2号墓[9]，1957年发掘的棒台子2号墓[10]，1957年发掘的南雪梅1号墓[11]，1958年发掘的上王家村墓[12]，1959年发掘的北园2号墓[13]，

1974年发掘的三道壕3号墓[14]，1975年发掘的鹅房1号墓[15]，1983年发掘的东门里墓[16]，1995年发掘的南环街墓[17]等。

这些墓葬的特点是用当地所产南芬岩石板支筑墓室，不同于中原地区同时代的砖墓，墓葬一般由墓门、棺室、回廊、左右耳室组成。壁画主要使用黑、白、朱、绿、黄等色直接绘于墓门两侧、回廊、耳室的石壁上，有的画面先用白粉涂地，一些规格略高的壁画墓中的色彩则更为丰富。壁画内容以反映墓主人生前生活为主题，如家居宴饮、杂技百戏、车马出行、庖厨、楼阁等题材。大致可归为五类：一是门卒、门犬，主要绘在墓门入口处两侧的立柱上；二是墓主（多为夫妇两人）坐帐宴饮和乐舞百戏。墓主夫妇坐帐宴饮图多绘于前廊左右耳室，有的也绘在棺室旁的小室内，乐舞百戏场面则多绘在前廊壁面；三是车骑出行，一般绘于回廊周壁，也有的绘在耳室或小室中；四是府邸庖厨，主要绘于后廊、后室或耳室和小室中；五是日月天象、各种祥瑞、流云纹、辟邪神兽，通常绘于室顶、门柱、梁枋、楣额上，也有个别图像绘在四壁上端。

如棒台子1号墓，由并列的3个棺室、环绕棺室的回廊和左、右、后3个耳室组成。墓门内两侧绘门卒和守门犬，左耳室和右耳室均绘墓主饮食像，前廊东壁绘两组乐舞百戏，分别面对左右耳室中的墓主像。前廊顶部绘日月、云气；右廊、左廊均绘车马行列；后廊绘楼阁、水井；后耳室绘厨房。北园1号墓后廊东壁的北部绘楼阁，南部绘"小府史"、高楼、射鸟、乐舞百戏等，左前耳室绘房屋人物、犬和斗鸡场面，有"代郡廪"题记。

墓主夫妇坐帐像、车骑出行、府邸楼阁为最重要的三大表现主题。辽阳壁画墓的内容、形式虽与中原地区一脉相承，但具体描绘上仍表现出强烈的地方色彩。在门侧刻画门卒、属吏为中原壁画墓所常见，但

在门柱上绘门犬则不见于中原地区的壁画墓。

辽阳汉魏壁画墓前后延续时间较长，前期墓主像只绘男子像，有的墓中根据埋葬多人的情况，绘制多幅墓主像。后期的壁画题材发生了一些变化，如墓主像注重于帷帐、屏风、侍者的刻画，营造出一个更为安适的室内气氛。这一期的墓主像中普遍增加了女主人的形象，规模较大的墓继续流行多套墓主画像。如三道壕3号墓前廊右部（相当于右侧室）西壁绘男墓主像，北壁绘女墓主像。车马出行题材一般由多辆马车和导从的骑吏组成，基本保持了汉代的特征。如辽阳北园壁画墓的车骑出行图，墓室右大壁及中央左右二小壁绘骑从图，有仪仗骑卫之别，武士前队，兜鍪重札，马皆雕鞍饰勒。一骑士手擎朱色大麾委地，一骑士仗幢从之。数骑持伞盖继之。辽阳棒台子屯壁画墓的出行图绘于墓内右廊的左右后三壁及左廊左壁，除右廊后壁外，每壁都分上下两段横画，表现出行场面。车队中人物形象包括主人、骑吏、骑士、士兵、车夫、随行等，车骑有金钲车、鼓车、黄钺车、黑盖车、白盖车等，仪仗高举曲柄华盖、黑幢、朱色长旗等。据画面统计：全队人173名，马127匹，车10辆，矛、戟、幢、盖、棨戟、旗帜等数目也不少。

绘有壁画的石室墓在辽阳一带所发现的东汉魏晋墓中所占比例并不高，所以，其墓主应不是一般平民。在三道壕窑业第二现场墓发现"□支令张□□"的题记，是惟一可以籍以了解墓主身份的线索。规模更大的墓葬，如北园1号墓、棒台子1号墓等，则有可能包括有郡守一级官吏的墓葬。

西晋时期的墓葬以辽阳上王家村墓为例，右耳室所绘的墓主画像，正面端坐于榻上，手执麈尾，曲屏环列，上覆斗帐，这些特征与发现于朝鲜安岳的冬寿墓（357年）等墓主像十分近似[18]，墓中描绘出行行列中的牛车亦具有晋以后牛车的特点。

辽西地区所发现的壁画墓主要是慕容鲜卑三燕文化的遗存。337年慕容皝在大棘城建立前燕，342年迁都龙城。后燕（384~407年）、北燕（407~436年）也相继以龙城为都城。龙城即唐代柳城，在今朝阳市。已发表的壁画墓材料有1982年清理的朝阳袁台子壁画墓[19]，1965年清理的北票西官营子北燕冯素弗及其妻属墓[20]，1973~1978年清理的朝阳大平房村1号墓[21]和朝阳北庙村1号墓[22]。该地区的壁画墓从多方面表现出4至5世纪中叶汉文化与少数民族文化交融的特征。

袁台子墓为前燕墓，墓壁先抹一层黄草泥，再抹一层白灰面，在白灰面上用红、黄、绿、赭、黑等色绘制壁画。壁画内容有：执矛的门吏，端杯执麈尾坐于帐下的墓主，奉食的人物，墓主夫妇宴饮，狩猎，牛车出行，四神，庭院，备膳，日月流云及墨书题记等，内容包罗万象。

冯素弗及其妻属墓为同冢异穴，椁室四壁及顶部抹石灰，灰面上绘壁画，所见色彩有朱红、橙黄、绿、黑等。冯素弗墓壁画大部脱落，四壁的画面只残存黑狗的形象和一个男子的头像。在椁顶9块盖石上绘有星象，墓内的柏木棺上亦彩画羽人、云气、屋宇及人物。墓中出土遗物大多与中原和南方同时期的器物相似，也有金质步摇冠等具有少数民族特色的器物，以及域外传入的鸭形器等罗马玻璃器等，墓主人冯素弗为北燕天王冯跋之弟、北燕宰相。同时发掘的冯素弗妻属墓，椁室四壁和顶部涂抹草泥和石灰，残存彩画绘有屋宇、侍女、黑狗、长尾黑鸟，出行画像，墓主人家居图等。

大平房村壁画墓，壁面及室顶抹草泥和白灰，其上绘壁画。北壁有墓主夫妇像，东壁绘侍女、庖厨和牛。耳室中的壁画不清。该墓形制、壁画和随葬品多与冯素弗墓相似，年代亦应为北燕。北庙村1号墓又称"沟门子壁画墓"，墓室壁面抹白灰，以黑、红两色绘壁画，西壁绘牛耕，东壁残存墓主夫妇家居、女子汲水、庖厨、黑犬等，北壁绘墓主夫妇像、山林等。该墓壁画与冯素弗墓相似，时代应为北燕。

朝阳地区的壁画墓是鲜卑人和受鲜卑文化影响的鲜卑化汉人的遗存。这些墓葬明显具有多种文化因素交融的特征，与辽东等地的魏晋壁画墓也有密切的联系。袁台子前燕墓利用石板、石条构筑墓室，其墓室结构明显地具有来自辽东汉文化的影响，以袁台子壁画墓为代表的石板搭盖的石室墓可能就是辽东大姓

的遗存[23]。这些墓葬的壁画不像辽东墓葬那样直接画在石板表面，而是先抹草泥和白灰层再作画，更像中原砖室墓的作法。袁台子墓壁画使用的颜色较为丰富，而另外几座墓的壁画只使用红、黑两色，反映出不同时代的差别。无论在辽东地区还是辽西地区，魏晋墓葬壁画的题材继承了汉代壁画墓的一些特点，如墓主画像、车马出行、庖厨、房舍、星相等，都与东汉晚期河北、河南、山东等地的壁画墓有许多继承关系，但也出现了一些自身的特点，如袁台子墓新出现的四神、狩猎等内容都不见于辽东地区。

高句丽壁画墓在辽宁地区发现较少，桓仁米仓沟的"将军墓"是辽宁首次发现的高句丽壁画墓[24]。整个墓室由巨石砌成，左右耳室、主室墓壁上都绘有壁画，内容以莲花、龙纹、流云等装饰纹、几何纹图案为主，画风简朴，技法流畅，具有高句丽壁画墓注重装饰的特征。

辽代壁画墓大体分布在辽上京、中京和燕山以南的辽南京和西京之间。辽宁地区已发现辽墓千余座，其中壁画墓主要分布在辽中的铁岭及辽西的朝阳、阜新地区。辽代聚族而葬颇为盛行，在朝阳地区已发现的家族墓主要有：耶律仁先家族墓地、耿氏家族墓、赵氏家族墓、刘氏家族墓等[25]。如耿延毅墓在前室和后室四壁都绘有彩色壁画，墓门两侧绘髡发武士，墓室内绘日月、人物、花卉、飞鸟等。壁画采用勾勒墨线、平涂色彩的画法，技法精湛[26]。

铁岭叶茂台辽墓群最早发现于1953年[27]，以后陆续发现，1975年大批发现并发掘，见之于报道的有7号[28]、16号[29]、19号[30]、22号墓[31]。各墓都有大批文物出土，其中16号墓内尚存巨大的石棺、精美的壁画和长篇墓志铭。据墓志记载，墓主人为辽末天祚帝天庆初年卒葬的北府宰相萧义，叶茂台西山在辽代称"圣迹山"，知该墓群是萧氏一系的家族墓地。萧义墓墓道东西两壁所绘的出行、归来图，墓门两侧的献食、相迎图，以及甬道壁所绘武士图，线条流畅，人物生动，造型逼真，为我们研究辽代晚期的绘画艺术和北方游牧民族的生活习俗提供了宝贵资料。

阜新发现的辽代壁画墓主要有：1949年发掘的清河门区西山村辽墓[32]，1993年发掘的彰武县马家壁画墓群[33]，1998年发掘的黄家沟辽墓[34]，1999年发掘的大板镇平顶山辽墓及阜新县平安地辽墓[35]，2001年开始发掘的关山萧和家族墓[36]，此外，还有辽许王壁画墓[37]，萧图古辞家族墓壁画，烧锅营子萧墓壁画，彰武县木头沟辽代晚期石板壁画墓[38]。关山辽墓是一处辽代中晚期最显赫的外戚萧和家族的墓地，其中萧和与夫人晋国公主的合葬墓规模最大，在墓道、墓门正面和过洞、天井都绘有壁画，至今大部分颜色鲜艳，保存完好。

辽宁地区辽墓壁画主要有以下一些特点：所见辽代壁画墓早中晚期的都有。早期如叶茂台辽墓，中晚期如耿延毅墓、关山辽墓壁画等。所发现的壁画墓既有契丹贵族也有汉人望族的墓葬，如契丹后族萧氏的族墓及辽朝政权中"韩、刘、马、赵"四大汉人家族的墓地等。辽墓壁画主要绘制在墓道两侧的墙壁上，如关山辽墓的出行图；在墓门两侧多绘制武士门神，门楣上绘花鸟，墓室穹隆顶上彩绘祥云图案等。

从辽代墓葬壁画的内容来看，多是北方游牧民族生产、生活、风情习俗等题材，十分丰富。人物画是辽墓壁画的主要题材，有童子、官吏、奴仆等不同身份的契丹人、汉人，表现集体出行、围猎、归来、宴饮、伎乐，生动形象地再现了辽代社会各阶层人物的特点与风貌。动物有海东青、仙鹤、马，器物有罐、骨朵、木棍、宝剑、奚车等。"奚车"常见于辽墓壁画，高大突出的车轮，显示出车主人生前的雍容华贵。此外，辽墓壁画也多见牡丹花、荷花，是契丹贵族墓葬绘画的一大特色。还有以祥云、楼阁、对弈为题材的墓葬壁画。

辽墓壁画内容有受中原唐、五代、宋绘画影响的痕迹，如云龙图、凤凰图、门神图等，就是直接吸收了中原地区贵族墓壁画的题材；有些壁画内容注重写实性，反映契丹民族的生活，如关山辽墓壁画描绘的契丹贵族游猎迁徙的生活场景，将画中的侍卫、奴仆、出行图等契丹化，丰富和发展了辽墓壁画的内容。

从辽墓壁画的艺术风格来看，既保留了契丹民族

独特的艺术风格，又充分汲取了中原地区唐、五代、宋朝绘画艺术的风格。绘画造型准确，色彩淡雅，用笔飞动流畅。在绘画技法上，既有只用墨线勾勒的简洁古朴的风格，又有工笔精绘、再敷彩着色的精美之作，充分表现了辽代画师高超的艺术水平。

金代壁画墓从北宋和辽代末年的石椁墓和仿木构砖室墓发展而来。从金代壁画墓的分布区域看，主要是在今河北和山西地区，即金朝西京和中都为中心的广大地区。从壁画内容看，金墓壁画题材源自北宋和辽代末年壁画。辽宁地区的金代壁画墓以朝阳马令墓为代表[39]，此墓年代是金大定二十四年，即南宋淳熙十一年（1184年），四壁绘壁画六幅，并墨书墓主姓氏、族望、官职。壁画内容有备膳、备马出行、侍女捧盘等场景，用墨线勾勒轮廓，红、绿、灰三色渲染敷彩。线条劲健优美，人物生动逼真。

辽宁地区元代的壁画墓以凌源富家屯元代墓群为代表[40]，在墓室白灰墙面上绘壁画，内容有启关图、仕女图、柳荫别墅图、游乐图、侍寝图等。壁画绘制水平较高。墓葬年代约为元代早中期，墓主人很有可能是蒙古族人。

辽宁地区从新石器时代后期的红山文化女神庙壁画及汉魏至辽金元时期考古发现的大量壁画墓资料，不仅丰富了各时代绘画的内容，而且还具有极高的历史价值、文化价值、艺术价值。为研究古代社会的生产、生活、文化、宗教、习俗提供了宝贵的资料。

二、吉林地区

吉林省地处东北松嫩平原中部，西、北是草原和森林，南邻辽东，东望大海，曾是许多古代民族聚居的地方，也是古代文化交流的重要通道。根据文献记载，吉林境内的古代民族至迟在周代即与中原政权建立了联系。此后，中原文化和移民大量植入吉林，对这里古代民族的精神信仰和物质生活产生了持续的影响，曾为土著的夫余、鲜卑、高句丽、靺鞨、契丹、女真、满族等民族先后在这里生活、崛起、融合，在缔造中华民族文化的历史进程中，曾作出过重要的贡献。

吉林省发现的古代壁画是在中原文化影响下产生的。吉林目前所知的古代壁画大致可分三个区域：一是高句丽政权都城所在的国内城（集安）地区，二是渤海政权都城所在的中京（和龙）、东京（珲春）一带，三是辽代契丹故地的今白城、双辽迤西。前两者为地方政权的国都，后者是契丹贵族修建头下军州城密集的地区。所见壁画分墓室壁画和庙堂壁画两大类。墓室壁画以高句丽时期为多，集中保存在集安市区周边高句丽时期的洞沟古墓群中。少量渤海壁画墓分布在延边地区。吉林西部的考古工作较弱，曾发现一些辽金时期的壁画墓和彩绘装饰墓，但完整画面保存甚少。庙堂壁画主要发现于渤海宫殿、寺庙、享堂遗址中，亦多见残壁，难窥全貌。目前省内见诸报道的古代壁画墓33座，其中高句丽壁画墓32座，渤海壁画墓1座。上述壁画墓虽均被盗掘，仍保留有较完整的墓室和绘画内容。

吉林省境内利用现代考古学方法记录古代壁画始于20世纪初。日俄战争后，考古调查在日本军国主义刺刀的掩护下遍及吉林各地。在早期调查延边地区渤海国建筑遗址时，曾发现有寺庙壁画的线索。30年代中后期，日本帝国主义在修筑中国东北通往朝鲜的铁路工程中，非法发掘了集安马槽墓、散莲花墓等一批高句丽壁画墓。稍后，日本学者池内宏等以日满文化协会邀请之名又来集安调查著录了舞踊墓等高句丽壁画古墓，并于1938年出版了田野考古报告《通沟》。这些工作虽然保留了一批珍贵的早期科学资料，却使学术研究充满了殖民主义色彩。

新中国成立以后，文物工作者立即开始了对集安高句丽壁画墓的调查和保护，成立了专门的文物保护机构，封堵了长年洞开的壁画墓墓门。1961年洞沟古墓群被国务院公布为全国重点文物保护单位，壁画墓开始得到更加有效的保护。60年代初以后，文物工作者首先调查确认了日本学者记录的壁画古墓，又陆续清理了麻线沟1号墓、五盔坟4号墓、三室墓、莲花墓、王字墓、禹山1041号墓、万宝汀1368号墓、长川1号墓、长川2号墓、长川4号墓、禹山3319号墓、散莲花墓等十余座壁画墓。60年代中期实施的洞沟古

墓群测绘工作和壁画墓内温湿度观测记录工作，使壁画墓具有了科学的保护档案。1963年，中朝联合考古队对集安的高句丽壁画墓进行了记录和复制，此后，吉林考古部门开始临摹部分墓室壁画。

1972~1982年，内蒙古自治区的哲里木盟（今通辽市）曾一度划归吉林省管辖。吉林省文物工作者在该区域进行文物普查的同时，于1972、1974年清理了库伦旗的4座辽代壁画墓。1980年，延边朝鲜族自治州博物馆清理了和龙县龙头山古墓群中的渤海文王第四女贞孝公主墓，首次发现唐代风格的大面积墓葬壁画。据出土墓志记载，贞孝公主卒葬于渤海文王大兴五十六年，即792年。后来的调查得知，龙头山墓群还保留有数座同时期的渤海壁画墓。

1992年始，吉林省文物工作者在国家文物局的支持下，对集安洞沟古墓群及高句丽壁画墓进行了一次大规模补测和影像记录，保存了一批完整的基础资料。在已故方起东所长、林至德馆长的带领下，集安现存壁画墓被全数拍摄，第一次建立起完整的影像档案。嗣后，壁画墓绝大多数被永久封闭。然而时隔未久，境内外不法分子勾结，对具有代表性的三室墓、长川1号墓疯狂盗揭，致使长川1号墓前室北壁人物风俗画面、三室墓多处画面被盗取或破坏，造成了不可弥补的重大损失。

2004年，吉林集安、辽宁桓仁两地高句丽遗迹的精华，以"高句丽王城、王陵及贵族墓葬"之名，被联合国教科文组织批准列入世界文化遗产名录。其中洞沟古墓群中具有重要学术价值和艺术价值的冉牟墓（JXM001）、环纹墓（JXM033）、角抵墓（JYM457）、舞踊墓（JYM458）、马槽墓（JYM1894）、散莲花墓（JYM1896）、王字墓（JSM332）、龟甲墓（JSM1204）、折天井墓（JSM1298）、禹山墓区3319号墓（JYM3319）、四神墓（JYM2112）、五盔坟4号墓（JYM2104）、五盔坟5号墓（JYM2105）长川1号墓（JCM1）、长川2号墓（JCM2）、长川4号墓（JCM4）等16座壁画墓名列其中。

高句丽壁画墓集中分布在鸭绿江右岸集安城区周边，由于地处高句丽早期都城附近，蕴含着壁画墓从

产生、发展到消亡的全部历史信息，在我国古代壁画发展史研究中，是一个不可缺少的重要环节。其重要性不仅在于年代链条完整，包含有高句丽社会发展进程、民族风俗变迁的内容，还因为高句丽壁画墓是汉晋壁画墓分布的边缘地区，具有地域的、民族的、文化交融的显著特征，其原真性与史料价值无可替代。

高句丽传统墓葬为积石墓。约4世纪中叶在贵族上层开始流行壁画墓。最早的壁画墓出现在朝鲜半岛的汉乐浪郡地区。又迅速传播到高句丽政权的都城集安地区。虽然高句丽西有辽东郡、南有乐浪郡两个壁画墓分布区的来源途径，但据墓葬形制和壁画分析，与乐浪的联系居多且持久。高句丽壁画墓作为一种外来因素，同既往高句丽传统墓葬迥然有别。首先，墓葬外形一改"积石为封"的习俗，改用封土为丘。墓室由简单的石圹变成了高敞的穹隆顶墓室，唯一保留的旧俗是筑墓于地上。其次，壁画墓由照搬中原壁画模式开始，虽历经模仿到改造，最终也没有超出中原壁画模式的窠臼。到高句丽晚期，以五盔坟4号墓、5号墓为代表的壁画墓墓室由地面转至地下，完成了与中原壁画墓殊途同归的嬗变。

集安现存的壁画墓虽然有30余座，因壁画内容与保存状况的不同，仅有9座墓壁画可供分析和欣赏。目前通行的研究将高句丽壁画墓分为四期。第一期，约4世纪中叶到5世纪初，以角抵、舞踊墓为代表。墓葬形制为单室穹隆顶，设双耳室，墓道偏西。有白灰地仗，壁画内容丰富。主壁绘墓主人家居生活，通壁的帷幔内有男女墓主人对坐，侍者，几案食物等。前壁是树木。左右两壁为生活场景，有狩猎、歌舞、备乘、庖厨等，角抵墓东壁的大幅角抵画面可能与墓主人生前经历有关。四壁与藻井间为一斗三升的梁柱、梁枋。藻井壁画同样精彩，除云气、星象、蔓草、日月外，还有瑞兽、瑞鸟、仙人；舞踊墓出现了尚不成熟的四神：朱雀为写实的雄鸡形象，青龙、白虎偏于一隅，玄武的位置竟然是二人角抵。角抵墓则只有日月二神。耳室绘房屋、侍者、树木等。墓道以狗守卫。这时的壁画延续了魏晋以来士大夫闲逸生活景象的描绘风格，均绘有牛车，同时加进了高句丽传

统风俗的内容。墓主人居墓中主要位置，神仙题材均位于象征天上的藻井。天、神、人共处一室，道家气氛较重，应该处在最初的模仿时期。第二期，约5世纪，以马槽墓、王字墓为代表。墓葬形制仍是单室穹隆顶，双耳室。西向。这时的穹隆顶趋于规范，已由一期的抹角圆形向叠涩方形转变。壁画内容从写实向图案演进。壁画布局与一期相似，生活场景的描绘由通壁单一内容渐变为一壁多内容，耳室、墓道壁画变得丰富起来，突出了象征财富的厩马、房屋等。出现了佛教题材的仰视莲花和象征帷幔的"王"字形大幅图案。这时期的墓葬还出土有鎏金冠饰、釉陶器、漆器等贵族使用的器物。表现墓主人经历的画面依然存在，如马槽墓的斩俘图。这一时期是高句丽壁画的发展、创新阶段，权贵思想与神仙观念正在形成。这期还发现有汉人亡入高句丽并担任其官吏者的砖室壁画墓，可以想象壁画内容必定对高句丽人产生影响。第三期，约5世纪末到6世纪中叶，以三室墓、长川1号墓为代表。这一时期是高句丽壁画墓的滥觞时期，墓葬形制有单室、双室、三室等，随之而来的是耳室的退化。墓室藻井由穹隆顶变为平行叠涩的覆斗形，但仍在四隅保留有抹角石。壁画中的写实性内容被神仙、力士所替代，流行守门武士或门吏。除长川1号墓外，主壁壁画多图案化或神仙化。四神已具有方位神的意义，但未像中原壁画中四神位置和形状那样规范。如三室墓是一个连续折返的三合院格局，各室均有四神且双双并列，但位置各异，仅第一室方位正确。佛教题材大量出现，如环纹墓墓道的护法狮子，长川1号墓的菩萨、拜佛、飞天等。将菩萨绘在墓葬中，是其笃信神灵却不谙佛教的原因。这时墓葬表现出的精神信仰仍以道家为主并已经形成主流。第四期，约6世纪中叶到高句丽灭亡的7世纪中叶，以五盔坟4号、5号墓为代表。此时高句丽政权中心已迁往平壤，具有权贵身份象征的壁画墓在我国所存数量较少，形制已趋于一致。集安的晚期墓葬形制为单室，均大抹角石叠涩藻井，墓室多移至地下。墓道已偏向南方。其中一个重要现象是壁画没有地仗，而是直接绘在石壁上，这表明此时对颜料配比、调和、加固的

技能已达到了较高的水平。这时壁画的显著特点是四神成为画面主体，在四壁上按方位描绘大幅的四神，藻井东西两侧均有日月神，砌石正面绘伏羲、女娲及古代传说中的轩辕、神农、奚仲等先贤。还有驾鹤驭龙、抚琴奏角、吹箫击鼓等先贤与仙人。墓道绘执戟护法，梁枋、藻井盖石绘蟠龙或行龙。壁画内容仍以道教题材为主，也有一些佛教题材如莲花、宝珠、火焰纹，道释一体的踏莲仙人等，其神仙氛围浓重。墓内色彩丰富，对比强烈，大量颜色保持如新。除前期地仗壁画所用的赭石、辰砂、土黄、烟墨等色彩外，新出现了石青、朱砂、铅白等颜色和黄色、中间色等。集安的高句丽晚期壁画墓营造之精细、绘画之丰富、色彩之艳丽，已超过同时期平壤附近的高句丽王陵，可以称为高句丽晚期壁画的颠峰之作。这种现象可能是高句丽晚期王权式微，远驻在别都集安的高句丽望族僭越所致。

渤海壁画墓是20世纪80年代渤海考古的重大发现，填补了吉林省唐代人物壁画墓分布的空白。渤海效仿唐代官制和礼制，其上层崇尚唐风，习唐诗文，盛行佛教，所见文物多现唐韵。1980年发掘的渤海贞孝公主墓，墓主系渤海文王大钦茂之四女，其墓在和龙县龙头山墓群中央，墓志记载葬于792年，该墓即是一座砖塔下的壁画墓。

墓室即塔宫，为长方形砖砌。四壁、甬道地仗均绘有人物图像共12人。甬道绘相对的仪卫武士，墓室两侧各有4人，北端2人，均面向墓门。人物着唐代服装中最流行的圆领袍服，色彩丰富饱满。据所执物品，可分侍卫、内侍、乐伎，其中还有男装女侍。壁画人物面庞丰腴，体形雍壮，为典型盛唐风格。贞孝公主墓规模不大，壁画也没有唐代公主墓壁画那样浩大的出行仪仗场面，但渤海贵族生活已跃然于壁上，这些人物可能就是贞孝公主近侍的写照。同墓地还发现有其他渤海王室贵族墓葬，出土三彩俑、玉带、墓志等珍贵文物。目前，文物保护工程正在进行中。

吉林省虽所处偏远，古代民族纷纭，但文物传统、精神文化与中原文化同脉。上述古墓壁画是一项

丰厚的精神财富，可供人们研究和欣赏。

说明：因本书所记局部壁画位置采用习惯方位注录，引用时请核对原报告。

三、黑龙江地区

黑龙江省考古发现的壁画墓主要在渤海国王陵区。其位于黑龙江省宁安市三陵乡政府所在地，1991年经考古发掘出土壁画的"三陵二号墓"，地处陵区东部的三星村东侧，东经129°06′54.63″；北纬44°10′02.55″。该陵区北倚漫岗，南临牡丹江，距渤海上京龙泉府北门约4公里。

1988年秋，黑龙江省文物考古研究所对早年被盗、并经日本考古学者进行过发掘的"三陵坟"，进行了系统的清理发掘，出土了大量的大型玄武岩建筑饰件、壁画残块、文字瓦、墓土残骸，并且在墓道底部清理出石砌雕凿棺床、整块玄武岩雕凿的踏道及石户枢等墓门构件。

1989年秋，继续对其周围的园墙遗存进行了探查试掘。查明三陵坟周围园墙的准确位置，园区分南北二区，三陵坟位于北区中部，园门南开，西临其他石墙园区。这次发掘工作，不仅确认了石墙的范围，更重要的是就在三陵坟正南、园区以外的农田之中，发现"神道"遗迹。略显凸起的神道，为人工夯筑，直接与三陵以东江段的渤海时期桥址相通。所以，由上京龙泉府北行通过"渤海七孔桥"（七墩八孔），西行至"神道"即可进入园区。当时，经我们研究发现，这一历来被定为渤海贵族的墓地，应属于渤海国王陵区。

1991年秋，黑龙江省文物考古研究所在地球物理勘探的基础上，对三陵坟东北角新发现墓葬（统一编号为"三陵二号墓"）进行考古发掘。

该墓整座墓室建在地下，地面之上略有凸起，原有夯土封堆已被破坏。墓室顶部为半球状白灰层封护，整座墓由墓道、甬道、墓室三部分组成，用雕凿整齐的玄武岩石块砌就，墓向朝南。墓顶由大块的玄武岩石板封盖，甬道开在墓室南壁中部，墓室上部为抹角叠涩藻井，墓室长约390、宽约330、高约245厘米，甬道长约270、宽约140、高约170厘米，墓室内摆放着十余具骨骼，为多人合葬，所出骨骼既有成年人的，也有儿童的。墓室和甬道的壁面、顶部的白灰层上，都绘有精美的壁画。

壁画内容可分为花卉和人物两类，墓室抹角叠涩藻井部分的壁画全部为花卉，基本形式为二方连续的团花，图案美观，色泽艳丽。墓室四壁及甬道两侧为人物形象，多已剥落，但人物的姿态与服饰仍依稀可辨，墓室四壁人物多为女性，面部丰腴，颇具唐风；甬道南端东西两壁所绘武士形象，造型生动传神。

渤海王陵区内大型石室壁画墓的发掘，为渤海史研究提供了葬俗礼制、埋葬制度、人种、建筑、艺术、服饰等多方面的宝贵资料，具有重要的研究价值。

注 释

[1]辽宁省文物考古研究所：《辽宁牛河梁红山文化'女神庙'与积石冢群发掘简报》，《文物》1986年第8期。

[2]东亚考古学会：《营城子——前牧城驿附近の汉代壁画砖墓》，《东方考古学丛刊》，第四册，昭和九年（1934年）。

[3]八木奘三郎：《辽阳发现的壁画古坟》，《东洋学报》11-1，1921年。

[4]原田淑人：《辽阳南林子の壁画古坟》，《国华》629号（1943年4月）。

[5]李文信：《辽阳北园画壁古墓记略》，《国立沈阳博物院筹略委员会汇刊》第一期，1947年10月。亦见《李文信考古文集》，辽宁人民出版社，1992年。

[6]李文信：《辽阳发现的三座壁画古墓》，《文物参考资料》1955年第5期。

[7]李文信：《辽阳发现的三座壁画古墓》，《文物参考资料》1955年第5期。

[8]李文信：《辽阳发现的三座壁画古墓》，《文物参考资料》1955年第5期。

[9]东北博物馆：《辽阳三道壕两座壁画墓的清理工作简报》，《文物参考资料》1955年第12期。

[10]王增新：《辽阳市棒台子二号壁画墓》，《考古》1960年第1期。

[11]王增新：《辽宁辽阳县南雪梅村壁画墓及石墓》，《考

古》1960年第1期。

[12]李庆发:《辽阳上王家村晋代壁画墓清理简报》,《文物》1959年第7期。

[13]辽阳市文物管理所:《辽阳发现三座壁画墓》,《考古》1980年第1期。

[14]辽阳市文物管理所:《辽阳发现三座壁画墓》,《考古》1980年第1期。

[15]辽阳市文物管理所:《辽阳发现三座壁画墓》,《考古》1980年第1期。

[16]冯永谦等:《辽阳旧城东门里东汉壁画墓发掘报告》,《文物》1985年第6期。

[17]辽宁省文物考古研究所:《辽宁辽阳南环街壁画墓》,《北方文物》1998年第3期。

[18]郑岩:《墓主画像研究》,《刘敦愿先生纪念文集》,山东大学出版社,1998年。

[19]辽宁省博物馆文物队等:《朝阳袁台子东晋壁画墓》,《文物》1984年第6期。

[20]黎瑶渤:《辽宁北票县西官营子北燕冯素弗墓》,《文物》1973年第3期。

[21]朝阳地区博物馆、朝阳县文化馆:《辽宁朝阳发现北燕、北魏墓》,《考古》1985年第10期。

[22]朝阳地区博物馆、朝阳县文化馆:《辽宁朝阳发现北燕、北魏墓》,《考古》1985年第10期。陈大为:《朝阳县沟门子晋壁画墓》,《辽海文物学刊》1990年第2期。

[23]田立坤:《袁台子壁画墓的再认识》,《文物》2002年第9期。

[24]武家昌等:《桓仁米仓沟高句丽壁画墓》,《辽宁考古文集》,辽宁民族出版社,2003年。

[25]朝阳市博物馆:《朝阳历史与文物》,辽宁大学出版社,1995年。

[26]朱子方等:《辽宁朝阳姑营子辽耿氏墓发掘报告》,《考古学集刊》(3),1983年。

[27]刘谦:《辽宁法库县叶茂台辽墓调查》,《考古通讯》1956年第3期。

[28]辽宁省博物馆、辽宁铁岭地区文物发掘小组:《法库叶茂台辽墓记略》,《文物》1975年第12期。

[29]温丽和:《辽宁法库县叶茂台辽肖义墓》,《考古》1989年第4期。

[30]马洪路、孟庆忠:《法库叶茂台十九号辽墓发掘简报》,《辽宁文物》总第3期,1982年。

[31]许志国、魏春光:《法库叶茂台第22号辽墓清理简报》,《北方文物》2000年第1期。

[32]李文信:《清河门西山村辽墓发掘报告》,《阜新辽金史研究》(第一辑),香港飞天出版社,1992年。

[33]张春雨、刘俊玉、孙杰:《彰武县文物志》,辽宁民族出版社,1996年。

[34]郭天刚等:《阜新黄家沟辽墓》,《阜新辽金史研究》(第四辑),中国社会出版社,2000年。

[35]梁姝丹:《从阜新辽墓壁画看辽代绘画艺术的风格特点》,《辽金史研究》,吉林大学出版社,2005年。

[36]华玉冰、万雄飞:《阜新辽代萧和家族墓地发掘出土精美壁画及墓志》,《中国文物报》2002年5月3日第一版。

[37]欧阳宾:《辽许王墓清理简报》,《阜新辽金史研究》(第一辑),香港飞天出版社,1992年。

[38]张春雨、刘俊玉、孙杰:《彰武县文物志》,辽宁民族出版社,1996年。

[39]辽宁省博物馆:《辽宁朝阳金代壁画墓》,《考古》1962年第4期。

[40]辽宁省博物馆、凌源县文化馆:《凌源富家屯元墓》,《文物》1985年第6期。

[41]池内宏、梅原末治:《通沟》,日满文化协会,1938年。

[42]吉林省博物馆辑安考古队:《吉林辑安麻线沟一号壁画墓》,《考古》1964年第10期。

[43]王承礼、韩淑华:《吉林辑安通沟第十二号高句丽壁画墓》,《考古》1964年第2期。

[44]吉林省博物馆:《吉林辑安五盔坟四号和五号墓清理略记》,《考古》1964年第2期。

[45]张雪岩:《集安两座高句丽封土墓》,《博物馆研究》(内部刊物)1988年第1期。

[46]集安县文物保管所、吉林省文物工作队:《吉林集安洞沟三室墓清理记》,《考古与文物》1981年第3期。

[47]李殿福:《集安洞沟三室墓壁画著录补正》,《考古与文物》1981年第3期。

[48] 李殿福：《集安洞沟三座壁画墓》，《考古》1983年第4期。

[49] 吉林省文物工作队、集安县文物保管所：《集安长川一号壁画墓》，《东北考古与历史》第1辑，文物出版社，1982年。

[50] 吉林省博物馆文物工作队：《吉林集安的两座高句丽墓》，《考古》1977年第2期。

[51] 张雪岩：《吉林集安东大坡高句丽墓葬发掘简报》，《考古》1991年第7期。

[52] 吉林省文物工作队：《吉林集安长川二号封土墓发掘纪要》，《考古与文物》1983年第1期。

[53] 方启东、刘萱堂：《集安下解放第31号壁画墓》，《北方文物》2002年第3期。

[54] 吉林省文物考古研究所、集安市文物保管所：《集安洞沟古墓群禹山墓区集锡公路墓葬发掘》，《高句丽研究文集》1993年。

[55] 延边朝鲜族自治州博物馆：《渤海贞孝公主墓发掘清理简报》，《社会科学战线》1982年第1期。

Murals Unearthed from Liaoning, Jilin and Hei Longjiang

Liu Ning, Fu Jiaxin, Zhao Pingchun, Gai Lixin

1.The Murals Unearthed in Liaoning Province

In Liaoning Province, some painting fragments, the earliest-known mural remains in China, were found at the Goddess Temple Site at the border of Lingyuan and Jianping counties in 1983; they were decorated either with reddish brown consecutive scroll designs, or triangular patterns alternating with reddish brown and yellowish white colors, which could be ascribed to the late Hongshan Culture, dating back to 5000 years ago[1].

The ealiest ancient tomb murals in Liaoning province were found in the Eastern Han tombs at Dalian and Liaoyan, and then in some Han & Wei tombs at Liaoyang, as well as in the Three Yan tombs at Chaoyang of western Liaoning; however, the contemporaneous Koguryo mural tombs have been mostly found in Huanren area. Finally, a lot of mural tombs in Liaoning could be ascribed to the Liao Dynasty, but relatively only a few could be ascribed to Jin and Yuan Dynasties.

The most impressive Eastern Han mural tomb should be the one found at Yingchengzi of Dalian area in 1931, dating on earlier Eastern Han Dynasty[2]. It's a multi-chambered tomb built of bricks, on the inside surface of the bricks some designs of linked roundels and grids are impressed and painted in red, yellow or white. The mural motifs on its entryway sides and back wall are varied, including the mythic animals, doorkeepers, clouds, auspicious birds, tendril, as well as the depiction of the tomb occupant accompanied by a flying transcendent. The depictions were outlined with ink and then painted with red color, demonstrating a high art achievement by the succinct composition and vivid drawing style.

Liaoyang, formerly named Xiangping, had become an administrative center of Liaodong Commandery since Qin-Han Dynasty. At the end of Eastern Han dynasty, it was controlled by Gongsun Du who ruled the Liaodong and Liaoxi commanderies, and became a territory of Gongsun and other strong clans until Gongsun Yuan was defeated by Sima Yi in 238 CE. Due to Gongsun Clan's regional ruling, this area was less disturbed by wars; as a result, the mural tombs of that time got a continuous development on the basis of tradition.

Over 20 mural tombs, dating on Eastern Han and Wei-Jin dynasties, have been reported, most of which were found at the northern and southeastern suburbs of modern Liaoyang City: the tomb excavated at Yingshuisi[3] in 1918, the tomb at Nanlinzi[4] in earlier 1940s, the No.1 tomb at Beiyuan[5] in 1943, the No.1 tomb at Bangtaizi[6] in 1944, the tomb at the 4th kiln factory of Sandaohao[7] in 1951 (with depictions of carts and horse-riders), the tomb of Zhang (a magistrate of Lingzhi) [8] in 1953, the No.1 and No.2 tombs at Sandaohao[9] in 1955, the No.2 tomb at Bangtaizi[10] in 1957, the No.1 tomb at Nanxuemei[11] in 1957, the tomb at Shangwangjiacun[12] in 1958, the No.2 tomb at Beiyuan[13] in 1959, the No.3 tomb at Sandaohao[14] in 1974, the No.2 tomb at E'fang[15] in 1975, the tomb at Dongmenli[16] in 1983, the tomb at Nanhuanjie[17] in 1995, etc.

These tombs are characteristic of being built of local stone slabs, which is distinct from the contemporaneous tombs found in the Central Plain, which were built of bricks; the tombs usually consisted of an entryway, a coffin chamber, a surrounding corridor and small side chambers. The mural was painted on the stone walls at both side of the entryway, the corridor and side chambers in black, white, red, green and yellow colors; some of the walls were plastered before being painted; some tombs in higher burial ranks are characteristic of more colorful depictions. The motifs, usually concerning the lifetime of the tomb occupants, consisted of scenes of feasts, entertainments, cooking in kitchens, and various buildings, which could be roughly divided into five types: (1) the door guardians and door dogs depicted on the columns of the entryway; (2) the tomb occupants (mostly the couple) and the scenes of feasts and entertainments under a canopy, mostly

depicted in both side chambers of the front corridor, some depicted in the small chambers of the main chamber; (3) the chariots and riders in procession, usually on walls of the surrounding corridors, some depicted on walls of the side or small chambers; (4) the buildings and scenes of cooking in kitchen, mostly depicted at back of the corridor or back chambers and small chambers; (5) the heavenly constellations, various auspicious signs, clouds and apotropaic beasts, mostly depicted on the ceilings, columns, beams and lintels, few depicted on the upper parts of the walls.

For example, the No.1 tomb at Bangtaizi, consisting of three paralleled coffin chambers, surrounding corridors and three side chambers, was depicted with door guardians and door dogs on both sides of the entryway; the tomb occupants and dining scene at both side chambers; two groups of dancing and entertainment scenes on the front wall of the corridor against the tomb occupants' portraits; the Sun, the Moon and clouds on the ceiling of the corridor; carts and horses in procession on both side walls of the corridor; buildings and wells on the wall of back corridor, and a kitchen on the wall of back chamber. Another tomb, the No.1 tomb at Beiyuan, was depicted on east wall of the back corridor with buildings at the northern part, a label "xiao fu shi" (Granary Clerk), a tower building, scenes of bird-shooting and dancing entertainments at the southern part; on its walls of the front side chamber, the scenes of figures in a building, dogs and cock-fighting were depicted and labeled with "dai jun lin", which might demonstrate it was some kind of storehouse.

The depictions of the tomb occupant couple under a canopy, the chariot and calvary procession and the buildings should be the most significant themes in tomb murals of this area. The themes, as well as its styles, apparently inherited from the Central Plain, but demonstrated some strong regional characteristics. For example, the depictions of door guardians and petty officials on entryway sides were popular in the Central Plain, but the door dogs have never been seen.

The mural tombs of Han and Wei dynasties in Liaoyang cover a long period, in the earlier examples only the male portraits were depicted, sometimes more than one portrait were shown if the tomb was occupied by more than one person. However, the situation had changed in the later portraits of the tomb occupant, a more comfortable circumstance was achieved by more attentions being paid on the descriptions of canopies, screens and attendants. In this period, the additional portrait of tomb occupant's wife had become popular, and the multiple portraits in lager tombs still existed; in Sandaohao Tomb No.3, a male portrait was depicted on the west wall at right of the front corridor (or right side chamber), and a female portrait was depicted on the north wall. The depiction of carts and riders in procession usually consist of several horse-drawn carts and some guiding riders, which inherited from the Han murals on the whole; in the case of Beiyuan Mural Tomb of Liaoyang, the depiction of procession was on the right wall and two small central walls, consisting of honor guardians and mounted entourages: a mounted warrior holding a large red flag preceded, another one holding a different flag following, and more riders holding an umbrella going after them. In the Bangtaizi Mural Tomb of Liaoyang, the procession scene was on three walls of the right corridor and left wall of the left corridor, all of the depictions, except the one on back wall of the right corridor, were divided into the upper and the lower registers; the figures in procession consisted of the tomb occupant, mounted attendants, soldiers, cart drivers, and other retinue; the caravan consists of various carts, including the bell cart, the drum cart, the cart with a large yellow battle axe, and the carts with black and white canopies; the honor guardians hold the umbrella with a crooked shaft, various black and red flags; in the procession, totally 173 figures, 127 horses, 10 carts and sorts of weapons, tools and flags were described.

The stone-chamber tombs with murals occupied a lower percentage of the Eastern Han and Wei-Jin tombs in Liaoyang, therefore their occupants might not be the common people. The label"□支令张□□", demonstrating that the occupant was Zhang, a local county magistrate, was the only clue about the occupant's status. In other cases, some larger tombs, like the No.1 tomb at Beiyuan and the No.1 tomb at Bangtaizi, might be occupied by the officials equivalent to prefecture governors.

The tomb at Shangwangjiacun of Liaoyang was an example of the Western Jin tombs, in which the tomb occupant's portrait was depicted at the right side chamber, the tomb occupant was seated on the ta-bed in a frontal pose, holding a fly whisk made of a deer tail, surrounded by a screen, and covered by a canopy, all these features are similar with those in Dongshou's tomb (357 CE) found at Anyue in Korea[18]; in addition, the ox cart in procession was depicted similarly to the one in post-Jin dynasty.

The mural tombs found in Western Liaoning should be mostly ascribed to the Murong Xianbei. In 337 CE, Murong Huang established the Former Yan Kingdom at Daji City, and then in 342, moved its capital to Longcheng (also called Liucheng in the Tang dynasty, modern Chaoyang City), which also severed as the capital of the following Later Yan and Northern Yan Kingdom. The reported tombs include the mural tomb excavated at Yuantaizi in 1982[19], Feng Sufu and his wife's tombs at Xiguangyingzi of Beipiao in 1965[20], the No.1 tomb at Dapingfang Village of Chaoyang in 1973-1978[21], and the No.1 tomb at Beimiao Village of Chaoyang[22]. These mural tombs demonstrate a hybrid of the nomadic ethnic groups and the Han cultures during the 4th to the middle 5th centuries CE.

The Yuangtaizi mural tomb, dating upon the Former Yan period, was plastered with a layer of yellow cob and a layer of white lime before it was painted in red, yellow, green, brown and black. The mural's motif is extensive, including the doorkeepers, the tomb occupant with a fly whisk in hand sitting under a canopy, food-serving attendants, the scenes of the deceased couple in dining, hunting, traveling in ox carts, the Four Supernatural Beings, the courtyard, food-preparing, the Sun, Moon and clouds, and inked inscriptions, etc.

The tombs of Feng sufu and his wife, having separate chambers but sharing a burial mound, were plastered on walls and ceilings and then painted in red, orange, green and black colors. In Feng Sufu's tomb, most of the murals on inside walls flaked off, only depictions of a black dog and a male's head have survived; however, a depiction of constellation has been remained on 9 ceiling slabs of the roof, and a feathered transcendent, clouds, building, figures were painted on the cypress coffin. Most of the unearthed funeral objects are similar to those found in contemporaneous southern tombs, but some objects characteristic of the nomadic tribes, such as the gold headdress "buyao", and some imported glassware like the duck-shaped Roman glass vessel, were also found. Feng Sufu, the tomb's occupant, was a prime minister and brother of Feng Ba, the ruler of Northern Yan. In Feng's wife's tomb, it was plastered and painted on the walls and ceilings, some depictions of buildings, female attendants, black dogs, black birds with long tails, scene of traveling and daily life of the tomb occupant have survived.

The mural tomb found at Dapingfang Village was also plastered and then painted. It depicted the tomb occupant couple on the north wall, female attendants, kitchen and ox on east wall, and some illegible paintings on the walls of the side chamber. Its construction, as well as the murals and funeral objects, are similar to Feng Sufu's tomb, therefore it should be dated on Northern Yan period. Another tomb, also called Goumenzi Mural Tomb, was plastered and painted in red and black, depicting the ox-plowing on its west wall, and the domestic scenes of the tomb occupant couple, water-drawing, cooking, and black dogs on east wall, the tomb occupant couple and forests on the north wall; which are similar to those in Feng Sufu's tomb, it should be also dated on Northern Yan period.

The mural tombs in Chaoyang Prefecture should be ascribed to either Xianbei people, or Han people who were influenced by the Xianbei custom; apparently they demonstrated a hybrid culture, and were closely related to the Wei-Jin tombs in Liaodong area as well. For example, the mural tombs built of slabs, such as the one found at Yuantaizi, are probably remains of some Powerful clans of Liaodong origin[23]; the murals, not alike those in Liaodong where the depictions were painted directly on the stone surfaces, were plastered before being painted, which resembled the procedure used in the Central Plain murals. Finally, the colors applied in Yuantaizi Mural Tomb were more varied than those in other tombs, in

the latter cases they were usually only depicted with red and black colors; the difference might be caused by times. Some of the mural themes of Wei-Jin dynasties, whether in Liaodong or in Liaoxi, inherited from the Han tombs, such as the tomb occupants' portraits, the depictions of carts and riders in procession, the kitchens, buildings and constellations, all demonstrating close relations with the murals of Later Eastern Han dynasty in Hebei, Henan, Shandong etc; however, some unique regional features also appeared, for example, the Four Divine Animals and the hunting scenes, which have never been seen in Liaodong area.

The Koguryo mural tombs are relatively rare in Liaoning, the "General's Tomb" at Micanggou of Huanren was the first Koguryo tomb ever found in this area[24]. The tomb was built of large rocks, depicting some geometrical or decorative designs like lotuses and dragons on the walls of side chambers and main chamber; it demonstrated a characteristic style of Koguryo murals in which more attentions were usually paid on the decorative effects.

In general, the mural tombs of the Liao dynasty were mostly found at Shangjing (Upper Capital) and Zhongjing (Central Capital) areas, as well as Nanjing (Southern Capital) and Xijing (Western Capital) areas to the south of the Yan Mountains. Among over 1000 tombs in Liaoning area, those with murals were found mostly at Tieling in the middle, and Chaoyang, Fuxin at the west. The clan or family cemeteries prevailed in the Liao dynasty, some of which have been found in Chaoyang area: the Family Cemeteries of Yelü Renxian's, Geng's, Zhao's, Liu's etc[25]. In the Geng's case, the tomb was depicted on the walls in both chambers: the warriors in Khitan hairstyle on sides of the entryway, the Sun, the Moon, figures, flowers and birds on walls of the chambers, displaying exquisite skills in drawing and coloring[26].

The Liao tombs at Yemaotai of Tieling were firstly found in 1953[27], more were found in following years, and many of them were excavated in 1975; some of them have been reported, including the No.7[28], No.16[29], No.19[30], No.22[31]. A large amount of remains survived, such as a big sarcophagus, an exquisite mural and an epitaph with a long text in the No.16 tomb. According to the epitaph, the occupant was Xiao Yi, who was a prime minister and died at the earlier years of Emperor Tianzhuo's reign in late Liao dynasty. The West Mountain at Yemaotai, where the cemetery was located, was also called "Mountain Shengji" at that time, which means "a holy place" and implies a cemetery location of Xiao's clan. The murals in Xiao Yi's tomb, depicting vividly the scenes of traveling and returning on walls of the passageway, serving food and greeting on walls of the entryway, and warriors on walls of the corridor, were valuable for the studies of painting arts and the nomadic tribe's custom in the later Liao dynasty.

The Liao tombs at Fuxin include: the tomb at Xishan Village of Qinghemen in 1949[32], the mural tomb cluster at Majia of Zhangwu County in 1993[33], the tomb at Huangjiagou in 1998[34], the Liao tombs at Pingdingshan of Daban Town and Ping'andi of Fuxin County in 1999[35], the Xiao He's Family Cemetery at Guanshan in 2001[36], and finally, the mural tomb of Prince Xu[37], the Xiao Tuguci's family cemetery, Xiao's tomb at Shaoguo Yingzi, and the slab mural tomb of late Liao dyasnty at Mutougou of Zhangwu County[38]. The Guanshan Cemetery was ascribed to Xiao He's Family, an illustrious family of the emperor's maternal relatives during the middle and later Liao dynasty, among which the joint burial of Xiao He and his wife was the biggest one; most of the murals, depicting on walls of the passageway, door leafs, corridor and shafts, have survived and been preserved well.

In general, the tomb murals in Liaoning area demonstrated some characteristics as following: the tombs could be dated on almost every periods of the Liao dynasty, such as the Yemaotai tomb in the earlier period, the Geng Yanyi's tomb and the Guanshan tomb in the middle an later periods; their occupants were either Khitan nobles, such as Xiao's Clan members, or the elite Han clans such as Han, Liu, Ma and Zhao, the four celebrated clans in Liao's regime; the murals were mostly depicted on walls of the passageways, such as the scene of traveling in Guanshan Tomb; some were depicted on both sides of the entryway, such as the Door Guardians, or on lintels and ceilings, such as flowers and birds.

The mural themes of Liao tombs were varied, including the production activities, daily life and custom of the northern nomadic tribes, but the human figures was obviously an important motif, including Khitan and Han people either in various status such as children, officials and attendants, or in various circumstances such as in traveling, hunting, returning, feasts or entertainments, which displayed vivid perspectives of the Liao society. In addition, some animals such as the Haidongqing (a kind of eagle), the divine crane, the horses, and some objects such as pots, mace, swords and *xiche* (a kind of carts used in nomadic tribes), appeared in murals; the xiche-cart was a fashionable theme in Liao's murals, usually demonstrating the owner's social status by its big wheels. Finally, the Khitan tombs were characteristic of peonies and lotuses in murals, as well as clouds, buildings and chess-playing.

Some of the mural themes in Liao tombs might be influenced by those of the Central Plain during the Tang, Five Dynasties and Song; for example, the depictions of dragons running in clouds, and phoenixes, Door Guardians apparently originated from the tomb murals in the Central Plain. However, some themes were more realistic, reflecting a local culture, such as the scenes of hunting and migrating in Guanshan Tombs. In addition, some representations of the attendants, servants, and traveling scene were remolded into Khitan style, demonstrating a new development in Liao murals.

The artistic trend, which was displayed in the Liao's tomb murals, apparently remained a unique style from its inherent Khitan tradition, meanwhile it assimilated some styles from those of the Tang, Five Dynasties and Song in the Central Plain; as a result, a new artistic trend was achieved by applying various techniques, either the ink drawings of simplicity or the realistic fine brushworks, which was characteristic of proper modeling, elegant coloring, and smooth drawing.

The mural tombs of the Jin dynasty might originate from the stone and the brick tombs in imitation of wooden structures during the Northern Song and late Liao Dynasties; most of them were found near Xijing (the Western Capital) and Zhongdu (the Central Capital) in modern Hebei and Shanxi provinces. Similarly, the mural themes might originate from those tombs of that time as well. For example, the Ma Ling's tomb at Chaoyang[39], which was a representative Jin tomb in Liaoning and was built in the 24th year of Dading Era, Jin dynasty, or 11th year of Chunxi Era, Southern Song dynasty (1184 CE), depicted the tomb occupant's lifetime in all aspects, including some details of serving food, preparing horses for traveling, holding dishes etc; totally six images were painted on the inside walls, and the occupant's name, clan origins and official positions were labeled as well. The mural was outlined firstly in ink and then applied with colors in red, green and grey; the profile was elegantly modeled, and the figures are vividly represented.

The mural tombs of the Yuan dynasty in Liaoning could be represented by the tomb cluster found at Fujiatun of Lingyuan county[40]. The tombs were plastered and then painted on the inside walls, depicting scenes of opening door, attendants, villas in the willow forest, traveling and entertainments, serving in the bedrooms, etc, demonstrating a higher skill of mural painting. These tombs, dating upon the earlier or middle periods of the Yuan dynasty, might be ascribed to the Mongol people.

The tomb murals in Liaoning area, either the earliest one found at the Goddess Temple of Hongshan Culture in the late Neolithic Period, or those dated upon the Han-Wei and Liao, Jin, Yuan dynasties, have demonstrated a high value in historical, cultural and artistic achievements, and provided us valubale materials for studies of the ancient production activities, daily life, cultures, religions and custom.

2.The Murals Unearthed in JiLin Province

Jilin province, lying in the center of the Song-nen Plain in Northeastern China, borders on the steppes and forests at its west and north, and adjoins Liaodong area at its south and the sea at its east. This area, which was occupied by the inhabitants of various ethnic groups in ancient times, was proved to be an important channel for the exchange of various

cultures. On the basis of textual references, the ancient inhabitants in Jinlin had established relations with the regimes of Central Plain since the Zhou dynasty. In the following centuries, more and more immigrants and their cultures were imported, which might have brought much influence on the aboriginal beliefs and material cultures. The people from various nationalities, such as Fuyu, Xianbei, Koguryo, Mohe, Khitan, Jurchen, and Manchu, had dwelled, developed in this area successively and were amalgamated, all of them contributed to the unified Chinese Nationality.

The ancient murals discovered in Jilin appeared due to the influences of the Central Plain cultures. The known murals so far were found at three regions: (1) near Guoneicheng (the Internal City, at modern Ji'an) which was a Koguryo's capital; (2) near Zhongjing (the Central Capital, at modern Helong) and Dongjing (the Eastern Capital, at modern Hunchun), which was a capital of Bohai Kingdom; (3) Khitan's home place in Liao Dynasty, at modern Baicheng and west of Shuangliao; the former two regions were once capitals of the regional regimes, the latter was located among the intensive military castles built by the Khitan nobles. The murals could be divided into two types: the tomb murals and the palace murals; the former could be largely dated upon the Koguryo period, most of which were discovered in the Donggou Tombs of Koguryo period near Ji'an, and a few mural tombs of Bohai Kingdom were discovered near Yanbian; however, in other areas of Jilin, few intact murals have been found except some dated on the Liao and Jin dynasties, which might be caused by the insufficient archaeological works. The latter, which is the palace mural, was largely found in the palaces, temples or ancestral memorials, but most of their remains were damaged and hard to be identified. So far, 33 ancient mural tombs have been reported, including 32 Koguryo tombs and 1 Barhae tomb; all of them have been robbed and disturbed, however some of the chambers and murals are preserved well.

The ancient murals in Jilin province have been recorded with modern archaeological methods since earlier 1920s. After the Japan-Russian War, Japanese investigators reached almost every place of Jilin province under the assistance of their army. They found some traces of temple murals in their investigations on the Barhae architectures in Yanbian area; and in later 1930s while the railway from Northeastern China to Korea was in construction, they excavated illegally some Koguryo mural tombs in Ji'an, such as the Stable Tomb and the Lotus Tomb. Shortly after, at the invitation of so-called Manchu-Japanese Cultural Association, Ikeuchi Hiroshi and other Japanese scholars came to Ji'an to investigate the Dancing Tomb and other Koguryo mural tombs, and finally published the field report Tong Gou in 1938. The archaeological works mentioned above have left us some valuable earlier scientific materials, although they were somewhat characteristic of colonialism.

After the establishment of the People's Republic of China, archaeologists initiated the investigation and protection programs on the Koguryo mural tombs in Ji'an; a special protection office was set up, and all of the entryways to the tombs were closed. In 1961, the Donggou Tomb Cluster was declared to be one of the National Key Cultural Relics Protection Sites, the mural tombs acquired a more effective protection. Since earlier 1960s, some mural tombs recorded by Japanese have been reconfirmed, and then over 10 tombs have been excavated, such as the No.1 tomb at Maxiangou, No.4 tomb at Wukuifen, the Three-chambered Tomb, the Lotus Tomb, the Tomb with Characters "wang (king)", No.1041 tomb at Yushan, No. 1368 tomb at Wanbaoting, No.1, No.2, No.4 tombs at Changchuan, No.3319 tomb at Yushan, the Scattered Lotus Tomb, etc. By surveying and mapping, as well as observation and record on the temperature and humidity, the Donggou Tombs' scientific preservation files have been established. In 1963, the Sino-Korean Joint Archaeological Team recorded and replicated some mural tombs in Ji'an, and then, the archaeologists of Jilin province also began to copy the murals.

Between 1972 and 1982, the archaeologists of Jilin provin ce carried out a general survey in Jerim Prefecture (modern Tongliao City), Inner Mongolia, while it was within the territory of Jinlin province, and excavated four mural tombs of the

Liao dynasty at Hureen County in 1972 and 1974. In 1980, the tomb of Princess Zhenxiao, who was the fourth daughter of King Wen of Bohai Kingdom, was excavated by archaeologists of Yanbian Museum at the Longtoushan Tomb Cluster, Helong County. According to the epitaph, Princess Zhenxiao was buried in 56th year, Daxing Era of King Wen's reign in Bohai Kingdom (792 CE). By further survey, it has been known that there were several more mural tombs of that time in the Longtoushan Tomb Cluster.

Since 1992, under the assistance of the State Bureau of Cultural Relics, the archaeologists of Jilin province carried out an extensive program to map and record the Koguryo mural tombs in the Donggou Tomb Cluster, and established a complete database. Under the leaderships of the late directors Fang Qidong and Lin Zhide, all of the surviving mural tombs in Ji'an have been photographed, and a complete image database has been established. Since then, most of the mural tombs have been closed forever, but shortly after, some lawbreakers from overseas and home robbed the representative Three-chambered Tomb and No.1 tomb at Changchuan, the murals were ruined severely.

In 2004, the Koguryo remains at Ji'an, Jinlin province, and Huanren, Liaoning province was approved to be included in the list of UNESCO World Cultural Heritage Sites under the title "Capital Cities and Tombs of the Ancient Koguryo Kingdom". In the Donggou Tomb Cluster, totally 16 tombs, which are valuable in studies and art, were included in the list: Ran Mou's Tomb (JXM001), Huanwen Tomb (with circles designs) (JXM033), Jiaodi Tomb (with depiction of wrestling) (JYM457), Wuyong Tomb (with depiction of dancing) (JYM458), Ma'cao Tomb (with depiction of stable)(JYM1894), Sanlianhua Tomb(with depiction of Scattered Lotus)(JYM1896), Wangzi Tomb (with characters wang-king) (JSM332), Guijia Tomb (with depiction of tortoise shell) (JSM1204), Zhetianjing Tomb (with depiction of shaft)(JSM1298), No.3319 in Yushan Tomb Cemetery(JYM3319), Sishen Tomb (with depiction of Four Divine Animals) (JYM2112), No.4 Tomb at Wukuifen (JYM2104), No.5 Tomb at Wukuifen (JYM2105), No.1 Tomb at Changchuan (JCM1), No.2 Tomb at Changchuan (JCM2), No.4 Tomb at Changchuan (JCM4).

The Koguryo mural tombs were mostly found at Ji'an and its vicinity, right side of the Yalu River, where the earlier capital of Koguryo was located; the tombs contained plenty of information concerning its birth, development and decline; the significance of these tombs lies not only in its successive times, but also in its remote location where a hybrid, regional and ethical culture could be formed.

Traditionally, the Koguryo tombs were built of rocks, but since the middle 4th century, the murals became in vogue in the Koguryo elite's tombs. The earliest mural tomb appeared at the Han dynasty's Lelang prefecture in the Korean Peninsula, then expanded to Ji'an area, the capital of Koguryo Kingdom. The mural tomb might originate either from the Liaodong prefecture on the west, or the Lelang prefecture on the east, but on the basis of the construction and mural styles, it was probably related with the Lelang area more closely and long-lasting. As a newly imported style, the mural tombs were distinct from the traditional tombs: firstly, in its construction, the rock cairns disappeared and the earth mound appeared, meanwhile the chambers were changed to have a domed ceiling from the previous stone cist, but the custom of building tombs on the ground had survived; secondly, in the mural styles, it originally copied those in the Central Plain, although some imitations and reforms appeared, it hadn't freed itself from the influences of the Central Plain mural tombs until an evolution was accomplished in the late Koguryo period when the tomb's ground construction was changed to the underground one, as in the case of No.4 and No.5 tombs at Wukuifen.

More than 30 mural tombs have survived in Ji'an, but due to their preserving conditions, only nine tombs may be considered. In general, the Koguryo mural tombs may be divided into four stages of development.

1) From the middle 4th century to earlier 5th century, represented by the Jiaodi Tomb (with depiction of wrestling) and the Wuyong Tomb (with depiction of Dancing). The tomb, consisting of a single chamber with a domed ceiling, two side

chambers and a deviated passageway, was plastered and painted with plenty of depictions on walls. On the main wall, it depicted the home living scenes: the tomb occupant couple sitting under a large canopy, the attendants standing by, and some food laid on the low table; on the front wall it depicted some trees; on the side walls, some lifetime scenes were depicted, such as hunting, singing and dancing, preparing for riding, kitchen etc. in the case of Jiaodi Tomb, the depictions of the wrestling on its east wall may be related to the tomb occupant's lifetime career. On the caissons, it depicted clouds and constellations, grasses, the Sun and the Moon, as well as the auspicious animals and birds, immortals; in the case of the Wuyong Tomb, the depiction of unfixed Four Divine Animals appeared: the Scarlet Bird was shaped as a realistic cock, the Green Dragon and White Tiger were arranged at corners, the Sombre Warrior (tortoise and snake) was represented by two wrestling persons; however, in the Jiaodi Tomb, only the Sun God and the Moon God were depicted. On the passageway walls, it depicted black dogs as a guardian. Apparently the murals of this stage displayed a scene of the leisure lifetime, which might inherited from the elite's lifestyle of Wei-Jin period, in addition to the ox carts, some Koguryo elements also appeared. The occupant's portrait was usually depicted at the main location, the immortals were usually depicted on the caissons which might represent the Heaven. The depictions of the Heaven, the immortals, and the secular persons shared the chambers, demonstrating a strong Taoist taste. It might be a stage of imitation of the Central Plain murals.

2) The 5th century, represented by Ma'cao Tomb (with depiction of stable) and Wangzi Tomb (with depiction of characters wang-king). This type of tombs, facing west, consisted of a single chamber with a domed ceiling and two side chambers□the structure of the domed ceiling tended to be more normative with its curved corners was altered to the overlapped square slabs. On the other hand, the murals had evolved as well, from the realistic depictions to the decorative designs; the mural's composition resembled those in the first stage, but the single scene had changed gradually to multiple scenes on a single wall; more scenes were depicted in the side chambers or the passageways; the themes of stables and buildings, which might represent the wealth, were highlighted; in addition, the Buddhist themes such as the lotus petals that turned upward, and the large patterns with character "王" (king) that might represented the canopy, appeared. Meanwhile, some objects, such as the gilded headdresses, glazed potteries, and lacquerwares, which might be used by the nobles, were unearthed. The depictions relating to the tomb occupant's lifetime career still existed, such as the depiction of beheading the prisoner shown in the Ma'cao (Stable) Tomb. It's a stage of development and innovation for the Koguryo murals, in which the aristocratic senses and the immortal beliefs appeared gradually. Meanwhile, some mural tombs built of bricks, which might be ascribed to the Han officials who fled from the Central Plain, have been discovered, probably their mural themes might influence those of the Koguryo murals.

3) From late 5th century to middle 6th century, represented by the Three-chambered Tomb and the No.1 Tomb at Changchuan. In this a stage, the Koguryo style of the mural tombs originated. The tomb's structure varied, consisting of single chamber, double chambers or triple chambers, meanwhile the side chambers declined; the domed ceiling altered to the frustum-shaped ceiling built of overlapped slabs, however, the curved slabs at the corners still existed. In the murals, the realistic themes were substituted by the immortals or the divine warriors, and the depiction of door guardians became popular; except those in No.1 tomb at Changchuang, the main depictions became more decorative or divine designs; the Four Divine Animals demonstrated the directional meanings, although it was not so normative in locations and shapes as those in the Central Plain, for example, the Three-chambered Tomb, consisting of three separated chambers, depicted the Four Divine Animals in each chamber, but the arrangement of the animals differed from each other, probably only the one in the first chamber was arranged correctly. In addition, lots of Buddhist themes emerged, such as the lion depicted in the passageway of the Huanwen Tomb (with circles designs), the Bodhisattva, flying Apsaras and scenes of worshiping Buddha in the No.1 Tomb at Changchuan. The depictions of Bodhisattva in tombs is said to be the results of the misunderstandings

on Buddhism; the basic belief demonstrated in tombs of this stage were still Taoism.

4) From middle 6th century to middle 7th century (at the decline of the Koguryo Kingdom), represented by the No.4 and No.5 tombs at Wukuifen. In this stage, Koguryo Kingdom moved its capital to Pyongyang, as a result, the mural tombs, a symbol of the elite's status, decreased within modern Chinese territory; in addition, the structures tended to be uniform. All of the later tombs found in Ji'an consisted of a single chamber and a caisson built of overlapped slabs; the chambers were built underground; the passageway faced south. An obvious change of the murals was that it was not plastered any longer before being painted on the stone walls, which might demonstrate a high skill in coloring. The murals were characteristic of the motif of the Four Divine Animals, which were depicted on the four walls according to their symbolic directions. In addition, the Sun God and the Moon God were depicted on both side of the caisson, the Fuxi and Nüwa, and the legendary Sages like Xuanyuan, Shennong and Xizhong, were depicted on the rockworks; some other sages and immortals, such as in the scenes of driving a dragon or crane, playing a zither, a horn, a flute or beating a drum, were depicted as well; the guardians holding a battle axe were depicted at the passageway, the coiled or flying dragons were depicted on the beams or the top stones of the caisson. Most of the mural themes related to Taoism, but some Buddhist motifs, such as lotus, jewels, flames, existed; in addition, some hybrid motifs of Buddhism and Taoism, like the Deity Standing on Lotus, appeared. The murals demonstrated a strong contrast in colors which were mostly preserved well; besides the previous colors, some new colors, such as azurite, vermilion, lead white, and some demitint colors, came in use. The mural tombs of the later Koguryo period in Ji'an were constructed so exquisitely, painted so extensively, and colored so brightly that they may be regarded as the culmination reached by the late Koguryo murals, even transcending the contemporaneous royal' tombs found in Pyongyang; it's said to be a result of the strong Koguryo clans' arrogating behaviors while the ruler's power declined.

The mural tombs of Bohai Kingdom, as a great discovery in 1980s, filled the vacancy of Tang dynasty's mural tombs in Jilin province. In the Barhae Kingdom, which imitated Tang's bureaucratic as well as ritual systems, the Tang's fashions were admired, language was learned by the elites; in addition, Buddhism was popular; as a result, the cultural relics demonstrated much Tang's taste. The tomb of Princess Zhenxiao, who was the fourth daughter of Dayemao, King Wen of Barhae Kingdom, was excavated at the center of Longtoushan Tomb Cluster, Helong County, in 1980; according to the epitaph, it was buried in 792.

The mural tomb was constructed beneath a brick pagoda, therefore the underground chamber of the pagoda was the tomb grave, which was built of rectangular bricks. It depicted 12 figures in the plastered chambers and corridors: two guardians of honor on both side of the corridor walls, facing to each other; four figures on each side of the chamber and two figures on the north wall, all facing to the entryway; all figures wearing the round-collar robe popular in the Tang dynasty. The figures, by the objects in their hands, may be identified as guardians, attendants, musicians, and female attendants in male costume; the figures were described as the configuration with a round face and a fleshy body, demonstrating a typical high Tang style. The tomb of Princess Zhenxiao was moderate in scale, nor the grand scene of procession have been seen as in the case of Tang princesses' tombs, however, the elite's life of the Barhae Kingdom was vividly depicted; these figures might be portrayed from the lifetime attendants of the princess. In the same cemetery, other tombs of the Barhae nobles have been discovered, some precious artifacts, such as the three-colored potteries, jade belts and epitaphs, have been found; currently the protection programs have been in progress.

Jilin province lies in a remote area, and the composition of its ancient inhabitants was fairly complex, however, its cultures as well as traditions could be traced to the same origin with those in the Central Plain. The mural tombs mentioned above are proved to be a precious heritage for studies and appreciations.

3.The Murals Unearthed in Heilongjiang Province

The Bohai's imperial cemetery was found at Sanling, Ning'an City, Heilongjiang Province, where the township government is located. The No.2 tomb of Sanling, which was excavated in 1991, lies at 129°06′54.63″E and 44°10′02.55″N, east side of Sanxing Village, and east of the cemetery. The cemetery, lying against the hills at north and facing to the Mudan River at south, was 4 km away from the north gate of Longquan city, Shangjing (Upper Capital) of Barhae Kingdom.

In 1988, the Sanling Tomb, which was robbed in ancient times and then excavated by Japanese archaeologists, was re-excavated systematically by Heilongjiang Provincial Institute of Archaeology; a lot of architectural ornaments built of basalts, fragments of murals, tiles with characters, and the tomb occupant's remains were unearthed, in addition, the stone coffin platform, stone steps built of basalts, and some parts of the stone door leaves, were found on the ground of the passageway.

In autumn of 1989, a tentative excavation on the cemetery's enclosing walls was carried out; as a result, the wall's locations and boundary were confirmed, and more significantly, the remains of the Spirit Way were found in the farmlands, at south of the Sanling Tomb, outside the cemetery. The cemetery could be divided into two sections: northern section and southern section; the Sanling Tomb was located at the center of the northern section; and the Spirit Way, which was made of rammed earth and slightly bulged from the ground, led to the Barhae period's bridge on the river near Sanling; therefore, along the Spirit Way one could reach the cemetery via the "Qikongqiao" (the Bridge with Seven Arches) from the Longquan City, Upper Capital. It's believed that the cemetery, which was regarded as a noble's cemetery, might be a imperial cemetery of the Barhae Kingdom.

In autumn of 1991, on basis of the geophysical prospecting, a newly found tomb (No.2 Tomb at Sanling) at the northeastern corner of the Sanling Tomb was excavated by Heilongjiang Provincial Institute of Archaeology.

The tomb was constructed underground, but its original mound was destroyed, leaving a slightly bulging hump on the ground. The tomb was built of basalt, facing south, consisting of a passageway, an inner corridor of about 270cm long, 140cm wide, 170cm high, and a chamber of about 390cm long, 330cm wide, 245cm high; the ceiling, in hemisphere shape, was plastered with a layer of lime on inside surface and sealed with a large basalt slab on its top; the inner corridor was centered at the south wall; the caisson was constructed by the overlapped slabs. Over 10 bodies, either of the adults or the children, were laid in the chamber, apparently it's a joint burial containing multiple persons. On walls of the chamber, the inner corridor, as well as the plastered ceiling, some exquisite murals were depicted.

The mural themes could be divided into two types: florals and figures; the former was depicted exquisitely at the chamber's caisson, in the shape of consecutive medallions; the latter was depicted on walls of the chamber and inner corridor, largely flaked off, but the poses and attires could be identified difficultly; most of the figures are representations of the female with fleshy faces, demonstrating a Tang's taste; the warriors were vividly depicted on both side of the corridor at its southern end.

The excavation of the Bohai Royal Cemetery, by providing us all aspects of valuable materials concerning Barhae's ritual and burial systems, ethnology, architectures, arts and costumes, no doubt had a magnificent value in academic researches.

References

[1] Institute of Archaeology in Liaoning. 1986. Excavation of the Deity Temple and a Cluster of Stone Heaped Tombs of Hongshan Culture at Niuheliang in Liaoning. Wenwu, 8.

[2] Toa Kokogakkai. 1934. Ying-ch'êng-tzu. Toho Kokogaku Sokan, vol. 4. Tokyo: Toa Kokogakkai.

[3] Yagi Sosaburo. 1921. Ryoyo Hakken no Hekiga Kofun. Toyo Gakuho, 11 (1).

[4] Harada Yoshito. 1943. Ryoyo Nanrinshi no Hekiga Kofun. Kokka, 629.

[5] Li Wenxin. 1992. Brief Notes on the Ancient Mural Tomb at Beiyuan, Liaoyang. Li Wenxin Kaogu (Wenji Li Wenxin's Collected Archaeological Works). Shenyang: Liaoning Renmin Publishing House.

[6] Li Wenxin. 1955. The Three Ancient Mural Tombs Found at Liaoyang. Wenwu Cankao Ziliao, 5.

[7] Ibid.

[8] Ibid.

[9] Northeast Museum. 1955. A Brief Report of the Excavation of Two Mural Tombs at Sandaohao of Liaoyang. Wenwu Cankao Ziliao, 12.

[10] Wang Tseng-hsin. 1960. Excavation of an Eastern Han Tomb with Painted Walls at Pang T'ai Tzu, City of Liaoyang, Liaoning. Kaogu, 1.

[11] Wang Tseng-hsin. 1960. The Mural Tombs and Stone Tombs at Nanxuemei Village, Liaoyang County, Liaoning. Kaogu, 1.

[12] Li Qingfa. 1959. A Brief Report on Excavation of the Mural Tomb of the Jin Dynasty at Shangwangjia Village, Liaoyang. Wenwu, 7.

[13] Committee for Preservation of Ancient Monuments, Liaoyang City. 1980. Three Mural Tombs Discovered at Liaoyang. Kaogu, 1.

[14] Ibid.

[15] Ibid.

[16] Feng Yongqian, Zou Baoku and others. 1985. Excavation of the Eastern Han Tomb with Wall Paintings near the East Gate of the Old City of Liaoyang. Wenwu, 6.

[17] Liaoning Provincial Institute of Cultural Relics and Archaeology. 1998. The Mural Tomb at Nanhuan Street, Liaoyang City, Liaoning. Beifang Wenwu, 3.

[18] Zheng Yan. 1997. On the Tomb Occupants' Portraits in Mural Tombs, in Liu Dunyuan Xiansheng Jinian Wenji (Commemorative Works for Mr. Liu Dunyuan). Jinan: Shandong University Press.

[19] Archaeological Team of Liaoning Provincial Museum and others. 1984. The Eastern Jin Tomb with Wall Paintings at Yuantaizi, Chaoyang. Wenwu, 6.

[20] Li Yaobo. 1973. The Northern Yan Tomb of Feng Sufu at Xiguanyingzi, Beipiao County, Liaoning. Wenwu, 3.

[21] The Museum of Chaoyang Prefecture. 1985. Excavation of Tombs from the Northern Yan and Northern Wei Dynasties in Chaoyang Area, Liaoning. Kaogu, 10.

[22] Ibid.; Chen Dawei. 1990. The Mural Tomb of Jin Dynasty at Goumenzi, Chaoyang County. Liaohai Wenwu Xuekan, 2.

[23] Tian Likun. 2002. Rethinking of the Mural Tomb at Yuangtaizi. Wenwu, 9.

[24] Wu Jiachang etc. 2003. The Koguryo Mural Tombs at Micanggou, Huanren. In Liaoning Kaogu Wenji. Shenyang: Liaoning Nationality Publishing House.

[25] Chaoyang Museum. 1996. Chaoyang Lishi yu Wenwu (History and Cultural Relics of Chaoyang). Shenyang:

Liaoning University Press.

[26] The Museum of Chaoyang Prefecture. 1983. Excavation of Nee Geng's Tomb of the Liao Dynasty at Guyingzi, Chaoyang, Liaoning. Kaoguxue Jikan (Papers on Chinese Archaeology), 3.

[27] Liu Qian. 1956. A Survey on the Liao Tombs at Yemaotai, Faku County, Liaoning. Kaogu Tongxun, 3.

[28] The Archaeological Team of the Liaoning Provincial Museum. 1975. Excavation of the Liao Dynasty Tomb at Yehmaotai in Faku County, Liaoning Province. Wenwu, 12.

[29] Wen Lihe. 1989. Excavation of Xiao Yi's Tomb of the Liao Dynasty at Yemaotai, Faku, Liaoning. Kaogu, 4.

[30] Ma Honglu and Meng Qingzhong. 1982. The Excavation of the Liao Tomb No. 19 at Yemaotai, Faku County. Liaoning Wenwu, 3.

[31] Xu Zhiguo and Wei Chunguang. 2000. The Excavation of the Liao Tomb No. 22 at Yemaotai, Faku County. Beifang Wenwu, 1.

[32] Li Wenxin. 1992. A Report on Excavation of the Liao Tomb at Xishan Village, Qinghemen. In Fuxin Liao-Jin Shi Yanjiu (Studies on Liao and Jin Histories in Fuxin), vol.1. Hong Kong: Feitian Publishing House.

[33] Zhang Chunyu, Liu Junyu and Sun Jie. 1996. Treatises on the Cultural Heritages in Zhangwu County (Zhangwuxian Wenwuzhi). Shenyang: Liaoning People's Publishing House.

[34] Guo Tiangang etc. 2000. The Liao Tomb at Huangjiagou, Fuxin. In Fuxin Liao-Jin Shi Yanjiu (Studies on Liao and Jin Histories in Fuxin) vol.4. Beijing: China Social Science Press.

[35] Liang Shudan. 2005. A Survey on the Artistic Styles of Liao Paintings from the Liao Tombs Discovered at Fuxin. in Liao-Jin Shi Yanjiu (Studies on Liao and Jin Histories).

[36] Hua Yubing and Wan Xiongfei. 2002. The Exquisite Murals and Epitaph Unearthed from Xiao He's Family Cemetery of the Liao Dynasty at Fuxin. Zhongguo Wenwu Bao, May 3:1.

[37] Ouyang Bin. 1992. The Excavation of Prince Xu's Tomb of the Liao Dynasty, in Fuxin Liao-Jin Shi Yanjiu (Studies on Liao and Jin Histories in Fuxin), No.1. Hong Kong: Feitian Publishing House.

[38] Zhang Chunyu, Liu Junyu and Sun Jie. 1996. Treatises on the Cultural Heritages in Zhangwu County (Zhangwuxian Wenwuzhi). Shenyang: Liaoning People's Publishing House.

[39] Liaoning Provincial Museum. 1962. The Mural Tomb of the Jin Dynasty at Chaoyang, Liaoning. Kaogu, 4.

[40] Liaoning Provincial Museum etc. 1985. The Tombs of the Yuan Dynasty at Fujiatun, Lingyuan. Wenwu, 6.

[41] Ikeuchi Hiroshi, Umehara Sueji. 1938. Tong Gou. Tokyo: Nichiman Bunka Kyokai.

[42] The Chian Archaeological Team, the Kirin Provincial Museum. 1964. The Wall-Painting Tomb No. 1 Unearthed at Mahsienkou, Chian, Kirin Province. Kaogu, 10.

[43] Wang Chêng-li and Han Shu-hua. 1964. Excavations of Kokuli Tomb No. 12 with Wall Paintings at T'ung Kou, Chi An, Kirin Province. Kaogu, 2.

[44] The Kirin Provincial Museum. 1964. Brief Report on the Excavations of Tomb No. 4 and 5 at Wu K'uei Fên, Chi An, Kirin Province. Kaogu, 2.

[45] Zhang Xueyan. 1988. Two Koguryo Tombs with Mounds at Ji'an. Bowuguan Yanjiu, 1.

[46] CPAM, Ji'an County and Jilin Provincial Archaeological Team. 1981. Notes on Excavation of the Three-chambered Tomb at Donggou, Ji'an, Jilin. Kaogu yu wenwu, 3.

[47] Li Dianfu. 1981. A Supplement of the Catalogs on the Murals of the Three-chambered Tomb at Donggou, Ji'an. Kaogu yu wenwu, 3.

[48] Li Dianfu. 1983. Three Mural Tombs at Donggou, Ji'an. Kaogu, 4.

[49] Jilin Provincial Archaeological Team and Ji'an County Provincial Archaeological Team. 1982. The No.1 Mural Tomb at Changchuan, Ji'an. Dongbei Kaogu yu Lishi, 1.

[50] Jilinsheng Bowuguan Wenwu Gongzuodui. 1977. Two Koguryo Tombs at Ji'an, Jilin. Kaogu, 2.

[51] Zhang Xueyan. 1991. A Preliminary Report on the Excavation of Koguryo Tombs at Dongdapo, Ji'an, Jilin. Kaogu, 7.

[52] Jilin Provincial Archaeological Team. 1983. Notes on Excavation of the No. 2 Mound Tomb at Changchuan, Ji'an, Jilin. Kaogu yu Wenwu, 1.

[53] Fang Qidong, Liu Xuantang. 2002. M31 Kao-Kou-Li Mural Tomb at Xiajiefang, Ji'an. Beifang Wenwu, 3.

[54] Jilin Provincial Institute of Cultural Relics and Archaeology and CPAM, Ji'an City. 1993. The Excavation of the Tombs in Yushan Cemetery, Donggou Tomb Cluster, Ji'an along Ji'an-Xilinhot Highway. Gaogouli Yanjiu Wenji (Works on Koguryo Studies). Yanji: Yanbian University Press.

[55] Yanbian Korean Autonomous Prefecture Museum. 1982. The Excavation of Princess Zhenxiao's Tomb of Bohai Kingdom. Shehui Kexue Zhanxian (Social Science Front), 1.

目 录 CONTENTS

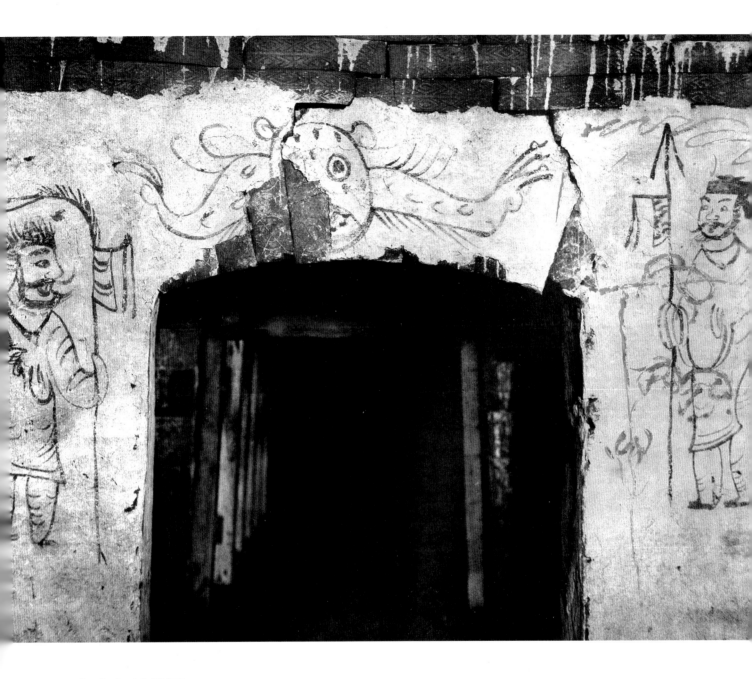

1.门卒与神兽图

东汉（25～220年）

1931年辽宁省大连市营城子壁画墓出土。原址保存。

墓向172°。位于主墓室南壁门洞上部及两旁。左右各画一门卒，左边门卒毛发上扬，须髭浓密，短衣，左手持籍，右手持剑，极尽粗犷之刻画。右边门卒黑帻，短衣，手持长枪一柄。门洞上方绘有辟邪神兽一只，巨口圆眼，双臂横张。

（撰文：陶亮 摄影：不详）

Door Guardians and Mythical Animal

Eastern Han (25-220 CE)

Unearthed from a mural tomb at Yingchengzi of Dalian, Liaoning, in 1931. Preserved on the original site.

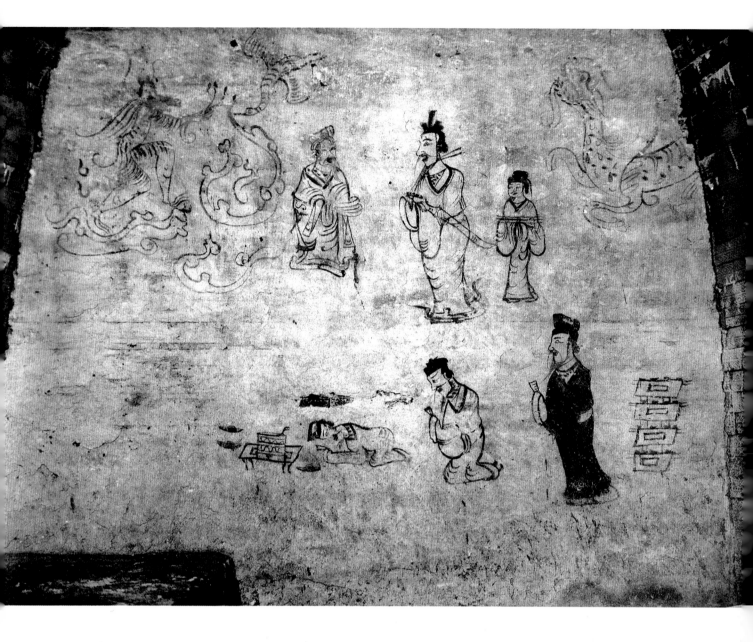

2. 祝祷升仙图

东汉（25～220年）

1931年辽宁省大连市营城子壁画墓出土。原址保存。

墓向172°。位于主墓室北壁。壁画分两层，上层从左至右依次为羽人、云气、凤鸟、老者、佩剑男子、侍童、腾龙。佩剑男子穿长袍，宽袖，正与对面戴冠老者交谈。从氛围来看，佩剑男子应是墓主人，老者或许是接引墓主升仙的仙使。壁画下层描绘属吏为墓主祷祝升仙场面。三男子依次顿首、跪拜、揖手。皆手持笏板，顿首男子身前为一小几案，上置樽形器，揖手男子身后依次摆放四个箧笥。整幅壁画以墨线勾勒，不施重彩，少数地方如领缘，衣袖等处以朱笔涂绘。

（撰文：陶亮　摄影：不详）

Ascending Fairland

Eastern Han (25-220 CE)

Unearthed from a mural tomb at Yingchengzi of Dalian, Liaoning, in 1931. Preserved on the original site.

3.属吏奏事图

东汉（25～220年）

高约66、宽约93厘米

2004年辽宁省辽阳市南郊街东汉墓出土。原址保存。

墓向北。位于墓内北耳室北壁，主人侧坐在西侧，属吏五人，靠前一人跪伏奏事，其余四人持简侍立。

<div align="right">（撰文：梁振晶　摄影：穆启文）</div>

Inferior Officials in Attendance

Eastern Han (25-220 CE)

Height ca. 66 cm; Width ca. 93 cm

Unearthed from an Eastern Han tomb at Nanjiaojie of Liaoyang, Liaoning, in 2004. Preserved on the original site.

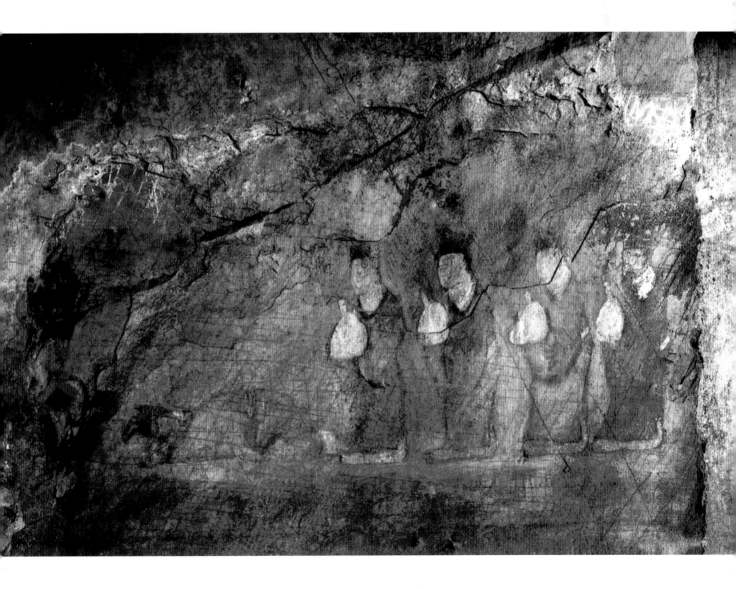

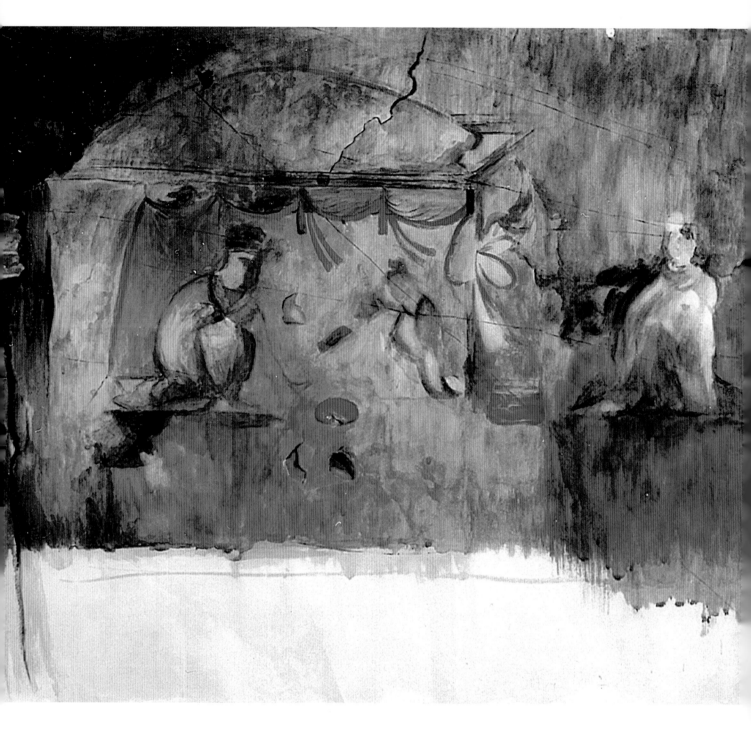

4.宴饮图

东汉（25～220年）

高约75、宽约212厘米

2004年辽宁省辽阳市南郊街东汉墓出土。原址保存。

墓向北。位于墓内北耳室西壁，为夫妇侧坐宴饮图，帐外有五名侍者，帐内一名侍者。

（撰文：梁振晶　摄影：穆启文）

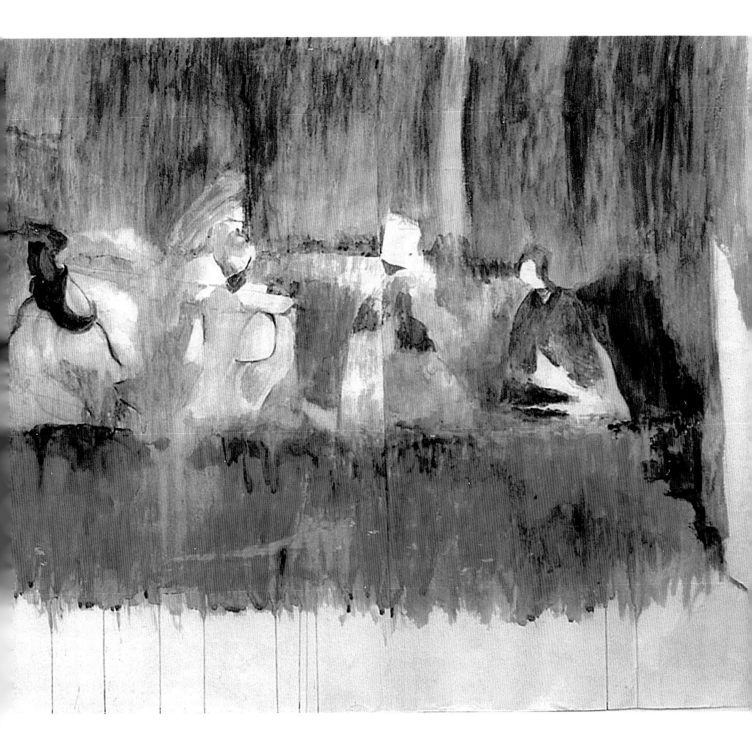

Feasting

Eastern Han (25-220 CE)

Height ca. 75 cm; Width ca. 212 cm

Unearthed from an Eastern Han tomb at Nanjiaojie of Liaoyang, Liaoning, in 2004. Preserved on the original site.

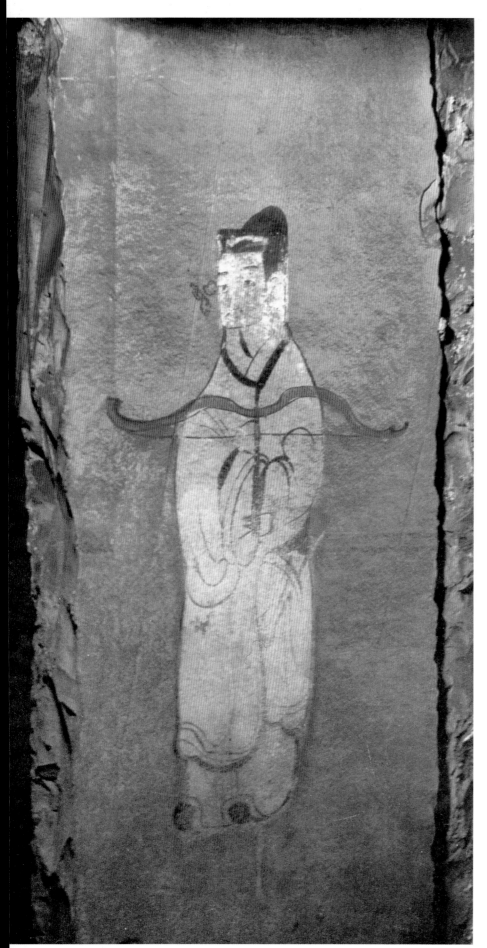

5.门卒图

东汉（25～220年）

高59、宽33厘米

1986年辽宁省辽阳市北园三号壁画墓出土。原址保存。

墓向南。位于墓室西墓门东侧门柱西壁。门卒头戴黑色巾帻，身着交领宽袍，皂缘领袖。下着肥袴，足蹬黑履，双臂内拢，捧一彤弓，腰佩朱赤色箭箙。八字髭须，神态恬静。

（撰文：陶亮　摄影：赵洪山）

Door Guardian

Eastern Han (25-220 CE)

Height 59 cm; Width 33 cm

Unearthed from the No.3 mural tomb at Beiyuan of Liaoyang, Liaoning, in 1986. Preserved on the original site.

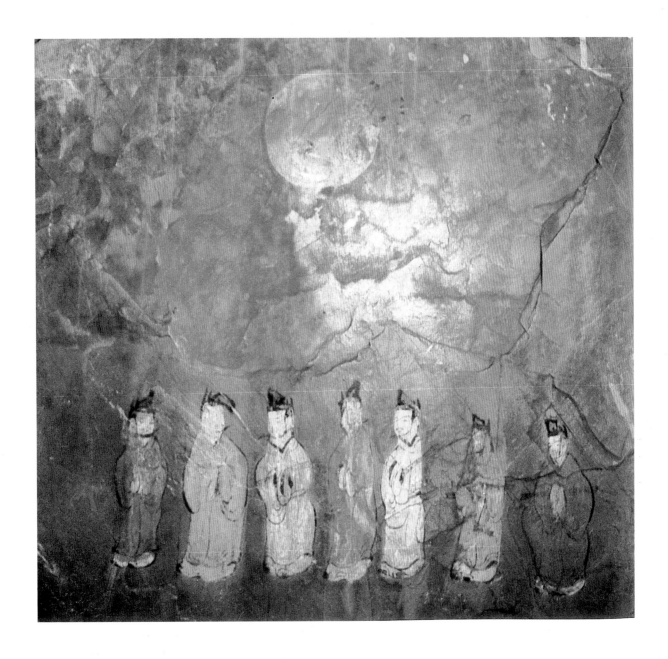

6. 属吏图

东汉（25～220年）

高67、宽66厘米

1986年辽宁省辽阳市北园三号壁画墓出土。原址保存。

墓向南。位于墓室前西耳室西壁。这是属吏画面的第一部分，画班列侍事小吏七位，皆双手持笏，并排而立。应当是墓主人属下的诸曹掾史。上空绘浅绿色明月，已漫漶难辨。

<div align="right">（撰文：陶亮　摄影：赵洪山）</div>

Inferior Officials

Eastern Han (25-220 CE)

Height 67 cm; Width 66 cm

Unearthed from the No.3 mural tomb at Beiyuan of Liaoyang, Liaoning, in 1986. Preserved on the original site.

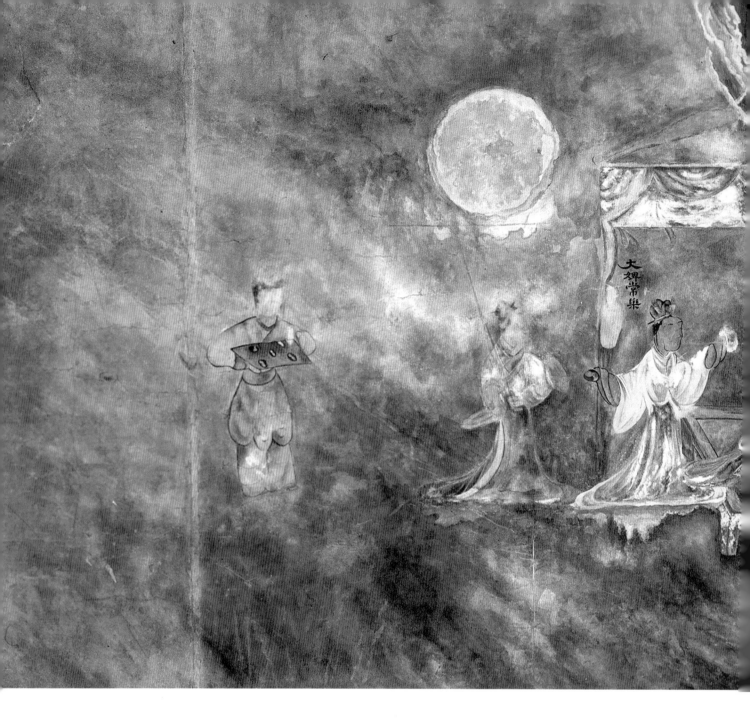

7.宴饮图（摹本）

汉魏之际（3世纪）

原壁画高140、宽190厘米

1957年辽宁省辽阳市棒台子二号壁画墓出土。原址保存。摹本现存于辽宁省博物馆。

墓向160°。位于墓内右小室右壁。正中画一男一女分坐左右方榻之上，榻间置一长几，几面上放紫红色圆案。右边之男子戴平顶黑帻，身后侍立二人。左边之妇人头上高起似戴发箍，红衣赭领，微露石绿色内衣，下用红线勾出褶裙，右手执杯。女主人身后侍立者3人，递进饮食。后一男子面目不清，手捧红色长方案，内置耳杯与筷子。两人及座榻均置红色帷帐内，帷幕高结，朱带下垂，内露石绿短帘。左上方高悬明月一轮。

（临摹：不详　撰文：陶亮　摄影：林利）

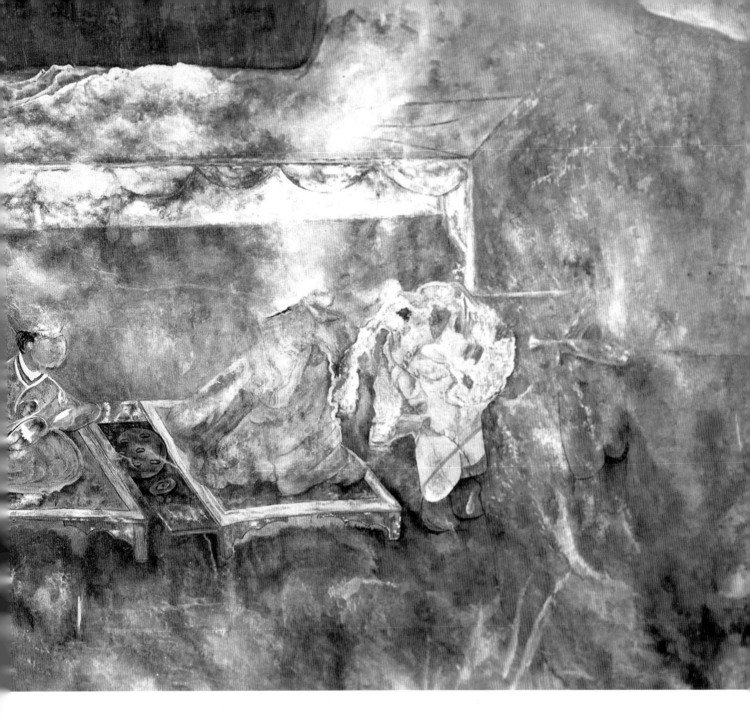

Feasting (Replica)

Between Han and Wei (3rd c. CE)

Original mural's height 140 cm; Width 190 cm

Unearthed from the No.2 mural tomb at Bangtaizi of Liaoyang, Liaoning, in 1957. Preserved on the original site. The replica is a collection of Liaoning Provincial Museum.

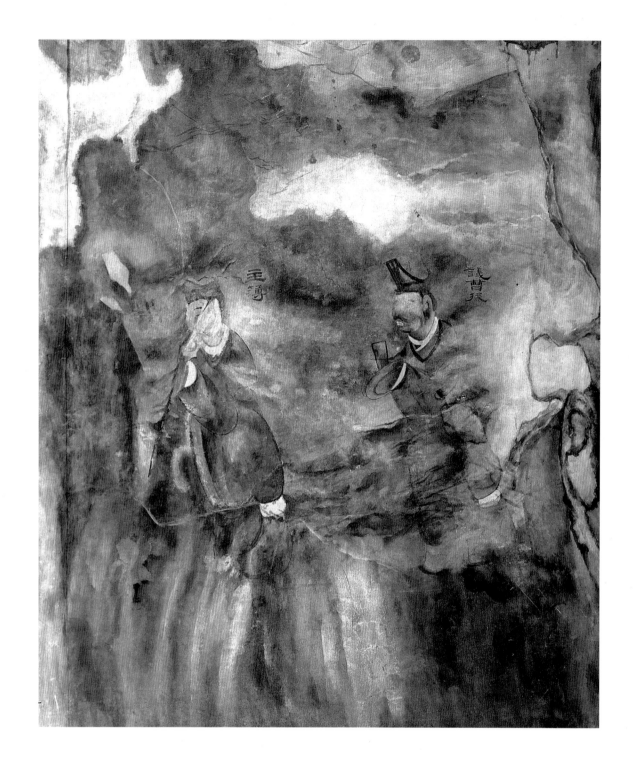

8. 主簿及议曹掾图（摹本）

汉魏之际（3世纪）

原壁画高140、宽100厘米

1957年辽宁省辽阳市棒台子二号壁画墓出土。原址保存。摹本现存于辽宁省博物馆。

墓向160°。位于右小室后壁。二府吏雁行躬立。前者黑冠，赭青袍，肥黑履，唇上微露髭须，拱手胸前，头后墨书"主簿"二字。后者黑冠，赭青袍，下露黑履，唇有髭须，双手捧笏板，头后墨笔隶书"议曹掾"三字。

（临摹：不详　撰文：陶亮　摄影：林利）

"ZhuBu" and "Yicaoyuan"(Supervisor and Inferiors) (Replica)

Between Han and Wei (3rd c. CE)

Original mural height 140 cm; Width 100 cm

Unearthed from the No.2 mural tomb at Bangtaizi of Liaoyang, Liaoning, in 1957. Preserved on the original site. The replica is a collection of Liaoning Provincial Museum.

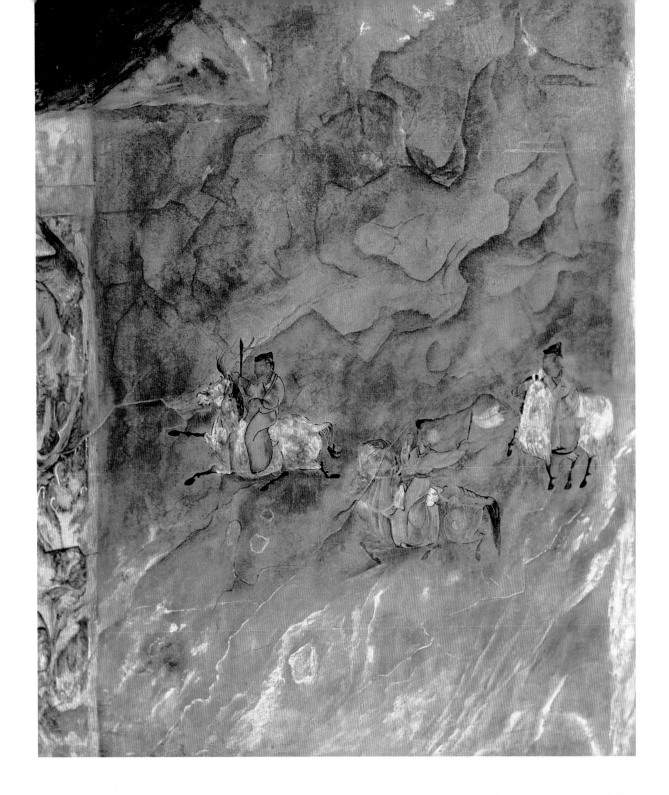

9. 车骑图（一）（摹本）

汉魏之际（3世纪）

原壁画高140、宽88厘米

1957年辽宁省辽阳市棒台子二号壁画墓出土。原址保存。摹本现存于辽宁省博物馆。

此墓的正门在前壁中部，南向偏东20°。此图位于左小室后壁。导骑三人，前后二骑居路右，中间一骑居左。骑吏皆着黑帻、红衣，土黄肥袴。前骑扬鞭策马，腾跃急行，中行者回臂扬鞭，似有所言，后骑紧勒缰绳，神态各异。

（临摹：不详　撰文：陶亮　摄影：林利）

Carts and Mounted Riders (1) (Replica)

Between Han and Wei (3rd c. CE)

Original mural height 140 cm; Width 88 cm

Unearthed from the No.2 mural tomb at Bangtaizi of Liaoyang, Liaoning, in 1957. Preserved on the original site. The replica is a collection of Liaoning Provincial Museum.

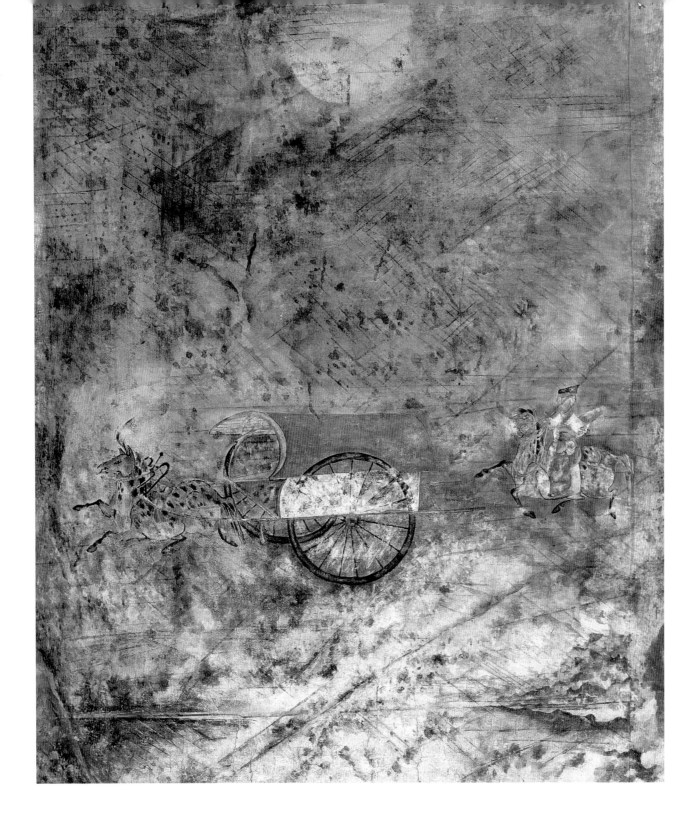

10. 车骑图（二）（摹本）

汉魏之际（3世纪）

原壁画高140、宽92厘米。

1957年辽宁省辽阳市棒台子二号壁画墓出土。原址保存。摹本现存于辽宁省博物馆。

墓向160°。位于左小室左壁。前有土红马驾红车一辆。御者形体模糊，车后从骑一人，黑帻，石绿袍红领缘，土黄肥袴。中天高悬一轮白日。

（临摹：不详　撰文：陶亮　摄影：林利）

Carts and Mounted Riders (2) (Replica)

Between Han and Wei (3rd c. CE)

Original mural height 140 cm; Width 92 cm

Unearthed from the No.2 mural tomb at Bangtaizi of Liaoyang, Liaoning, in 1957. Preserved on the original site. The replica is a collection of Liaoning Provincial Museum.

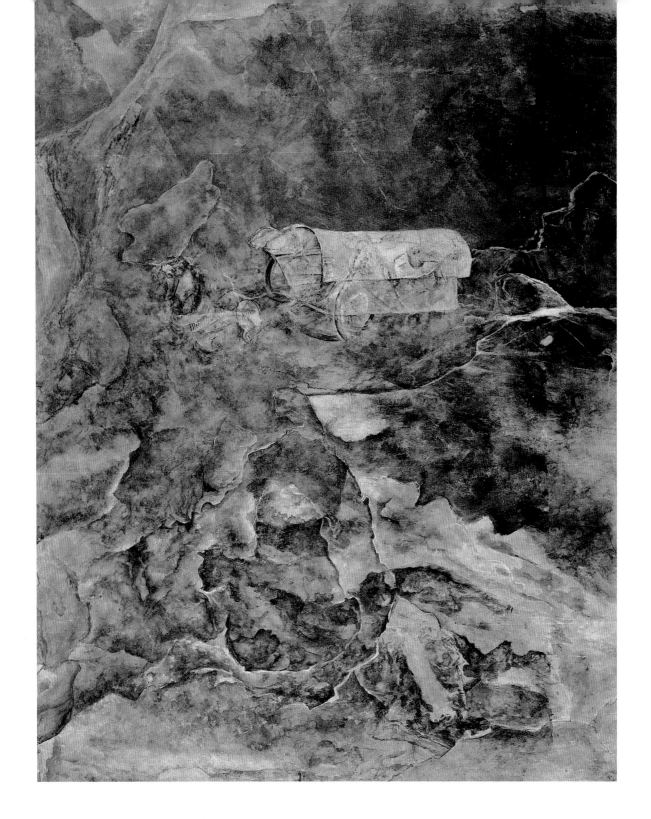

11. 楼宅、车列图（摹本）（局部）

汉魏之际（3世纪）

原壁画高140、宽512厘米。

1957年辽宁省辽阳市棒台子二号壁画墓出土。原址保存。摹本现存于辽宁省博物馆。

墓向160°。位于后室后壁，三层楼房宅院一处，左墙中部设有院门，列车4辆，一字排开，作趋进宅门状。此图为其中第三辆，土红马驾车，漫圆顶幕石绿帷，朱栅红厢，墨轮，车内似坐一红衣人。

（临摹：不详　撰文：陶亮　摄影：林利）

Mansion, Courtyard and Lines of Carts (Replica) (Detail)

Between Han and Wei (3rd c. CE)

Original mural height 140 cm; Width 512 cm

Unearthed from the No.2 mural tomb at Bangtaizi of Liaoyang, Liaoning, in 1957. Preserved on the original site. The replica is a collection of Liaoning Provincial Museum.

12.对坐饮食图（摹本）

汉魏之际（3世纪）

原壁画高105、宽80厘米

1955年辽宁省辽阳市三道壕一号壁画墓出土。原址保存。摹本现存于辽宁省博物馆。

墓向南。位于右小室前壁。二人对坐于方席之上，前置短几。一人黑帻，一人黄角巾，皆宽衣博袖，拱手对坐，榻间似陈设物品，惜已模糊不清。

（临摹：李万成、唐郅　撰文：陶亮　摄影：林利）

Dining Seated Face-to-Face (Replica)

Between Han and Wei (3rd c. CE)

Original mural height 105 cm; Width 80 cm

Unearthed from the No. 1 mural tomb at Sandaohao of Liaoyang, Liaoning, in 1955. Preserved on the original site. The replica is a collection of Liaoning Provincial Museum.

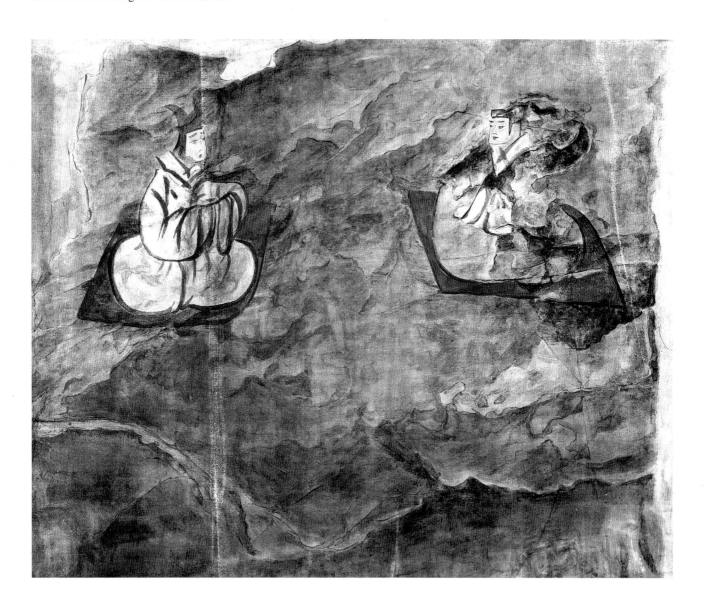

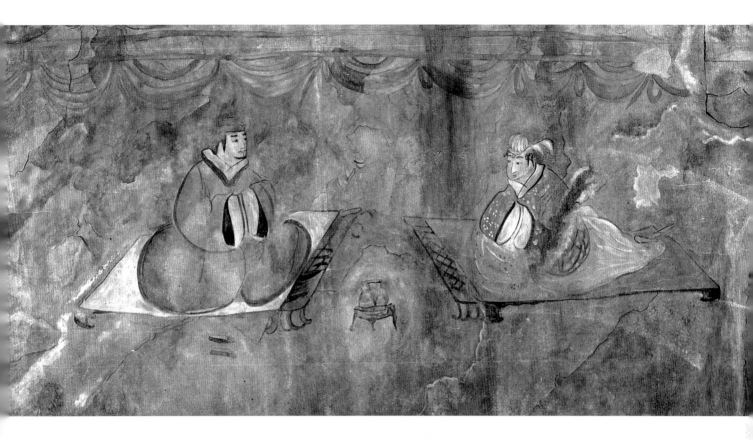

13. 夫妇对坐图（一）（摹本）

汉魏之际（3世纪）

原壁画高105、宽140厘米

1955年辽宁省辽阳市三道壕一号壁画墓出土。原址保存。摹本现存于辽宁省博物馆。

墓向南。位于右小室右壁。男女二人对坐方榻之上。男子有髭须，青巾淡青袍，白领缘，拱手端坐，榻右地上有黑鞋一双。对面方榻之上坐一妇人，橙色花衣，下系白裙。头戴发帻，后有花饰。榻前各置一短几，榻间地上有一三足食器。画面上方高悬帷幕。

（临摹：李万成、唐邽　撰文：陶亮　摄影：林利）

Tomb Occupant Couple Seated Face-to-Face (1) (Replica)

Between Han and Wei (3rd c. CE)

Original mural height 105 cm; Width 140 cm

Unearthed from the No. 1 mural tomb at Sandaohao of Liaoyang, Liaoning, in 1955. Preserved on the original site. The replica is a collection of Liaoning Provincial Museum.

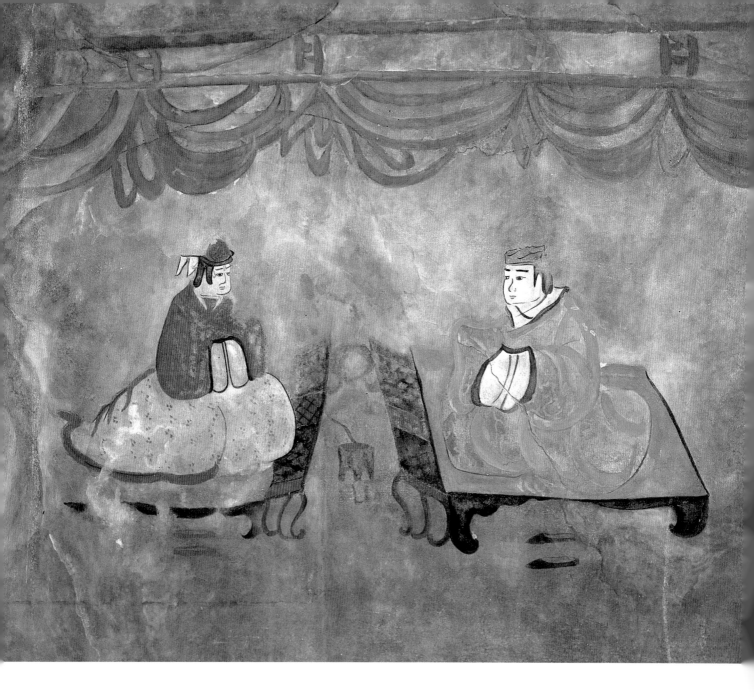

14. 夫妇对坐图（二）（摹本）

汉魏之际（3世纪）

原壁画高105、宽80厘米

1955年辽宁省辽阳市三道壕一号壁画墓出土。原址保存。摹本现存于辽宁省博物馆

墓向南。位于右小室后壁。二人对坐于方榻之上，前置短几，中间地上置樽，器口上露有长柄勺。妇人头戴发帻，后插发簪，上穿红衣，下着红边花白裙，白领袖。榻侧置红鞋一双。男子头裹青巾、宽袖大袍，白领袖，拱手端坐。榻侧置黑鞋一双。二人上方高悬赭红色帷幕。

（临摹：李万成、唐郢　撰文：陶亮　摄影：林利）

Tomb Occupant Couple Seated Face-to-Face (2) (Replica)

Between Han and Wei (3rd c. CE)

Original mural height 105 cm; Width 80 cm

Unearthed from the No. 1 mural tomb at Sandaohao of Liaoyang, Liaoning, in 1955. Preserved on the original site. The replica is a collection of Liaoning Provincial Museum.

15. 庖厨图（摹本）

汉魏之际（3世纪）

原壁画高116、宽90厘米

1955年辽宁省辽阳市三道壕一号壁画墓出土。原址保存。摹本现存于辽宁省博物馆。

墓向160°。位于左小室左壁。画面分两层：下部为圆底灰白陶瓮四个。上部画横杆一根，右起分挂肉块、雉杂、野兔、心肺等肉食。

<div align="right">（临摹：李万成、唐郢　撰文：陶亮　摄影：林利）</div>

Cooking (Replica)

Between Han and Wei (3rd c. CE)

Original mural height 116 cm: Width 90 cm

Unearthed from the No. 1 mural tomb at Sandaohao of Liaoyang, Liaoning, in 1955. Preserved on the original site. The replica is a collection of Liaoning Provincial Museum.

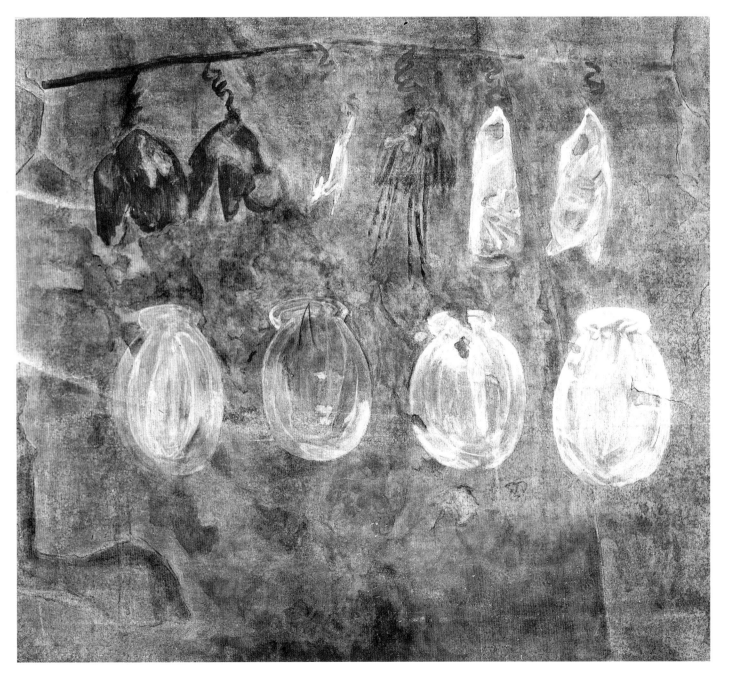

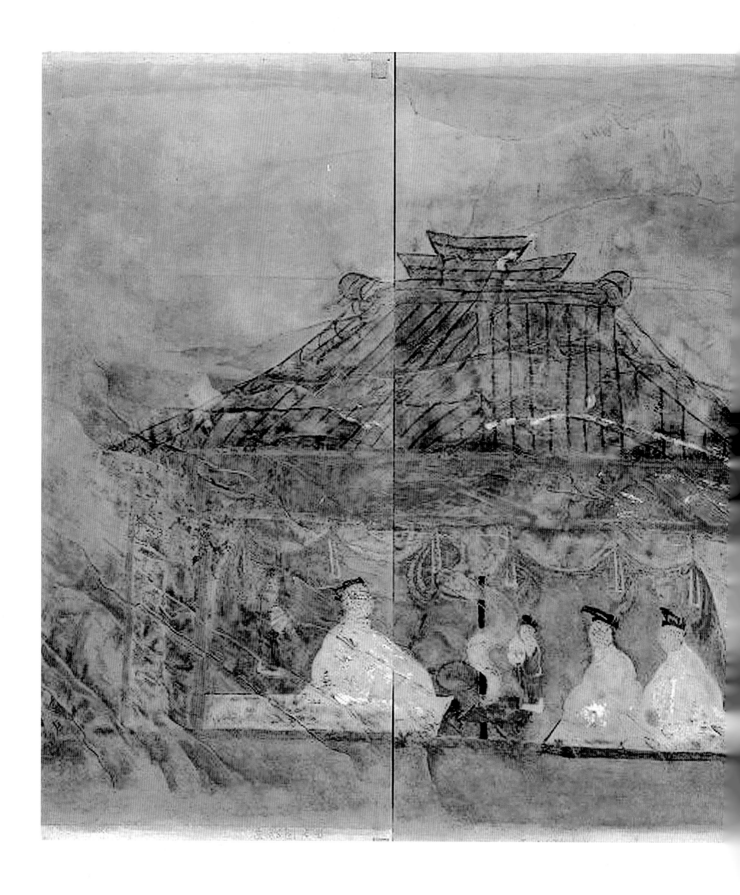

16.宴饮图（摹本）

汉魏之际（3世纪）

摹本高99、宽137厘米

1943年辽宁省辽阳市北园一号墓出土。原址保存。摹本现存于辽宁省博物馆。

墓向西南。绘于后面突出小室之后、左二壁。画面绘一座单檐庑殿厅堂，堂中帷幕高卷。尊者一人白衣黑冠，就左侧面右坐席上，前列案食器等，蒸气高腾上达檐际。右面二人相对坐，神态肃然。二小吏捧瓶恭侍。堂右绿树一株，二小吏捧瓶欲趋堂上。现摹本中只见一名小吏。堂右及右壁则朱墨狼藉，不明原状。

（临摹：不详　撰文：陶亮　摄影：林利）

Feasting (Replica)

Between Han and Wei (3rd c. CE)

Height 99 cm; Width 137 cm

Unearthed from the mural tomb at Beiyuan of Liaoyang, Liaoning, in 1943. Preserved on the original site. The replica is a collection of Liaoning Provincial Museum.

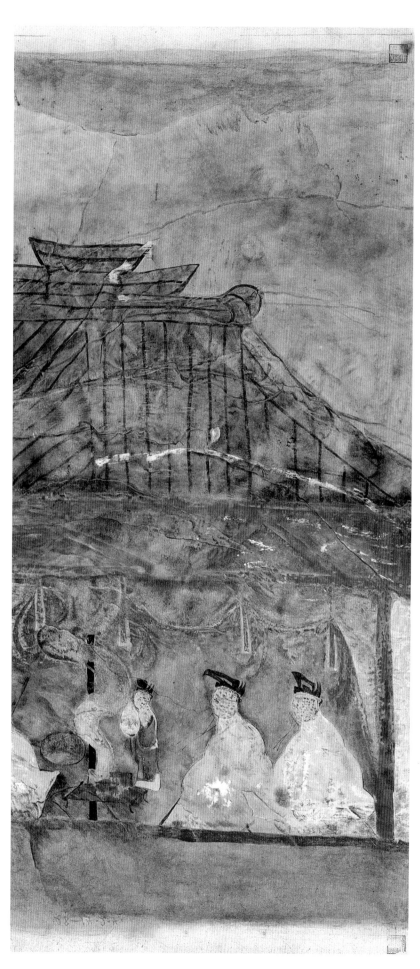

17.宴饮图（局部）（摹本）

汉魏之际（3世纪）

1943年辽宁省辽阳市北园一号墓出土。原址保存。摹本现存于辽宁省博物馆。

墓向西南。此图位于后面突出小室之后、左二壁。庑殿堂中，帷幕高卷。图右二人，神态肃然。

（临摹：不详　撰文：陶亮

摄影：林利）

Feasting (Detail) (Replica)

Between Han and Wei (3rd c. CE)
Unearthed from the mural tomb at Beiyuan of Liaoyang, Liaoning, in 1943. Preserved on the original site. The replica is a collection of Liaoning Provincial Museum.

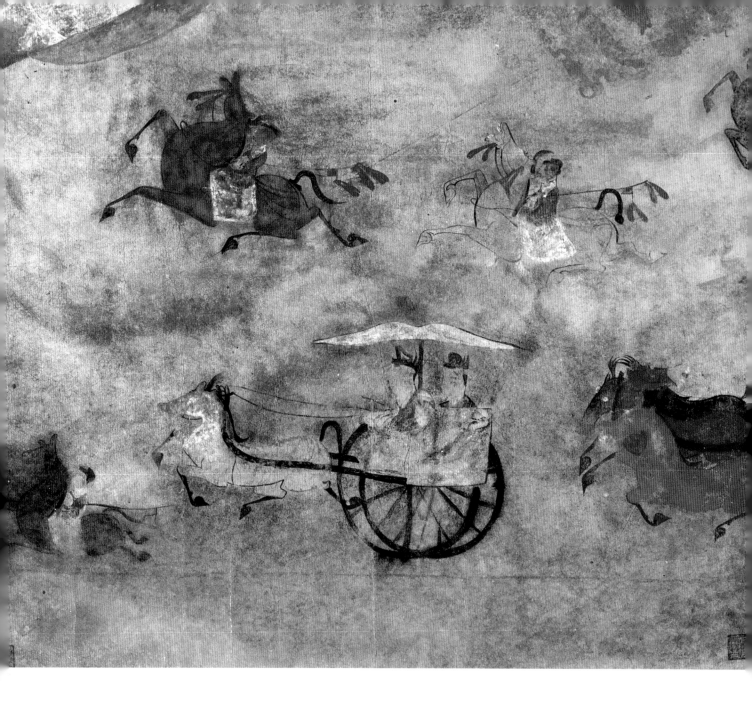

18. 车列图（局部）（摹本）

汉魏之际（3世纪）

1943年辽宁省辽阳市北园一号墓出土。原址保存。摹本现存于辽宁省博物馆。

墓向西南。位于墓室左壁。车骑行于山脚之下，队前黑帻长袍骑吏一人，队后黑帻长袍骑吏二人，车队靠山一方有骑吏四人护持。车共三乘，前为白盖车，一马引车，车上二人，皆黑帻，御手红袍。次为帷车一辆，三马共驾，御手红袍黑帻。骑吏四人并驾于后。其后又白盖车一辆，形制同于最前一车。

（临摹：不详　撰文：陶亮　摄影：林利）

Carts in Procession (Detail) (Replica)

Between Han and Wei (3rd c. CE)

Unearthed from the mural tomb at Beiyuan of Liaoyang, Liaoning, in 1943. Preserved on the original site. The replica is a collection of Liaoning Provincial Museum.

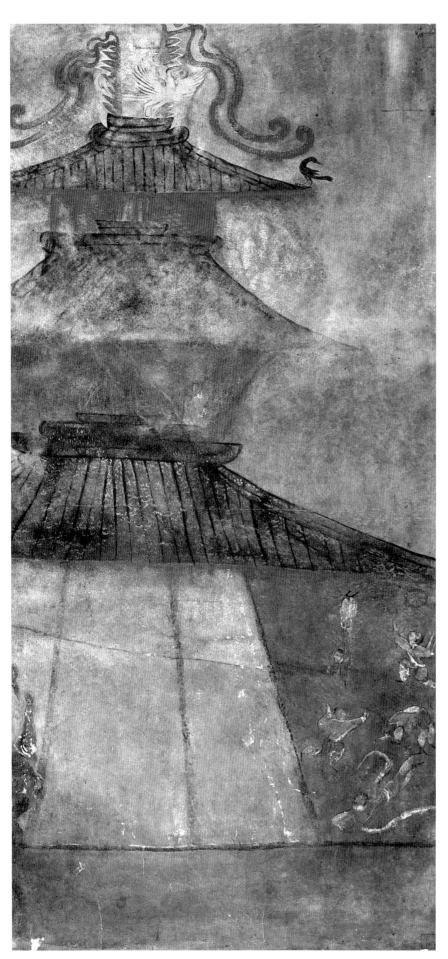

19.阙楼图（摹本）

汉魏之际（3世纪）

1943年辽宁省辽阳市北园一号墓出土。原址保存。摹本现存于辽宁省博物馆。墓向西南。位于墓室后壁。正面阙楼三层，黛瓦朱栏，赤户青琐，顶立凤鸟，左右并植赤色长旗，上结朱绶。中层坐一妇人。上层右垂脊上立一鸟，长尾巨目，作回首惊顾欲飞状，远方立一人，裸而着蔽膝，弯弓向鸟作势欲射。楼阁下为倒立、弄丸、跳剑、舞轮、反弓、兽舞等百戏乐舞。

（临摹：不详　撰文：陶亮

摄影：林利）

Gate Tower (Replica)

Between Han and Wei (3rd c. CE)
Unearthed from the mural tomb at Beiyuan of Liaoyang, Liaoning, in 1943. Preserved on the original site. The replica is a collection of Liaoning Provincial Museum.

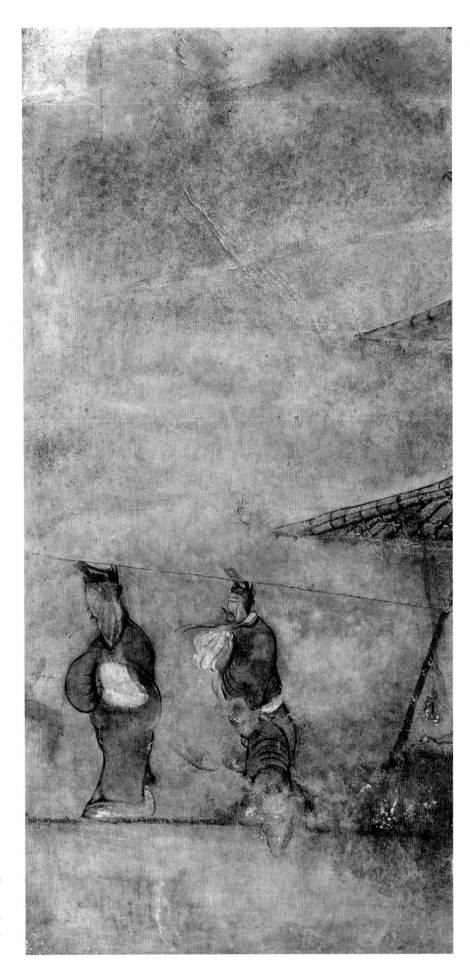

20.属吏图（摹本）

汉魏之际（3世纪）

1943年辽宁省辽阳市北园一号墓出土。原址保存。摹本现存于辽宁省博物馆。

墓向西南。位于墓室后壁西端层楼之左下，原题有"小府吏"三字。二人左向，拱手而立。原画左题有"教以勤化以诚"六字。

（临摹：不详　撰文：陶亮
摄影：林利）

Inferior Officials (Replica)

Between Han and Wei (3rd c. CE)
Unearthed from the mural tomb at Beiyuan of Liaoyang, Liaoning, in 1943. Preserved on the original site. The replica is a collection of Liaoning Provincial Museum.

21. 斗鸡图（一）（摹本）

汉魏之际（3世纪）

1943年辽宁省辽阳市北园一号墓出土。原址保存。摹本现存于辽宁省博物馆墓向西南。位于墓室左方突出小室正壁及右壁。赤冠雄鸡二羽，其一张喙奋目，两翼微展，颈羽戟立，怒态可掬，另一铩羽败逃，回首惊顾。地上血迹斑斑，间以残羽。

（临摹：不详　撰文：陶亮　摄影：林利）

Cockfighting Game (1) (Replica)

Between Han and Wei (3rd c. CE)
Unearthed from the mural tomb at Beiyuan of Liaoyang, Liaoning, in 1943. Preserved on the original site. The replica is a collection of Liaoning Provincial Museum.

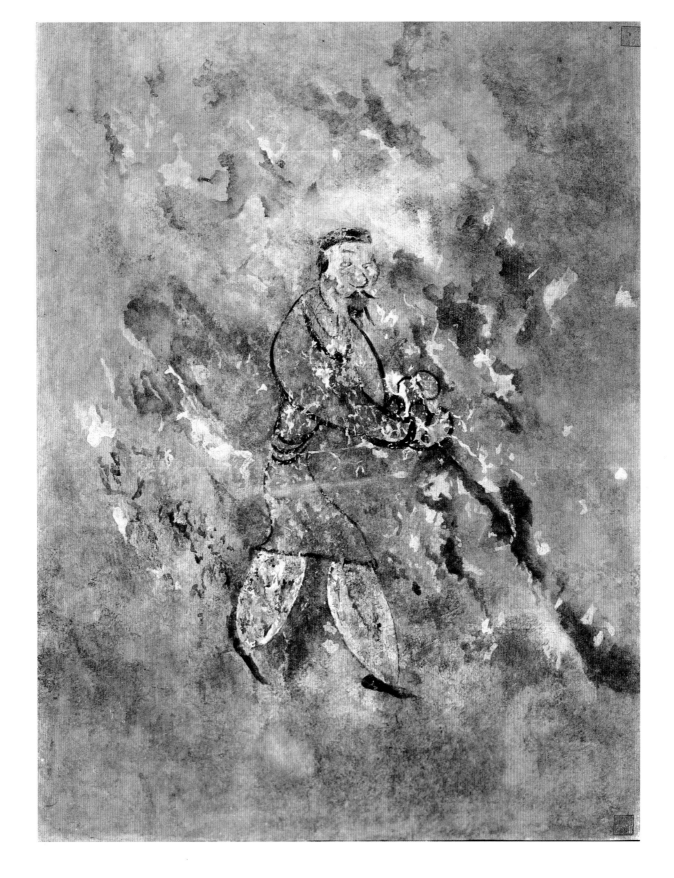

22. 斗鸡图（二）（摹本）

汉魏之际（3世纪）

1943年辽宁省辽阳市北园一号墓出土。原址保存。摹本现存于辽宁省博物馆。

斗鸡图之右壁部分。一老者短衣大袴，双手捧物趋前。

（临摹：不详　撰文：陶亮　摄影：林利）

Cockfighting Game (2) (Replica)

Between Han and Wei (3rd c. CE)

Unearthed from the mural tomb at Beiyuan of Liaoyang, Liaoning, in 1943. Preserved on the original site. The replica is a collection of Liaoning Provincial Museum.

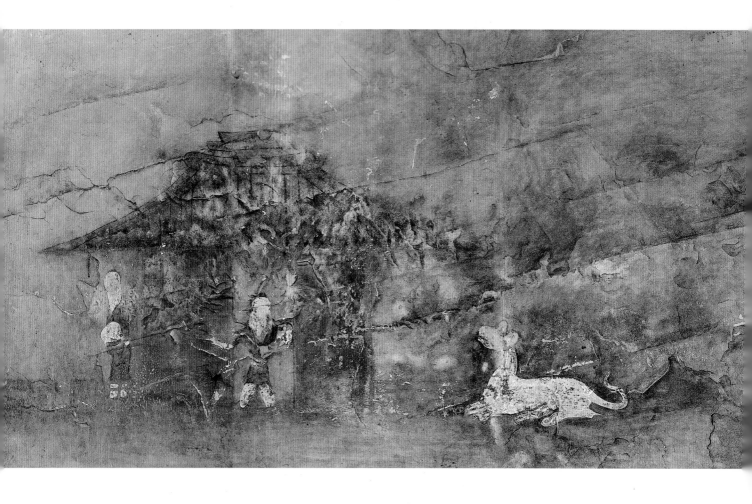

23. 仓廪图（摹本）

汉魏之际（3世纪）

1943年辽宁省辽阳市北园一号墓出土。摹本现存于辽宁省博物馆。

墓向西南。位于墓室前左小室左后二壁。原画题有"代郡廪"一行三字。仓廪形如瓦屋，阶上朱栏绕之，留有出入路口。仓户偏右半启，一小吏双手捧物走出仓室之左下檐。右阶下卧一白犬，长嘴微露舌端，双耳微圆而竖。二目眈眈注视仓门。

（临摹：不详　撰文：陶亮　摄影：林利）

Storehouse (Replica)

Between Han and Wei dynasties (3rd c. CE)

Unearthed from the mural tomb at Beiyuan of Liaoyang, Liaoning, in 1943. Preserved on the original site. The replica is a collection of Liaoning Provincial Museum.

24. 仓官图（摹本）

汉魏之际（3世纪）

高100、宽62厘米

1943年辽宁省辽阳市北园一号墓出土。原址保存。摹本现存于辽宁省博物馆。

墓向西南。位于墓室前左小室右壁，为仓廪图之局部。冠服一人向仓立，双手似有所捧，仪态高雅，应为仓官。

（临摹：不详　撰文：陶亮　摄影：林利）

Storehouse Keeper (Replica)

Between Han and Wei dynasties (3rd c. CE)

Height 100 cm; Width 62 cm

Unearthed from the mural tomb at Beiyuan of Liaoyang, Liaoning, in 1943. Preserved on the original site. The replica is a collection of Liaoning Provincial Museum.

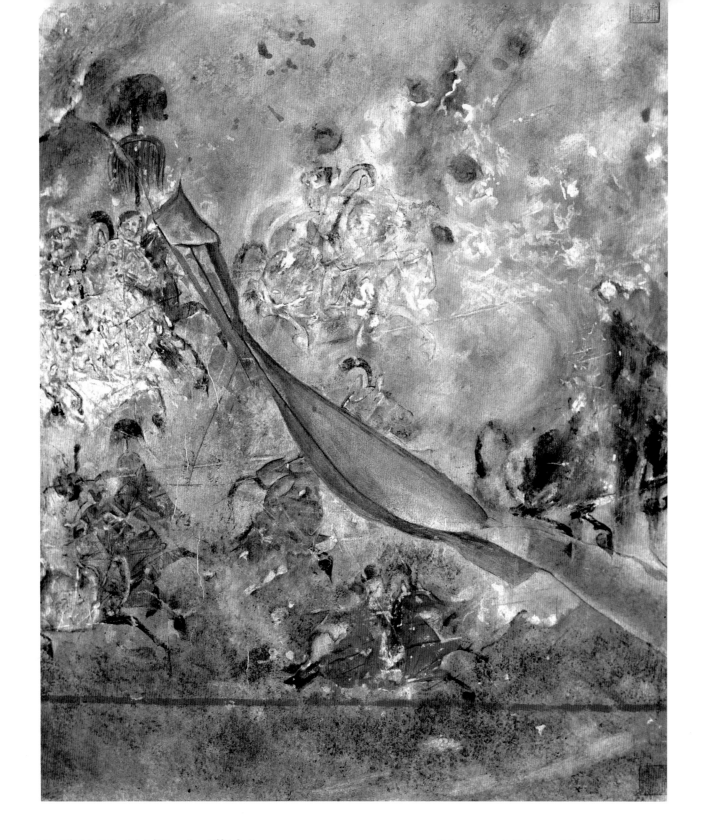

25.骑从图（局部一）（摹本）

汉魏之际（3世纪）

1943年辽宁省辽阳市北园一号墓出土。原址保存。摹本现存于辽宁省博物馆。墓西南向。位于墓室左大壁及中央左右二小壁。横排六人，每二骑并进约百余骑，存者可见三分之一。武士前队，兜鍪重札，马皆雕鞍饰勒。执长兵佩剑先导者数十人。次冠服乘者数人。一骑士手擎朱色大麾委地，一仗幢从之，继以持伞盖者数骑。此图为局部。

（临摹：不详　撰文：陶亮　摄影：林利）

Mounted Riders in Procession (Detail 1) (Replica)

Between Han and Wei (3rd c. CE)

Unearthed from the mural tomb at Beiyuan of Liaoyang, Liaoning, in 1943. Preserved on the original site. The replica is a collection of Liaoning Provincial Museum.

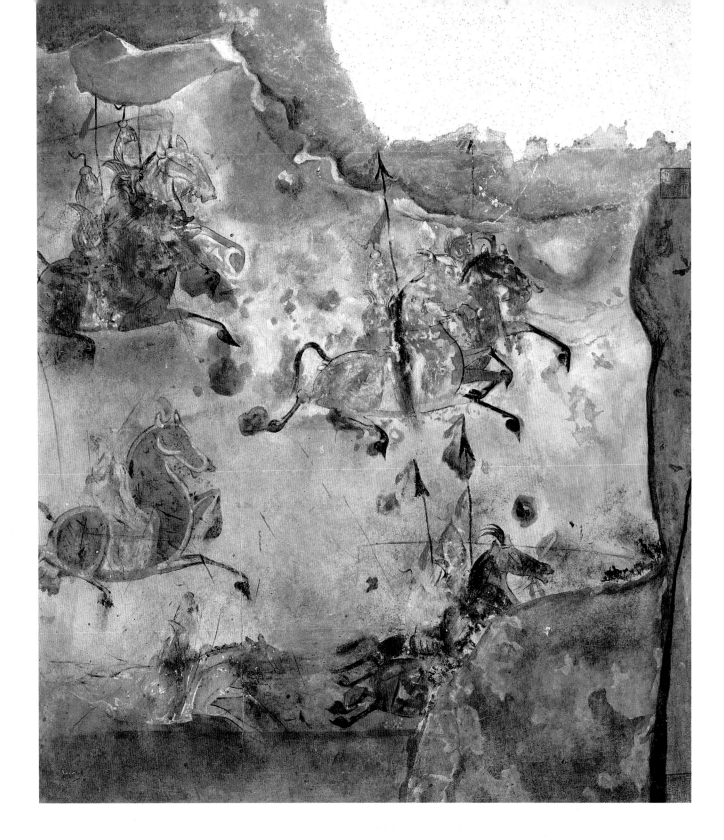

26.骑从图（局部二）（摹本）

汉魏之际（3世纪）

1943年辽宁省辽阳市北园一号墓出土。原址保存。摹本现存于辽宁省博物馆。墓向西南。位于墓室右大壁及中央左右二小壁。横排六人，每二骑并进约百余骑，存者可见三之一。武士前队，兜鍪重札，马皆雕鞍饰勒。执长兵佩剑先导者数十人。次冠服乘者数人。一骑士手擎朱色大麾委地，一仗幢从之,继以持伞盖者数骑。此图为局部。

（临摹：不详　撰文：陶亮　摄影：林利）

Mounted Riders in Procession (Detail 2) (Replica)

Between Han and Wei (3rd c. CE)

Unearthed from the mural tomb at Beiyuan of Liaoyang, Liaoning, in 1943. Preserved on the original site. The replica is a collection of Liaoning Provincial Museum.

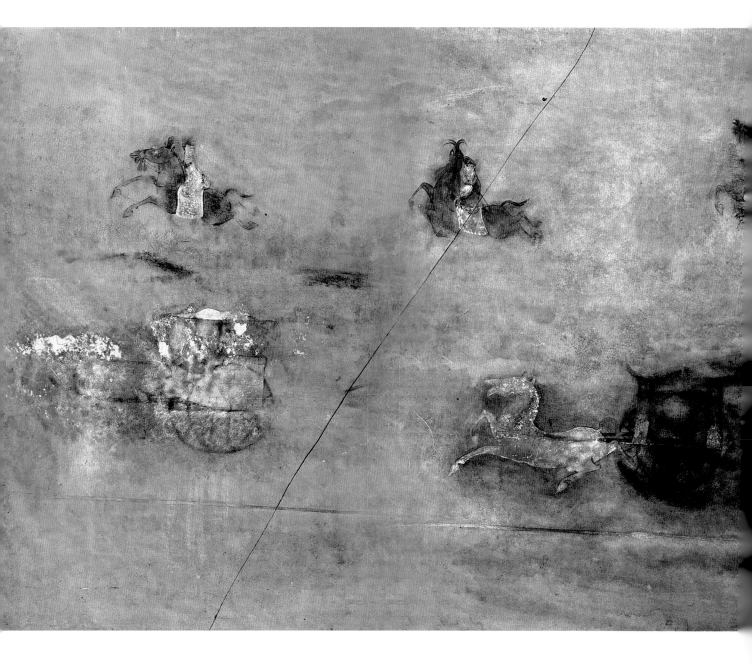

27. 车舆图（摹本）

汉魏之际（3世纪）

高94、宽242厘米

1943年辽宁省辽阳市北园一号墓出土。原址保存。摹本现存于辽宁省博物馆。

墓向西南。位于墓室中左大壁。现存车四辆，白盖车二，黑盖车二，骑吏五人。

（临摹：不详　撰文：陶亮　摄影：林利）

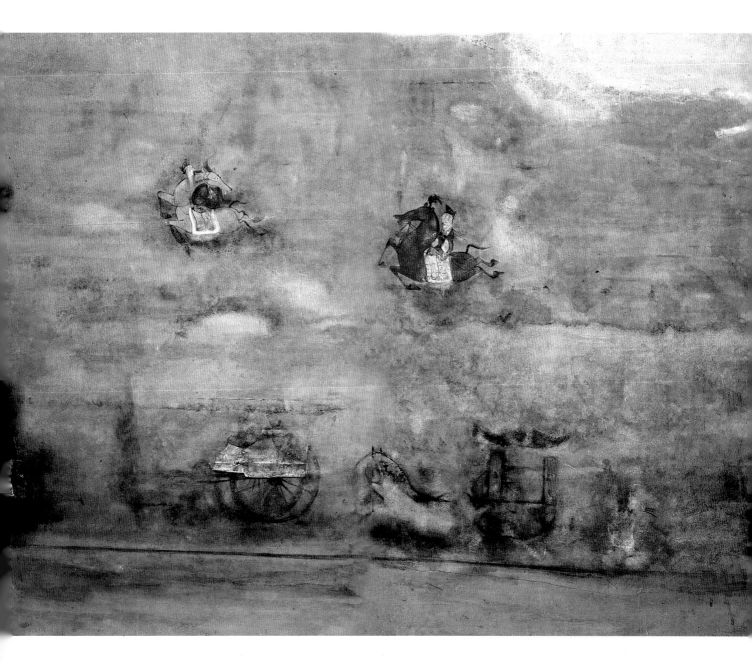

Carts in Procession (Replica)

Between Han and Wei (3rd c. CE)

Height 94 cm; Width 242 cm

Unearthed from the mural tomb at Beiyuan of Liaoyang, Liaoning, in 1943. Preserved on the original site. The replica is a collection of Liaoning Provincial Museum.

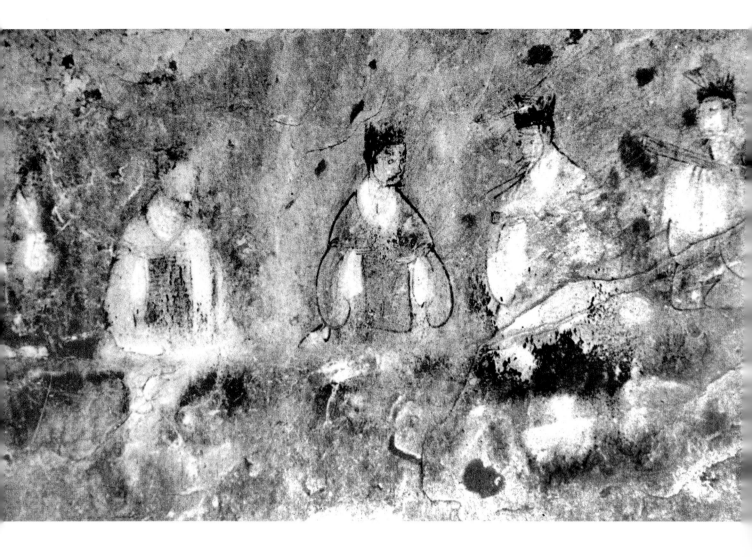

28.人物图

汉魏之际（3世纪）

宽120、高20厘米

1975年辽宁省辽阳市鹅房一号壁画墓出土。原址保存。

墓向210°。位于前室左耳室正壁中部。此图为壁画右半部分。绘男像五，中间四人较大，身穿绿袍，白缘领袖，微有胡须，头戴进贤冠，垂长带，皆拱手而坐，似在交谈。左端男像较小，站立。手有所持，当是侍从。

（撰文：陶亮　摄影：不详）

Figures

Between Han and Wei (3rd c. CE)

Height 20 cm; Width 120 cm

Unearthed from No.1 mural tomb at E'fang of Liaoyang, Liaoning, in 1975. Preserved on the original site.

29.宴饮图

汉魏之际（3世纪）

高17、宽64厘米

1975年辽宁省辽阳市鹅房一号壁画墓出土。原址保存。

墓向210°。位于前室左耳室左壁。右侧三男面左，头戴黑帻，着红绿袍，白缘领袖，拱手而坐，神色恭敬。左侧一男一女，面右。男子头戴黑帻，身穿长袍，白缘领袖，拱手坐。女子高髻，身穿红袍，拱手坐于男子身后。席间有一男子做倒立表演。一侍女低眉侍立。下方绘有一个长方形四足漆案，案上放一朱绘圆盖盒，右边为圆盘一个，左边为圆形漆奁一具。

（撰文：陶亮　摄影：不详）

Feasting

Between Han and Wei (3rd c. CE)

Height 17 cm; Width 64 cm

Unearthed from No.1 mural tomb at E'fang of Liaoyang, Liaoning, in 1975. Preserved on the original site.

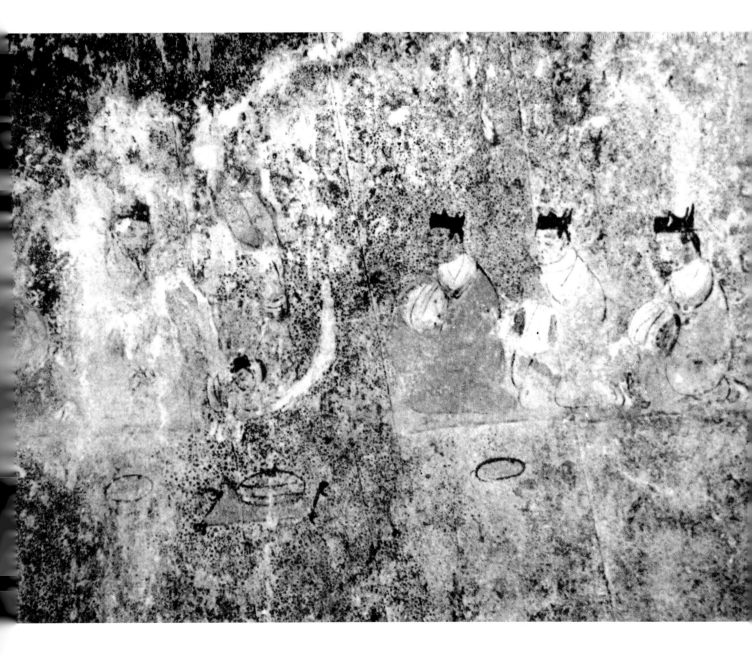

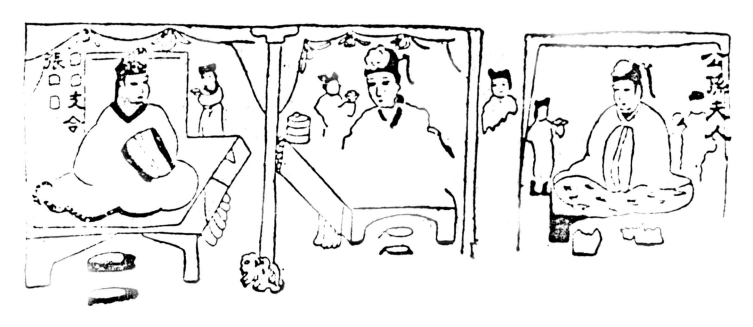

▲30. 家居图（摹本）

汉魏之际（3世纪）

壁高85厘米，全长175厘米，画面高45厘米

1953年辽宁省辽阳市三道壕窑业第二现场令支令张君墓出土。原址保存。

墓向12°。位于右小室右壁及后壁。全壁画堂屋三间，每间都帷幕高悬。左间画一男子面右坐方榻上，榻下地上放黑鞋一双，当是男主人，旁立一小侍捧杯进饮食。背后有墨书题记两行"□令支令张□□"。中间方榻上与男子对面坐一妇人，高髻簪花，地上有红鞋一双，右前角放一圆食盒上置一小红耳杯。旁一双髻侍女捧盘进食，背后柱上有墨笔隶书"□夫人"三字。右间一妇人面左坐方榻上，高髻插花，后有曲簪垂长饰，背后墨书"公孙夫人"四字。

（临摹：李文信　撰文：温科学　摄影：不详）

Domestic Scene (Replica)

Between Han and Wei (3rd c. CE)

Height of the wall 85 cm, overall length 175 cm; Height of the mural 45 cm

Unearthed from the mural tomb of Magistrate Zhang at the 2nd site of Sandaohao Kiln of Liaoyang, Liaoning, in 1953. Preserved on the original site.

31. 墓主人像（摹本）▶

前燕（337～370年）

画面高80.5、宽65.2厘米

1982年辽宁省朝阳市十二台营子乡袁台子村壁画墓出土。原址保存。摹本现存于辽宁省博物馆。

墓向170°。位于前室西龛内。画面上方帷幕高悬，帷帐挽结，下垂朱带。左右有屏障。主人坐于帐下方榻之上，戴黑冠，面长圆，浓眉大眼，高鼻，红唇，大耳，留须。身着右衽红袍，黑领，广袖。左手平放于胸腹之前，右手执麈尾于右肩前。左方屏后立二侍女，高髻，着方领长衣，面目不清。右方屏后亦立侍女，仅见高髻。下部画面已模糊不清。

（临摹：刘忠诚、王维忠　撰文：都惜青　摄影：林利）

Portrait of Tomb Occupant (Replica)

Former Yan Period (337-370 CE)

Height 80.5 cm; Width 65.2 cm

Unearthed from a mural tomb at Yuantaizicun of Shi'ertaiyingzi, Chaoyang, Liaoning, in 1982. Preserved on the original site; the replica is a collection of Liaoning Provincial Museum.

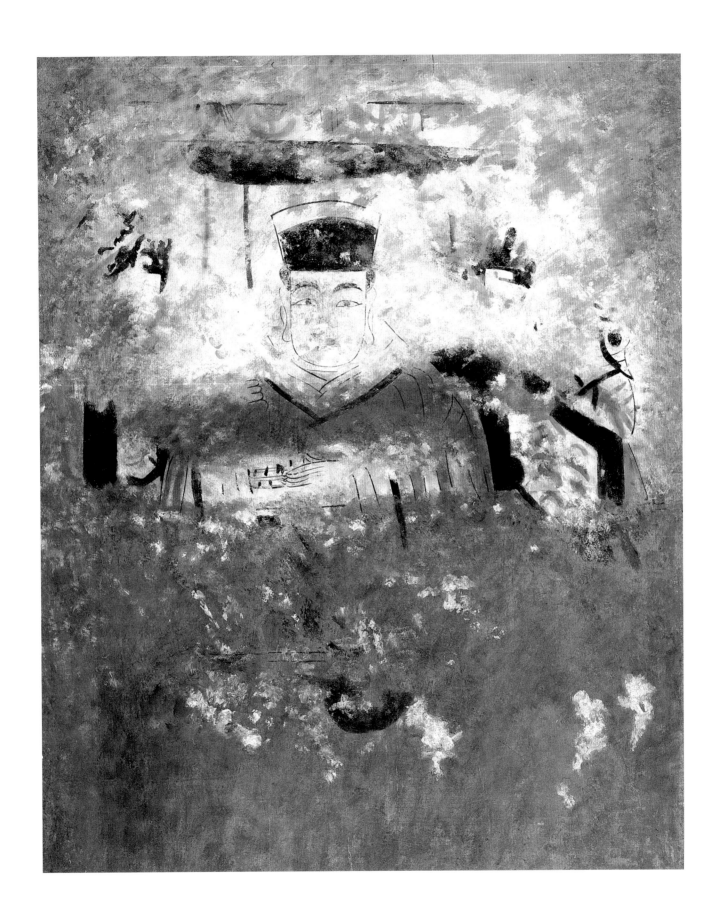

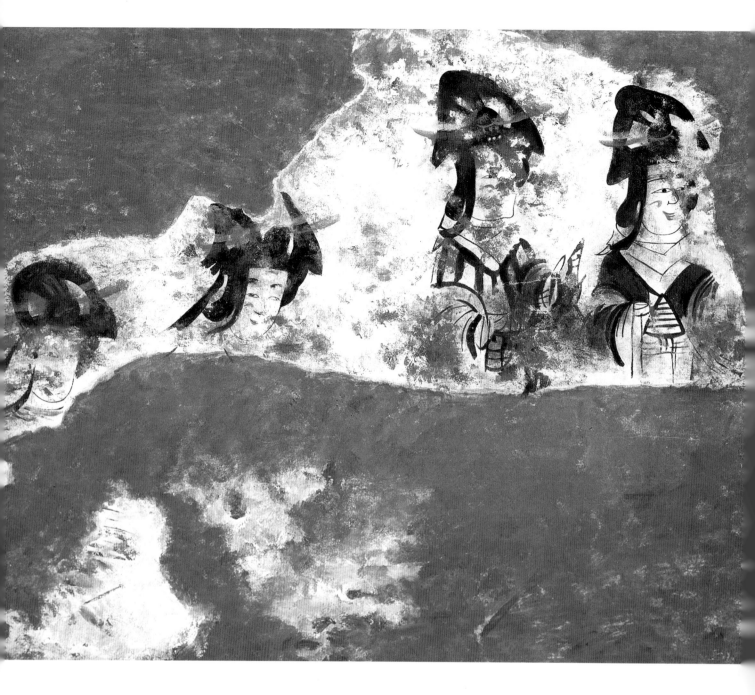

32.侍女图（摹本）

前燕（337～370年）

画面高53、宽66厘米

1982年辽宁省朝阳市十二台营子乡袁台子村壁画墓出土。原址保存。摹本现存于辽宁省博物馆。

墓向170°。位于主人图前面的南壁上。上部画面东西并列四人，均面向墓主人。画面右侧二人站立，手捧器物；左侧二人仅见头部。四人均双环高髻，横贯朱笄。面部方圆，弯眉大眼，高鼻，朱唇，额、颧骨部均涂朱。着方领长袍，装束艳丽。下部已漫漶不清。

（临摹：刘忠诚、王维忠　撰文：都惜青　摄影：林利）

Maids (Replica)

Former Yan Period (337-370 CE.)

Height 53 cm; Width 66 cm

Unearthed from a mural tomb at Yuantaizicun of Shi'ertaiyingzi, Chaoyang, Liaoning, in 1982. Preserved on the original site; the replica is a collection of Liaoning Provincial Museum.

33. 奉食图（摹本）

前燕（337～370年）

画面高51、宽98.5厘米

1982年辽宁省朝阳市十二台营子乡袁台子村壁画墓出土。原址保存。摹本现存于辽宁省博物馆。

墓向170°。位于西壁前部，一列七人。在自左至右第五、六人头上部有墨书题铭，现只可识出"二月己……子……殡背万……墓……墓奠"等楷书字样。在第一人头上部还残存一龙首。

<div align="right">（临摹：刘忠诚、王维忠　撰文：都惜青　摄影：林利）</div>

Food Serving (Replica)

Former Yan Period (337-370 CE.)

Height 51 cm; Width 98.5 cm

Unearthed from a mural tomb at Yuantaizicun of Shi'ertaiyingzi, Chaoyang, Liaoning, in 1982. Preserved on the original site; the replica is a collection of Liaoning Provincial Museum.

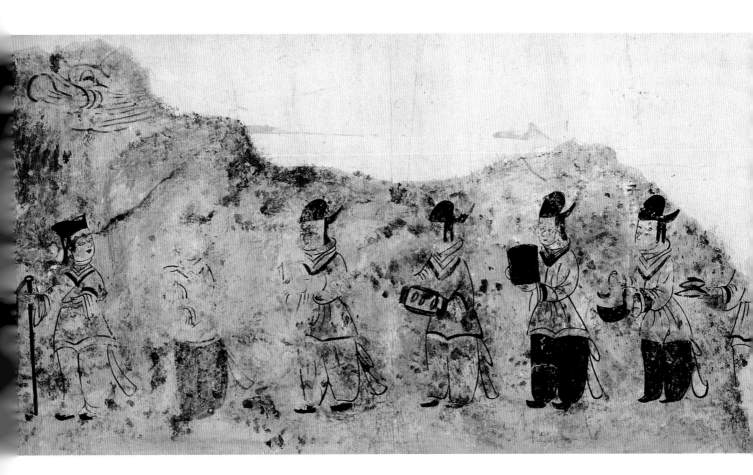

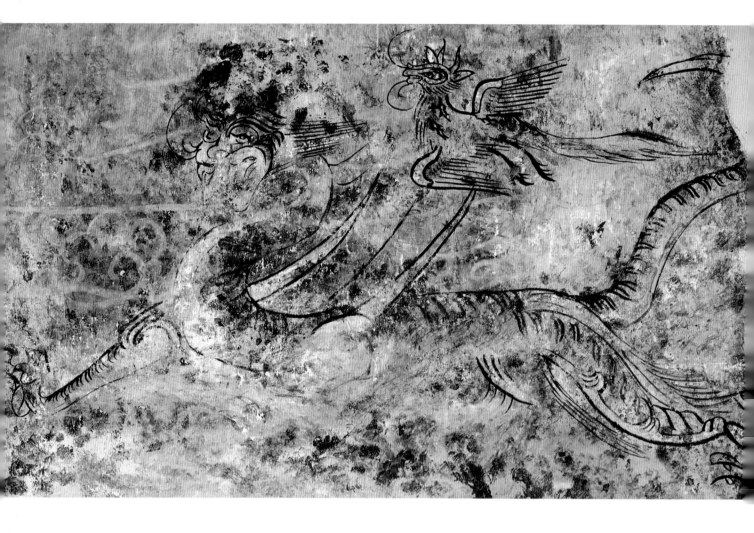

34. 白虎图（摹本）

前燕（337～370年）

画面高62、宽105厘米

1982年辽宁省朝阳市十二台营子乡袁台子村壁画墓出土。原址保存。摹本现存于辽宁省博物馆。

墓向170°。位于西壁奉食图的下部。画白虎、朱雀，皆墨线构图。白虎张嘴露齿，双目圆睁，昂首曲身扬尾，作奔腾姿态。虎上方画昂首、展翼的朱雀，作飞翔姿态。

（临摹：刘忠诚、王维忠　撰文：都惜青　摄影：林利）

White Tiger (Replica)

Former Yan Period (337-370 CE)

Height 62 cm; Width 105 cm

Unearthed from a mural tomb at Yuantaizicun of Shi'ertaiyingzi, Chaoyang, Liaoning, in 1982. Preserved on the original site; the replica is a collection of Liaoning Provincial Museum.

35.黑熊图（摹本）

前燕（337~370年）

画面残高17.5、宽27厘米

1982年辽宁省朝阳市十二台营子乡袁台子村壁画墓出土。原址保存。摹本现存于辽宁省博物馆。

墓向170°。位于西壁奉食图上部垫石上，画面脱落。北端仅存一黑熊，竖耳，张嘴露舌，前肢掌上举，下肢站立。黑熊直接用墨涂染而不加勾勒。

（临摹：刘忠诚、王维忠　撰文：都惜青　摄影：林利）

Black Bear (Replica)

Former Yan Period (337-370 CE)

Surviving height 17.5 cm; Width 27 cm

Unearthed from a mural tomb at Yuantaizicun of Shi'ertaiyingzi, Chaoyang, Liaoning, in 1982. Preserved on the original site; the replica is a collection of Liaoning Provincial Museum.

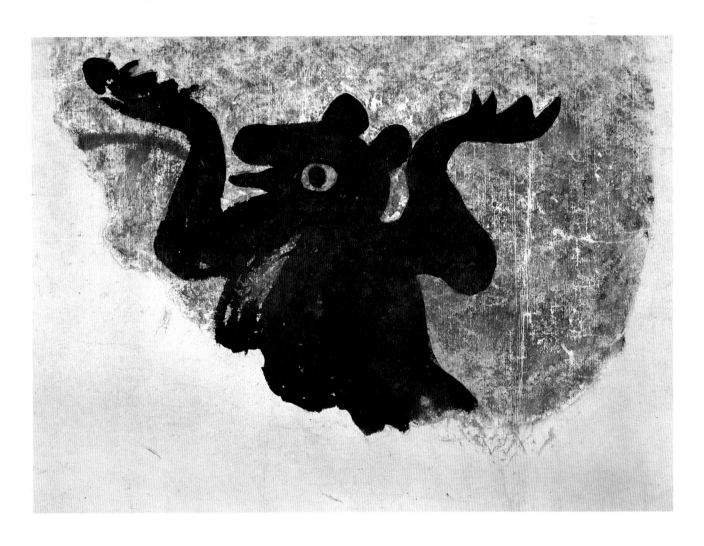

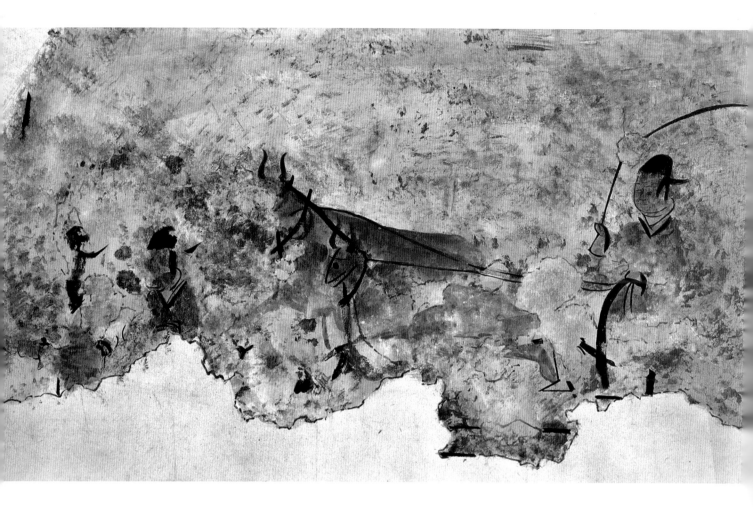

36.牛耕图（摹本）

前燕（337～370年）

画面高39、宽69厘米

1982年辽宁省朝阳市十二台营子乡袁台子村壁画墓出土。原址保存。摹本现存于辽宁省博物馆。

墓向170°。位于西壁龛顶部，绘红、黄二牛挽犁耕作。一扶犁者圆脸，黑帻，着方领短衣，领边袖口镶黑边，束腰，长裤，左手扶犁，右手扬鞭赶牛。牛前并列二人，黑帻，着青色短衣，领边袖口亦镶黑边，束腰，似在协助耕作。画法较为简洁，两牛牛身直接用颜色涂绘，不用墨线勾勒，很有特色。

（临摹：刘忠诚、王维忠　撰文：都惜青　摄影：林利）

Ox Plowing (Replica)

Former Yan Period (337-370 CE.)

Height 39 cm; Width 69 cm

Unearthed from a mural tomb at Yuantaizicun of Shi'ertaiyingzi, Chaoyang, Liaoning, in 1982. Preserved on the original site; the replica is a collection of Liaoning Provincial Museum.

37. 庭院图（摹本）

前燕（337～370年）

画面高83.5、宽91厘米

1982年辽宁省朝阳市十二台营子乡袁台子村壁画墓出土。原址保存。摹本现存于辽宁省博物馆。

墓向170°。位于西壁后部，以墨线勾出高大的砖筑院墙，院内有过墙的高树，院内一人。画面上方停放三台车，有二人手持木梯。车旁亦有一人，均裹黑帻。其余画面已漫漶不清。

（临摹：刘忠诚、王维忠　撰文：都惜青　摄影：林利）

Courtyard (Replica)

Former Yan Period (337-370 CE)

Height 83.5 cm; Width 91 cm

Unearthed from a mural tomb at Yuantaizicun of Shi'ertaiyingzi, Chaoyang, Liaoning, in 1982. Preserved on the original site. The replica is a collection of Liaoning Provincial Museum.

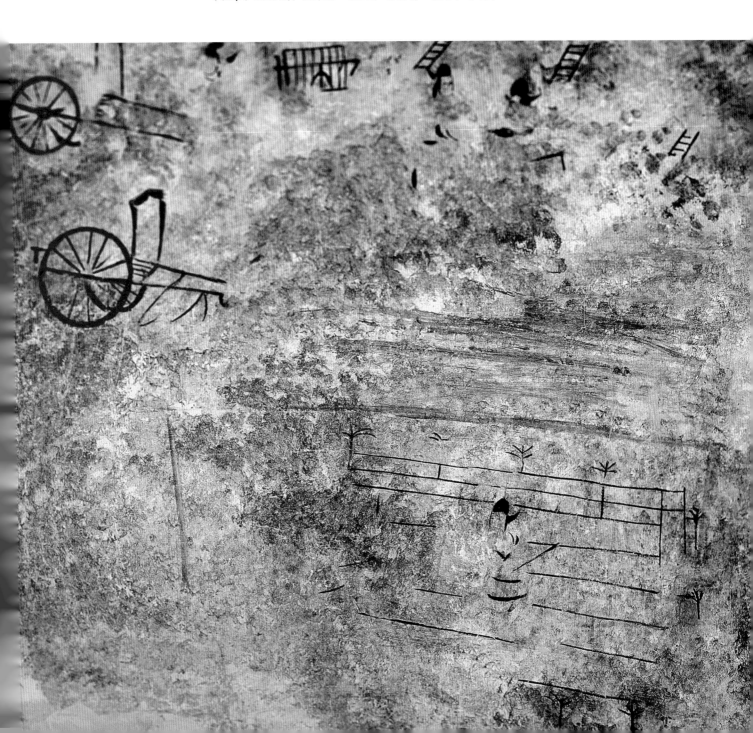

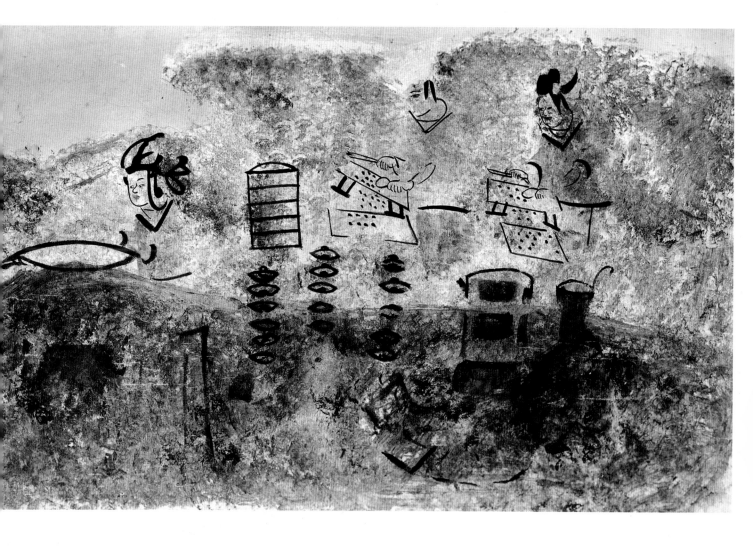

38. 备膳图（摹本）

前燕（337～370年）

画面高52、宽83厘米

1982年辽宁省朝阳市十二台营子乡袁台子村壁画墓出土。原址保存。摹本现存于辽宁省博物馆。

墓向170°。位于东壁后部，画中三人。右一人黑帻，着斜领短衣，领边袖口镶黑边，长裤，右手持刀，左手持物，俯首于俎案上作切菜姿态。俎旁置盛菜的方盘，下置樽、魁等器。中间一人装束、动作均与前同，前置三排杯盘。左边一女子，高髻，着斜领衣，忙于灶前。灶上置釜，女子身后有一五层笼屉。

<div align="right">（临摹：刘忠诚、王维忠　撰文：都惜青　摄影：林利）</div>

Preparation for a Meal (Replica)

Former Yan Period (337-370 CE)

Height 52 cm; Width 83 cm

Unearthed from a mural tomb at Yuantaizicun of Shi'ertaiyingzi, Chaoyang, Liaoning, in 1982. Preserved on the original site. The replica is a collection of Liaoning Provincial Museum.

39. 车骑图（摹本）

前燕（337～370年）

画面高42.5、宽65厘米

1982年辽宁省朝阳市十二台营子乡袁台子村壁画墓出土。原址保存。摹本现存于辽宁省博物馆。

墓向170°。位于东壁壁龛上部，画面左上方绘一牛车，黄牛驾辕，车上高篷，前有门帘，上缀成排的泡饰。旁有车夫一人，黑帻，蓝色短衣，作牵牛姿态。牛车前方左右各有一人，均黑帻，短衣，长裤，黑鞋，骑于马上并列而行。车骑图与狩猎图，应是整幅连壁大作的出猎场面，象征主人出猎时前导后从的图景。

（临摹：刘忠诚、王维忠　撰文：都惜青　摄影：林利）

Ox Cart and Mounted Riders (Replica)

Former Yan Period (337-370 CE)

Height 42.5 cm; Width 65 cm

Unearthed from a mural tomb at Yuantaizicun of Shi'ertaiyingzi, Chaoyang, Liaoning, in 1982. Preserved on the original site. The replica is a collection of Liaoning Provincial Museum.

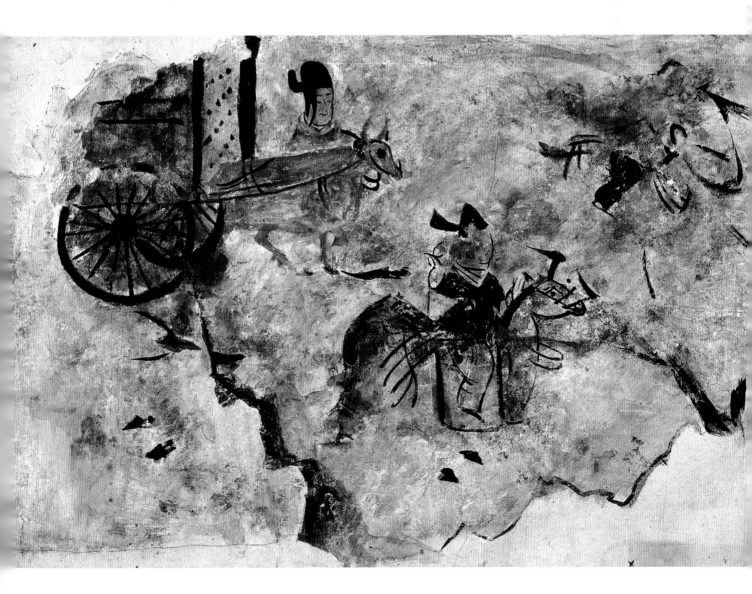

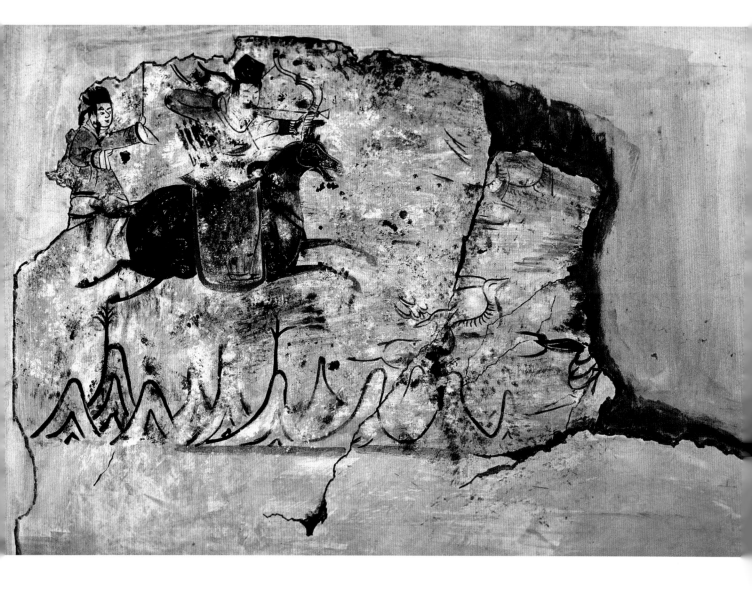

40. 狩猎图（摹本）

前燕（337～370年）

画面高58.5、宽85.5厘米

1982年辽宁省朝阳市十二台营子乡袁台子村壁画墓出土。原址保存。摹本现存于辽宁省博物馆。

墓向170°。位于东壁前部，图中墓主人骑在昂首奔驰的黑马上，马鞍勒俱全，及颈銮饰都很清晰。主人裹黑帻，身着斜领、红袖口浅绿色短衣，束腰系带，黄色长裤，黑鞋。身背黑色箭囊，囊中装四支箭，箭尾端黑羽、红缨。左手执弓，右手拉弦瞄准待射。马前方有群鹿、黄羊，正飞驰奔逃。马后一人，黑帻，斜领，黄色短衣，黑裤，黑鞋，左手扬鞭催马。下方画起伏的山峦及树木，人大于山的画法与魏晋时代的山水画风格一致。

（临摹：刘忠诚、王维忠　撰文：都惜青　摄影：林利）

Hunting (Replica)

Former Yan Period (337-370 CE.)

Height 58.5 cm; Width 85.5 cm

Unearthed from a mural tomb at Yuantaizicun of Shi'ertaiyingzi, Chaoyang, Liaoning, in 1982. Preserved on the original site. The replica is a collection of Liaoning Provincial Museum.

41.牛车图（摹本）

前燕（337～370年）

画面高32、宽50厘米

1982年辽宁省朝阳市十二台营子乡袁台子村壁画墓出土。原址保存。摹本现存于辽宁省博物馆。

墓向170°。位于东耳室东壁的南部。绘牛车一乘，黑轮辕，高篷，篷前有矮档隔，篷两侧有高篷架，顶有飘带。车夫一人，黑帻，短衣，黑裤，黑鞋。

（临摹：刘忠诚、王维忠　撰文：都惜青　摄影：林利）

Ox Cart (Replica)

Former Yan Period (337-370 CE)

Height 32 cm; Width 50 cm

Unearthed from a mural tomb at Yuantaizicun of Shi'ertaiyingzi, Chaoyang, Liaoning, in 1982. Preserved on the original site. The replica is a collection of Liaoning Provincial Museum.

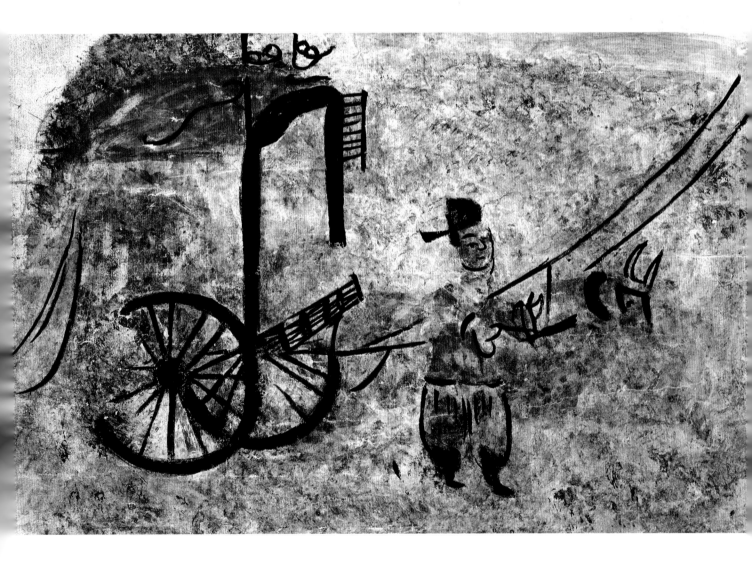

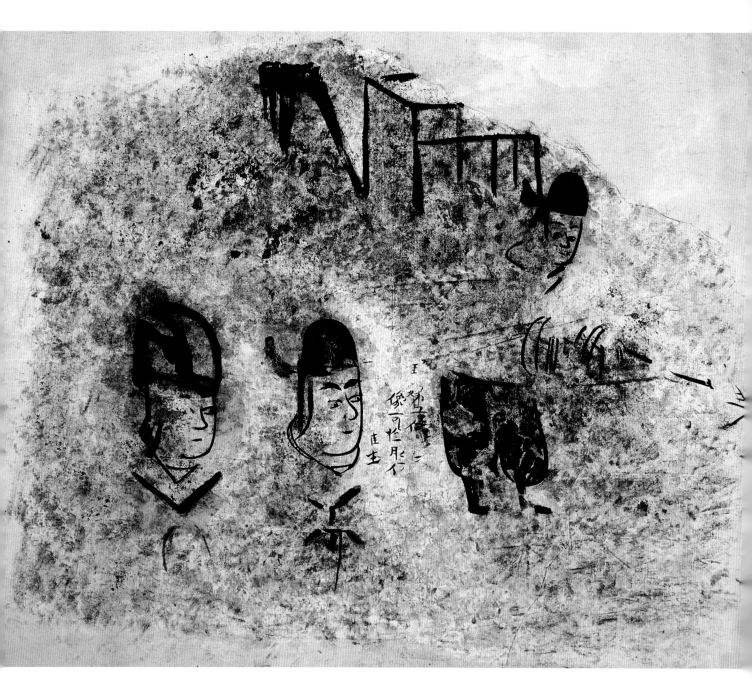

42. 侍从备车图（摹本）

前燕（337～370年）

画面残高43、宽51厘米

1982年辽宁省朝阳市十二台营子乡袁台子村壁画墓出土。原址保存。摹本现存于辽宁省博物馆。

墓向170°。位于东耳室南壁，大部画面漫漶不清。并列男女两人。女人居左，高髻，圆脸，高鼻，着方领长袍。男人居右，方圆脸，高鼻。黑帻，着圆领长袍。男像右侧有墨书题铭"[夫]妇君向□芝□像可检取□□主"，共三行十四字，楷书体。右上斜另有一男子，黑帻，斜领短衣，长裤，黑鞋。双臂前伸，似作取物姿态。身后似有。这幅画似表现侍者服侍主人夫妇出行的场面。

（临摹：刘忠诚、王维忠　撰文：都惜青　摄影：林利）

Preparing a Cart

Former Yan Period (337-370 CE)

Height 43 cm; Width 51 cm

Unearthed from a mural tomb at Yuantaizicun of Shi'ertaiyingzi, Chaoyang, Liaoning, in 1982. Preserved on the original site. The replica is a collection of Liaoning Provincial Museum.

43.太阳图（摹本）

前燕（37～370年）

太阳直径19.5厘米；金乌高8.7、长12厘米

1982年辽宁省朝阳市十二台营子乡袁台子村壁画墓出土。摹本现存于辽宁省博物馆。

墓向170°。位于狩猎图上方的顶盖上。太阳涂朱，内有一只金乌，三足，长尾，作昂首展翅状。

<div align="right">（临摹：刘忠诚、王维忠　撰文：都惜青　摄影：林利）</div>

The Sun (Replica)

Former Yan Period (337-370 CE)

Diamete 19.5 cm; Bird's height 8.7 cm, Length 12 cm

Unearthed from a mural tomb at Yuantaizicun of Shi'ertaiyingzi, Chaoyang, Liaoning, in 1982. Preserved on the original site. The replica is a collection of Liaoning Provincial Museum.

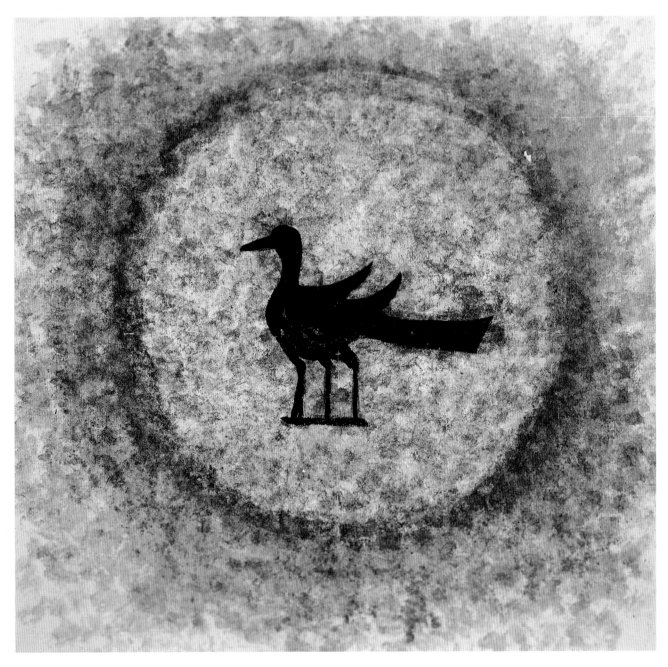

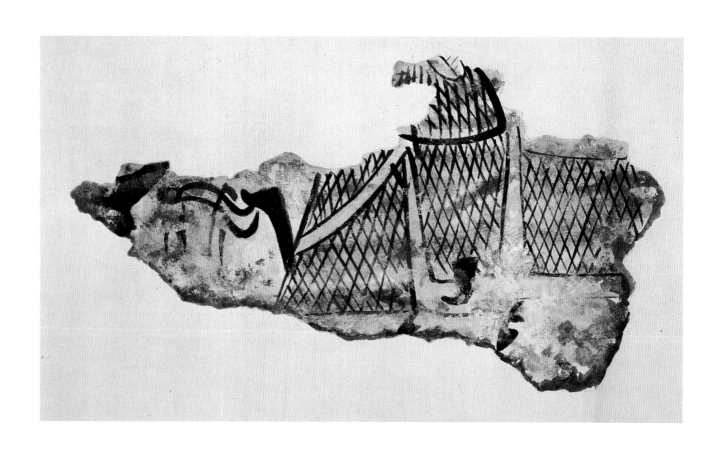

◀44.甲士骑马图（摹本）

前燕（337～370年）

画面高25.5、宽43厘米。

1982年辽宁省朝阳市十二台营子乡袁台子村壁画墓出土。摹本现存于辽宁省博物馆。

墓向170°。位于南面额石上。整个额石白灰面已脱落，画面中有一马，首尾残，披甲，黑蹄。马背骑甲士一人，长裤，黑鞋，面目不清。

（临摹：刘忠诚、王维忠　撰文：都惜青　摄影：林利）

Armored Mounted Warrior (Replica)

Former Yan Period (337-370 CE)

Height 25.3 cm; Width 43 cm

Unearthed from a mural tomb at Yuantaizicun of Shi'ertaiyingzi, Chaoyang, Liaoning, in 1982. Preserved on the original site. The replica is a collection of Liaoning Provincial Museum.

▼45.星象图（摹本）

北燕（409～436年）

1965年辽宁省北票县西官营子冯素弗1号墓出土。摹本现存于辽宁省博物馆

墓向东西。绘于墓室内椁顶。九块盖石联为一幅，内容为日月星云等。由于东（右）四石与西（左）五石不是一次画成，画法稍有不同。西（左）起第四石的南部绘一轮红日，画面微残，但可以看出内有黑色线条，可能为"金乌"。西（左）起第三石中部绘一圆月，是用淡黄色线勾出一个圈来表示月形，内有一只墨绘的"玉兔"。此外，群星和流云布满整个画面，多以红色、黄色、绿色的圆点和带卷钩形云头的曲线表示。

（临摹：李梗、金德宣　撰文：温科学　摄影：林利）

Heavenly Constellations (Replica)

Northern Yan Period (409-436 CE)

Unearthed from Feng Sufu's Tomb No.1 of Xiguanyingzi of Beipiao, Liaoning, in 1965. The replica is a collection of Liaoning Provincial Museum.

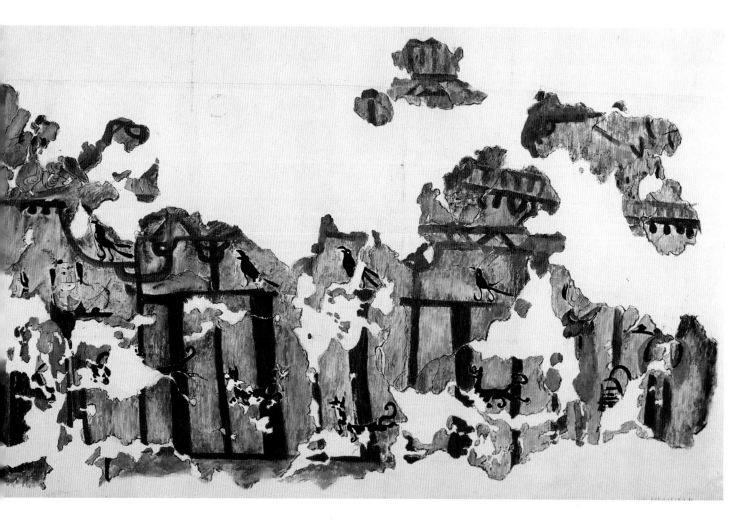

46.建筑图（摹本）

北燕（409～436年）

高114、宽176.5厘米

1965年辽宁省北票县西官营子冯素弗2号墓出土。摹本现存于辽宁省博物馆。

墓向255°。位于墓内石椁的西壁。图中建筑物高大，形似门楼，有两层檐，檐下均有架，下层檐下的构架比较清晰。下层角檐的斜脊之上有一动物。檐下左右两端各立两个侍女，四人都穿缥青领的红襦，下着彩条裙。左端两个侍女，前者臂部有物，似是捧持杯盘。右后一侍女与此相同。侍女可见4只黑狗，檐下亦见4只长尾黑鸟。

（临摹：李梗、金德宣　撰文：温科学　摄影：林利）

Building (Replica)

Northern Yan Period (409-436 CE)

Height 114 cm; Width 176.5 cm

Unearthed from Feng Sufu's Tomb No.2 of Xiguanyingzi, Beipiao, Liaoling, in 1965. The replica is a collection of Liaoning Provincial Museum.

47. 人物图（摹本）

北燕（409～436年）

高76.5、宽128.5厘米

1965年辽宁省北票县西官营子冯素弗2号墓出土。摹本现存于辽宁省博物馆。

墓向255°。位于墓内石椁的东壁。右端残存一个侍女的彩裙。左边，在一根楹柱之旁立二人，南向，红衣彩裙，但颈部有黑圆领似武士装。面部除口唇外，眉间、右鬓、右颊涂有朱点。头顶挽高髻，分发为三绺，簪长笄。前立者执长柄仪仗，残缺不辨原形。左边二人似为两个女侍卫。

（临摹：李梗、金德宣　撰文：温科学　摄影：林利）

Figures (Replica)

Northern Yan Period (409-436 CE.)

Height 76.5 cm; Width 128.5 cm

Unearthed from Feng Sufu's Tomb No.2 of Xiguanyingzi, Beipiao, Liaoling, in 1965. The replica is a collection of Liaoning Provincial Museum.

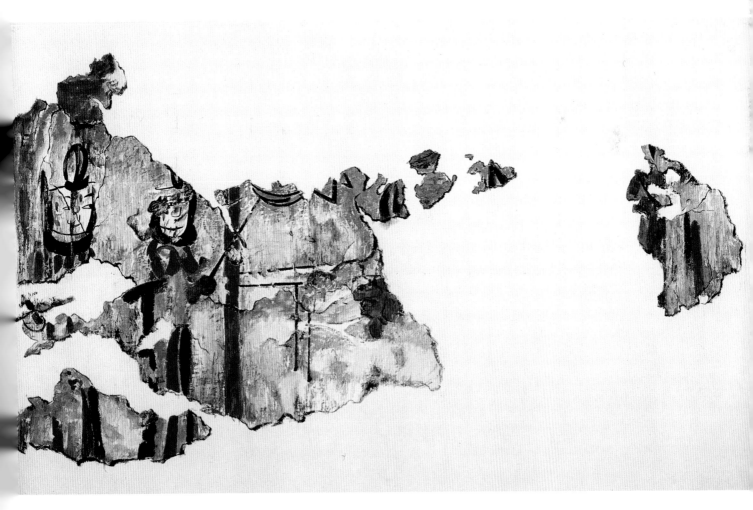

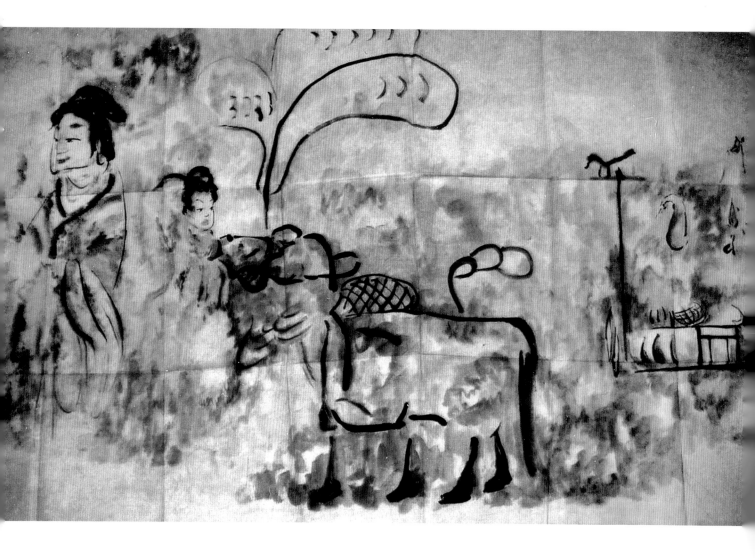

48.出行图与庖厨图（摹本）

北燕（409～436年）

高65、宽120厘米

1976年辽宁省朝阳市龙城区大平房镇北山北燕壁画墓出土。

墓向183°。壁画保存不好，仅东壁壁画还较清楚，北壁画有墓主像，但已模糊不清，仅可见男像束发和女像一点发式，余皆不清。东壁壁画内容为出行图与庖厨图。出行图中，一女人立姿前行，身着铁红色右衽长袍，头顶高发卷束。身后一牵牛女，回首牵牛。后有一株形似芭蕉的植物。庖厨图与出行图相距仅10厘米。灶前一女子，弯腰回首，作烧火状。灶上方摆一架，挂有鸭、鹅。

（临摹：孙国龙　撰文：孙国平　摄影：不详）

Traveling and Cooking (Replica)

Northern Yan Period (409-436 CE)

Height 65 cm; Width 120 cm

Unearthed from a Northern Yan mural tomb at Beishan of Dapingfang, Longcheng District, Chaoyang, Liaoning, in 1976.

49. 墓主人像（摹本）

北燕（409～436年）

残高36、宽50厘米

辽宁省朝阳县北沟门子北燕壁画墓出土。

墓向183°。位于墓室后壁，由于墓室遭到破坏，壁画大部分脱落，仅存有墓主人像头部。男像居右，女像居左。男像头戴高冠、细眉、凤眼、方脸、小口、八字胡，神态安祥。女像挽有盘状发髻，两侧黑发下垂。面部仅剩一只眼睛和红唇，余皆脱落。

（临摹：孙国龙　撰文：孙国平　摄影：不详）

Portrait of Tomb Occupant (Replica)

Northern Yan Period (409-436 CE)

Surviving height 36 cm; Width 50 cm

Unearthed from a Northern Yan mural tomb at Beigoumenzi of Chaoyang, Liaoning.

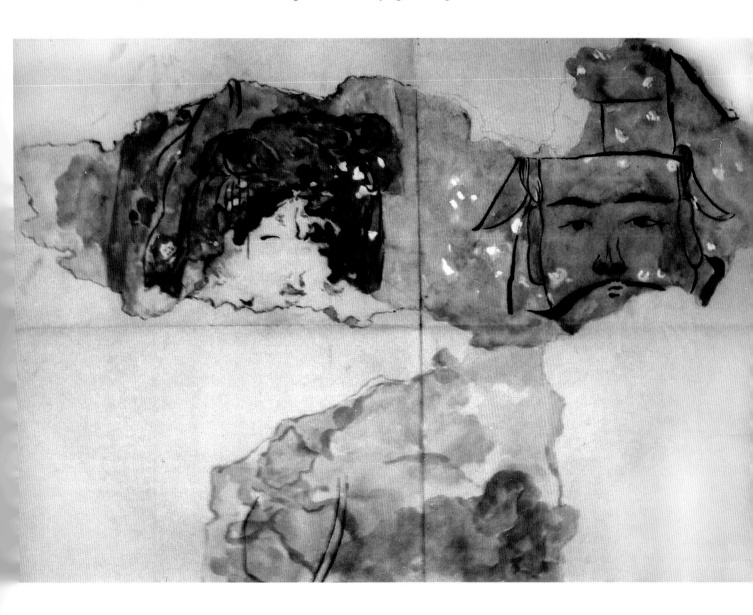

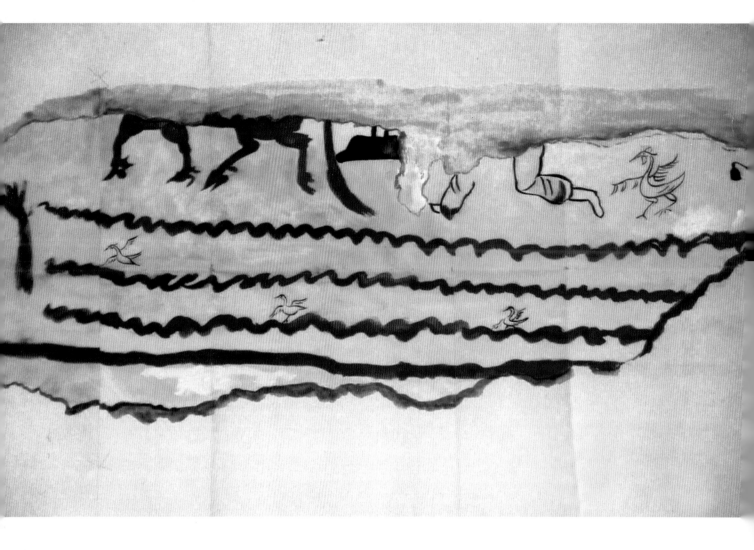

50.牛耕图（摹本）

北燕（409～436年）

残高23、宽65厘米

1978年辽宁省朝阳县北沟门子北庙北燕壁画墓出土。

墓向182°。位于墓室西壁。刚发现时，壁画非常完整鲜艳。牛耕图刚发现时，一人扬鞭扶犁，一牛用力拉犁。人后跟一只雄鸡，雄鸡之后，一孩童打锄前行。牛与人下方是三条田垅，一横杠代表地边界。垅间有小鸟飞舞。可惜现在耕牛、犁与耕夫上半部缺失，孩童缺失。牛与田垅均用铁红色，人物用黑线勾出衣纹，点缀上红点。雄鸡与飞鸟、锄头均用墨线勾画而成。

（临摹：孙国龙　撰文：孙国平　摄影：不详）

Ox Plowing (Replica)

Northern Yan Period (409-436 CE)

Height 23 cm; Surviving Width 65 cm

Unearthed from a Northern Yan mural tomb at Beigoumenzi of Chaoyang, Liaoning, in 1978.

51.山林图（摹本）

北燕（409～436年）

高26、宽39厘米

1978年辽宁省朝阳县北沟门子北庙北燕壁画墓出土。

墓向182°。位于墓室西北角的转角石上。画法比较简单，以铁红色勾画而成，共有4座半山，其中有三山山顶长出一树，形成山林风景。

（临摹：孙国龙　撰文：孙国平　摄影：不详）

Landscape (Replica)

Northern Yan Period (409-436 CE)

Height 26 cm; Width 39 cm

Unearthed from a Northern Yan mural tomb at Beigoumenzi of Chaoyang, Liaoning, in 1978.

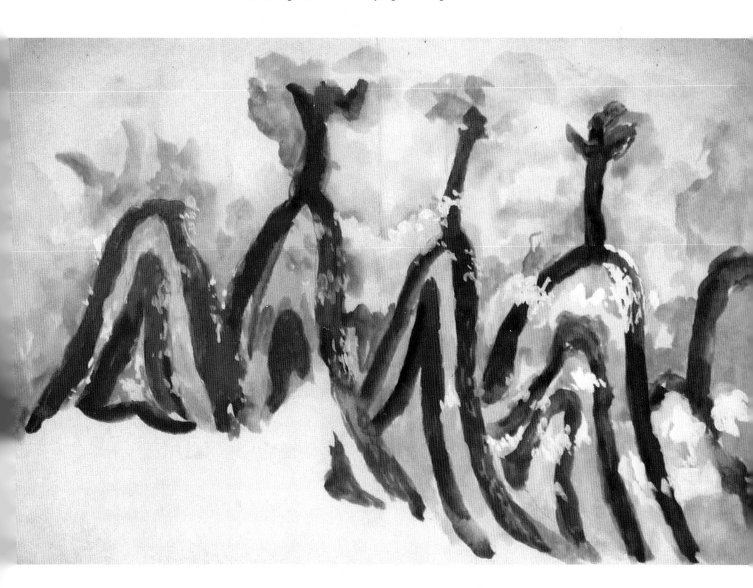

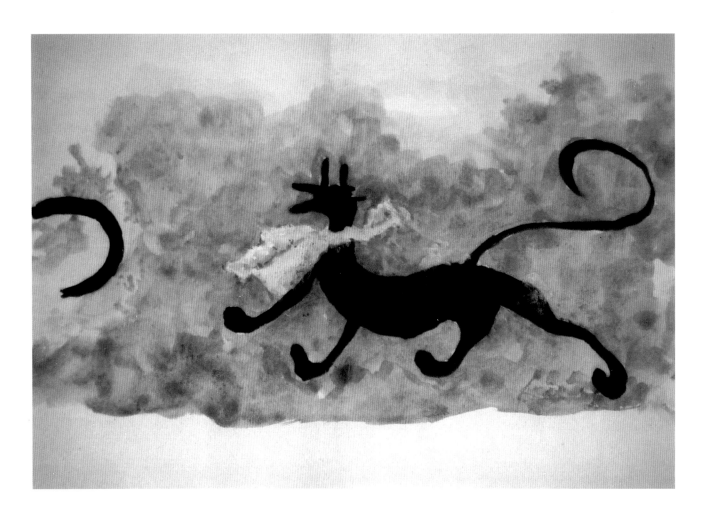

52.天狗图（摹本）

北燕（409~436年）

高14、宽30厘米

1978年辽宁省朝阳县北沟门子北庙北燕壁画墓出土。

墓向182°。位于墓室东壁。一狗作前奔状，昂首张口，双耳直立，长尾上翘。狗前方是另一只狗尾。在狗颈处有一块条状缺损。

（临摹：孙国龙　撰文：孙国平　摄影：不详）

Heavenly Dogs (Replica)

Northern Yan Period (409-436 CE)

Height 14 cm; Width 30 cm

Unearthed from a Northern Yan mural tomb at Beigoumenzi of Chaoyang, Liaoning, in 1978.

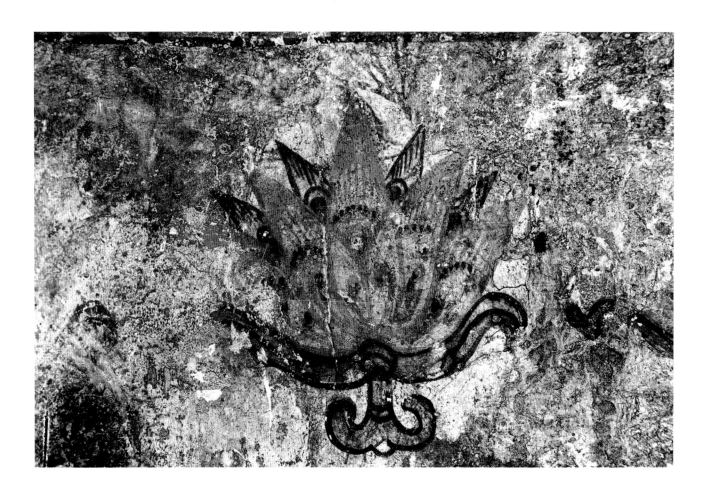

53.莲花图（局部）

高句丽（4世纪末～5世纪初）

1991年辽宁省桓仁县米仓沟将军墓出土。原址保存。

墓向290°。侧视莲花形象光影交错表现花瓣、花叶及花蒂，色彩鲜艳。

<div align="right">（撰文：温科学　摄影：穆启文）</div>

Lotus (Detail)

Koguryo (late 4th c.- early 5th c. CE)

Unearthed from the General Tomb of Micanggou of Huanren, Liaoning, in 1991. Preserved on the original site.

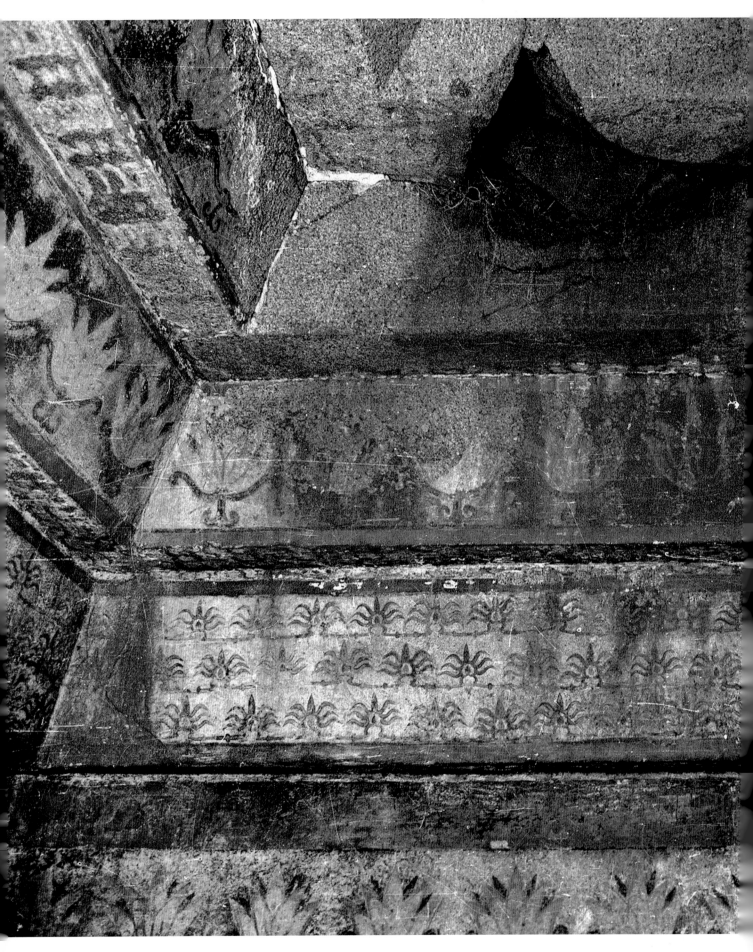

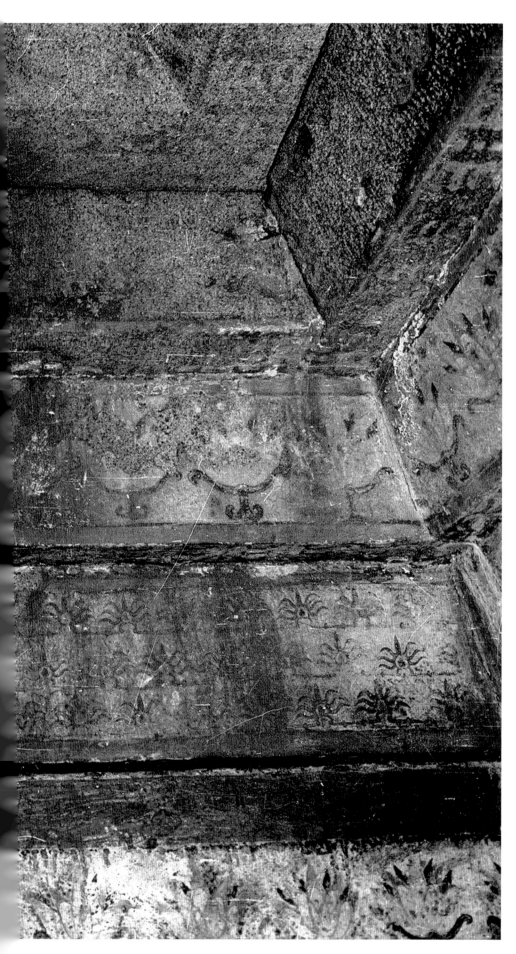

54.莲花图

高句丽（4世纪末～5世纪初）

1991年辽宁省桓仁县米仓沟将军墓出土。原址保存。

墓向290°。位于主室东壁。四壁所绘莲花，全部为侧视莲花，由朱红、黑两种颜色绘成。每行11朵，每朵花高26、宽24厘米，花瓣长17厘米正面绘五片花瓣，以朱红色勾勒成形，花瓣上用黑色以点组成线的半弧形来表示花蕊。在两瓣交叉处，线条相压，形成了又一层花瓣，成为多层的花朵。花朵下用黑笔绘船锚形花托，使花自然稳重。

（撰文：温科学　摄影：穆启文）

Lotus

Koguryo (late 4th c.- early 5th c. CE)
Unearthed from the General Tomb of Micanggou of Huanren, Liaoning, in 1991. Preserved on the original site.

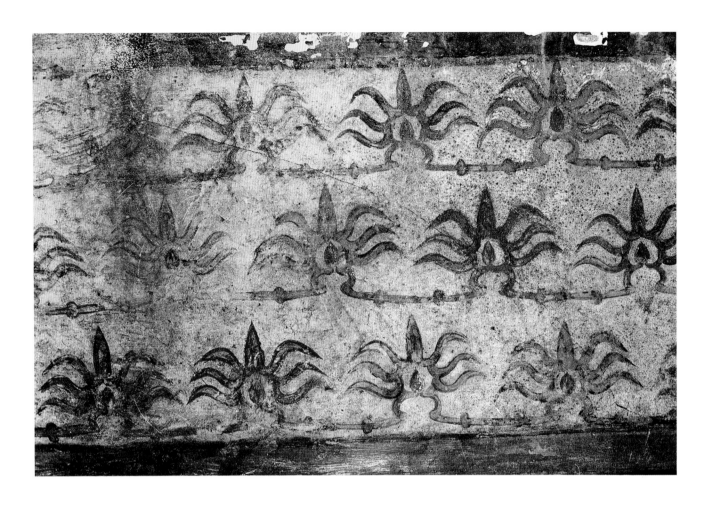

55.变形莲花图（局部）

高句丽（4世纪末～5世纪初）

每朵莲花高11.5、宽16厘米

1991年辽宁省桓仁县米仓沟将军墓出土。原址保存。

墓向290°。位于主室四壁的第一层叠涩梁上。叠涩梁的上下绘有两条朱红色的装饰带，上窄下宽。装饰带中间绘有三行写意变形莲花纹，每朵莲花间根蒂相联。每壁的叠涩梁上绘这种莲花53朵。纹饰均用墨线勾边，其内涂黄、绿、赭、红、黑、白色，以黄、绿、赭色居多，涂红、黑色的仅有几例。

（撰文：温科学　摄影：穆启文）

Deformed Lotus (Detail)

Koguryo (late 4th c.- early 5th c. CE)

Single lotus height 11.5 cm; Width 16 cm

Unearthed from the General Tomb of Micanggou of Huanren, Liaoning, in 1991. Preserved on the original site.

56.龙纹图

高句丽（4世纪末～5世纪初）

影作梁宽17、长350厘米；上层龙高10、宽5厘米

1991年辽宁省桓仁县米仓沟将军墓出土。原址保存。

墓向290°。位于主室四壁上部，同叠涩梁的相交处。此处饰绘影作梁，以朱红色饰地，其上用墨线勾绘出纹饰。所绘纹饰分上下两层。上层为两条龙形纹饰，龙颈相缠，龙首相对，相互对称。在两龙之间的空隙处，绘一长鼓形图案。下层纹饰带与上部基本相同，只绘龙的上部，而无下部及长鼓图案。此龙形及长鼓形图案，在高句丽壁画中属首次发现。每壁的影作梁纹饰带上饰绘53条龙纹。整幅壁画画工较潦草，甚至有不成比例、错位等现象。

（撰文：温科学 摄影：穆启文）

Designs of Dragon

Koguryo (late 4th c.- early 5th c. CE)

Beam's width 17 cm, length 350 cm; Dragon's height 10 cm, width 5 cm

Unearthed from the General Tomb of Micanggou of Huanren, Liaoning, in 1991. Preserved on the original site.

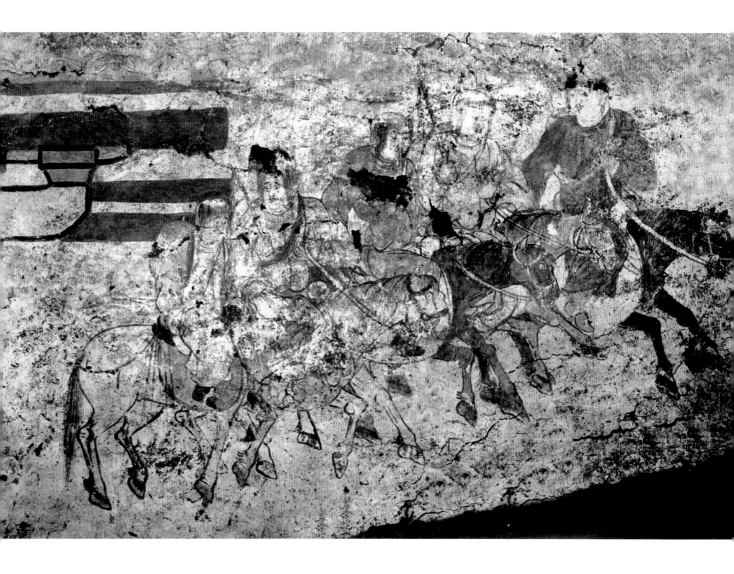

57.出行图（一）（局部）

辽重熙十四年（1045年）

高约160、宽230厘米

2000年辽宁省阜新县关山M4辽萧和墓出土。现存于辽宁省文物考古研究所。

墓向120°。位于墓道北壁中段。为契丹人出行队伍中的第二组，五名契丹侍从骑马而行，皆髡发，着圆领窄袖袍，足蹬靴。右起第一人着红袍，骑黑马。第二人着白袍，骑黄马。第三人着黄袍，骑红马。第四五人均白袍白马，并在行进间相互交谈。第五人背负一鼓，可能为旗鼓曳刺。图中左侧用彩绘表现倚柱和一斗三升托替木式斗拱。

（撰文：万雄飞　摄影：穆启文）

Traveling (1) (Detail)

14th Year of Chongxi Era, Liao (1045 CE)

Height ca. 160 cm; Width 230 cm

Unearthed from the tomb of Xiao He, Tomb No.4 at Guanshan of Fuxin, Liaoning, in 2000. Preserved in the Liaoning Provincial Institute of Cultural Relics and Archaeology.

58.出行图（二）（局部）

辽重熙十四年（1045年）

高约140、宽200厘米

2000年辽宁省阜新县关山M4辽萧和墓出土。现存于辽宁省文物考古研究所。

墓向120°。位于墓道北壁中段。为壁契丹人出行队伍中的第三组，两名契丹侍从骑马而行，髡发，皆着白色长袍。右起第一人骑黄马，左手控缰，右手持鞭置于右肩。第二人骑红马，左手控缰，右手持鞭，腰间悬挂一柄骨朵。后方即为驼车，二人当为驼车前导。

<div align="right">（撰文：万雄飞　摄影：穆启文）</div>

Traveling (2) (Detail)

14th Year of Chongxi Era, Liao (1045 CE)

Height ca. 140 cm; Width 200 cm

Unearthed from the tomb of Xiao He, Tomb No.4 at Guanshan of Fuxin, Liaoning, in 2000. Preserved in the Liaoning Provincial Institute of Cultural Relics and Archaeology.

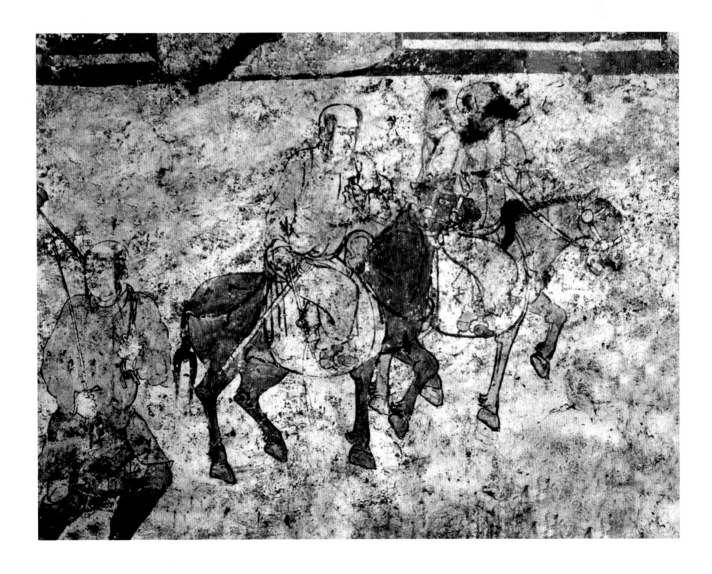

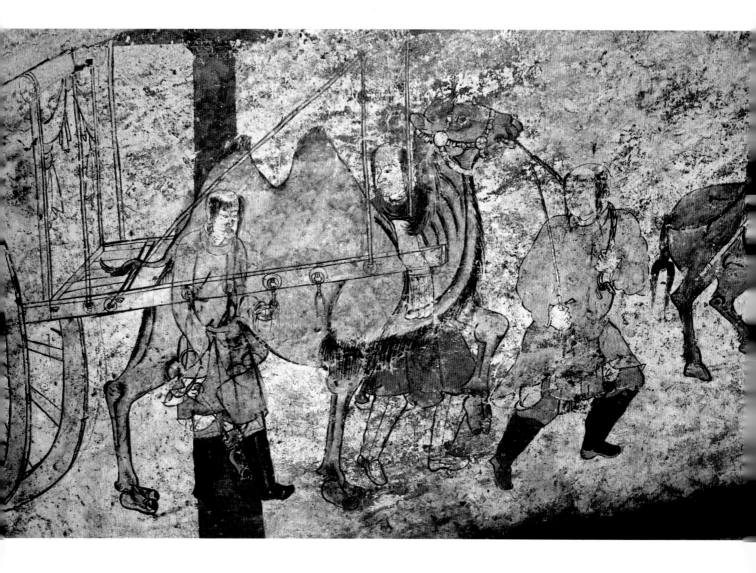

59.驼车图

辽重熙十四年（1045年）

高约180、宽250厘米

2000年辽宁省阜新县关山M4辽萧和墓出土。现存于辽宁省文物考古研究所。

墓向120°。位于墓道北壁后段。为契丹人出行队伍中的第四组，三名契丹青年驭者牵引一辆驼车，皆髡发，着圆领窄袖长袍，足蹬黑靴。右起第一人左手握缰绳，右手持鞭，回首而望，第二人着红袍，立于驼颈左侧，第三人于驼侧扶辕。驾辕驼为一双峰黄驼，高大健硕，驾一辆高轮棚式毡车。

（撰文：万雄飞　摄影：穆启文）

Camel Cart (Detail)

14th Year of Chongxi Era, Liao (1045 CE)

Height ca. 180 cm; Width 250 cm

Unearthed from the tomb of Xiao He, Tomb No.4 at Guanshan of Fuxin, Liaoning, in 2000. Preserved in the Liaoning Provincial Institute of Cultural Relics and Archaeology.

60.仪卫图

辽重熙十四年（1045年）

高约160，宽230厘米

2000年辽宁省阜新县关山M4辽萧和墓出土。现存于辽宁省文物考古研究所。

墓向120°。位于墓道南壁中段。为汉人出行队伍中的第二组，4人均为汉人文官装束，戴展脚幞头，圆领窄袖长袍，下穿吊敦，第一人着皂色圆领广袖长袍，肩扛宝剑。第二人着白袍，肩扛伞盖。第三人着黄袍，肩扛交椅。第四人着白袍，手持长链水罐。

（撰文：万雄飞　摄影：穆启文）

Ceremonial Guard

14th Year of Chongxi Era, Liao (1045 CE)

Height ca. 160 cm; Width 230 cm

Unearthed from the tomb of Xiao He, Tomb No.4 at Guanshan of Fuxin, Liaoning, in 2000. Preserved in the Liaoning Provincial Institute of Cultural Relics and Archaeology.

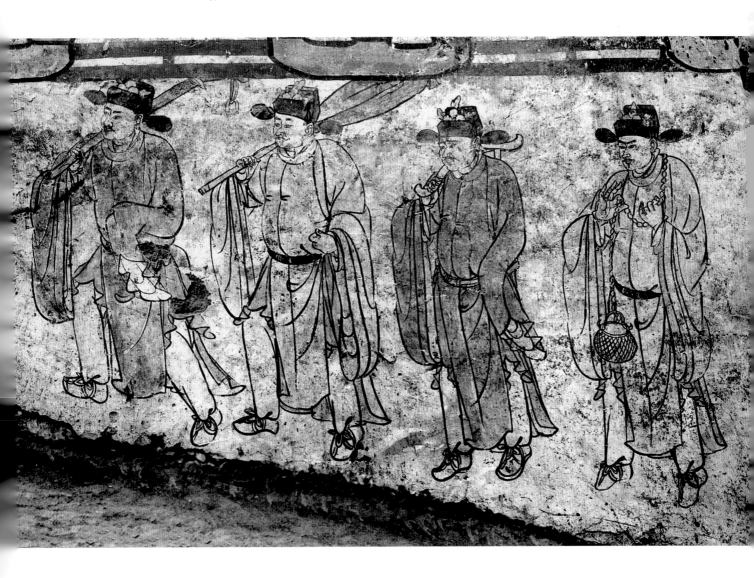

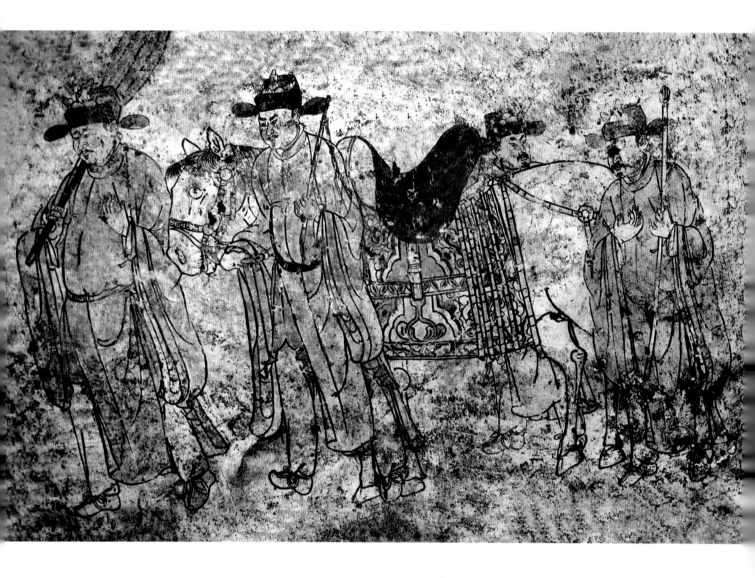

61. 鞍马图

辽重熙十四年（1045年）

高约180，宽约230厘米

2000年辽宁省阜新县关山M4辽萧和墓出土。现存于辽宁省文物考古研究所。

墓向120°。位于关山M4墓道南壁中段。为汉人出行队伍中的第三组，4人均为汉人文官装束，头戴直脚幞头，着圆领广袖长袍，下穿吊敦，第一人扛伞，第二人牵马持鞭，第三人立于马身右侧，第四人持骨朵。白马体长而壮硕，鞍辔齐备，或为男墓主坐骑。

（撰文：万雄飞　摄影：穆启文）

Saddled Horse

14th Year of Chongxi Era, Liao (1045 CE)

Height ca. 180 cm; Width ca. 230 cm

Unearthed from the tomb of Xiao He, Tomb No.4 at Guanshan of Fuxin, Liaoning, in 2000. Preserved in the Liaoning Provincial Institute of Cultural Relics and Archaeology.

62.花卉图

辽重熙十四年（1045年）

高约50、宽约180米

2000年辽宁省阜新县关山M4辽萧和墓出土。现存于辽宁省文物考古研究所。

墓向120°。位于关山M4墓门拱眼壁内。花红叶绿，色彩艳丽。

（撰文：万雄飞　摄影：穆启文）

Flowers

14th Year of Chongxi Era, Liao (1045 CE)

Height ca. 50 cm; Width ca. 180 cm

Unearthed from the tomb of Xiao He, Tomb No.4 at Guanshan of Fuxin, Liaoning, in 2000. Preserved in the Liaoning Provincial Institute of Cultural Relics and Archaeology.

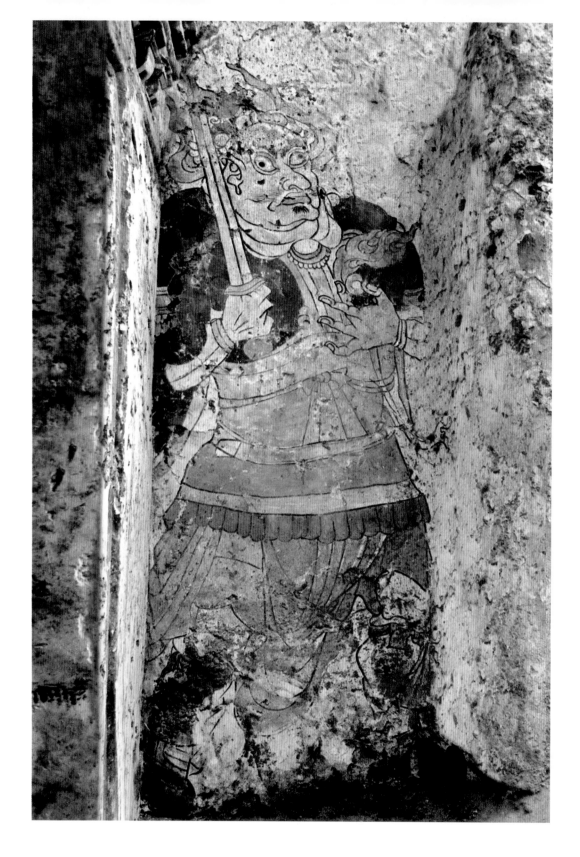

63.门神图（一）

辽重熙十四年（1045年）

高约480、宽约210厘米

2000年辽宁省阜新县关山M4辽萧和墓出土。现存于辽宁省文物考古研究所。墓向120°。位于天井北壁。门神作武将装束，头生角，黄面，左手掐一火焰宝珠，右手仗剑，神态狰狞。

（撰文：万雄飞　摄影：穆启文）

Door God (1)

14th Year of Chongxi Era, Liao (1045 CE)

Height ca. 480 cm; Width ca. 210 cm

Unearthed from the tomb of Xiao He, Tomb No.4 at Guanshan of Fuxin, Liaoning, in 2000. Preserved in the Liaoning Provincial Institute of Cultural Relics and Archaeology.

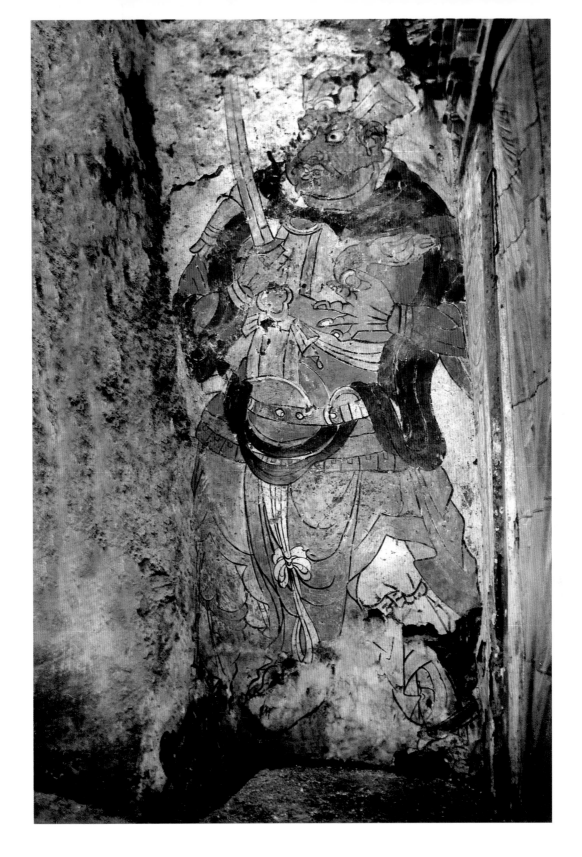

64. 门神图（二）

辽重熙十四年（1045年）

高约480、宽约210厘米

2000年辽宁省阜新县关山M4辽萧和墓出土。现存于辽宁省文物考古研究所。墓向120°。位于天井南壁。门神作武将装束，头戴武弁冠，红脸，左手掐一火焰宝珠，右手仗剑，怒目而视。

（撰文：万雄飞　摄影：穆启文）

Door God (2)

14th Year of Chongxi Era, Liao (1045 CE)

Height ca. 480 cm; Width ca. 210 cm

Unearthed from the tomb of Xiao He, Tomb No.4 at Guanshan of Fuxin, Liaoning, in 2000. Preserved in the Liaoning Provincial Institute of Cultural Relics and Archaeology.

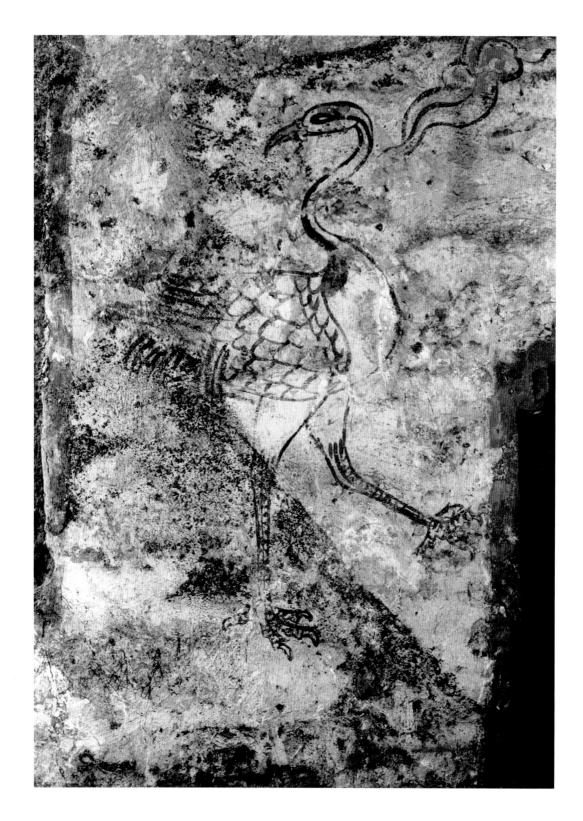

65. 舞鹤图（一）

辽咸雍四年（1068年）

高约110、宽约70厘米

2000年辽宁省阜新县关山M3辽萧知行墓出土。原址保存。

墓向100°。位于墓门过洞南壁。鹤顶丹红，单足而立，回首张望，神情机警。

（撰文：万雄飞　摄影：穆启文）

Dancing Crane (1)

4th Year of Xianyong Era, Liao (1068 CE)

Height ca. 110 cm; Width ca. 70 cm

Unearthed from the tomb of Xiao Zhixing, Tomb No.3 at Guanshan of Fuxin, Liaoning, in 2000. Preserved on the original site.

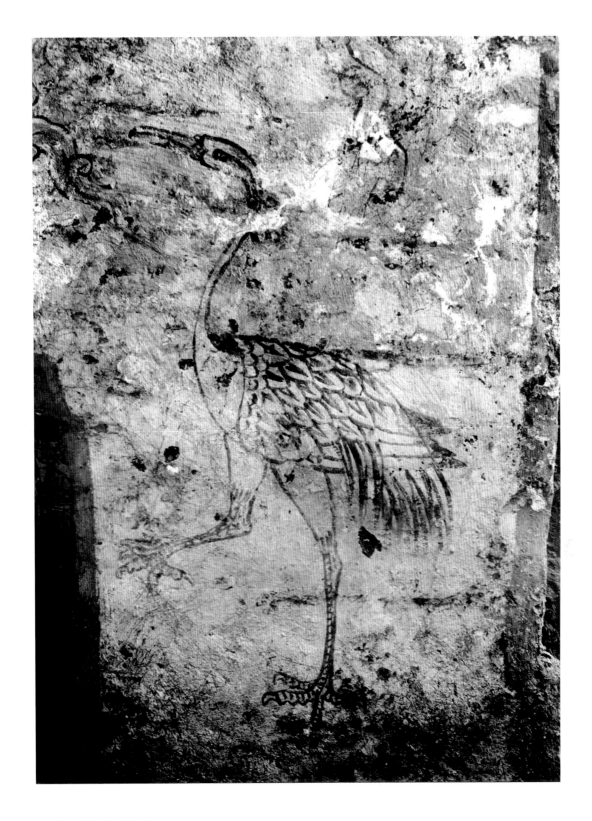

66. 舞鹤图（二）

辽咸雍四年（1068年）

高约110、宽约70厘米

2000年辽宁省阜新县关山M3辽萧知行墓出土。原址保存。

墓向100°。位于墓门过洞北壁。鹤顶丹红，单足而立，昂首

张喙，凝视前方，神态娴雅。

（撰文：万雄飞　摄影：穆启文）

Dancing Crane (2)

4th Year of Xianyong Era, Liao (1068 CE)

Height ca. 110 cm; Width ca. 70 cm

Unearthed from the tomb of Xiao Zhixing, Tomb No.3 at Guanshan of Fuxin, Liaoning, in 2000. Preserved on the original site.

67.天官图

辽咸雍四年（1068年）

高80、宽约50厘米

2000年辽宁省阜新县关山M3辽萧知行墓出土。原址保存。
墓向100°。位于墓门过洞北壁小龛内，天官束发戴冠，留长
髯，身穿交领广袖长袍，双手捧一盘仙桃，脚下伏一灵龟。

（撰文：万雄飞　摄影：穆启文）

Taoist Priest

4th Year of Xianyong Era, Liao Dynasty
(1068 CE)

Height 80 cm; Width ca. 50 cm

Unearthed from the tomb of Xiao Zhi-
xing, Tomb No.3 at Guanshan of Fuxin,
Liaoning, in 2000. Preserved on the
original site.

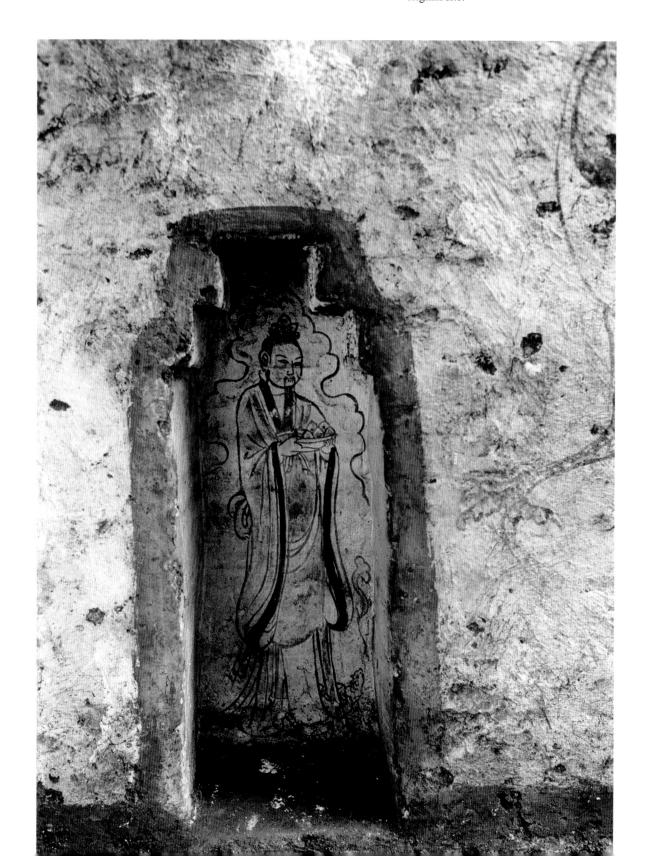

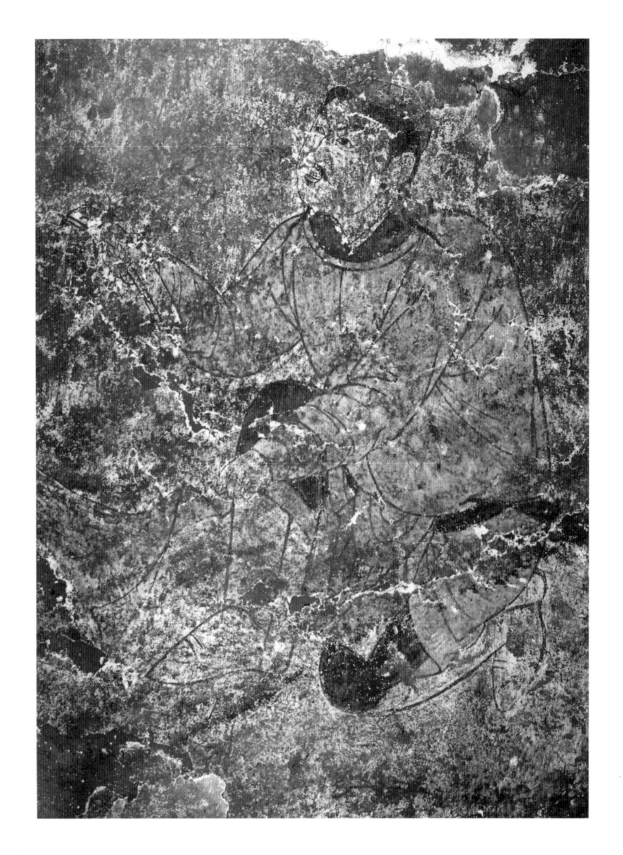

68.侍从图（一）

辽大康二年（1076年）

高110、宽约80厘米

2000年辽宁省阜新县关山M8辽萧德让墓出土。原址保存。

墓向155°。位于墓道北壁后段。契丹侍从一人，髡发，着黄色圆领窄袖长袍，下着红色裤，白靴，单膝跪地，左手握拳，右手持一黄色长条状物，似为经卷，作进奉状。

（撰文：万雄飞　摄影：穆启文）

Attendants (1)

2nd Year of Dakang Era, Liao (1076 CE)
Height 110 cm; Width ca. 80 cm
Unearthed from the tomb of Xiao Derang, Tomb No.8 at Guanshan of Fuxin, Liaoning, in 2000. Preserved on the original site.

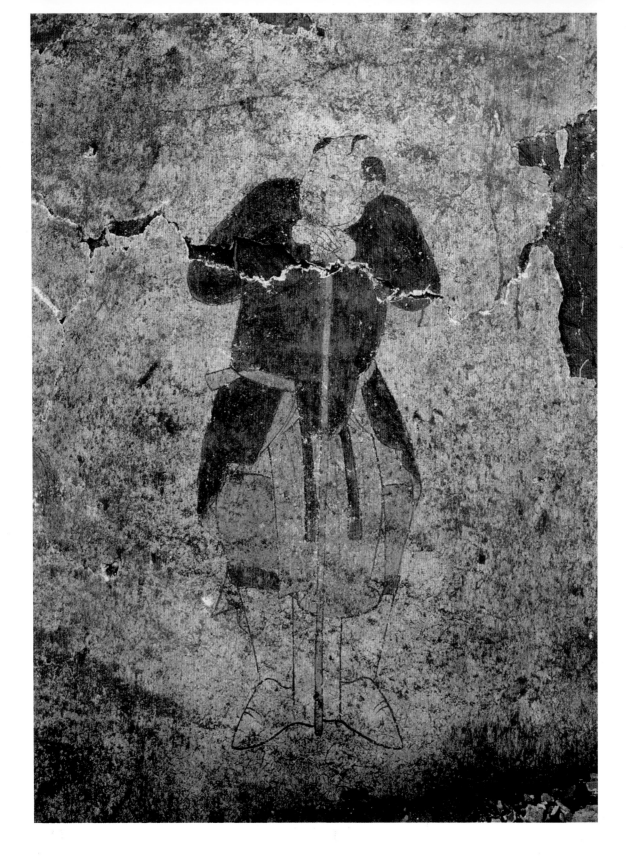

69.侍从图（二）

辽大康二年（1076年）

高约150、宽约80厘米

2000年辽宁省阜新县关山M8辽萧德让墓出土。原址保存。

墓向155°。位于墓道北壁前段。契丹侍从一人，髡发，着赭色圆领窄袖长袍脚穿长筒白靴，双手拄一长柄骨朵，下颌枕于手上，侧立休息。

（撰文：万雄飞　摄影：穆启文）

Attendants (2)

2nd Year of Dakang Era, Liao (1076 CE)

Height ca. 150 cm; Width ca. 80 cm

Unearthed from the tomb of Xiao Derang, Tomb No.8 at Guanshan of Fuxin, Liaoning, in 2000. Preserved on the original site.

70.侍从图

辽乾统七年（1107年）

高约150、宽约80厘米

2000年辽宁省阜新县关山M9辽萧知微墓出土。原址保存。
墓向110°。位于墓道北壁前段。部分残毁。契丹侍从一
人，髡发，身着红袍回头张望，手中似握缰绳。

（撰文：万雄飞　摄影：穆启文）

Attendants

7th Year of Qiantong Era, Liao (1107 CE)
Height ca. 150 cm; Width ca. 80 cm
Unearthed from the tomb of Xiao Zhiwei,
Tomb No.9 at Guanshan of Fuxin, Liaoning,
in 2000. Preserved on the original site.

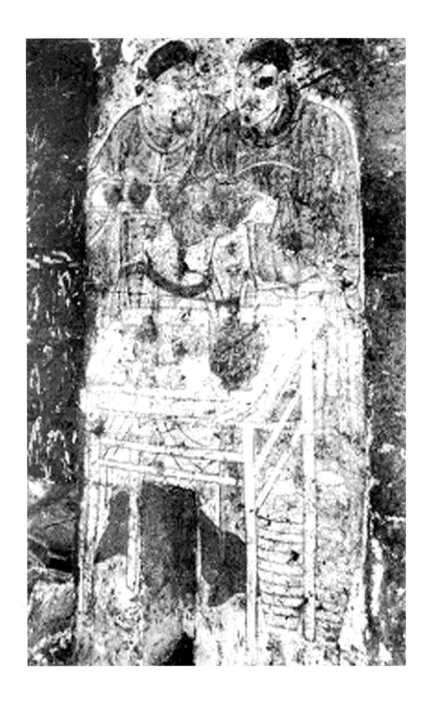

71.进酒图

辽天庆二年（1112年）

画面高171、宽91.5厘米

1976年辽宁省法库县叶茂台16号辽萧义墓出土。

墓向160°。位于甬道东壁，与备食图相对。图中绘二男子，皆面有短须，身着圆领长袍，腰系带，脚穿靴。一人戴黑色巾子，双手托一方盘，盘中置3个酒盏。右侧一男子髡发，带耳环，双手捧一酒尊，内置一长柄酒勺，为一套茶具。二人身前置一方形高桌，桌上置一注壶及酒杯数盏，桌下有大酒坛两个。

（撰文：都惜青　摄影：王军）

Wine Serving

2nd Year of Tianqing Era, Liao (1112 CE)

Height 171 cm; Width 91.5 cm

Unearthed from the tomb of Xiao Yi, Tomb No.16 at Yemaotai of Faku, Liaoning, in 1976.

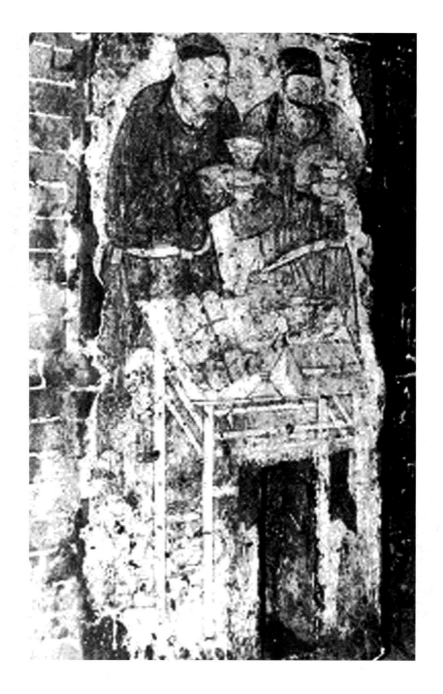

72.奉茶图

辽天庆二年（1112年）

画面高171、宽91.5厘米

1976年辽宁省法库县叶茂台16号辽萧义墓出土。

墓向160°。位于甬道西壁。画二男子站立桌前，身着圆领长袍，束腰带。一人头戴黑色巾子，另一人髡发。二人各捧盏托，上有茶盏，前设方形高桌，桌面上正中放一小罐，盖已敞开，罐口露一勺柄，其旁有两个盏托，托上各有一茶盏，桌上还有一函书籍，另有一个包裹。桌下另有一人，蹲在火盆旁，手拿火筷，在播弄炭火。炭火上坐着一汤瓶和有扣盖的小罐。

（撰文：都惜青　摄影：王军）

Tea Serving

2nd Year of Tianqing Era, Liao (1112 CE)

Height 171 cm; Width 91.5 cm

Unearthed from the tomb of Xiao Yi, Tomb No.16 at Yemaotai of Faku, Liaoning, in 1976.

73.侍从图

辽（907～1125年）

1974年辽宁省法库县叶茂台7号辽墓出土。

墓向165°。位于主室门外东侧。绘有四人，俱面向南。前面有三人，身材较矮。中间一人圆脸、面庞丰满，髡顶，额鬓留发，身着黄色圆领长袍，有袍带下垂，红鞋，双手合于腹部似作捧物状。右面一人亦圆脸，髡发，着交领长袍，领及袍带为红色。左面一人，于额前分发，圆领红袍，黄带。

（撰文：都惜青　摄影：不详）

Attendants

Liao (907-1125 CE)

Unearthed from Tomb No.7 at Yemaotai of Faku, Liaoning, in 1974.

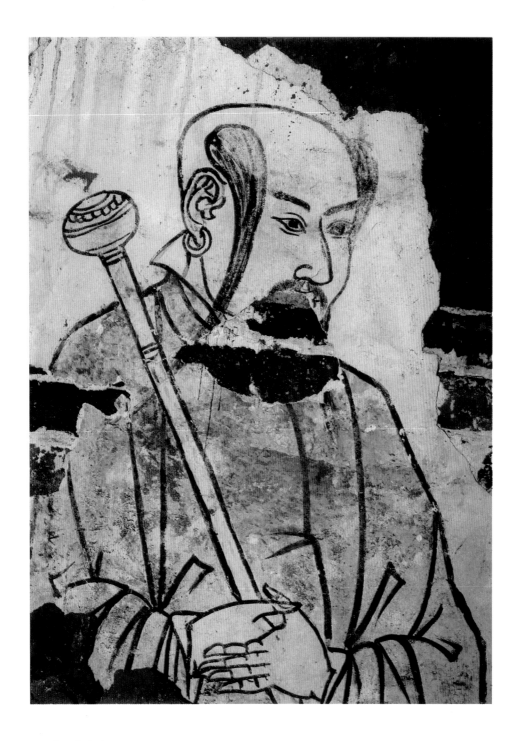

74.门吏图

辽（907～1125年）

高约70、宽50厘米

2000年辽宁省阜新县关山M5出土。原址保存。

墓向123°。位于墓门过洞北壁。存上半身，为契丹门吏，髡发，着圆领窄袖长袍，双手捧一长柄骨朵。

<div align="right">（撰文：万雄飞　摄影：穆启文）</div>

Door Guardian

Liao (907-1125 CE)

Height ca. 70 cm; Width 50 cm

Unearthed from Tomb No.5 at Guanshan of Fuxin, Liaoning, in 2000. Preserved on the original site.

75.契丹侍从图（一）

辽（907～1125年）

人物高约150～160厘米

1994年辽宁省朝阳市建平县黑水镇七贤营子村水泉一号辽墓出土。

墓向东南。位于甬道北壁。绘契丹侍从七人，分为四组，此系靠近主室西起第一组，契丹侍从二人，皆髡发，髭须，戴耳环，抄手朝西站立。左侧人身着灰绿色圆领窄袖长袍，腰束红色带，带侧系黄色匕首，足穿灰绿长靴；右侧一人身着赭色圆领窄袖长袍，腰束丹色带，足穿黑色长靴。壁画上边沿绘出垂幔其下饰有三朵流云。

（撰文：都惜青　摄影：孙国龙、郭英石）

Khitan Attendants (1)

Liao (907-1125 CE)

Figure Height ca. 150-160 cm

Unearthed from Liao Tomb No.1 of Shuiquan, Qixianyingzicun, at Heishui, Jianping of Chaoyang, Liaoning, in 1994.

76.契丹侍从图（二）

辽（907~1125年）

人物高约150~160厘米

1994年辽宁省朝阳市建平县黑水镇七贤营子村水泉一号辽墓出土。

墓向东南。位于甬道北壁西起第二组。绘契丹侍从二人，髡发，髭须，戴耳环。左侧一人身着黄袍，袍面以白色勾勒牡丹团花。左手握黑色革带，右手微握，食指上翘，头微侧似与右边人欲语状；右侧一人，身着绿袍，袍面的胸、肩、肘等部位用墨线勾勒牡丹团窠图案，图案布局对称。双手拄骨朵。壁画上边沿绘有垂幔并饰以流云白鹤。

（撰文：都惜青　摄影：孙国龙、郭英石）

Khitan Attendants (2)

Liao (907-1125 CE)

Figure Height ca. 150-160 cm

Unearthed from Liao Tomb No.1 of Shuiquan, Qixianyingzicun, at Heishui, Jianping of Chaoyang, Liaoning, in 1994.

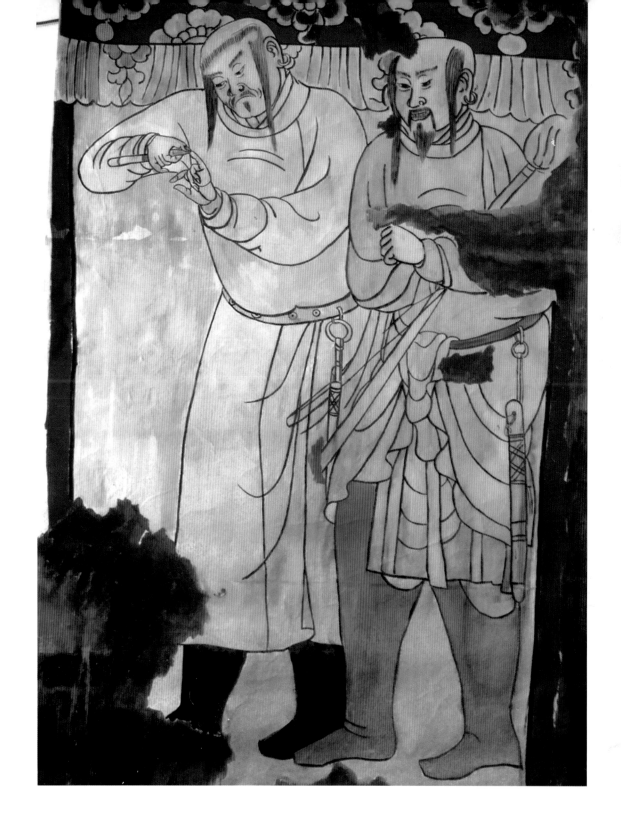

77.契丹侍从图（三）

辽（907～1125年）

人物高约150～160厘米

1994年辽宁省朝阳市建平县黑水镇七贤营子村水泉一号辽墓出土。

墓向东南。位于甬道北壁西起第四组。绘契丹侍从二人。髡发，髭须，戴耳环。左侧一人身着灰白色长袍，足穿黑色长靴，白色带，系有匕首。右手握匕刀修饰左手指甲，头部微倾。右侧一人身着黄色长袍，腰束丹色革带，带左系有匕首，衣缘撩拔至腰间，下着灰绿色吊敦，怀抱骨朵而立。壁画上边沿绘有垂幔。

（撰文：都惜青　摄影：孙国龙、郭英石）

Khitan Attendants (3)

Liao (907-1125 CE)

Figure Height ca. 150-160 cm

Unearthed from Liao Tomb No.1 of Shuiquan, Qixianyingzicun, at Heishui, Jianping of Chaoyang, Liaoning, in 1994.

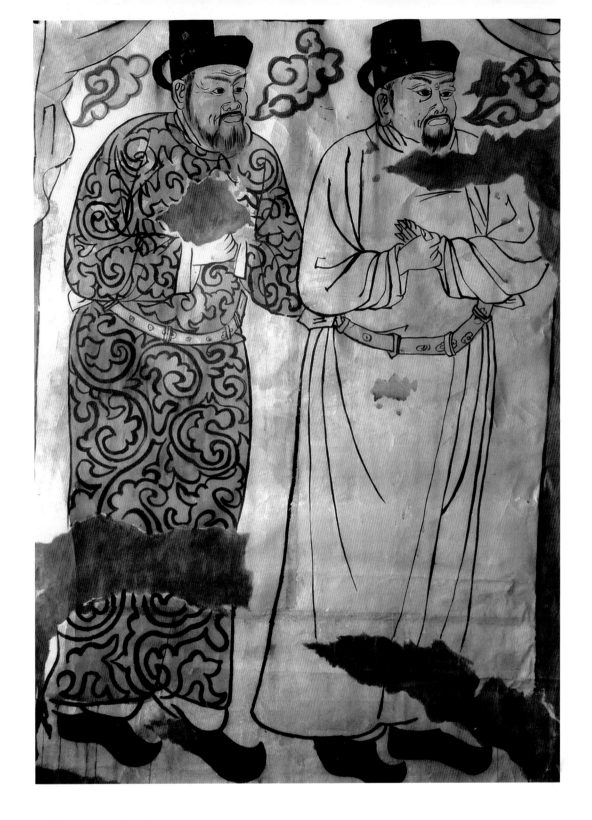

78.汉人侍从图（一）

辽（907~1125年）

人物高约150~160厘米

1994年辽宁省朝阳市建平县黑水镇七贤营子村水泉一号辽墓出土。

墓向东南。位于甬道南壁。绘汉人侍从七人，分为四组，此系靠近主室起第一组，绘汉人侍从二人，皆头戴黑色交脚幞头，叉手朝西站立。左侧一人髯须，着赭色圆领长袍，袍面以墨线勾勒忍冬草纹，足登皂靴；右侧一人髭须厚唇，身着白色圆领窄袖外袍，腰束丹色革带，足穿皂靴。壁画上边沿绘有垂幔饰有流云。

（撰文：都惜青　摄影：孙国龙、郭英石）

Han Attendants (1)

Liao (907-1125 CE)

Figure Height ca. 150-160 cm

Unearthed from Liao Tomb No.1 of Shuiquan, Qixianyingzicun, at Heishui, Jianping of Chaoyang, Liaoning, in 1994.

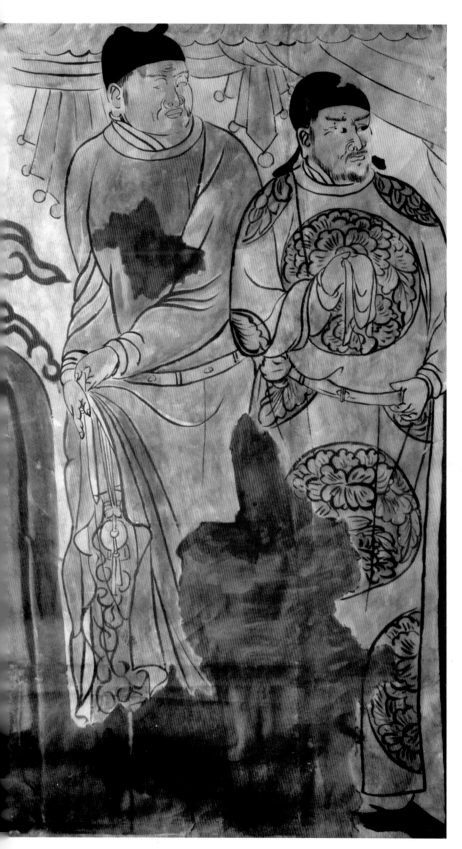

79.汉人侍从图（二）

辽（907～1125年）

人物高约150～160厘米

1994年辽宁省朝阳市建平县黑水镇七贤营子村水泉一号辽墓出土。

墓向东南。位于甬道南壁西起第二组。绘汉人侍从二人。左侧一人头戴黑色前踏式无脚幞头，小鬓须，身着章丹色外袍，丹色束带，外袍袍角撩起，右手提握，并显露出佩玉饰件，头面西回盼，面向墓室。右侧一人头戴软脚幞头，鬓须，身着圆领窄袖皂色外袍，袍面用墨线勾勒出对称的牡丹团窠图案。红色束带，黑色鞋，右手执巾帕，左手握腰带。壁画上边沿绘有垂幔饰以流云。

（撰文：都惜青　摄影：孙国龙、郭英石）

Han Attendants (2)

Liao (907-1125 CE)

Figure Height ca. 150-160 cm

Unearthed from Liao Tomb No.1 of Shuiquan, Qixianyingzicun, at Heishui, Jianping of Chaoyang, Liaoning, in 1994.

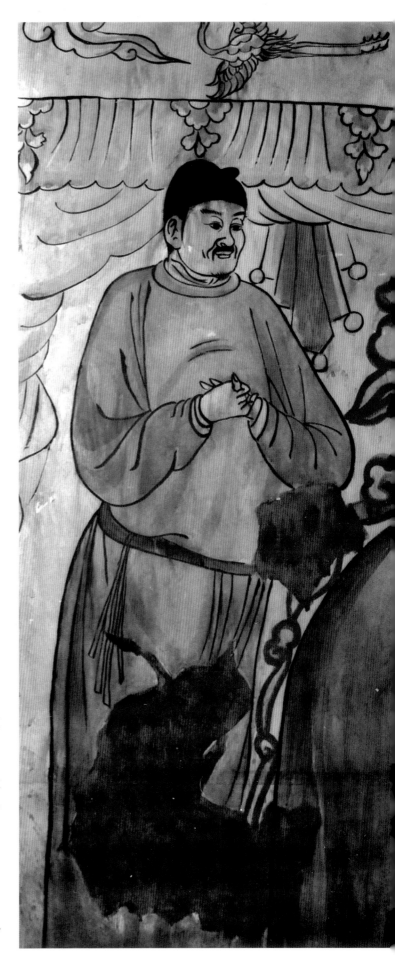

80.汉人侍从图（三）

辽（907～1125年）

人物高约150～160厘米

1994年辽宁省朝阳市建平县黑水镇七贤营子村水泉一号辽墓出土。

墓向东南。位于甬道南壁西起第三组。绘汉人臣僚一人，头戴黑色前踣式无脚幞头，小髯须，身着皂青色外袍，红色束带，行叉手礼，面西而立。壁画上边沿绘有垂幔饰以流云飞鹤。

（撰文：都惜青　摄影：孙国龙、郭英石）

Han Attendants (3)

Liao (907-1125 CE)

Figure Height ca. 150-160 cm

Unearthed from Liao Tomb No.1 of Shuiquan, Qixianyingzicun, at Heishui, Jianping of Chaoyang, Liaoning, in 1994.

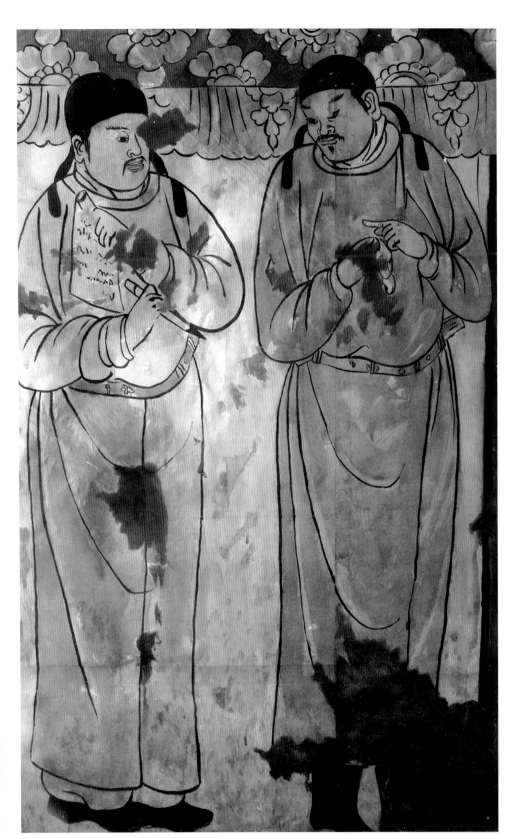

81.汉人侍从图（四）

辽（907～1125年）

人物高约150～160厘米

1994年辽宁省朝阳市建平县黑水镇七贤营子村水泉一号辽墓出土。墓向东南。位于甬道南壁西起第四组。绘汉人侍从二人，头戴黑色软脚幞头，脚带折垂两肩，身着黄色外袍，黄色束带，黑色麻鞋。左侧一人右手执毛笔，左手握卷簿，作记录状；右侧一人头内倾，右手握物，左手伸食指，头微侧欲语。壁画上边沿绘有垂幔。

（撰文：都惜青　摄影：孙国龙、
郭英石）

Han Attendants (4)

Liao (907-1125 CE)

Figure Height ca. 150-160 cm

Unearthed from Liao Tomb No.1 of Shuiquan, Qixianyingzicun, at Heishui, Jianping of Chaoyang, Liaoning, in 1994.

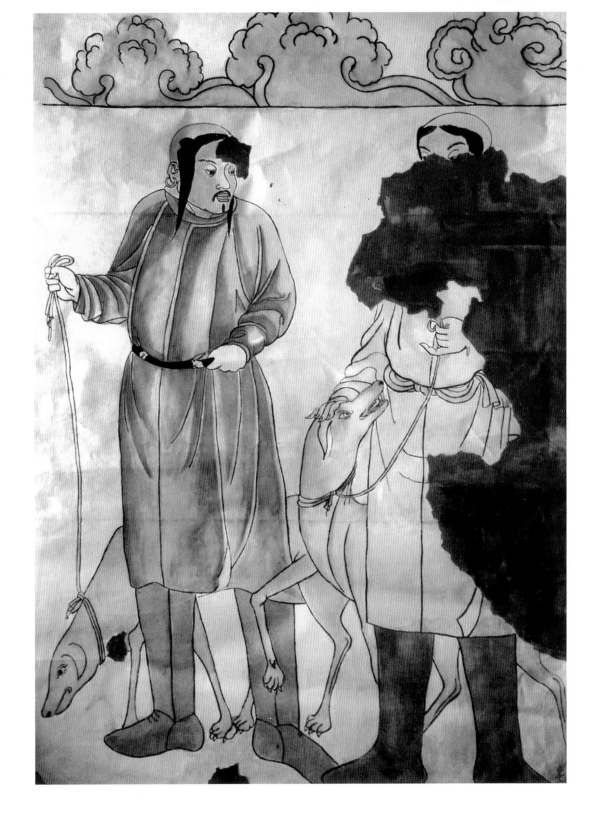

82. 侍从图（一）

辽（907～1125年）

人物高约150～160厘米

1994年辽宁省朝阳市建平县黑水镇七贤营子村水泉二号辽墓出土。

墓向东南。位于甬道北壁绘侍从五人，分为三组，此系靠近主室西起第一组。左侧一人髡发，小髭须，戴耳环，身着土黄色圆领窄袖外袍，黑色革带，灰蓝色长靴。左手握革带，右手牵白犬一条，犬低头而嗅。右侧一人髡发，身着蓝色外袍，丹色束带，深蓝色长靴。左手牵白犬一条，右手抚摸犬头，犬呈亲近主人之态。壁画上边沿绘云纹。

（撰文：都惜青　摄影：孙国龙、郭英石）

Attendants (1)

Liao (907-1125 CE)

Figure Height ca. 150-160 cm

Unearthed from Liao Tomb No.2 of Shuiquan, Qixianyingzicun, at Heishui, Jianping of Chaoyang, Liaoning, in 1994.

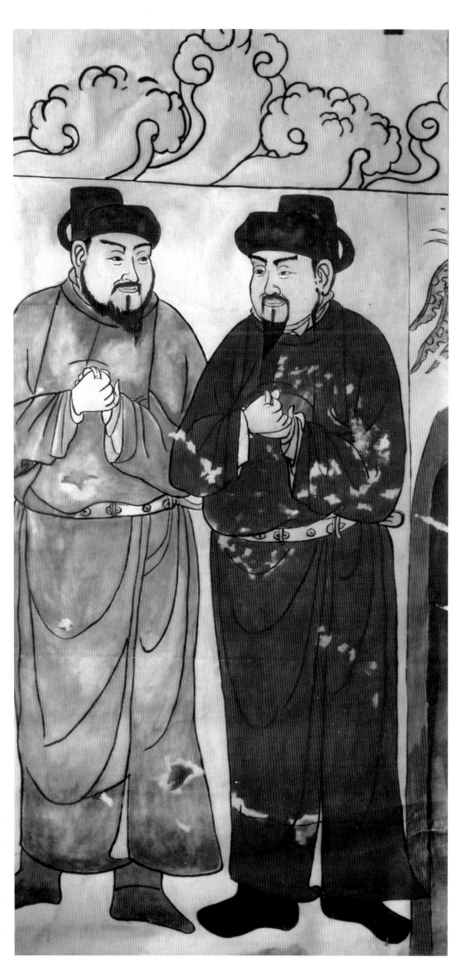

83.侍从图（二）

辽（907～1125年）

人物高约150～160厘米

1994年辽宁省朝阳市建平县黑水镇七贤营子村水泉二号辽墓出土。

墓向东南。位于甬道北壁西起第二组。绘汉人侍从二人。左侧人头戴交脚幞头，小髭，连鬓胡须，身着蓝色长袍，腰束红带，褐色麻鞋；右侧人头戴交脚幞头，须髯，身着大红圆领窄袖长袍，内衬粉色窄袖中单，粉色腰带，黑色鞋。二人皆叉手而立。壁画上边沿绘云纹。

（撰文：都惜青　摄影：孙国龙、郭英石）

Attendants (2)

Liao (907-1125 CE)

Figure Height ca. 150-160 cm

Unearthed from Liao Tomb No.2 of Shuiquan, Qixianyingzicun, at Heishui, Jianping of Chaoyang, Liaoning, in 1994.

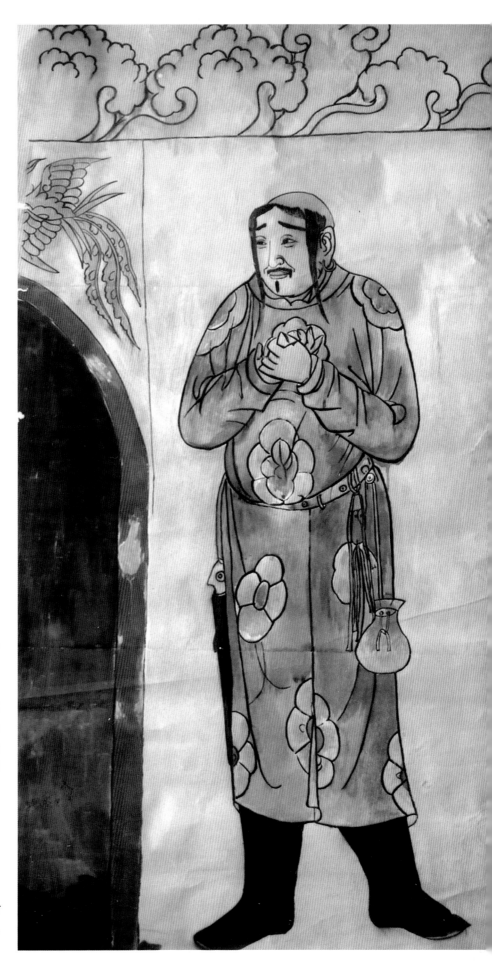

84.侍从图（三）

辽（907～1125年）

人物高约150～160厘米

1994年辽宁省朝阳市建平县黑水镇七贤
营子村水泉二号辽墓出土。

墓向东南。位于甬道北壁西起第三组。
绘契丹侍从一人，髡发，小髭须，戴耳
环，外着圆领窄袖青色长袍，袍面绘数朵
粉色四瓣团窠花朵，丹色革带，带左系粉
色橐袋，右系匕首，足穿黑色长靴，叉手
面西而立。壁画上边沿绘云纹。

（撰文：都惜青　摄影：孙国龙、
郭英石）

Attendants (3)

Liao (907-1125 CE)

Figure Height ca. 150-160 cm

Unearthed from Liao Tomb No.2 of
Shuiquan, Qixianyingzicun, at Heishui,
Jianping of Chaoyang, Liaoning, in 1994.

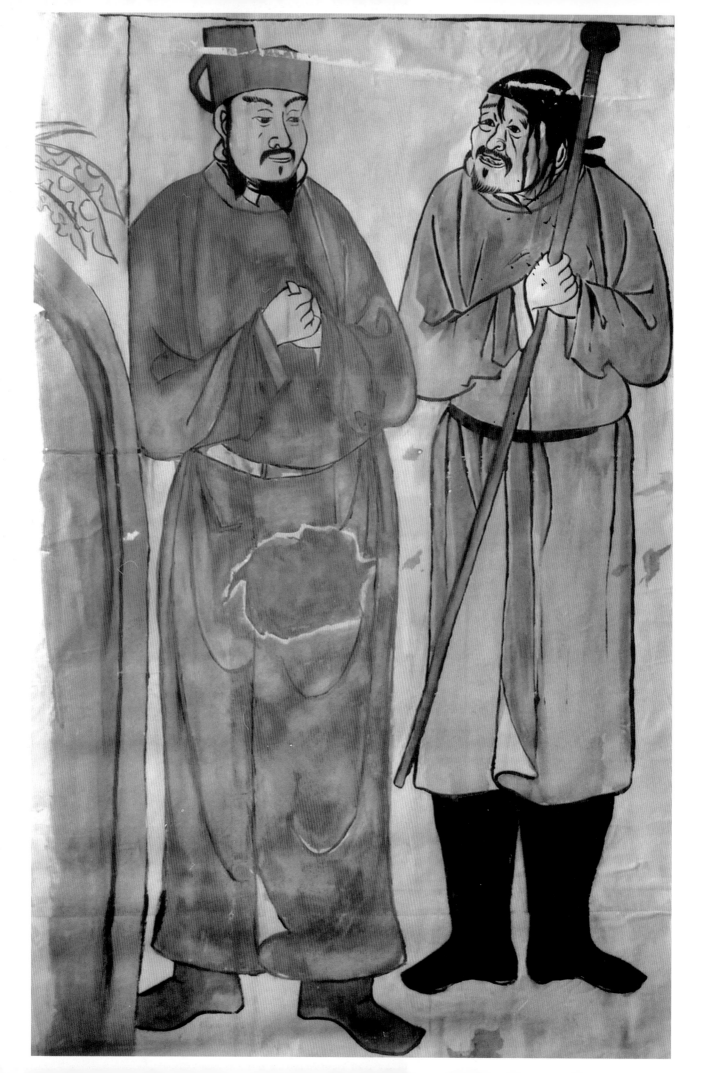

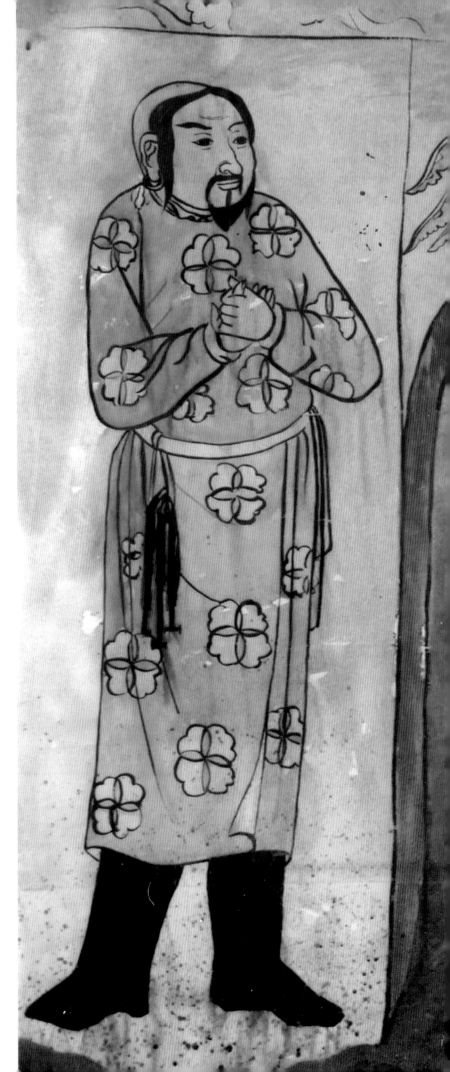

◀85.侍从图（四）

辽（907～1125年）

人物高约150～160厘米

1994年辽宁省朝阳市建平县黑水镇七贤营子村水泉二号辽墓出土。

墓向东南。位于甬道南壁。绘侍从五人，分为三组，此系西起第二组，绘侍从二人，左侧为汉人侍从，头戴交脚幞头，须髯，身着大红色窄袖外袍，褐色麻鞋，行叉手礼；右侧侍从小髭须，头戴黑色巾子，有带垂头后，身着黄色窄袖袍，足穿黑色长靴，腰束黑带，双手执骨朵，侧视而立。

（撰文：都惜青　摄影：孙国龙、郭英石）

Attendants (4)

Liao (907-1125 CE)

Figure Height ca. 150-160 cm

Unearthed from Liao Tomb No.2 of Shuiquan, Qixianyingzicun, at Heishui, Jianping of Chaoyang, Liaoning, in 1994.

86.侍从图（五）▶

辽（907～1125年）

人物高约150～160厘米

1994年辽宁省朝阳市建平县黑水镇七贤营子村水泉二号辽墓出土。

墓向东南。位于甬道南壁西起第三组。绘契丹侍从一人，髡发，髭须，身着青色圆领窄袖长袍，袍面绘数朵粉红色四瓣团花，腰束革带，带上系有棕绳状物，足穿黑色长靴，面西叉手而立。

（撰文：都惜青　摄影：孙国龙、郭英石）

Attendants (5)

Liao (907-1125 CE)

Figure Height ca. 150-160 cm

Unearthed from Liao Tomb No.2 of Shuiquan, Qixianyingzicun, at Heishui, Jianping of Chaoyang, Liaoning, in 1994.

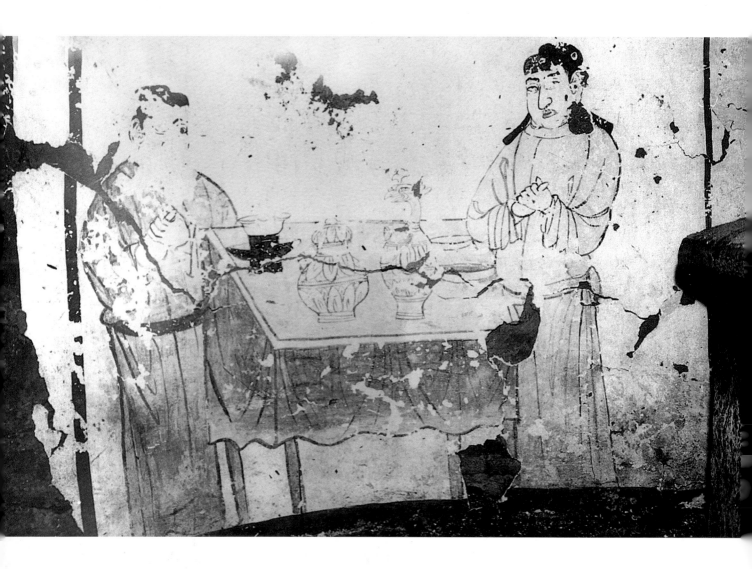

87.奉侍图（一）

辽（907～1125年）

2000年辽宁省朝阳市龙城区召都巴镇辽墓出土。

墓向190°。位于墓室西壁前半部。画面中间为一方桌，桌边有围幔，桌上摆放六件器物。两件黄釉浅腹平底盘；一件黄釉带流、外饰莲瓣的凤首瓶；一件黄釉饰莲瓣带盖注子；一件黑色盏托，上承一件黄釉花口茶盏。桌两侧各有一汉人侍者叉手而立，其中左侧一人戴黑色幞头，身着绿色圆领长袍，腰束黑带；右侧一人戴黑色软脚幞头，着圆领黄色长袍，腰束黄带。

（撰文：都惜青　摄影：不详）

Serving and Attending (1)

Liao (907-1125 CE)

Unearthed from the Liao Tomb at Zhaoduba, Longcheng District of Chaoyang, Liaoning, in 2000.

88.奉侍图（二）

辽（907~1125年）

2000年辽宁省朝阳市龙城区召都巴镇辽墓出土。

墓向190°。位于墓室东壁前半部。画面中间为一浅绿色方桌，桌边有红色围幔，桌上摆放四件器物，均施淡黄色釉。一件为侈口酒尊，侈口，鼓腹；一件为浅腹长盘，敞口，多曲圈足；一副盏托，上为花口盏，下为多曲圈足的盏托；一件凤首瓶，短流，外饰莲瓣纹。桌两侧各有一汉人侍者叉手而立，其中左侧一人戴黑色幞头，腰系黑带，身着圆领红色长袍；右侧人物戴黑色幞头，身着圆领绿色长袍。二人皆执叉手礼。壁画上部绘有垂幔和通贯墓壁一周的花帘装饰。

（撰文：都惜青　摄影：不详）

Serving and Attending (2)

Liao (907-1125 CE)

Unearthed from the Liao Tomb at Zhaoduba, Longcheng District of Chaoyang, Liaoning, in 2000.

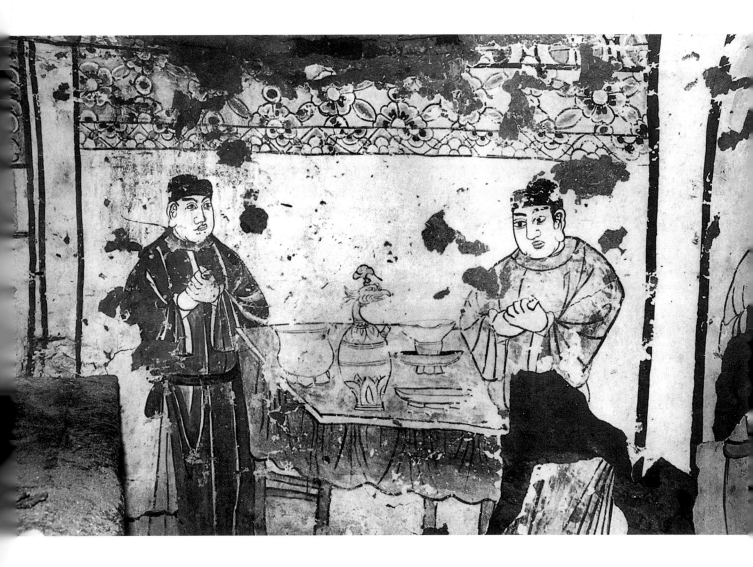

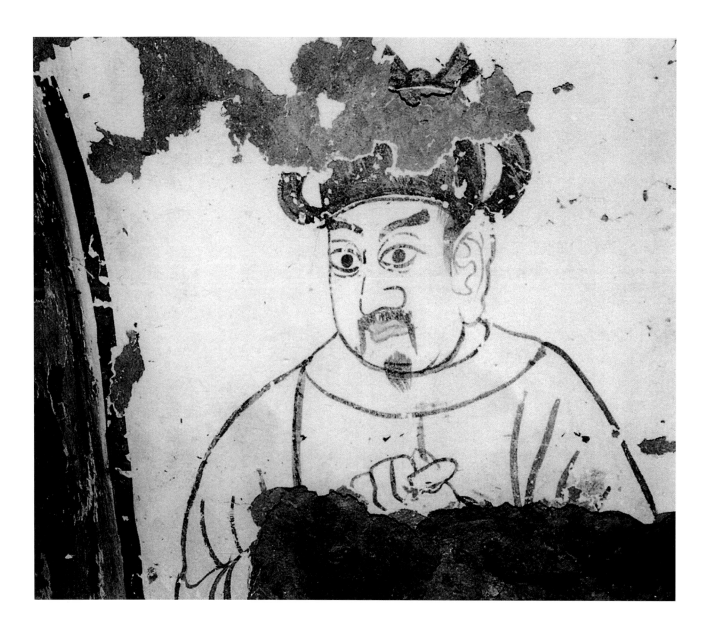

89. 人物图

辽（907～1125年）

2000年辽宁省朝阳市龙城区召都巴镇辽墓出土。

墓向190°。位于甬道东壁。绘一汉人侍者，仅存头部及上半身。头戴黑色交脚幞头，身着黄色圆领长袍，红唇，黑须，执叉手礼。

（撰文：都惜青　摄影：不详）

Figure

Liao (907-1125 CE)

Unearthed from the Liao Tomb at Zhaoduba, Longcheng District of Chaoyang, Liaoning, in 2000.

90.奉酒图

辽（907～1125年）

1987年辽宁省朝阳市木头城子乡十家村辽墓出土。

墓向312°。位于墓室东壁前部。画面中有一方漆桌，桌上置盘盏、碗、温碗、执壶等，桌前方有鸡腿瓶。桌后并立三人，左侧二人头戴黑色交脚幞头，身穿圆领窄袖袍，腰系革带，一人捧劝盘并盏，一人执注子面北而立；右侧一人头戴黑巾，怀抱骨朵面右而立。

（撰文：都惜青　摄影：不详）

Wine Serving

Liao (907-1125 CE)

Unearthed from the Liao Tomb at Shijiacun, at Mutouchengzi of Chaoyang, Liaoning, in 1987.

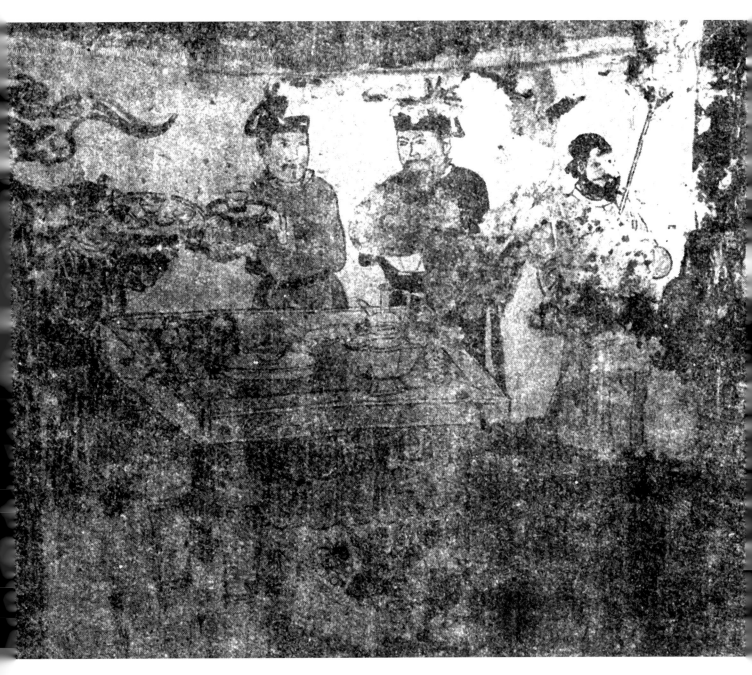

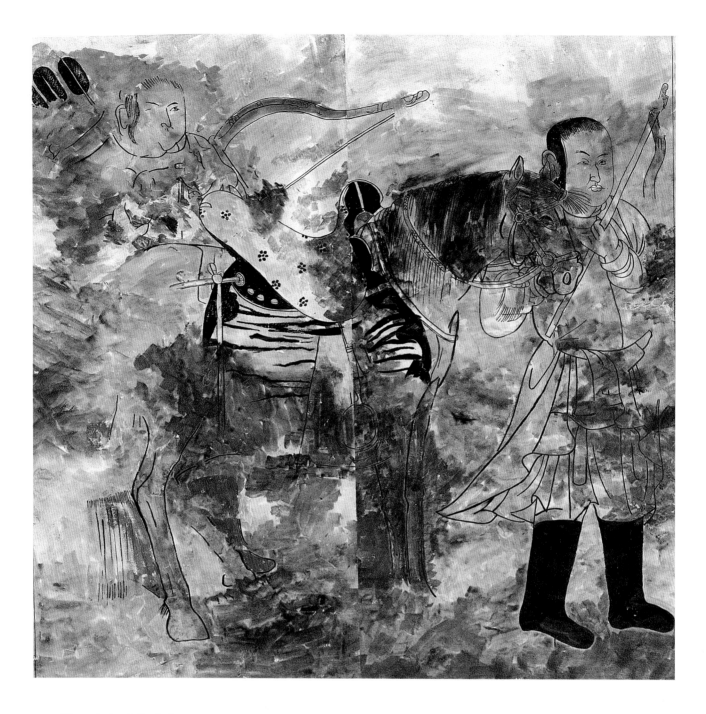

91.鞍马图（摹本）

辽（907～1125年）

高约190、宽约170厘米

2000年辽宁省阜新市太平乡四家子村出土。原址保护。

墓向东。位于墓内门道西壁（全部）。画面中一马二人，枣红马，着黑色鞍鞯。前一人执缰控马，留垂髻，着淡红色圆领窄袖长袍，足蹬黑色长靴，右手引缰，左手持缠。马后一人亦留垂髻，着圆领长袍，手持长弓，身背箭箙。

（临摹：不详　撰文：梁振晶　摄影：穆启文）

Saddled Horse (Replica)

Liao (907-1125 CE)

Height ca. 190 cm; Width ca. 170 cm

Unearthed from Sijiazicun, at Taiping of Fuxin, Liaoning, in 2000. Preserved on the original site.

92.牵驼图（摹本）

辽（907～1125年）

高约190、宽170米

2000年辽宁省阜新市太平乡四家子村出土。原址保存。

墓向东。位于墓内门道东壁。为墓主人出使远行。画面中一棕色双峰驼正向前徐行，背驮一方形竹笼。控驼人留垂髻，身着圆领窄袖长袍，足穿红色长靴，右手引缰，左手执鞭。

（临摹：不详　撰文：梁振晶　摄影：穆启文）

Driving a Camel (Replica)

Liao (907-1125 CE)

Height ca. 190 cm; Width 170 cm

Unearthed from Sijiazicun, at Taiping of Fuxin, Liaoning, in 2000. Preserved on the original site.

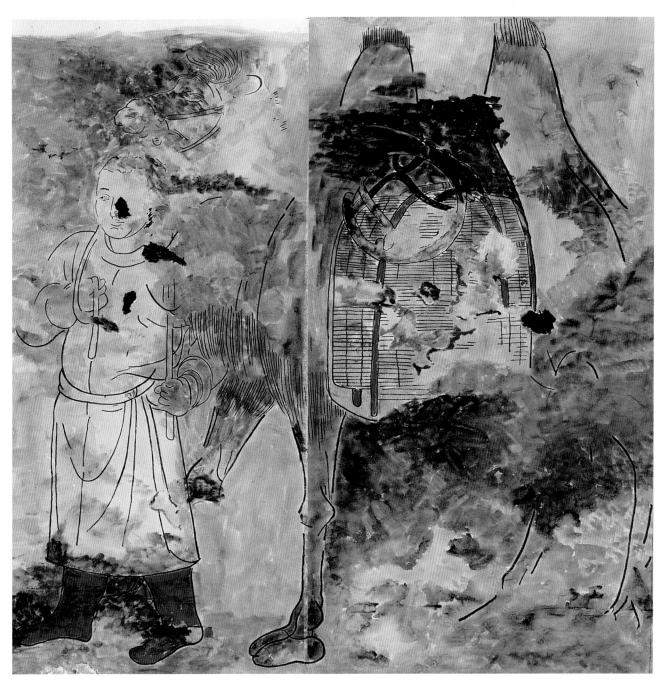

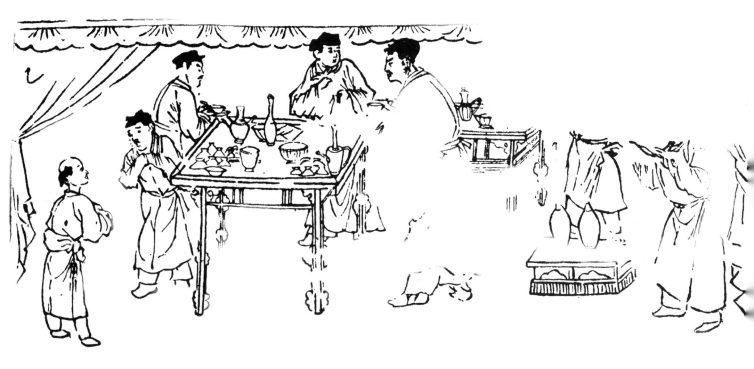

93.备膳图（摹本）

金大定二十四年（1184年）

高82、全长164厘米

1961年辽宁省朝阳市朝阳师范学院内金墓出土。

墓向南。此图位于墓室西壁。画面上边是双墨线内涂红色，左右两端和底边皆单墨线外涂绿色。上绘高悬的帷幔，堂中置二方桌，一桌上摆有汤瓶、茶盏等一组茶具，玉壶春瓶、劝盏等一组酒具，另一桌上有注壶、碗等。桌旁有瓶架，上立梅瓶两只。整个画面以南面一桌为中心，七人正在忙碌备膳。头戴方巾，身着方领长袍者，在桌旁安排布置。左右各一人，手捧盘、碗。再前方二人，一人黑巾、长袍、束带；一人髡发，长袍腰带下挂黑色皮囊，两人拱手相揖。

（临摹：不详　撰文：都惜青）

Preparing for a Meal (Replica)

24th Year of Dading Era, Jin (1184 CE)

Height 82 cm; overall Length 184 cm

Unearthed from the Jin Tomb at Chaoyang Normal College in Chaoyang, Liaoning, in 1961.

94. 侍女图（摹本）

金大定二十四年（1184年）

存高41～60厘米

1961年辽宁省朝阳市朝阳师范学院内金墓出土。

墓向南。位于墓室北壁东部。两边绘有帷幔，中绘一侍女立像，发髻处漫漶不存，面向左，身着灰色左衽窄袖衣，后襟长而曳地，前襟短小，左右有带巾下垂，下穿束口裤，露双足。双手捧帨巾。

（临摹：不详　撰文：都惜青）

Maid (Replica)

24th Year of Dading Era, Jin (1184 CE)

Surviving height 41-60 cm

Unearthed from the Jin Tomb at Chaoyang Normal College in Chaoyang, Liaoning, in 1961.

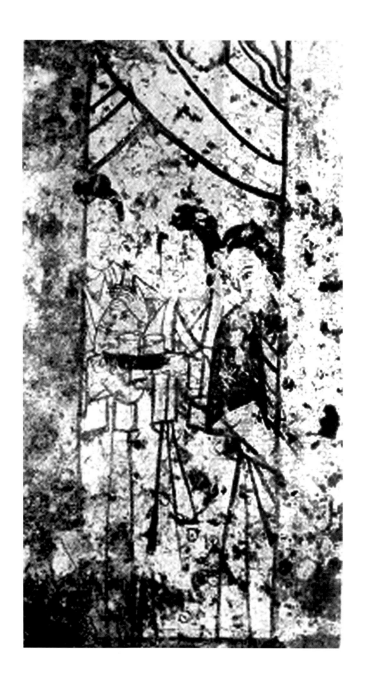

▲ 95.启门奉酒图

元（1206～1368年）

高95、宽78厘米

1983年辽宁省凌源县三家子乡老宫杖子村富家屯一号元墓出土。

墓向190°。位于墓门外上部的额墙上。画面上画朱红色大门，门上有兽首衔环铺首及排列整齐的门钉，大门左扇开启，其间上部可见左右分开的帷幔和垂带，其下三个侍女正在向外张望，三人均梳髻，额间点一痣。右侧第一人身穿蓝色左衽长衫，外罩黑色半臂；第二人身着白色长衫，罩蓝色半臂，双手端一黑色劝盘，内放两只酒盏；第三人身着红色左衽长衫，罩蓝色半臂，双手捧持玉壶春瓶。从门隙中可见此人身旁画有银铤。

（撰文：都惜青 摄影：李振石）

Wine Serving at the Door

Yuan (1279-1368 CE)

Height 95 cm; Width 78 cm

Unearthed from the Yuan Tomb No.1 at Fujiatun, Laogongzhangzicun in Sanjiazi of Lingyuan, Liaoning, in 1969.

◄96.仕女图（一）

元（1206～1368年）

高96、宽51厘米

1969年辽宁省凌源县三家子乡老宫杖子村富家屯一号元墓出土。

墓向190°。位于墓门外西侧翼墙。绘一侧立仕女，长眉细目，丰颐圆颏，额间点一痣，顶结纱髻，彩带飘拂。身穿红色交领长衫，外罩白色半臂，红披肩，腰间系带，环绶悬垂，拱手而立。

（撰文：都惜青　摄影：李振石）

Beauty (1)

Yuan (1279-1368 CE)

Height 96 cm; Width 51 cm

Unearthed from the Yuan Tomb No.1 at Fujiatun, Laogongzhangzicun in Sanjiazi of Lingyuan, Liaoning, in 1969.

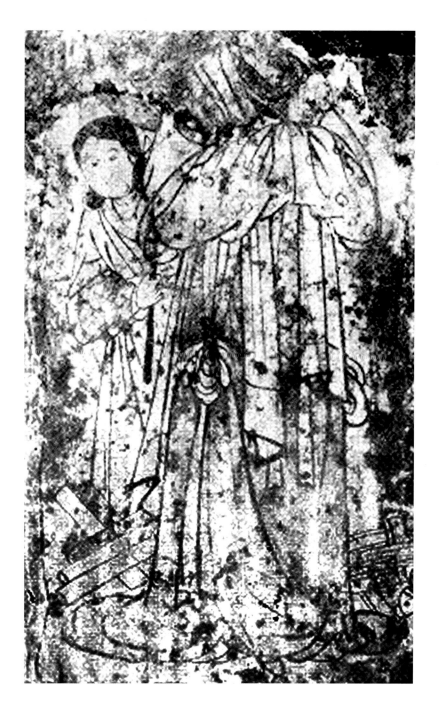

97.仕女图（二）▲

元（1206～1368年）

高76、宽55厘米

1983年辽宁省凌源县三家子乡老宫杖子村富家屯一号元墓出土。

墓向190°。位于墓门外东侧翼墙。周边有墨色边栏，绘一侧立仕女，仕女头部残损，身穿粉红色交领广袖长衫，白披肩，腰间垂环绶，衣下露云头鞋，身后站一侍女。侍女身材较小，额间点朱，耳侧结双垂髻，着交领窄袖长衫，双手擎红色纨扇。地面上画银铤等物。

（撰文：都惜青　摄影：李振石）

Beauty (2)

Yuan (1279-1368 CE)

Height 76 cm; Width 55 cm

Unearthed from the Yuan Tomb No.1 at Fujiatun, Laogongzhangzicun in Sanjiazi of Lingyuan, Liaoning, in 1969.

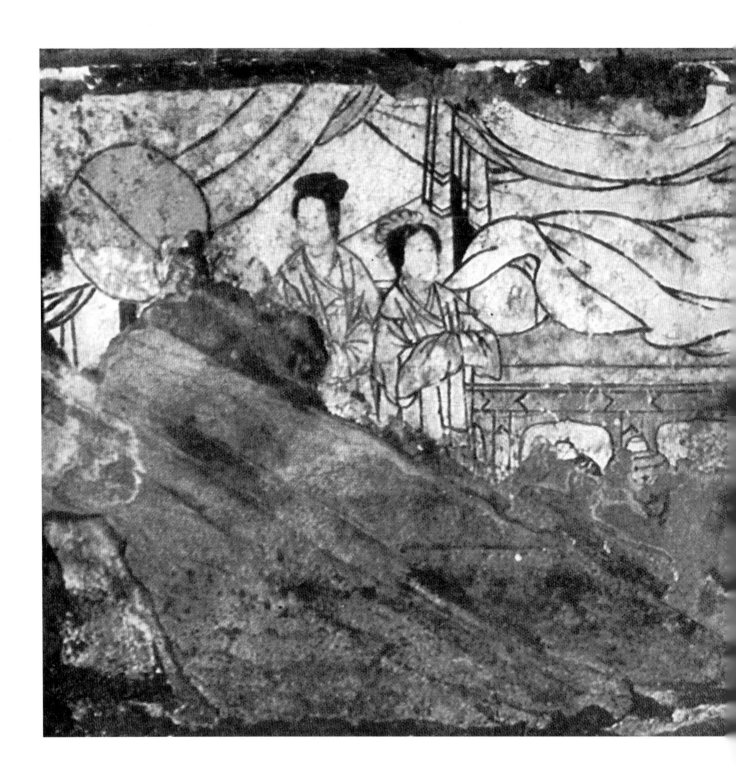

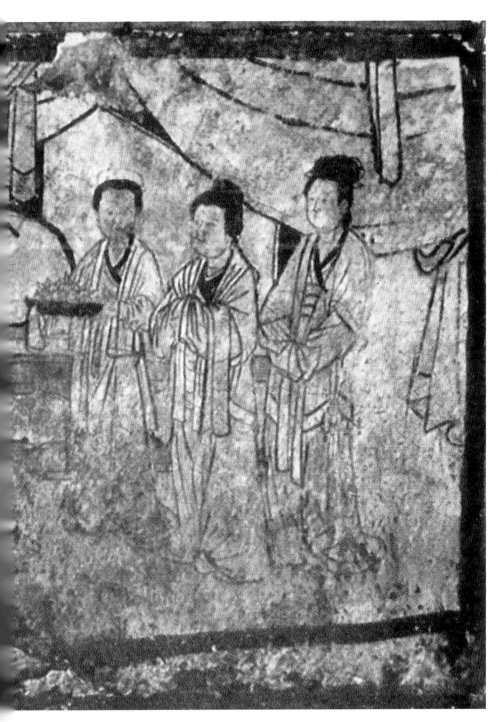

98.侍寝图

元（1206～1368年）

高100、宽216厘米

1983年辽宁省凌源县三家子乡老宫杖子村富家屯一号元墓出土。

墓向190°。位于墓室后壁，周边有墨色界栏。画中帷幔高悬，下有床榻，床上铺被衾枕头，床前放两只小口带盖梅瓶。画面右侧绘三名侍女，并列而立，其中一人端一盘，内置杂宝，另一人执帨巾；第三人抄手而立；画面左侧绘鱼贯而行三人，前面一人走近床榻，双手拱于胸前；中间一人身材较高，抄手而立；其后面跟随一侍女，头结绿纱发髻，擎一柄红色团扇。诸女子均长衫左衽，外罩半臂短衣。下部因墙面脱落，画面不存。

（撰文：都惜青　摄影：李振石）

Attending at Bedroom

Yuan (1279-1368 CE)

Height 100 cm; Width 216 cm

Unearthed from the Yuan Tomb No.1 at Fujiatun, Laogongzhangzicun in Sanjiazi of Lingyuan, Liaoning, in 1969.

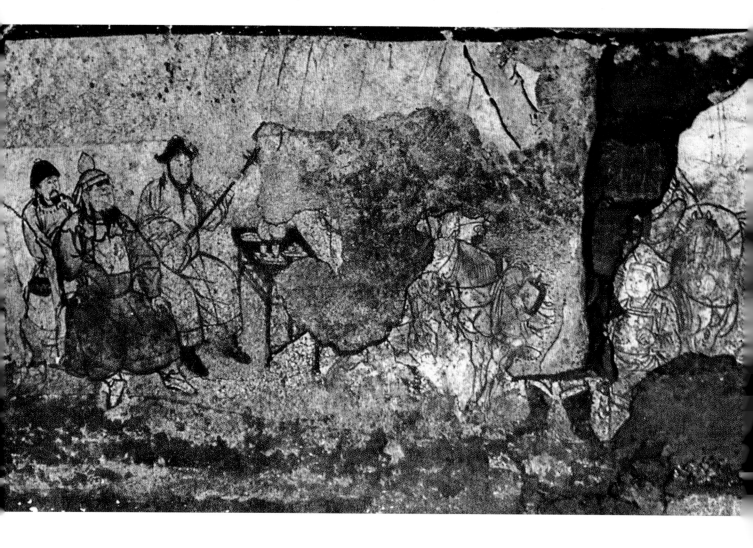

99. 游乐图

元（1206～1368年）

高90、宽173厘米

1983年辽宁省凌源县三家子乡老宫杖子村富家屯一号元墓出土。

墓向190°。位于墓室东壁。周边有较宽的墨线界栏，右侧画二人与已备好的四匹马。一人头戴红缨帽，身穿方领长袍，左手曲肘向前；另一人穿黑色长靴，手持三弦琴。二人身后四马，短耳长鬃，头戴笼络，颈系红缨，身备鞍鞴。左侧画墓主人端坐于交椅上，头戴钹笠冠，身穿带云肩的窄袖长袍，足蹬靴；其身后站一仆人，墓主人左侧坐一琴师，琴师右膝置三弦琴火不思，双手正在弹拨。前面置一黑漆高腿长方桌，桌上圆盘内放玉壶春瓶，方盘内盛杯子，高足盘内放桃子。壁画上部画一从右侧斜出的柳树，枝条缀满绿叶，披拂低垂。

（撰文：都惜青　摄影：李振石）

Picnicking

Yuan (1279-1368 CE)

Height 90 cm; Width 173 cm

Unearthed from the Yuan Tomb No.1 at Fujiatun, Laogongzhangzicun in Sanjiazi of Lingyuan, Liaoning, in 1969.

100.侍女图

高句丽（4世纪中叶）

高约50、宽约30厘米

1938年著录。吉林省集安市洞沟古墓群禹山墓区中部角抵墓。原址保存。

墓向230°。主壁家居图中左侧男主人女侍，拱手面向主人侍立，着短襦肥箭，翘尖履。

（撰文：傅佳欣、赵昕、林世香 摄影：谷德平）

Maid

Koguryo (Middle 4th c. CE)

Height ca. 50 cm; Width ca. 30 cm

Cataloged in 1938. Jiaodi (Wrestling) Tomb at the Yushan Cemetery of Donggou Tomb Cluster in Ji'an, Jilin. Preserved on the original site.

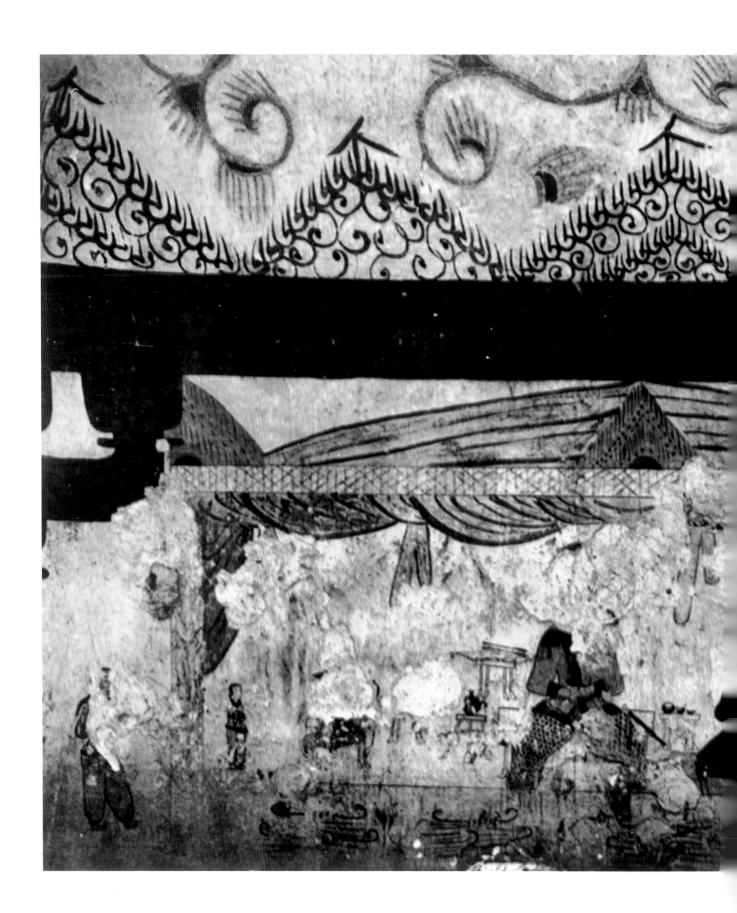

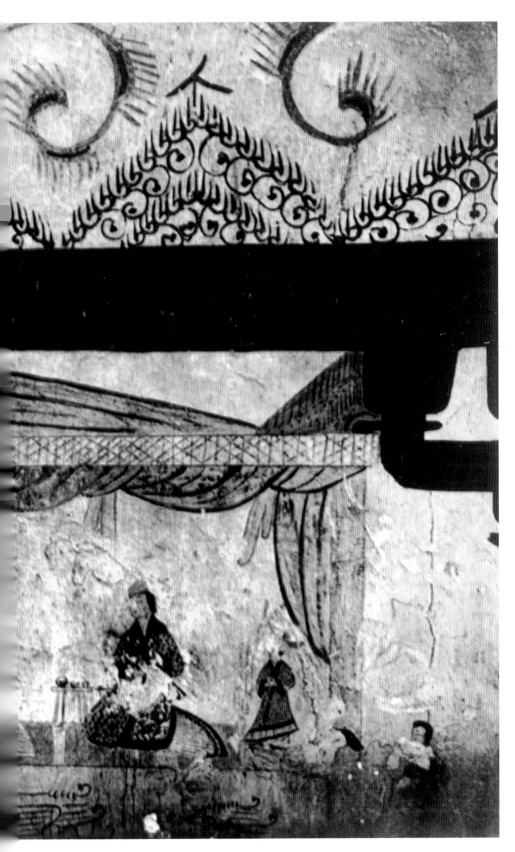

101.夫妇对坐图

高句丽（4世纪中叶）

高约220、宽约290厘米

1938年著录。吉林省集安市洞沟古墓群禹山墓区中部角抵墓。原址保存。墓向230°。此系主壁家居图。高屋帷幔下男主人居中高坐于几上，左佩刀，面向二女，两女拱手次第跪阙毯上，俯首面向男主人。男主人身后有男女侍者各一人，女主人各有女仆一人。为表现尊卑，侍者比例均稍小。男女主人旁边均有矮几，上置弓矢、食盒及食物。

（撰文：傅佳欣、赵昕、林世香

摄影：谷德平）

Tomb Occupant Couple Seated Face-to-Face

Koguryo (Middle 4th c. CE)
Height ca. 220 cm; Width ca. 290 cm
Cataloged in 1938. Jiaodi (Wrestling) Tomb at the Yushan Cemetery of Donggou Tomb Cluster in Ji'an, Jilin. Preserved on the original site.

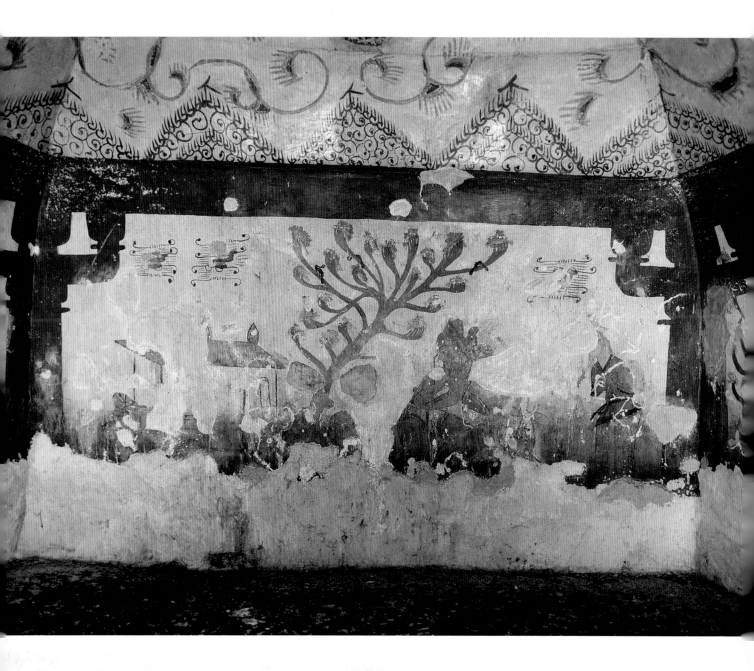

102.墓室东壁壁画

高句丽（4世纪中叶）

高170、宽320厘米

1938年著录。吉林省集安市洞沟古墓群禹山墓区中部角抵墓。原址保存。

墓向230°。庭院生活场景。画中大树将画面分为两部分：右侧为廊柱四阿顶房屋，屋外有一人似庖厨。左侧为二力士角抵，一老者观看。角抵二人均赤膊，仅着短胯，正奋力相抵。其一人高鼻深目，短髭上翘，似西域胡人形象。观看之老者结巾挂杖，长髯白发，着短衣肥箭。周围的天、树、地则绘云气、栖鸟、卧兽。

<div align="right">（撰文：傅佳欣、赵昕、林世香　摄影：苏楠、谷德平）</div>

Mural on the East Wall of the Tomb Chamber

Koguryo (Middle 4th c. CE)

Height 170 cm; Width 320 cm

Cataloged in 1938. Jiaodi (Wrestling) Tomb at the Yushan Cemetery of Donggou Tomb Cluster in Ji'an, Jilin. Preserved on the original site.

103. 墓室西壁壁画

高句丽（4世纪中叶）

高170、宽320厘米

1938年著录。吉林省集安市洞沟古墓群禹山墓区中部角抵墓。原址保存。

墓向230°。备乘画面。中间为两株大树，树下有一队等待出发的人马。前边为两乘鞍马，各有站立驭者，后面有侍者和牛车，均面向北壁墓主人。

（撰文：傅佳欣、赵昕、林世香　摄影：苏楠、谷德平）

Mural on the West Wall of the Tomb Chamber

Koguryo (Middle 4th c. CE)

Height 170 cm; Width 320 cm

Cataloged in 1938. Jiaodi (Wrestling) Tomb at the Yushan Cemetery of Donggou Tomb Cluster in Ji'an, Jilin. Preserved on the original site.

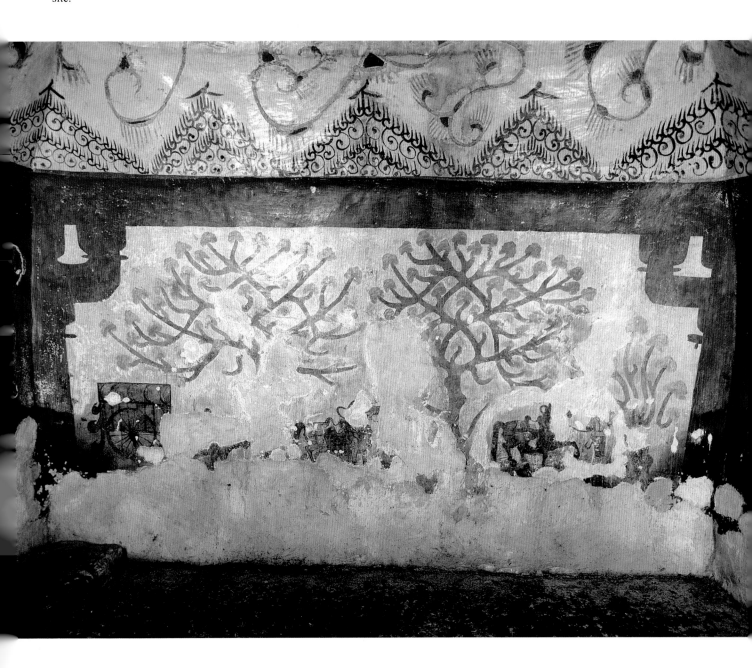

104.三足乌

高句丽（4世纪中叶）

高约70、宽约80厘米

1938年著录。吉林省集安市洞沟古墓群禹山墓区中部角抵墓。原址保存。

墓向230°。东藻井中部。暗红色圆形太阳，中间绘墨色三足乌面左而立。

<div align="right">（撰文：傅佳欣、赵昕、林世香　摄影：苏楠、谷德平）</div>

Three-legged Bird

Koguryo (Middle 4th c. CE)

Height ca. 70 cm; Width ca. 80 cm

Cataloged in 1938. Jiaodi (Wrestling) Tomb at the Yushan Cemetery of Donggou Tomb Cluster in Ji'an, Jilin. Preserved on the original site.

105.藻井南侧

高句丽（4世纪中叶）

藻井高160厘米

1938年著录。吉林省集安市洞沟古墓群禹山墓区中部角抵墓。原址保存。

墓向230°。平行叠涩的穹隆藻井。自下而上绘连续山形图案和云气、星象，东西绘有三足乌、蟾蜍以像日月。

（撰文：傅佳欣、赵昕、林世香　摄影：苏楠、谷德平）

South Side of the Caisson Ceiling

Koguryo (Middle 4th c. CE)

Height 160 cm

Cataloged in 1938. Jiaodi (Wrestling) Tomb at the Yushan Cemetery of Donggou Tomb Cluster in Ji'an, Jilin. Preserved on the original site.

106. 蟾蜍

高句丽（4世纪中叶）

高约50、宽约60厘米

1938年著录。吉林省集安市洞沟古墓群禹山墓区中部角抵墓。原址保存。

墓向230°。东藻井中部。线条勾勒的圆形月亮，内绘墨线黄色蟾蜍。

（撰文：傅佳欣、赵昕、林世香　摄影：苏楠、谷德平）

Fabled Toad

Koguryo (Middle 4th c. CE)

Height ca. 50 cm; Width ca. 60 cm

Cataloged in 1938. Jiaodi (Wrestling) Tomb at the Yushan Cemetery of Donggou Tomb Cluster in Ji'an, Jilin. Preserved on the original site.

107.家居图

高句丽（4世纪中叶）

高约110、宽约170厘米

1938年著录。吉林省集安市洞沟古墓群禹山墓区中部舞踊墓。原址保存。

墓向230°。此系主壁墓主人家居图中部。帷幔装饰的屋中，男女主人相对坐于条凳上。男主人面向左，头戴折风冠，短襦肥箭，袖手聆听。女主人面向右，着长襦长裙，左手上举似在说话。中间有形体稍小的跪侍向男主人献食，两主人间摆放有相等的几案和食物，下方为一组伴唱的女优。

（撰文：傅佳欣、赵昕、林世香　摄影：引自《通沟》1938年）

Home Living

Koguryo (Middle 4th c. CE)

Height ca. 110 cm; Width ca. 170 cm

Cataloged in 1938. Wuyong (Dancing) Tomb at the Yushan Cemetery of Donggou Tomb Cluster in Ji'an, Jilin. Preserved on the original site.

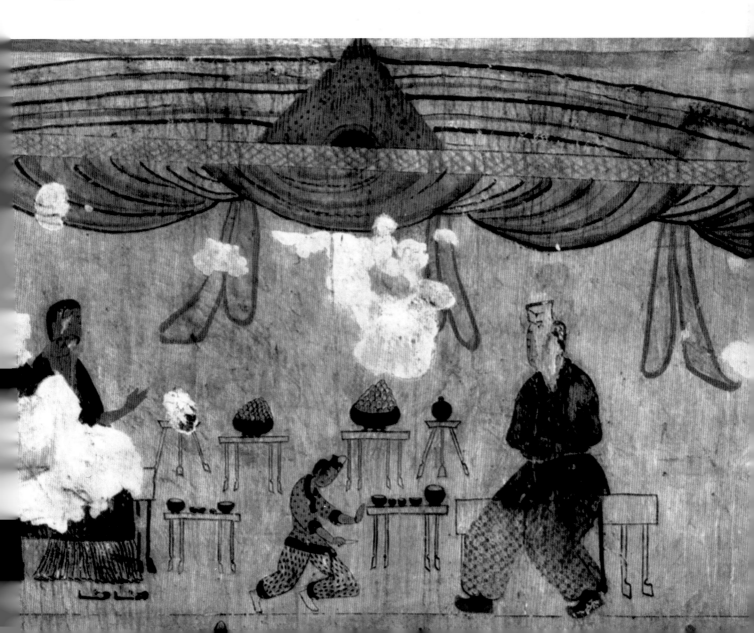

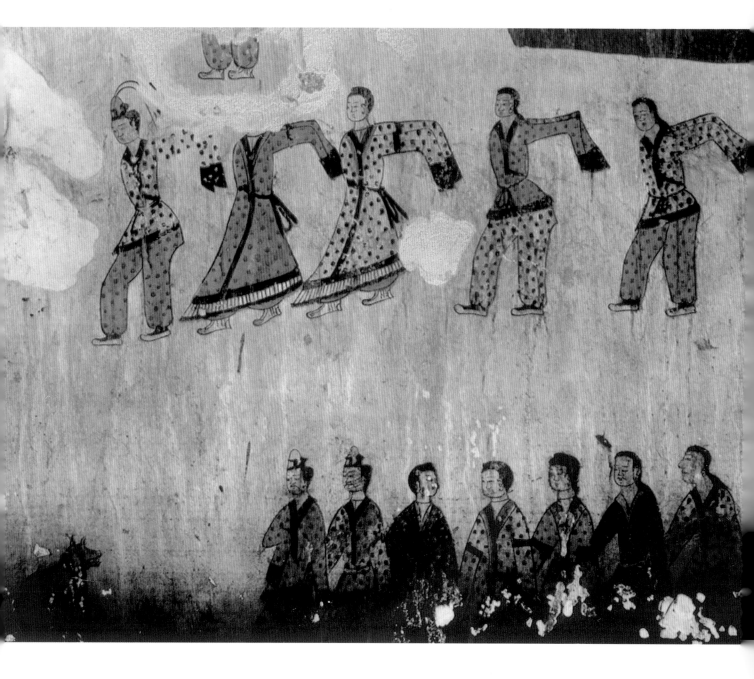

108.歌舞图

高句丽（4世纪中叶）

高约100、宽约130厘米

1938年著录。吉林省集安市洞沟古墓群禹山墓区中部舞踊墓。原址保存。

墓向230°。著名的舞踊图右上局部群舞场景。上方一人领舞，五人相随，均作同一舞姿。队首者头饰两条雉尾，长袖下垂，其后四人分长裙、短襦两组，动感颇强。下方为七人伴唱队伍，排成一列，着对衽或左衽短襦，间有回首者，使画面愈显生动。

（撰文：傅佳欣、赵昕、林世香　摄影：引自《通沟》1938年）

Dancing and Singing

Koguryo (Middle 4th c. CE)

Height ca. 100 cm; Width ca. 130 cm

Cataloged in 1938. Wuyong (Dancing) Tomb at the Yushan Cemetery of Donggou Tomb Cluster in Ji'an, Jilin. Preserved on the original site.

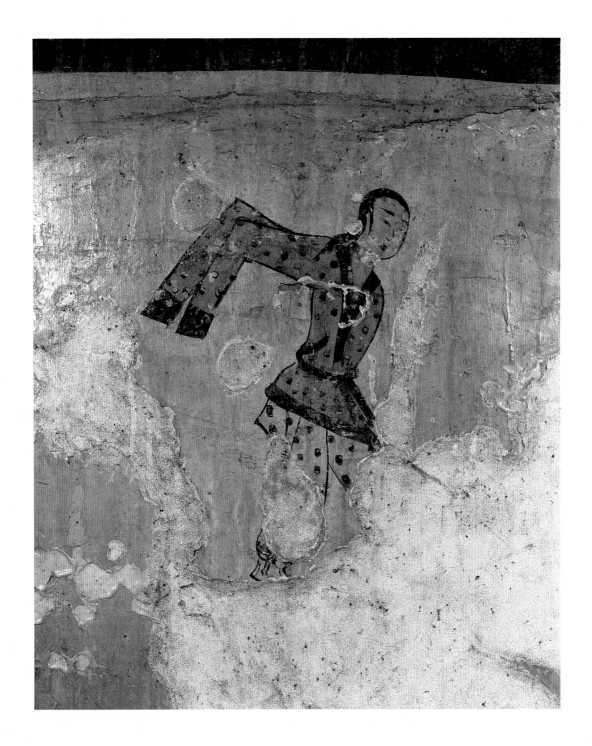

109.领舞人

高句丽（4世纪中叶）

高约70、宽40厘米

1938年著录。吉林省集安市洞沟古墓群禹山墓区中部舞踊墓。原址保存。

墓向230°。舞踊图中上局部，面对群舞队列的领舞人。身着对衽短襦、长裤，作踏顿状舞姿。

<div align="right">（撰文：傅佳欣、赵昕、林世香　摄影：苏楠、谷德平）</div>

Leading Dancer

Koguryo (Middle 4th c. CE)

Height ca. 70 cm; Width 40 cm

Cataloged in 1938. Wuyong (Dancing) Tomb at the Yushan Cemetery of Donggou Tomb Cluster in Ji'an, Jilin. Preserved on the original site.

110. 观舞者

高句丽（4世纪中叶）

高约70、宽约90厘米

1938年著录。吉林省集安市洞沟古墓群禹山墓区中部舞踊墓。原址保存。

墓向230°。舞踊图左下局部。男性中年主人头带方冠，驻马凝神，面向群舞与伴唱者。马身装配有络、辔、鞍、障泥等部件和饰物，马前、后各有一狗，主人骑乘之后有侍女一人，执物以待，似为赏赐。

<div style="text-align: right">（撰文：傅佳欣、赵昕、林世香　摄影：引自《通沟》1938年）</div>

Dancing Watcher

Koguryo (Middle 4th c. CE)

Height ca. 70 cm; Width ca. 90 cm

Cataloged in 1938. Wuyong (Dancing) Tomb at the Yushan Cemetery of Donggou Tomb Cluster in Ji'an, Jilin. Preserved on the original site.

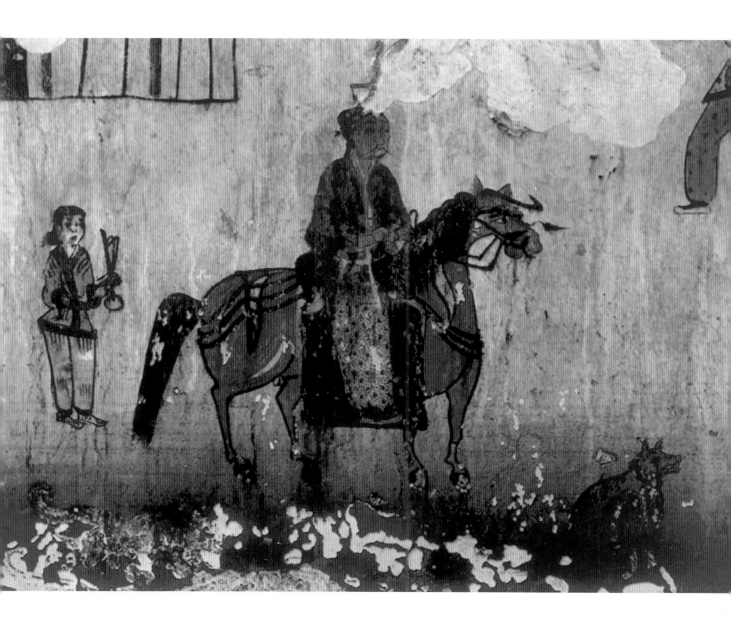

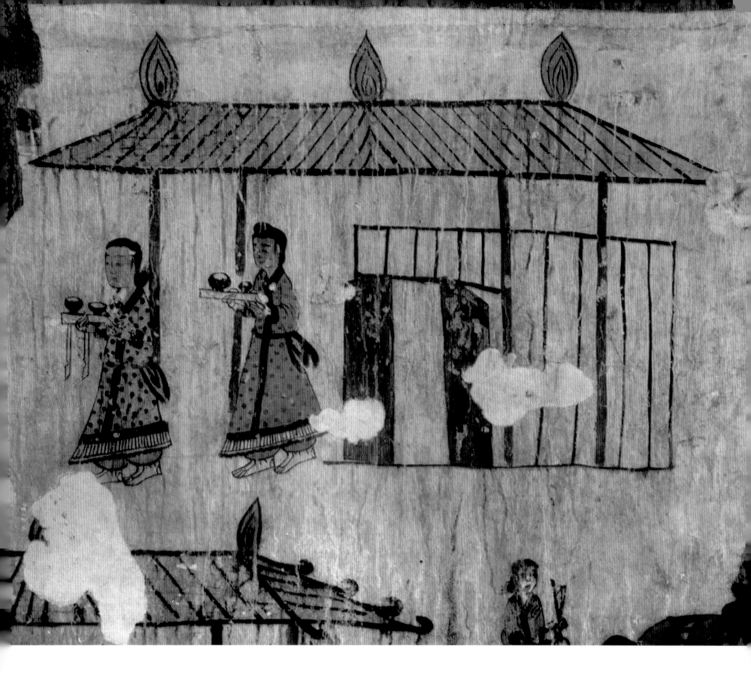

111.侍奉图

高句丽（4世纪中叶）

高约70、宽约80厘米

1938年著录。吉林省集安市洞沟古墓群禹山墓区中部舞踊墓。原址保存。

墓向230°。舞踊图左上局部侍女奉食场景。两女侍鱼贯自木栅栏对开门扉中走出，身后为四阿顶房屋。前后侍女双手各执长方几和方盘，其上有碗钵盛食物，面向主壁墓主人方向而去。

（撰文：傅佳欣、赵昕、林世香　摄影：引自《通沟》1938年）

Serving and Attending

Koguryo (Middle 4th c. CE)

Height ca. 70 cm; Width ca. 80 cm

Cataloged in 1938. Wuyong (Dancing) Tomb at the Yushan Cemetery of Donggou Tomb Cluster in Ji'an, Jilin. Preserved on the original site.

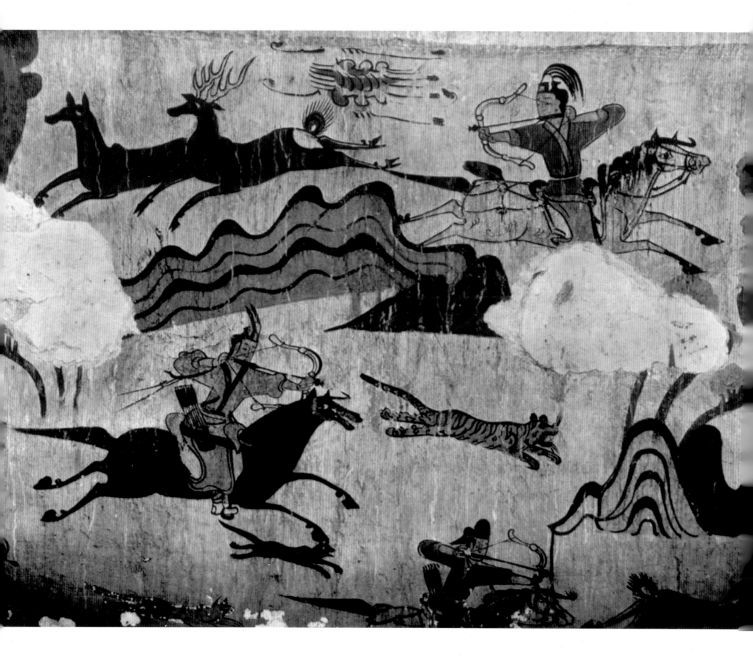

112.狩猎图

高句丽（4世纪中叶）

高约100、宽约160厘米

1938年著录。吉林省集安市洞沟古墓群禹山墓区中部舞踊墓。原址保存。

墓向230°。位于墓室北壁梁枋下，绘狩猎场景局部。山树间有三人骑马迂回驰骋，分射鹿、虎。最上者头戴雉翎冠，回身张弓瞄准一对奔鹿，弓上待发的是鸣镝。中间者头戴双雉翎，正在携黑犬追逐逃逸之虎。下方为头戴巾帻猎者，已满弓对准一只奔鹿。

（撰文：傅佳欣、赵昕、林世香　摄影：引自《通沟》1938年）

Hunting

Koguryo (Middle 4th c. CE)

Height ca. 100 cm; Width ca. 160 cm

Cataloged in 1938. Wuyong (Dancing) Tomb at the Yushan Cemetery of Donggou Tomb Cluster in Ji'an, Jilin. Preserved on the original site.

113. 狩猎者

高句丽（4世纪中叶）

高约35、宽约40厘米

1938年著录。吉林省集安市洞沟古墓群禹山墓区中部舞踊墓。原址保存。

墓向230°。狩猎场景局部。为一驭马缓驰的猎者，头戴雉翎冠，满囊箭矢却收弓俯首，似在观看前方射猎景象。

（撰文：傅佳欣、赵昕、林世香　摄影：引自《通沟》1938年）

Hunter

Koguryo (Middle 4th c. CE)

Height ca. 35 cm; Width ca. 40 cm

Cataloged in 1938. Wuyong (Dancing) Tomb at the Yushan Cemetery of Donggou Tomb Cluster in Ji'an, Jilin. Preserved on the original site.

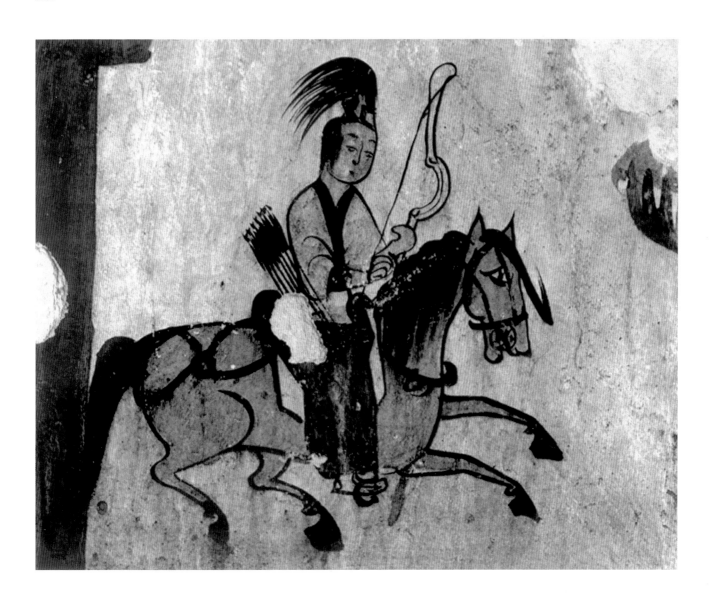

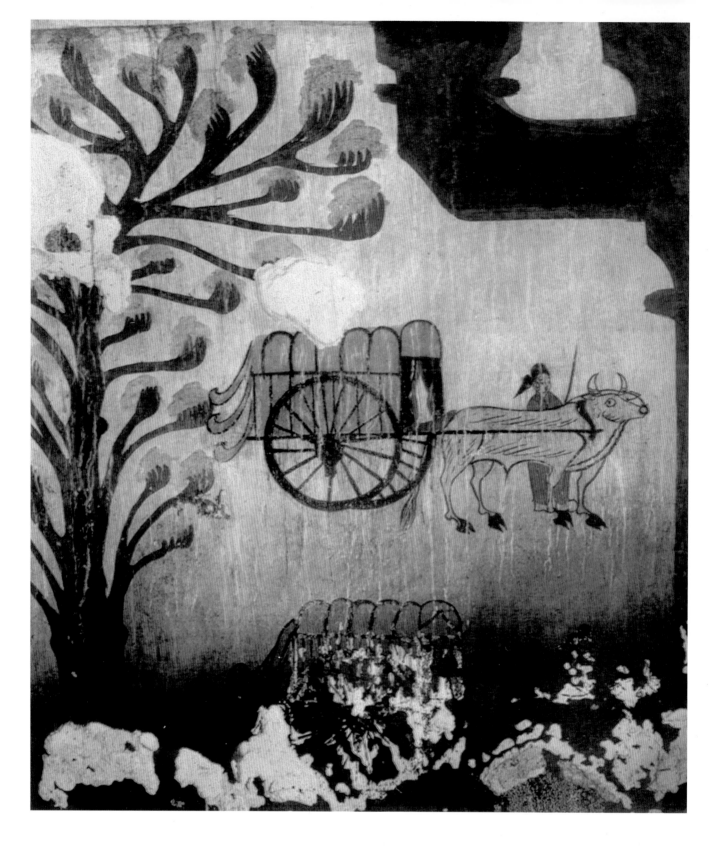

114. 牛车图

高句丽（4世纪中叶）

高约120、宽约100厘米

1938年著录。吉林省集安市洞沟古墓群禹山墓区中部舞踊墓。原址保存。

墓向230°。与狩猎场景相隔的牛车备乘画面。树下有并待的两架牛车，均为布幛围成的辒车。车旁有红衣驭者执鞭侍立，驭者头裹巾帻，面向主壁。下部牛车略漫漶。

（撰文：傅佳欣、赵昕、林世香　摄影：引自《通沟》1938年）

Ox Carts

Koguryo (Middle 4th c. CE)
Height ca. 120 cm; Width ca. 100 cm
Cataloged in 1938. Wuyong (Dancing)
Tomb at the Yushan Cemetery of
Donggou Tomb Cluster in Ji'an, Jilin.
Preserved on the original site.

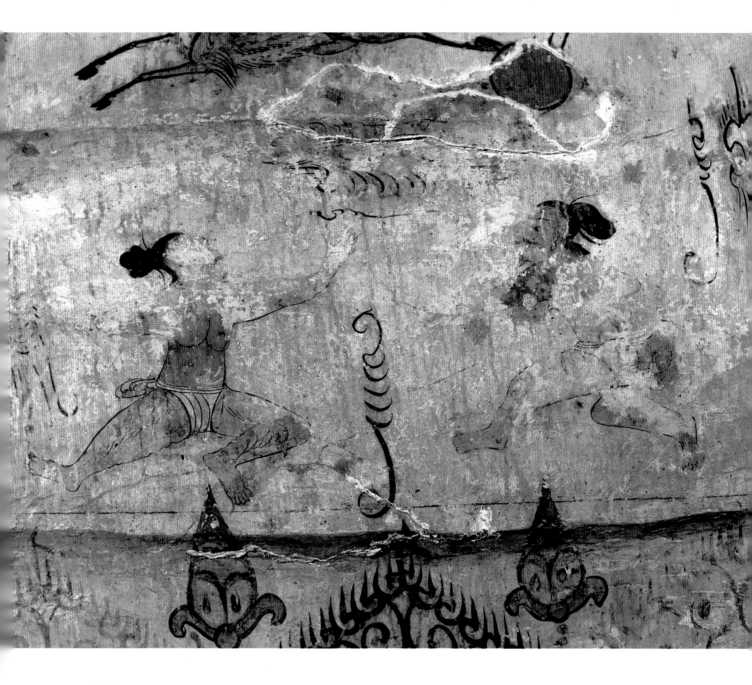

115. 角抵图

高句丽（4世纪中叶）

高约50、宽约60厘米

1938年著录。吉林省集安市洞沟古墓群禹山墓区中部舞踊墓。原址保存。

墓向230°。藻井北面第一层叠涩中间的角抵图。两人束发裸身，正待相搏。按照该墓其他三壁的壁画模式，此处应该是玄武图像，这种现象说明，高句丽早期壁画的四神观念尚不成熟。

（撰文：傅佳欣、赵昕、林世香　摄影：苏楠、谷德平）

Wrestling Scene

Koguryo (Middle 4th c. CE)

Height ca. 50 cm; Width ca. 60 cm

Cataloged in 1938. Wuyong (Dancing) Tomb at the Yushan Cemetery of Donggou Tomb Cluster in Ji'an, Jilin. Preserved on the original site

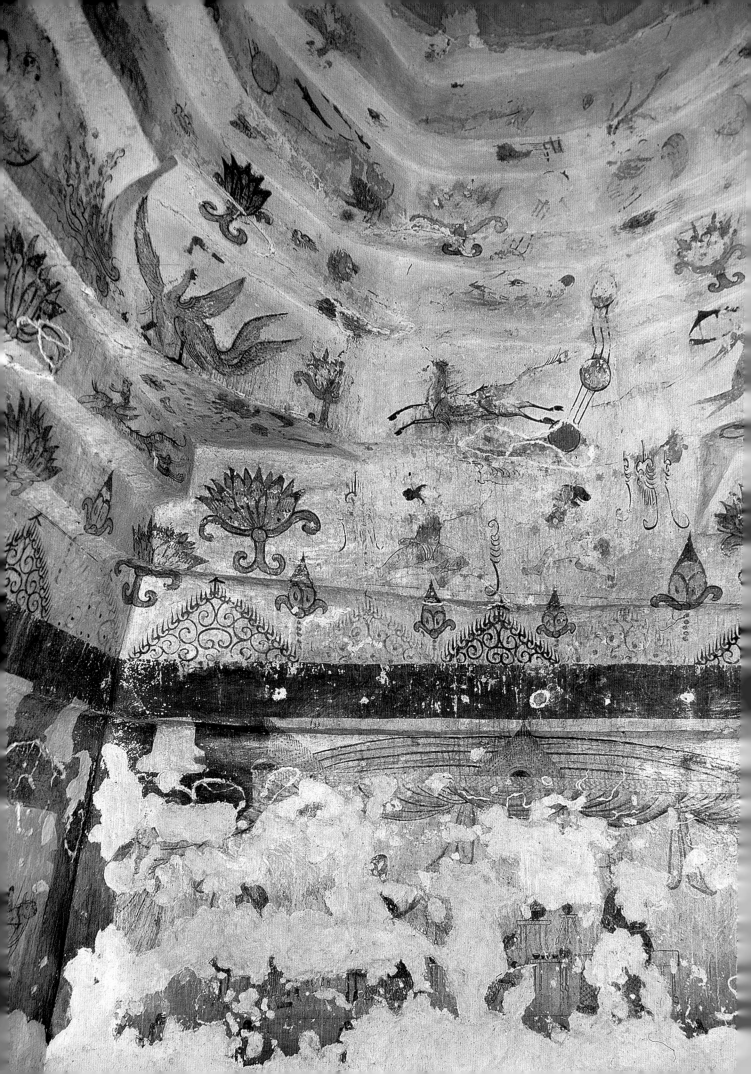

116.藻井（北侧）

高句丽（4世纪中叶）

藻井高180厘米

1938年著录。吉林省集安市洞沟古墓群禹山墓区中部舞踊墓。原址保存。

墓向230°。抹角叠涩的穹隆藻井，自下而上绘有梁枋、山云纹连续图案、侧视莲花图案、日月、朱雀、角抵、仙人、神兽、云气、星斗等。

（撰文：傅佳欣、赵昕、林世香　摄影：苏楠、谷德平）

North Side of the Caisson Ceiling

Koguryo (Middle 4th c. CE)

Height 180 cm

Cataloged in 1938. Wuyong (Dancing) Tomb at the Yushan Cemetery of Donggou Tomb Cluster in Ji'an, Jilin. Preserved on the original site.

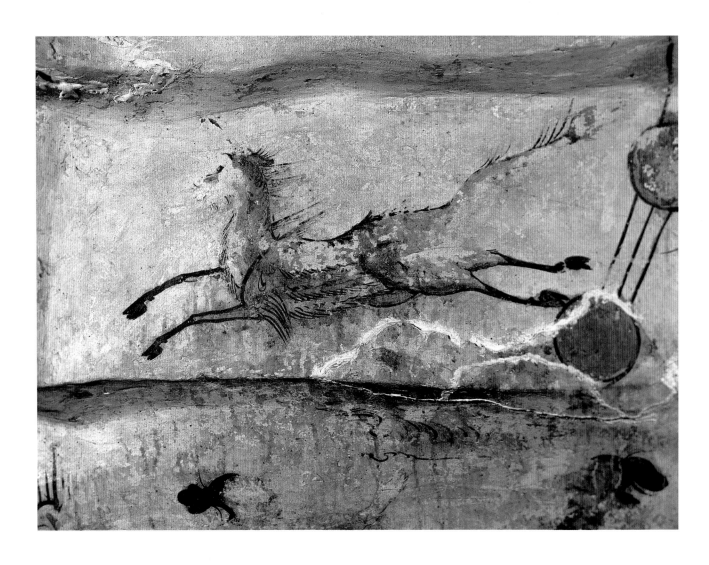

117. 瑞兽（一）

高句丽（4世纪中叶）

高约45、宽约60厘米

1938年著录。吉林省集安市洞沟古墓群禹山墓区中部舞踊墓。原址保存。

墓向230°。北藻井第三重叠涩正中瑞兽，略漫漶。

（撰文：傅佳欣、赵昕、林世香　摄影：苏楠、谷德平）

Mythical Animal (1)

Koguryo (Middle 4th c. CE)

Height ca. 45 cm; Width ca. 60 cm

Cataloged in 1938. Wuyong (Dancing) Tomb at the Yushan Cemetery of Donggou Tomb Cluster in Ji'an, Jilin. Preserved on the original site.

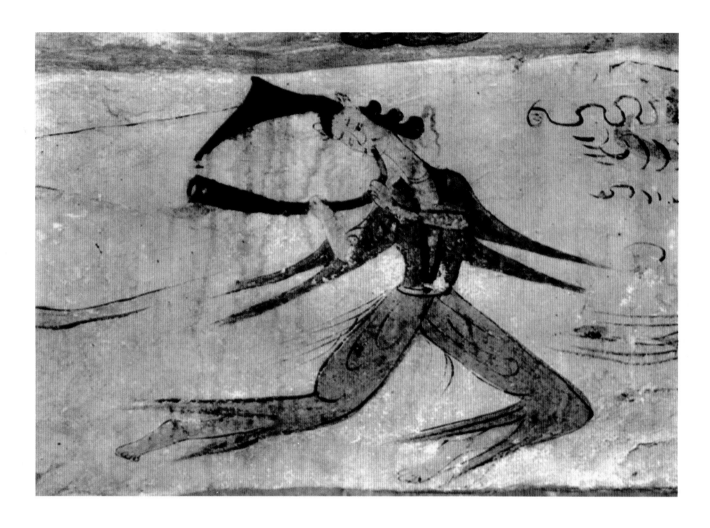

118.吹角仙人

高句丽（4世纪中叶）

高约40、宽约60厘米

1938年著录。吉林省集安市洞沟古墓群禹山墓区中部舞踊墓。原址保存。

墓向230°。藻井东北第三重叠涩抹角处飞翔的仙人。仙人戴高冠，额旁有双角，蓄短髭，着红色紧身羽衣，袖口和裤口作旒苏状，双手执弯角吹奏，呈回首跨步飞翔状态。

（撰文：傅佳欣、赵昕、林世香　摄影：引自《通沟》1938年）

Horn-blowing Immortal

Koguryo (Middle 4th c. CE)

Height ca. 40 cm; Width ca. 60 cm

Cataloged in 1938. Wuyong (Dancing) Tomb at the Yushan Cemetery of Donggou Tomb Cluster in Ji'an, Jilin. Preserved on the original site.

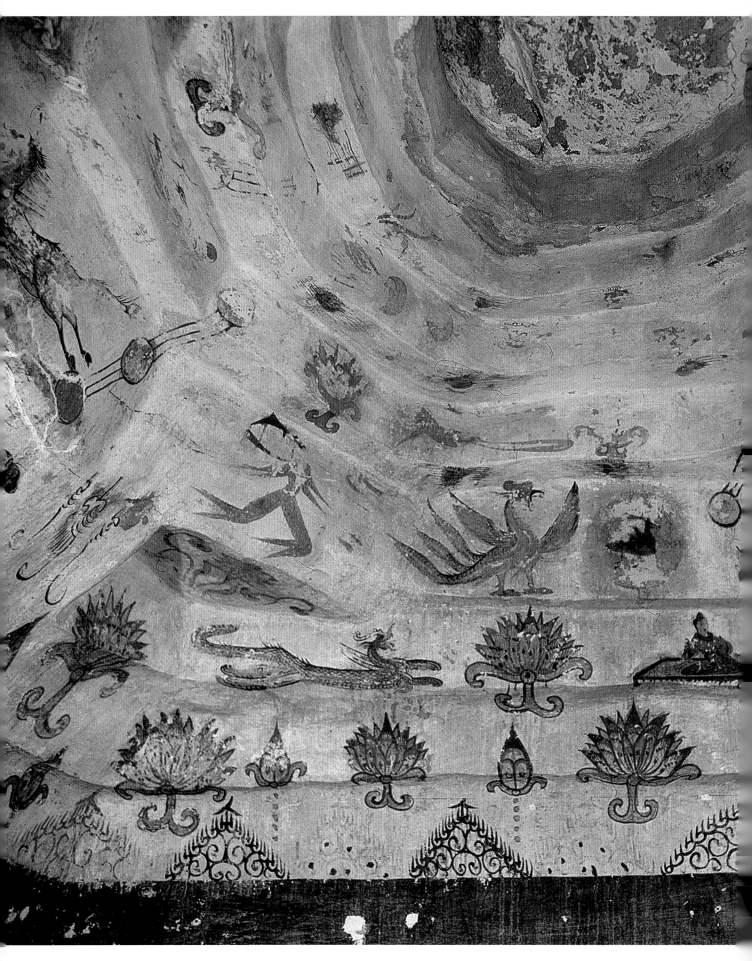

126

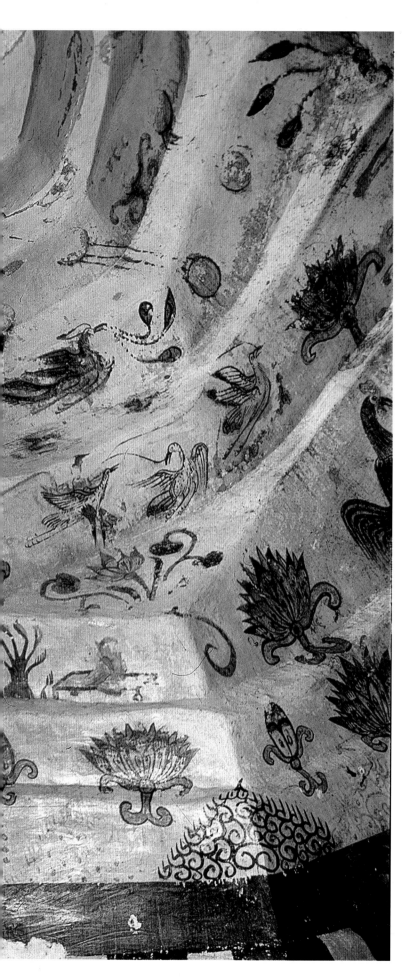

119.藻井（东侧）

高句丽（4世纪中叶）

藻井高约190厘米

1938年著录。吉林省集安市洞沟古墓群禹山墓区中部舞踊墓。原址保存。

墓向230°。抹角叠涩藻井。自下而上为梁枋、山云形连续图案、侧视莲花间以莲蕾、榻上讲道仙人和瑞兽、瑞鸟和三足乌、星象等。

（撰文：傅佳欣、赵昕、林世香　摄影：苏楠、谷德平）

East Side of the Caisson Ceiling

Koguryo (Middle 4th c. CE)

Height ca. 190 cm

Cataloged in 1938. Wuyong (Dancing) Tomb at the Yushan Cemetery of Donggou Tomb Cluster in Ji'an, Jilin. Preserved on the original site.

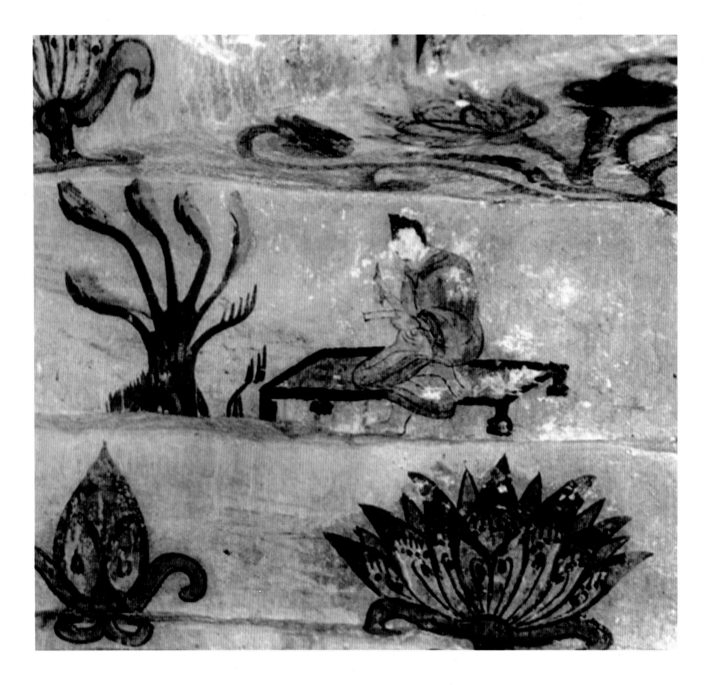

120. 讲道仙人

高句丽（4世纪中叶）

高约40、宽约50厘米

1938年著录。吉林省集安市洞沟古墓群禹山墓区中部舞踊墓。原址保存。

墓向230°。藻井第三层叠涩仙人图像。人物坐于榻上，跣足，左腿垂下，右腿盘踞，手执简牍，似与北面相对的榻上仙人讲道。

（撰文：傅佳欣、赵昕、林世香　摄影：引自《通沟》1938年）

Preaching Immortal

Koguryo (Middle 4th c. CE)

Height ca. 40 cm; Width ca. 50 cm

Cataloged in 1938. Wuyong (Dancing) Tomb at the Yushan Cemetery of Donggou Tomb Cluster in Ji'an, Jilin. Preserved on the original site.

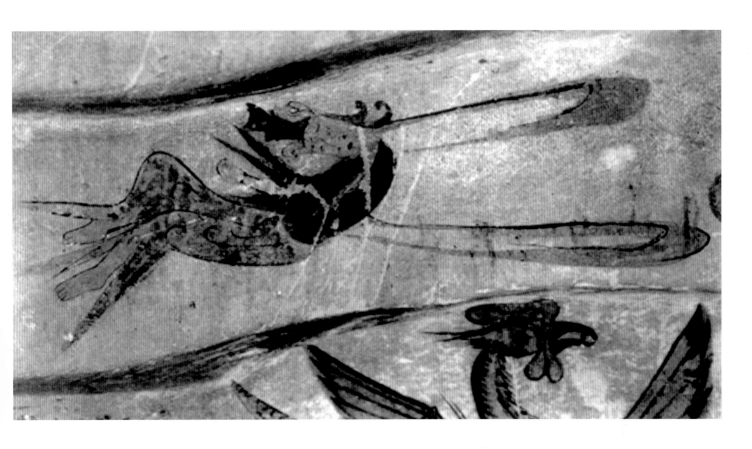

121. 飞翔仙人

高句丽（4世纪中叶）

高约30、宽约70厘米

1938年著录。吉林省集安市洞沟古墓群禹山墓区中部舞踊墓。原址保存。

墓向230°。藻井四层叠涩北端仙人。人物头上有两角，戴高冠，长发末端卷曲，作颌首屈身飞翔形态。身后有两条环状飘带，动感极强。

（撰文：傅佳欣、赵昕、林世香　摄影：引自《通沟》1938年）

Flying Immortal

Koguryo (Middle 4th c. CE)

Height ca. 30 cm; Width ca. 70 cm

Cataloged in 1938. Wuyong (Dancing) Tomb at the Yushan Cemetery of Donggou Tomb Cluster in Ji'an, Jilin. Preserved on the original site.

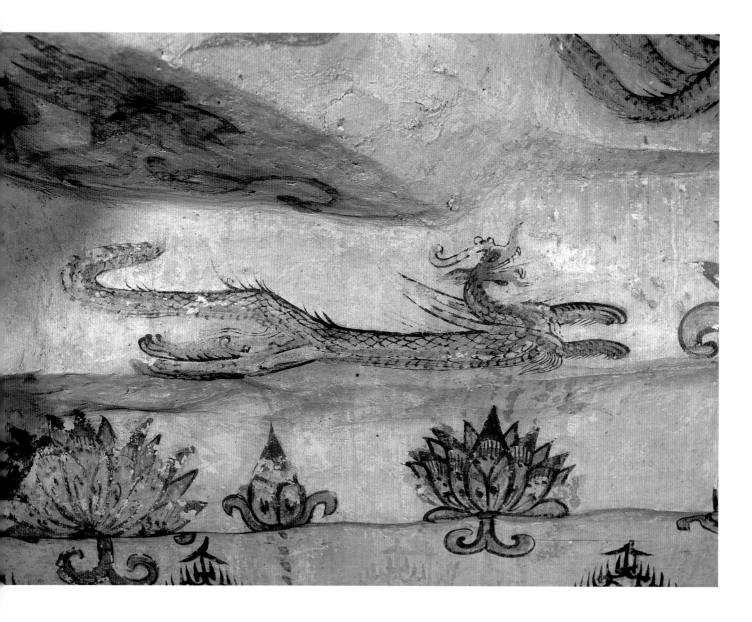

122.藻井瑞兽（一）

高句丽（4世纪中叶）

高约60、宽约80厘米

1938年著录。吉林省集安市洞沟古墓群禹山墓区中部舞踊墓。原址保存。

墓向230°。藻井第三层抹角石所绘青龙。有龙头、蛇身、兽足、兽尾。龙之形态尚不成熟。

<div align="right">（撰文：傅佳欣、赵昕、林世香　摄影：苏楠、谷德平）</div>

Mythical Animal at Caisson (1)

Koguryo (Middle 4th c. CE)

Height ca. 60 cm; Width ca. 80 cm

Cataloged in 1938. Wuyong (Dancing) Tomb at the Yushan Cemetery of Donggou Tomb Cluster in Ji'an, Jilin. Preserved on the original site.

123.藻井（南侧）

高句丽（4世纪中叶）

高约100、宽约110厘米

1938年著录。吉林省集安市洞沟古墓群禹山墓区中部舞踊墓。原址保存。

墓向230°。以朱雀为中心的藻井画面。第二层叠涩中心为两只相对的朱雀，形状、色彩与公鸡相似。下方依次为侧视莲花及花蕾、山云形连续图案、梁枋。四层叠涩中间为莲花，左为瑞鸟，右为仙人与瑞兽。五层叠涩有仙人、瑞鸟、星象等。画面色彩以暗红、黑为主。朱雀形态尚在早期阶段。

（撰文：傅佳欣、赵昕、林世香　摄影：苏楠、谷德平）

South Side of the Caisson Ceiling

Koguryo (Middle 4th c. CE)

Height ca. 100 cm; Width ca. 110 cm

Cataloged in 1938. Wuyong (Dancing) Tomb at the Yushan Cemetery of Donggou Tomb Cluster in Ji'an, Jilin. Preserved on the original site.

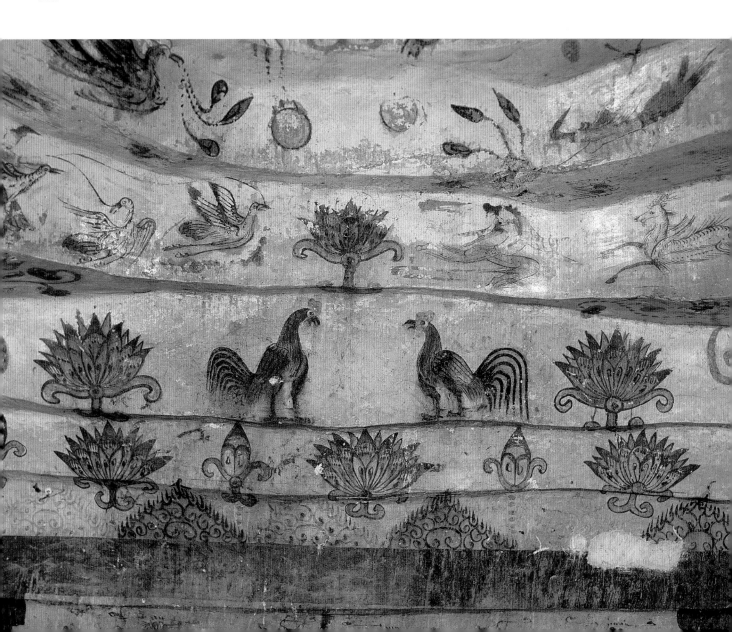

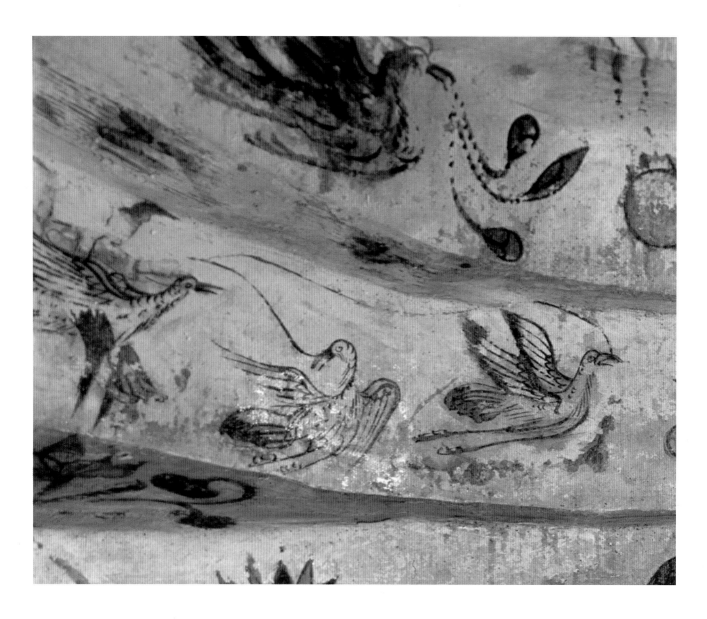

124.衔绶瑞鸟

高句丽（4世纪中叶）

高约50、宽约70厘米

1938年著录。吉林省集安市洞沟古墓群禹山墓区中部舞踊墓。原址保存。

墓向230°。藻井抹角画面。上方为衔绶戴胜形状瑞鸟。下方有三只同飞的瑞鸟，均衔绶带。中间似为回颈鸣叫的仙鹤，动态优雅。

（撰文：傅佳欣、赵昕、林世香　摄影：苏楠、谷德平）

Mythical Birds Holding Ribbons in Mouth

Koguryo (Middle 4th c. CE)

Height ca. 50 cm; Width ca. 70 cm

Cataloged in 1938. Wuyong (Dancing) Tomb at the Yushan Cemetery of Donggou Tomb Cluster in Ji'an, Jilin. Preserved on the original site.

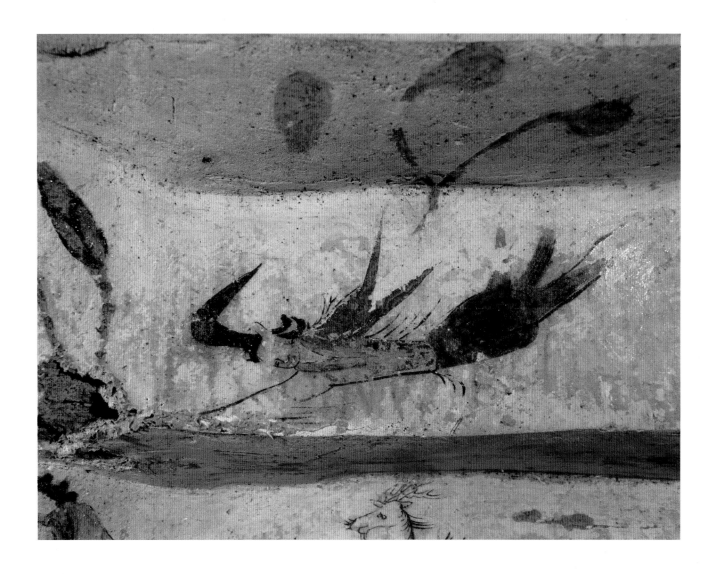

125. 仙人

高句丽（4世纪中叶）

高约30、宽约50厘米

1938年著录。吉林省集安市洞沟古墓群禹山墓区中部舞踊墓。原址保存。

墓向230°。藻井西南抹角所绘仙人。作平身飞翔状，长发折飘，一手前伸，衣服背面有旒苏或飘带。

（撰文：傅佳欣、赵昕、林世香　摄影：苏楠、谷德平）

Immortal

Koguryo (Middle 4th c. CE)

Height ca. 30 cm; Width ca. 50 cm

Cataloged in 1938. Wuyong (Dancing) Tomb at the Yushan Cemetery of Donggou Tomb Cluster in Ji'an, Jilin. Preserved on the original site.

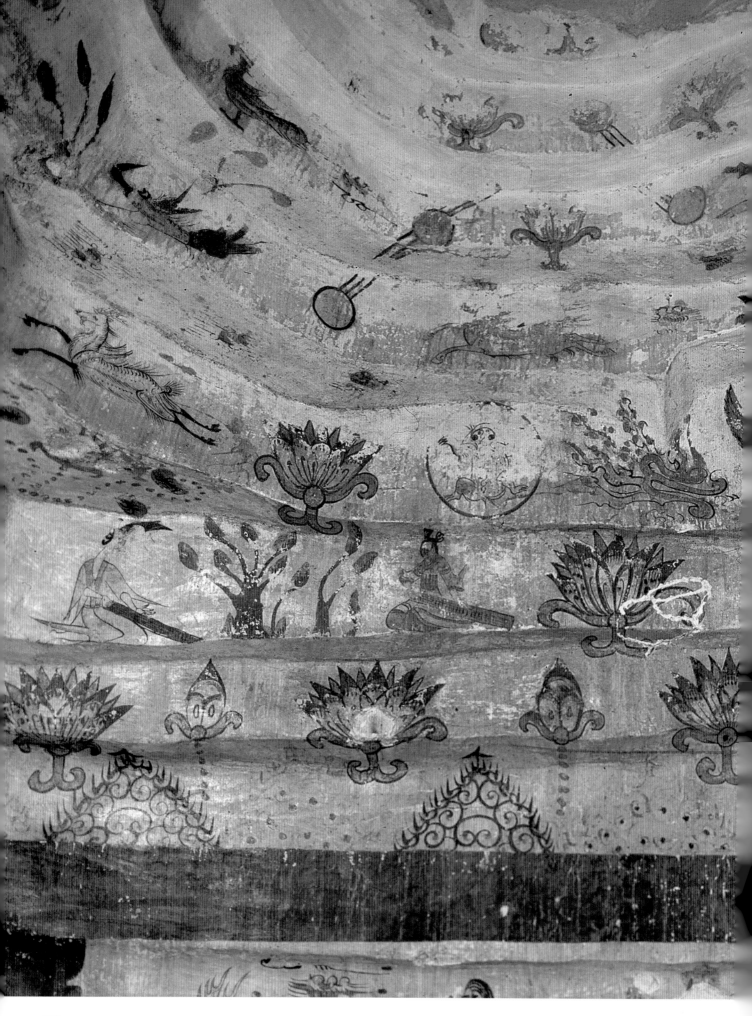

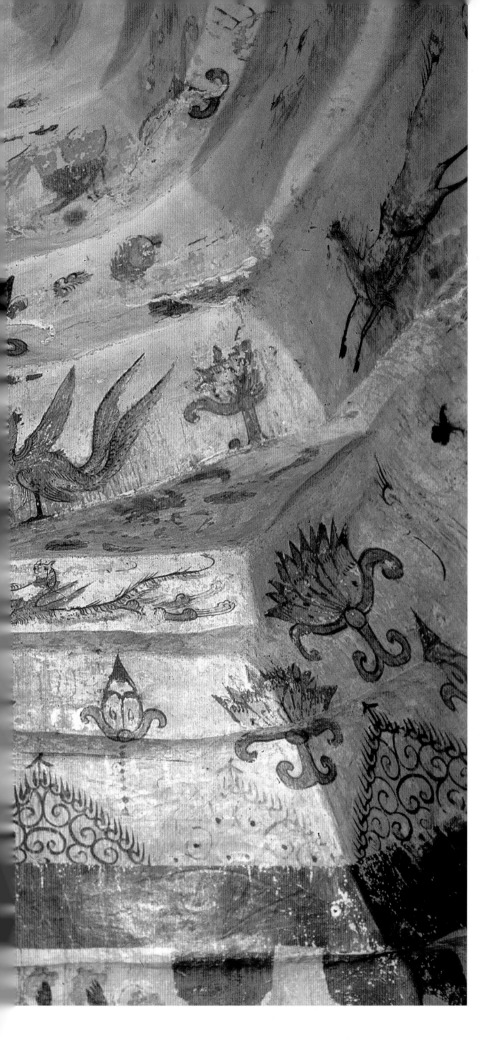

126. 藻井（西侧）

高句丽（4世纪中叶）

藻井高约190厘米

1938年著录。吉林省集安市洞沟古墓群禹山墓区中部舞踊墓。原址保存。

墓向230°。抹角叠涩藻井，以第三层叠涩蟾蜍图案为中心，绘有山云图案、瑞禽、抚琴仙人、瑞兽、莲花、星象等。

（撰文：傅佳欣、赵昕、林世香　摄影：
苏楠、谷德平）

West Side of the Caisson Ceiling

Koguryo (Middle 4th c. CE)

Height ca. 190 cm

Cataloged in 1938. Wuyong (Dancing) Tomb at the Yushan Cemetery of Donggou Tomb Cluster in Ji'an, Jilin. Preserved on the original site.

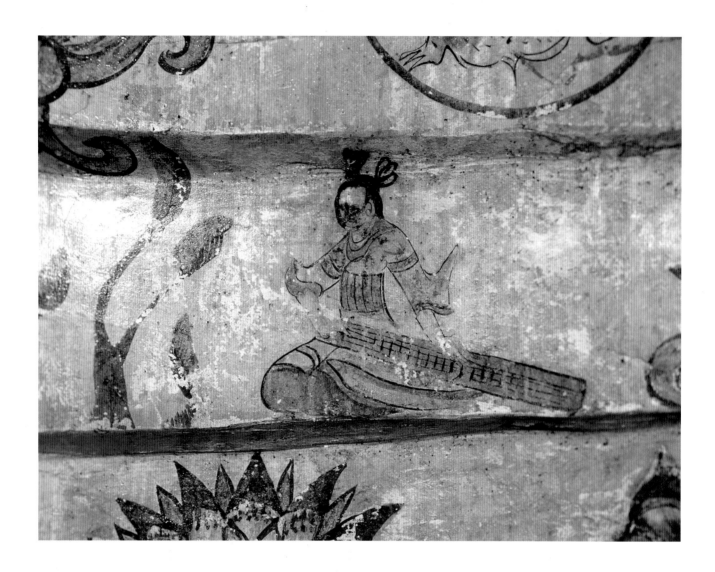

127.抚琴仙人（一）

高句丽（4世纪中叶）

高约40、宽约60厘米

1938年著录。吉林省集安市洞沟古墓群禹山墓区中部舞踊墓。原址保存。

墓向230°。西藻井第二层叠涩中间抚琴仙人。女相，头梳双髻，上着圆领紧衣，下为长裙，跪坐，低首抚琴。

<div align="right">（撰文：傅佳欣、赵昕、林世香　摄影：苏楠、谷德平）</div>

Qin-Zither-playing Immortal (1)

Koguryo (Middle 4th c. CE)

Height ca. 40 cm; Width ca. 60 cm

Cataloged in 1938. Wuyong (Dancing) Tomb at the Yushan Cemetery of Donggou Tomb Cluster in Ji'an, Jilin. Preserved on the original site.

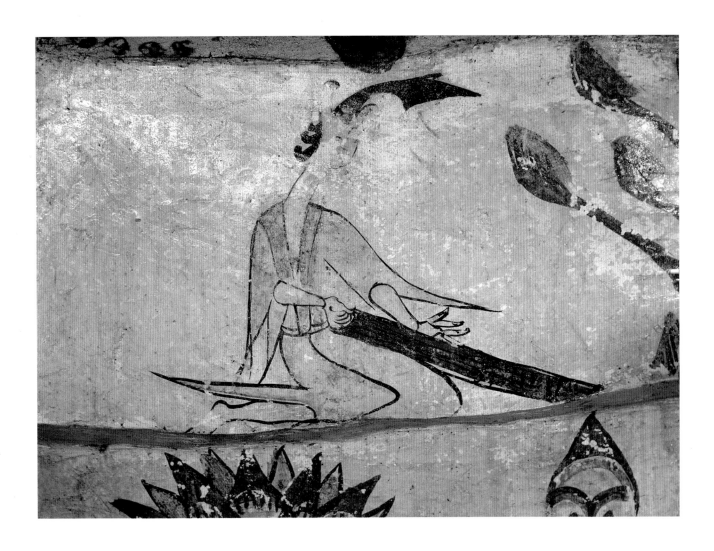

128. 抚琴仙人（二）

高句丽（4世纪中叶）

高约40、宽约60厘米

1938年著录。吉林省集安市洞沟古墓群禹山墓区中部舞踊墓。原址保存。

墓向230°。西藻井第二层叠涩南端抚琴仙人。高髻螺发，头上有双角，着对衽短宽袖羽衣，跣足，跪坐抚琴。

（撰文：傅佳欣、赵昕、林世香　摄影：苏楠、谷德平）

Qin-Zither-playing Immortal (2)

Koguryo (Middle 4th c. CE)

Height ca. 40 cm; Width ca. 60 cm

Cataloged in 1938. Wuyong (Dancing) Tomb at the Yushan Cemetery of Donggou Tomb Cluster in Ji'an, Jilin. Preserved on the original site.

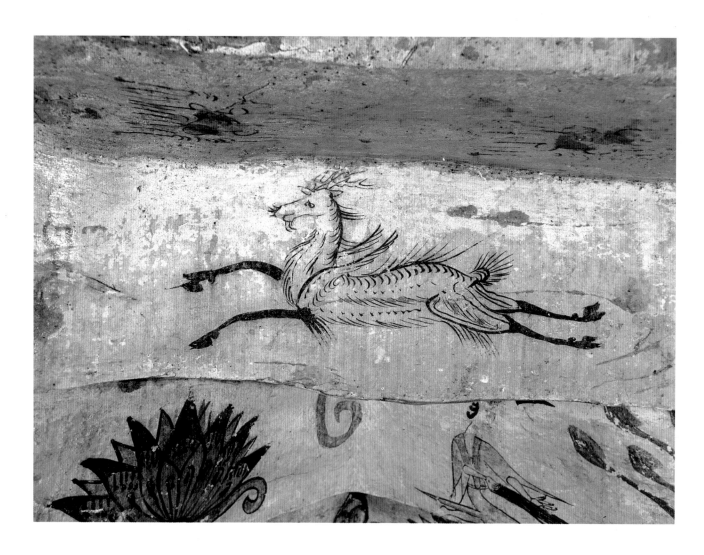

129.藻井瑞兽（二）

高句丽（4世纪中叶）

高约40、宽约60厘米

1938年著录。吉林省集安市洞沟古墓群禹山墓区中部舞踊墓。原址保存。

墓向230°。西藻井三层叠涩抹角处瑞兽。鹿头，偶蹄，长鬣，似有双翅。

（撰文：傅佳欣、赵昕、林世香　摄影：苏楠、谷德平）

Mythical Animal at Caisson (2)

Koguryo (Middle 4th c. CE)

Height ca. 40 cm; Width ca. 60 cm

Cataloged in 1938. Wuyong (Dancing) Tomb at the Yushan Cemetery of Donggou Tomb Cluster in Ji'an, Jilin. Preserved on the original site.

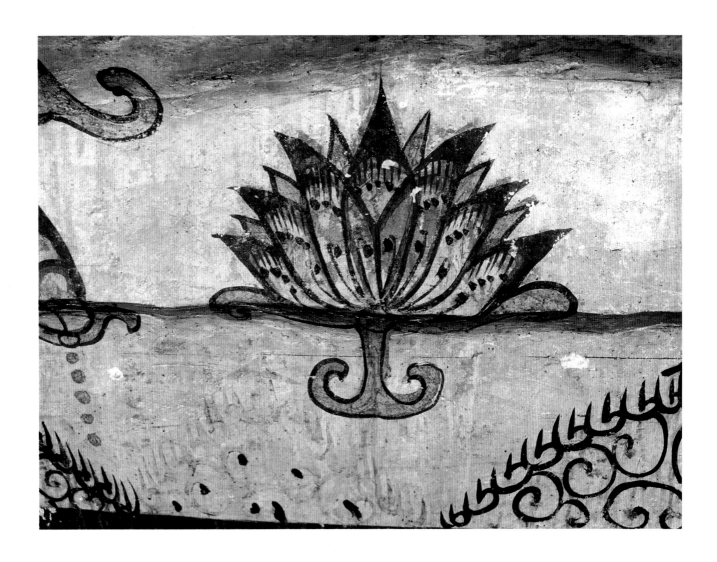

130.莲花图

高句丽（4世纪中叶）

高约40、宽约60厘米

1938年著录。吉林省集安市洞沟古墓群禹山墓区中部舞踊墓。原址保存。

墓向230°。藻井抹角石下的侧视复瓣莲花。

（撰文：傅佳欣、赵昕、林世香　摄影：苏楠、谷德平）

Lotus

Koguryo (Middle 4th c. CE)

Height ca. 40 cm; Width ca. 60 cm

Cataloged in 1938. Wuyong (Dancing) Tomb at the Yushan Cemetery of Donggou Tomb Cluster in Ji'an, Jilin. Preserved on the original site.

◀ **131.环纹图案**

高句丽（5世纪）

壁高160厘米

1938年著录。吉林省集安市洞沟古墓群下解放墓区南端环纹墓。原址保存。

墓向240°。四隅影作黄褐色木构柱枋，上绘墨色蟠虬纹。主壁皆彩绘连续的圆环图案，东、北、西壁上下分五排，每排五环，排环相错。圆环自外向内分为七色：黑、暗红、浅蓝、黄、蓝、紫，黄色圆心。应为仿织锦图案。

（撰文：傅佳欣、赵昕、林世香　摄影：谷德平）

Circle Designs

Koguryo (5th c. CE)

Height 160 cm

Cataloged in 1938. Huanwen (Circle Designs) Tomb at the Xiajiefang Cemetery of Donggou Tomb Cluster in Ji'an, Jilin. Preserved on the original site.

▼ **132.斩俘图**

高句丽（5世纪）

高约100、宽约120厘米

1938年著录。吉林省集安市洞沟古墓群禹山墓区中部马槽墓。原址保存。

墓向262°。并列两墓同封，此系北墓南壁壁画局部。画面中间为骑马武士，带兜鍪，执戟，正在策马刺杀。其人、马均着披甲，鞍座上系有飘动的长旒。武士之后，有形体稍小二人，亦头戴兜鍪，身披铠甲，一站一跪。站立者正举刀欲砍身前的跪俘。此应是墓主人生活经历写照。

（撰文：傅佳欣、赵昕、林世香　摄影：苏楠、谷德平）

Beheading Prisoner

Koguryo (5th c. CE)

Height ca. 100 cm; Width ca. 120 cm

Cataloged in 1938. Macao (stable) Tomb at the Yushan Cemetery of Donggou Tomb Cluster in Ji'an, Jilin. Preserved on the original site.

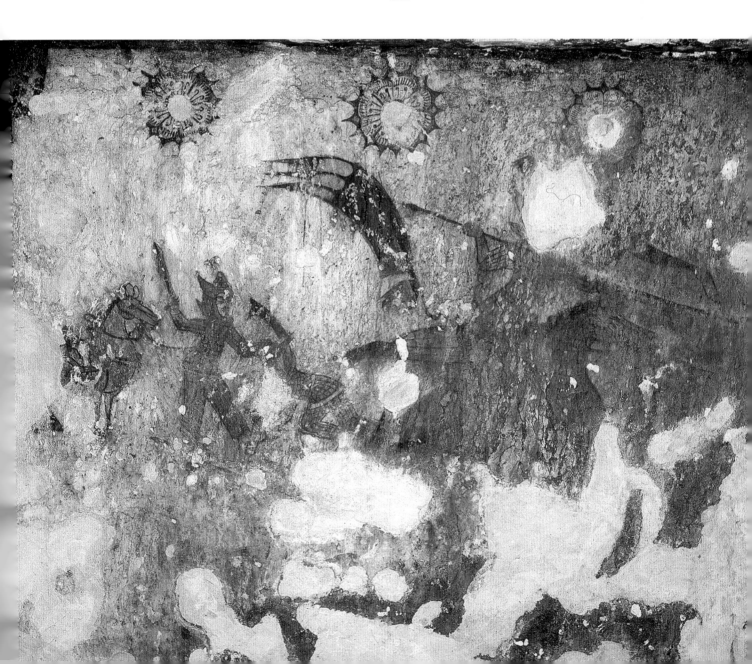

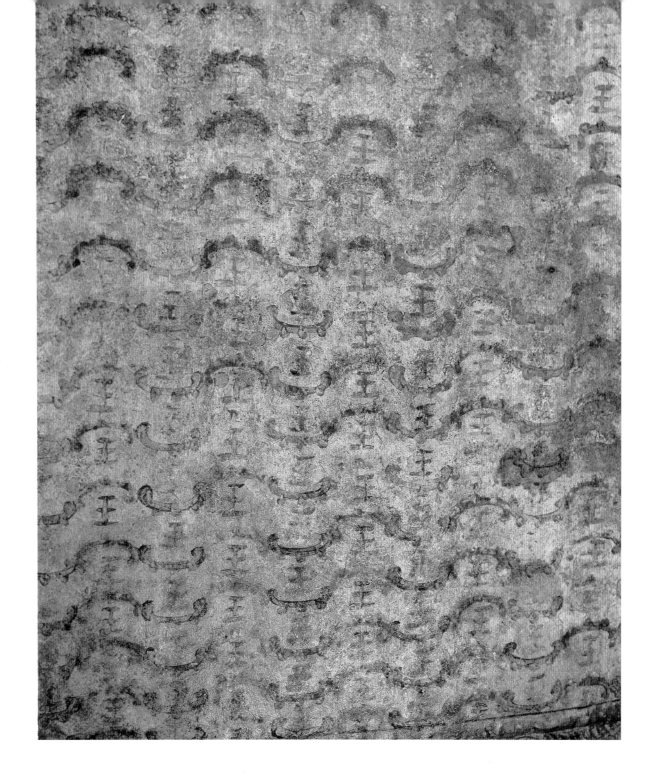

133. 西壁壁画

高句丽（5世纪）

高约30、宽约60厘米

1966年吉林省集安市洞沟古墓群山城下墓区王字墓出土。原址保存。

墓向150°。墓室主壁所绘"王"字图案应象征织锦。王字间有波浪状蟠虬纹相隔，波峰暗红色，波谷及王字为绿色。

<div align="right">（撰文：傅佳欣、赵昕、林世香　摄影：苏楠、谷德平）</div>

Mural on the West Wall of the Tomb Chamber

Koguryo (5th c. CE)

Height ca. 30 cm; Width ca. 60 cm

Vnearthed from Wang "王" (king) Tomb at the Shanchengxia Cemetery of Donggou Tomb Cluster in Ji'an, Jilin, in 1966. Preserved on the original site.

134.出行图

高句丽（6世纪）

高50、宽约280厘米

1938年著录。吉林省集安市洞沟古墓群禹山墓区中部三室墓。原址保存。

墓向270°。局部遭盗揭破坏，此系三室墓一室北壁墓主人出行图。十一人的出行队列，自帷帐高屋下出行。前有男侍领路，次为男主人、女主人，其后有男侍五人、女侍三人，或执伞，或拱手，一字西行。下方为狩猎场景，仅存放鹰人。

（撰文：傅佳欣、赵昕、林世香　摄影：苏楠、谷德平）

Procession Scene

Koguryo (6th c. CE)

Height 50 cm; Width ca. 280 cm

Cataloged in 1938. Three-chambered Tomb at the Yushan Cemetery of Donggou Tomb Cluster in Ji'an, Jilin. Preserved on the original site.

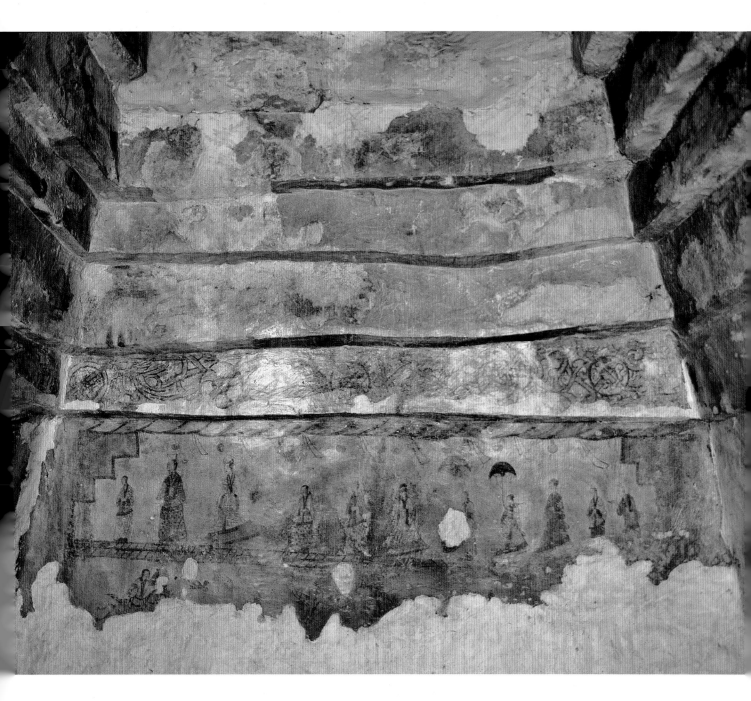

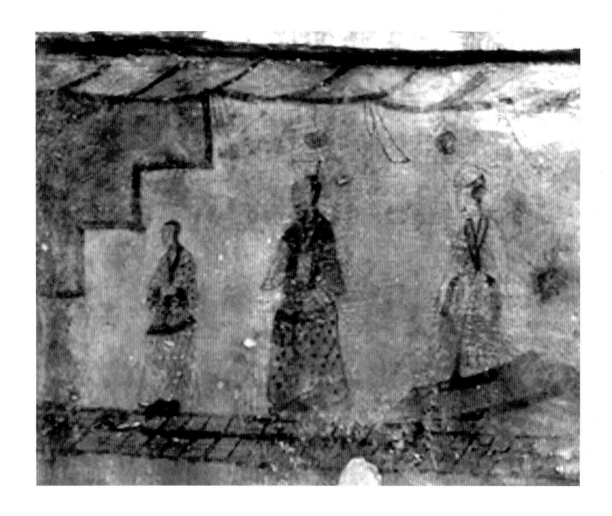

135. 出行图（局部）

高句丽（6世纪）

高约80、宽约80厘米

1938年著录。吉林省集安市洞沟古墓群禹山墓区中部三室墓。原址保存。

墓向270°。第一室出行图局部。前方为引路侍者，着花衣肥筩，袖手伫立。其后为男主人，穿左衽短衣，肥筩，头戴折风弁，蓄短髭，双手自然置胸前。其后为女主人，头带软帽，着左衽宽袖短袍，花长裙，袖手跟随。

（撰文：傅佳欣、赵昕、林世香　摄影：苏楠、谷德平）

Procession Scene (Detail)

Koguryo (6th c. CE)

Height ca. 80 cm; Width ca. 80 cm

Cataloged in 1938. Three-chambered Tomb at the Yushan Cemetery of Donggou Tomb Cluster in Ji'an, Jilin. Preserved on the original site.

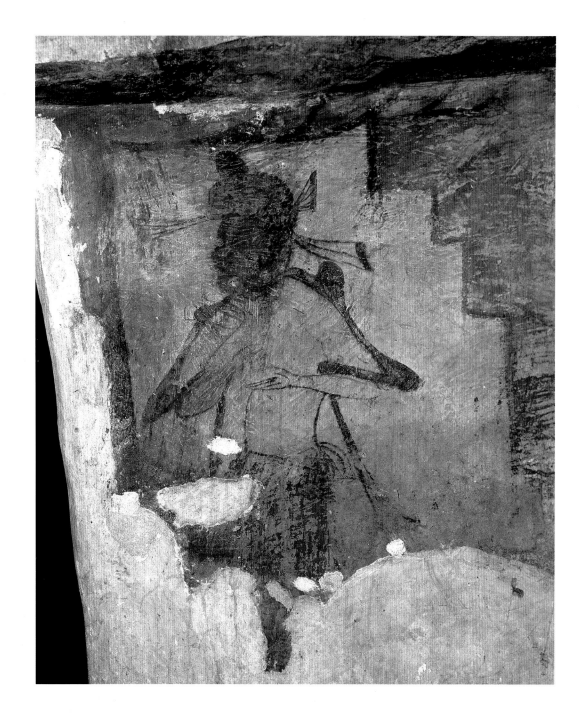

136.门吏图

高句丽（6世纪）

高约100、宽约80厘米

1938年著录。吉林省集安市洞沟古墓群禹山墓区中部三室墓。原址保存。

墓向270°。此为第一室正门西侧门吏。头缚巾带，双手执物于胸前，肩披丝带绕过小臂，腰亦系带，面门而立。脱色较甚。

（撰文：傅佳欣、赵昕、林世香　摄影：苏楠、谷德平）

Door Guardian

Koguryo (6th c. CE)

Height ca. 100 cm; Width ca. 80 cm

Cataloged in 1938. Three-chambered Tomb at the Yushan Cemetery of Donggou Tomb Cluster in Ji'an, Jilin. Preserved on the original site.

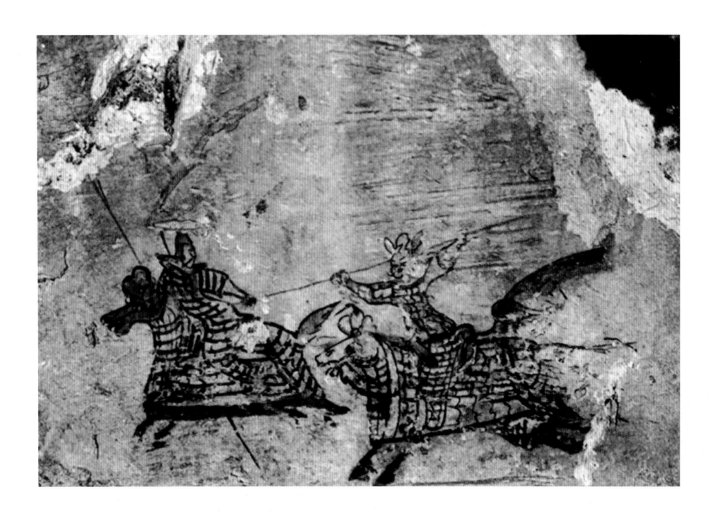

137.攻城图

高句丽（6世纪）

高约30、宽约40厘米

1938年著录。吉林省集安市洞沟古墓群禹山墓区中部三室墓。原址保存。

墓向270°。第一室攻城画面局部，此系攻城战斗的骑战场面。两重铠骑士各执长矛，一人收矛败走，一人挺矛追逐。此画上方，还有二人徒手格斗画面。

（撰文：傅佳欣、赵昕、林世香　摄影：引自《通沟》1938年）

City Attacking

Koguryo (6th c. CE)

Height ca. 30 cm; Width ca. 40 cm

Cataloged in 1938. Three-chambered Tomb at the Yushan Cemetery of Donggou Tomb Cluster in Ji'an, Jilin. Preserved on the original site.

138. 力士图（一）

高句丽（6世纪）

高150、宽211厘米

1938年著录。吉林省集安市洞沟古墓群禹山墓区中部三室墓。原址保存。

墓向270°。第二室东壁通壁高的托梁力士。束发为髻，青面，短髭，着紫色短袖上衣，圆领，系腰。衣服有数条飘带似羽衣，蹲踞状，双手反腕托梁，上承绘有双玄武的梁枋。脚下两侧各有蛇和双头蛇。

<div align="right">（撰文：傅佳欣、赵昕、林世香　摄影：苏楠、谷德平）</div>

Guardian Dvarapala (1)

Koguryo (6th c. CE)

Height 150 cm; Width 211 cm

Cataloged in 1938. Three-chambered Tomb at the Yushan Cemetery of Donggou Tomb Cluster in Ji'an, Jilin. Preserved on the original site.

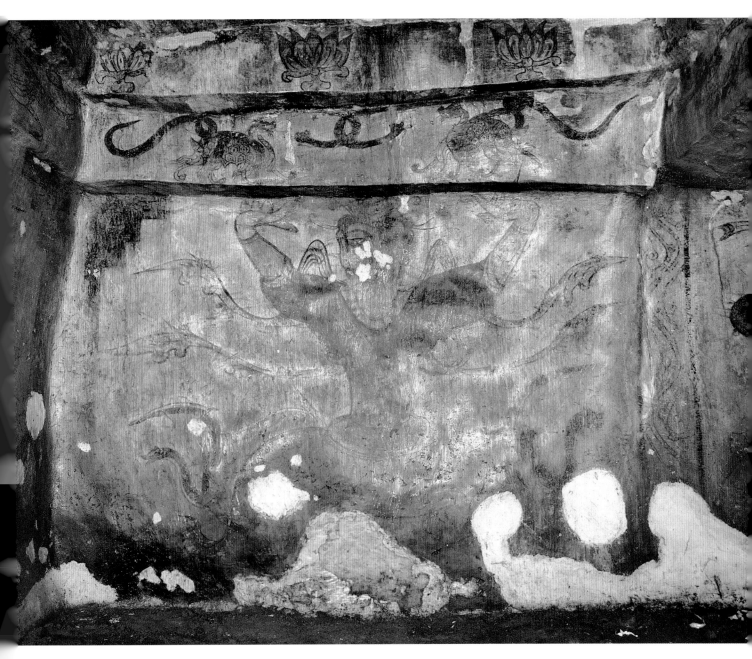

139. 力士图（二）

高句丽（6世纪）

高150、宽293厘米

1938年著录。吉林省集安市洞沟古墓群禹山墓区中部三室墓。原址保存。

墓向270°。第二室南壁托梁力士。黑色发髻，黄面，短髭，着黄色短身锦衣，袖口饰莲瓣，黄裤，束腰带。蹲踞，双手托梁。

<div align="right">（撰文：傅佳欣、赵昕、林世香　摄影：苏楠、谷德平）</div>

Guardian Dvarapala (2)

Koguryo (6th c. CE)

Height 150 cm; Width 293 cm

Cataloged in 1938. Three-chambered Tomb at the Yushan Cemetery of Donggou Tomb Cluster in Ji'an, Jilin. Preserved on the original site.

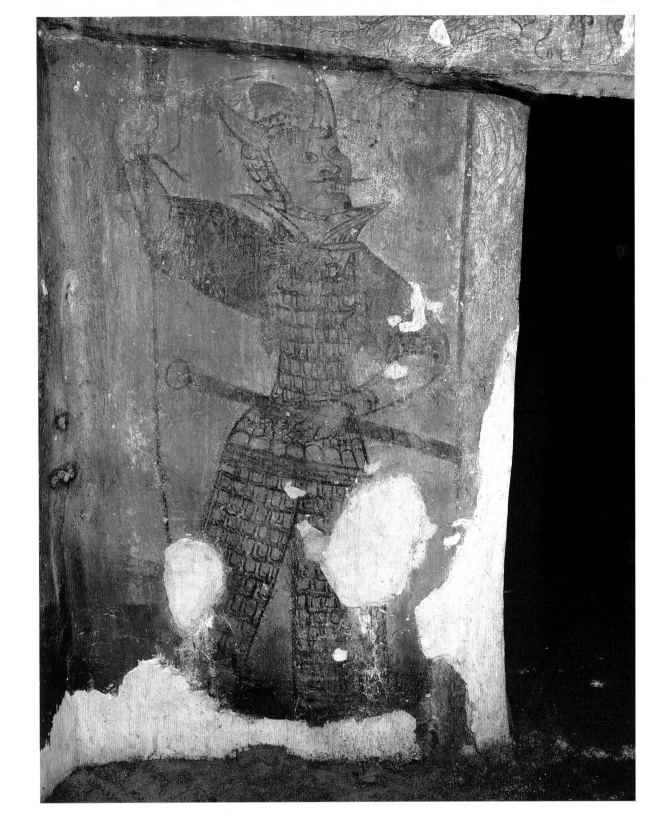

140. 铠甲武士图

高句丽（6世纪）

高约150、宽约120厘米

1938年著录。吉林省集安市洞沟古墓群禹山墓区中部三室墓。原址保存。

墓向270°。第二室西壁守门武士。略侧身面向北甬道，身着短袖甲衣、长甲裤，横髭，双目圆睁，头盔外露三个角或角饰。右手高挂长矛，左手执环首腰刀，足蹬钉履，分腿站立。此画面已被盗揭所破坏。

（撰文：傅佳欣、赵昕、林世香　摄影：苏楠、谷德平）

Armoured Warrior

Koguryo (6th c. CE)

Height ca. 150 cm; Width ca. 120 cm

Cataloged in 1938. Three-chambered Tomb at the Yushan Cemetery of Donggou Tomb Cluster in Ji'an, Jilin. Preserved on the original site.

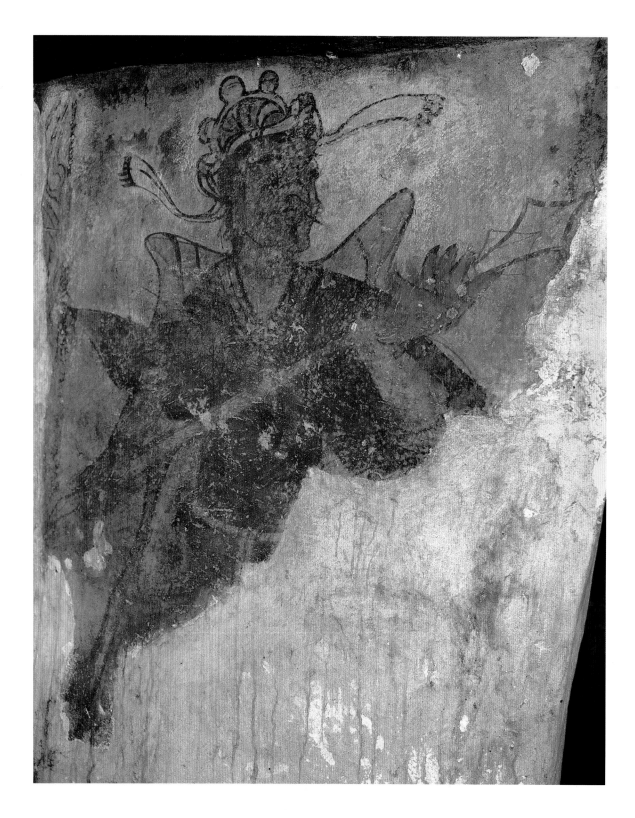

141.武士图

高句丽（6世纪）

高约90、宽约60厘米

1938年著录。吉林省集安市洞沟古墓群禹山墓区中部三室墓。原址保存。

墓向270°。第二室南门东侧守门武士。略侧身面向甬道，头裹巾帻，穿红色短袖上衣，系腰带。双手握墓戟。

（撰文：傅佳欣、赵昕、林世香　摄影：苏楠、谷德平）

Door Guardian

Koguryo (6th c. CE)

Height ca. 90 cm; Width ca. 60 cm

Cataloged in 1938. Three-chambered Tomb at the Yushan Cemetery of Donggou Tomb Cluster in Ji'an, Jilin. Preserved on the original site.

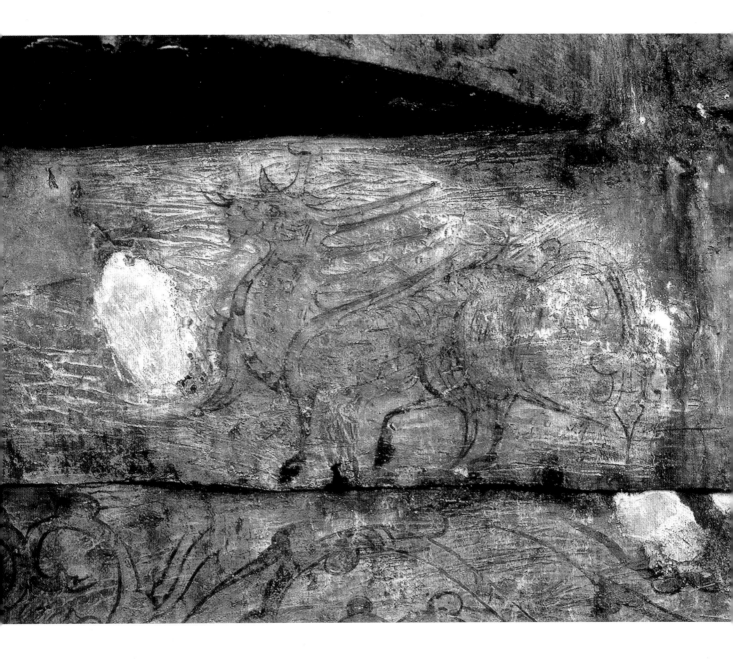

142. 神兽图（一）

高句丽（6世纪）

高约30、宽约40厘米

1938年著录。吉林省集安市洞沟古墓群禹山墓区中部三室墓。原址保存。

墓向270°。第二室北藻井绘类獬豸形状。鹿身，头上有独角，虬状尾，项背及后腿有长鬃。

<div align="right">（撰文：傅佳欣、赵昕、林世香　摄影：苏楠、谷德平）</div>

Mythical Animal (1)

Koguryo (6th c. CE)

Height ca. 30 cm; Width ca. 40 cm

Cataloged in 1938. Three-chambered Tomb at the Yushan Cemetery of Donggou Tomb Cluster in Ji'an, Jilin. Preserved on the original site.

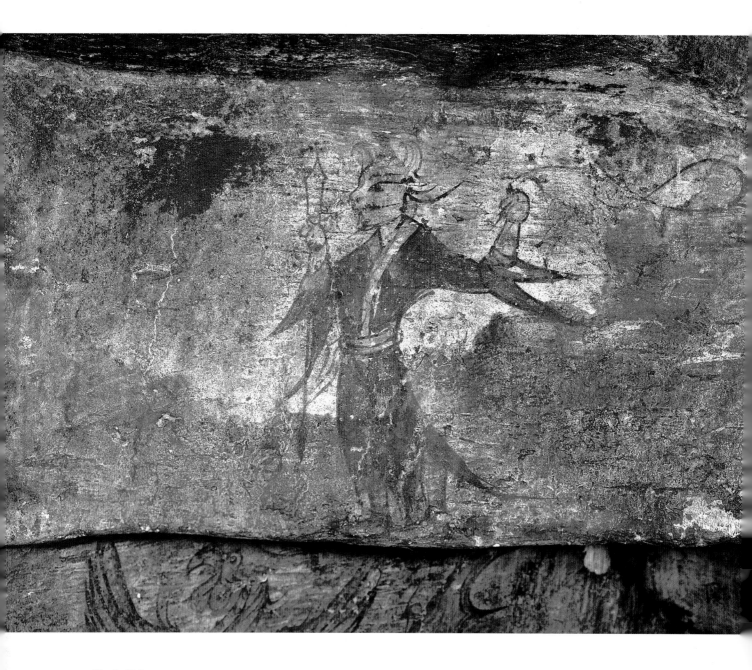

143.仙人图

高句丽（6世纪）

高约20、宽约30厘米

1938年著录。吉林省集安市洞沟古墓群禹山墓区中部三室墓。原址保存。

墓向270°。第二室藻井抹角石红衣仙人形象。头上有三个弯角，着右衽红袍，侧身，右手柱棨戟，左手上举，束腰。

（撰文：傅佳欣、赵昕、林世香　摄影：苏楠、谷德平）

Immortal

Koguryo (6th c. CE)

Height ca. 20 cm; Width ca. 30 cm

Cataloged in 1938. Three-chambered Tomb at the Yushan Cemetery of Donggou Tomb Cluster in Ji'an, Jilin. Preserved on the original site.

144. 神兽图（二）

高句丽（6世纪）

高约40、宽约50厘米

1938年著录。吉林省集安市洞沟古墓群禹山墓区中部三室墓。原址保存。

墓向270°。第二室藻井神鹿形象。红色，身上间有白点，昂首站立，项背有鬃毛。

<div align="right">（撰文：傅佳欣、赵昕、林世香　摄影：苏楠、谷德平）</div>

Mythical Animal (2)

Koguryo (6th c. CE)

Height ca. 40 cm; Width ca. 50 cm

Cataloged in 1938. Three-chambered Tomb at the Yushan Cemetery of Donggou Tomb Cluster in Ji'an, Jilin. Preserved on the original site.

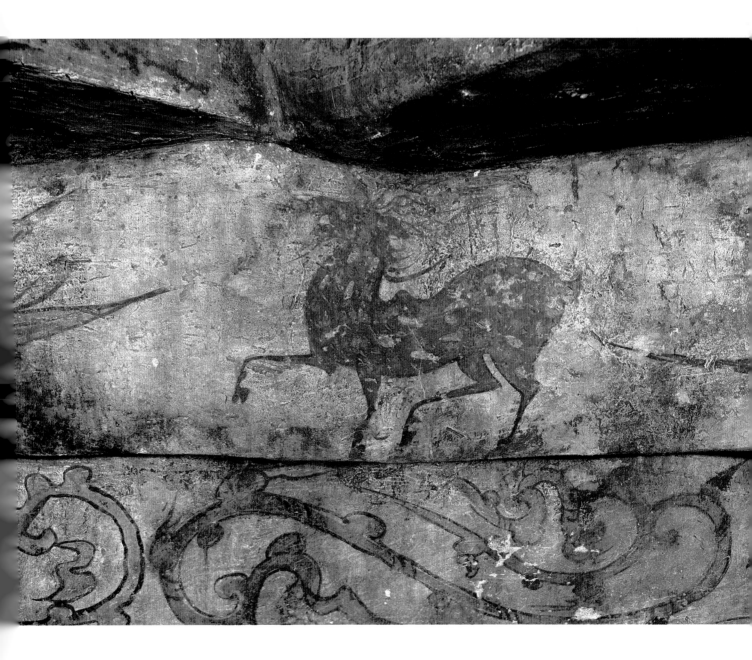

145.伎乐仙人

高句丽（6世纪）

高约40、宽约50厘米

1938年著录。吉林省集安市洞沟古墓群禹山墓区中部三室墓。原址保存。

墓向270°。第二室藻井抹角石相背飞翔的两个仙人。左边为吹角仙人，右边为弹阮仙人，均着长袍飘带，跣足。弹阮仙人似有头光。

<div align="right">（撰文：傅佳欣、赵昕、林世香　摄影：苏楠、谷德平）</div>

Immortal Musicians

Koguryo (6th c. CE)

Height ca. 40 cm; Width ca. 50 cm

Cataloged in 1938. Three-chambered Tomb at the Yushan Cemetery of Donggou Tomb Cluster in Ji'an, Jilin. Preserved on the original site.

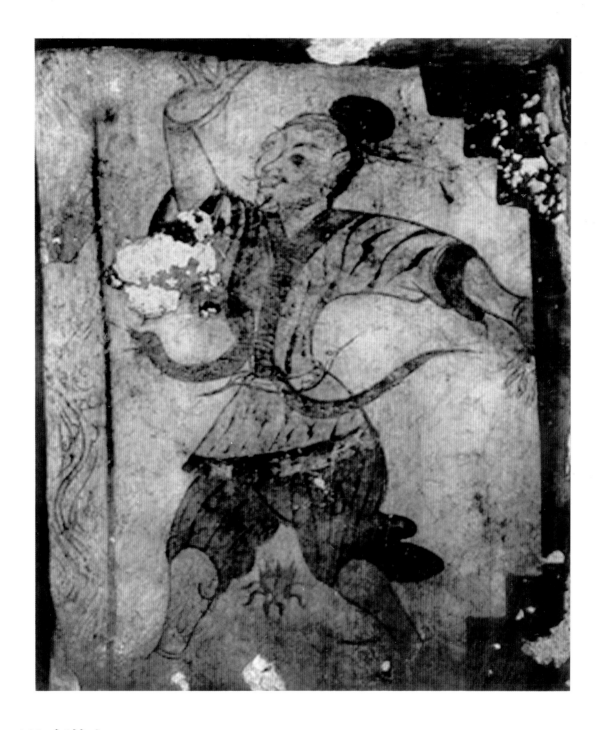

146. 舞蛇人

高句丽（6世纪）

高约90、宽约70厘米

1938年著录。吉林省集安市洞沟古墓群禹山墓区中部三室墓。原址保存。

墓向270°。第三室东壁舞蛇人形象。侧身面北行走，昂首圆目，短髭，圆髻，上着紧袖黄短衣，下着红短裤，跣足。右手托梁，左手撑柱，颈上搭蛇舞于胸前。叉腿空间有一朵莲花。

（撰文：傅佳欣、赵昕、林世香　摄影：引自《通沟》1938年）

Dancer Holding a Snake

Koguryo (6th c. CE)

Height ca. 90 cm; Width ca. 70 cm

Cataloged in 1938. Three-chambered Tomb at the Yushan Cemetery of Donggou Tomb Cluster in Ji'an, Jilin. Preserved on the original site.

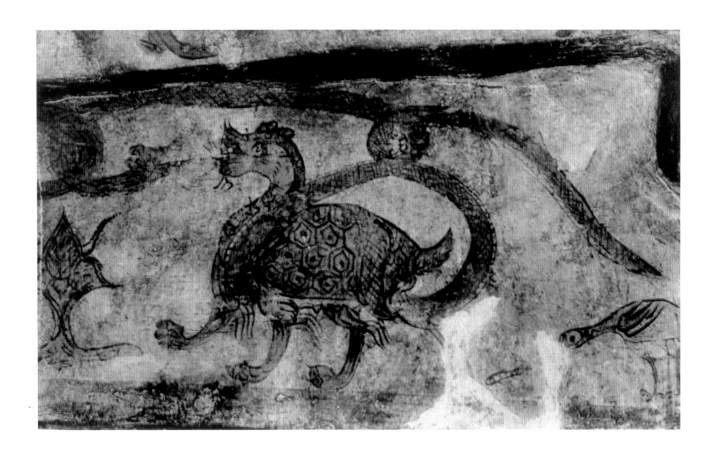

147. 玄武

高句丽（6世纪）

高约20、宽约50厘米

1938年著录。吉林省集安市洞沟古墓群禹山墓区中部三室墓。原址保存。

墓向270°。第三室东梁枋所绘两个玄武之一。龟蛇缠绕，两头相向，龟板花纹为六角形，绿色，长足。

（撰文：傅佳欣、赵昕、林世香　摄影：引自《通沟》1938年）

Sombre Warrior

Koguryo (6th c. CE)

Height ca. 20 cm; Width ca. 50 cm

Cataloged in 1938. Three-chambered Tomb at the Yushan Cemetery of Donggou Tomb Cluster in Ji'an, Jilin. Preserved on the original site.

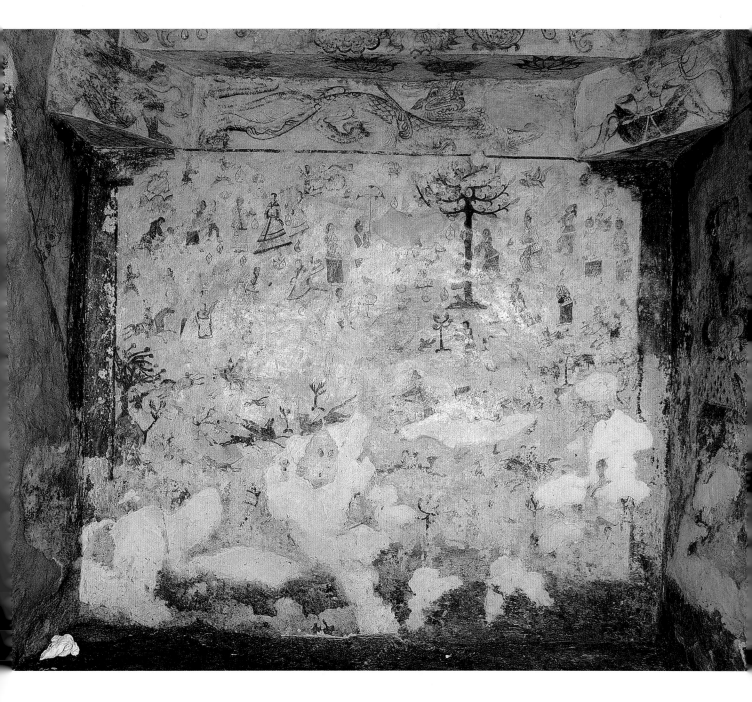

148. 墓前室北壁壁画

高句丽（6世纪）

高189、宽237厘米

1970年吉林省集安市洞沟古墓群长川墓区长川1号墓出土。原址保存。

墓向233°。此系前室北壁重要而丰富的高句丽风俗画面。左上至右上为百戏、角抵、跳丸、戏猴及观赏人物。左中为墓主人郊游享乐场景。下方是全景式的狩猎场面，自左至右为猎熊、猎豕、猎虎、猎鹿、猎貂、猎雉等，猎人有徒步、有埋伏、有骑乘、有纵鹰……局部被盗揭破坏。

（撰文：傅佳欣、赵昕、林世香　摄影：苏楠、谷德平）

Mural on the North Wall of the Front Chamber

Koguryo (6th c. CE)

Height 189 cm; Width 237 cm

Unearthed from Tomb No.1 of Changchuan at the Changchuan Cemetery of Donggou Tomb Cluster in Ji'an, Jilin, in 1970. Preserved on the original site.

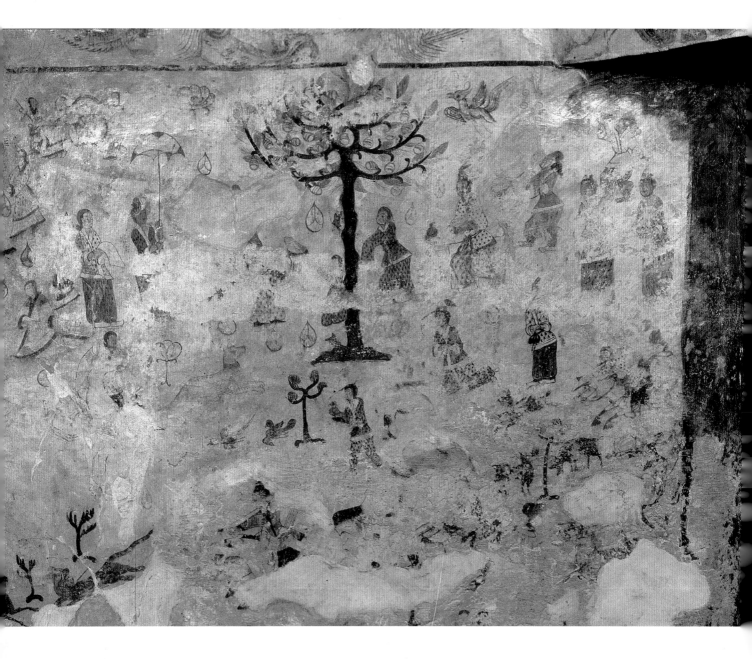

149. 游乐图

高句丽（6世纪）

高约80、宽约90厘米

1970年吉林省集安市洞沟古墓群长川墓区长川1号墓出土。原址保存。

墓向233°。前室北壁右上部百戏游乐场面局部。上有表演跳丸者，正抛球丸于空中，旁有观者。左边树上有项系绳索的猕猴正在下树，戏者在树下等候。旁边有坐在凳上的观者和立、跪侍者。

<div align="right">（撰文：傅佳欣、赵昕、世香　摄影：苏楠、谷德平）</div>

Acrobatics Playing Scene

Koguryo (6th c. CE)

Height ca. 80 cm; Width ca. 90 cm

Unearthed from Tomb No.1 of Changchuan at the Changchuan Cemetery of Donggou Tomb Cluster in Ji'an, Jilin, in 1970. Preserved on the original site.

150.男主仆图

高句丽（6世纪）

高约80、宽约100厘米

1970年吉林省集安市洞沟古墓群长川墓区长川1号墓出土。原址保存。

墓向233°。前室北壁中部墓主人安坐在梧桐树左侧的黄色高凳上。环周侍者六人，卧犬一只。侍女有执伞、捧巾、跪侍、抚琴等，表明主人地位之尊。

（撰文：傅佳欣、赵昕、林世香　摄影：苏楠、谷德平）

Master and Attendants

Koguryo (6th c. CE)

Height ca. 80 cm; Width ca. 100 cm

Unearthed from Tomb No.1 of Changchuan at the Changchuan Cemetery of Donggou Tomb Cluster in Ji'an, Jilin, in 1970. Preserved on the original site.

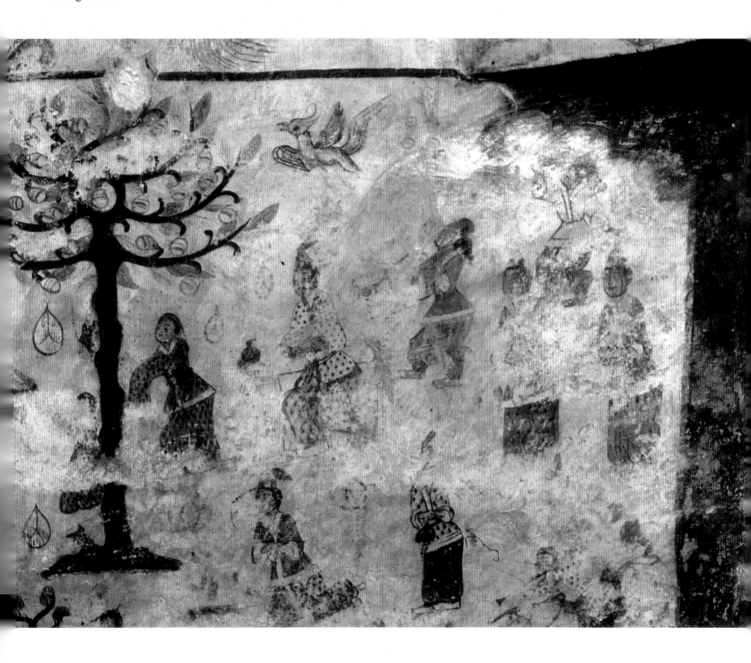

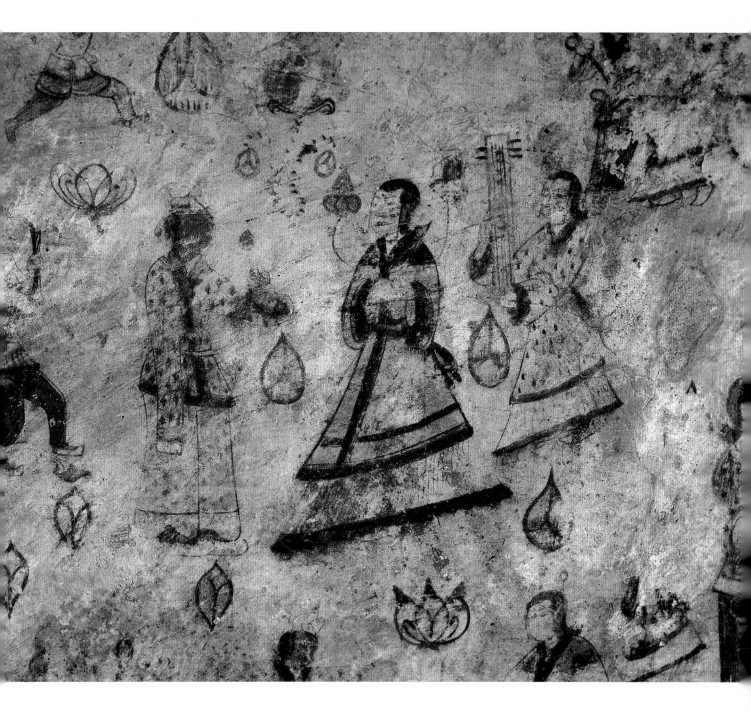

151.女主仆图

高句丽（6世纪）

高约50、宽约50厘米

1970年吉林省集安市洞沟古墓群长川墓区长川1号墓出土。原址保存。

墓向233°。前室北壁左上女主人出游场面。中间女主人穿高领长裙，袖手缓行；前有穿短衣肥筲女侍，正单手奉物。后边为捧竖琴侍女，着长裙，据琴轴知为五弦琴。

（撰文：傅佳欣、赵昕、林世香　摄影：苏楠、谷德平）

Hostess and Maids

Koguryo (6th c. CE)

Height ca. 50 cm; Width ca. 50 cm

Unearthed from Tomb No.1 of Changchuan at the Changchuan Cemetery of Donggou Tomb Cluster in Ji'an, Jilin, in 1970. Preserved on the original site.

152.狩猎人

高句丽（6世纪）

高约30、宽约40厘米

1970年吉林省集安市洞沟古墓群长川墓区长川1号墓出土。原址保存。

墓向233°。前室北壁狩猎场景局部，放鹰者手执鹰鹞，正在捕雉，前方已有一鹰飞向猎物。

<div align="right">（撰文：傅佳欣、赵昕、林世香　摄影：苏楠、谷德平）</div>

Hunter

Koguryo (6th c. CE)

Height ca. 30 cm; Width ca. 40 cm

Unearthed from Tomb No.1 of Changchuan at the Changchuan Cemetery of Donggou Tomb Cluster in Ji'an, Jilin, in 1970. Preserved on the original site.

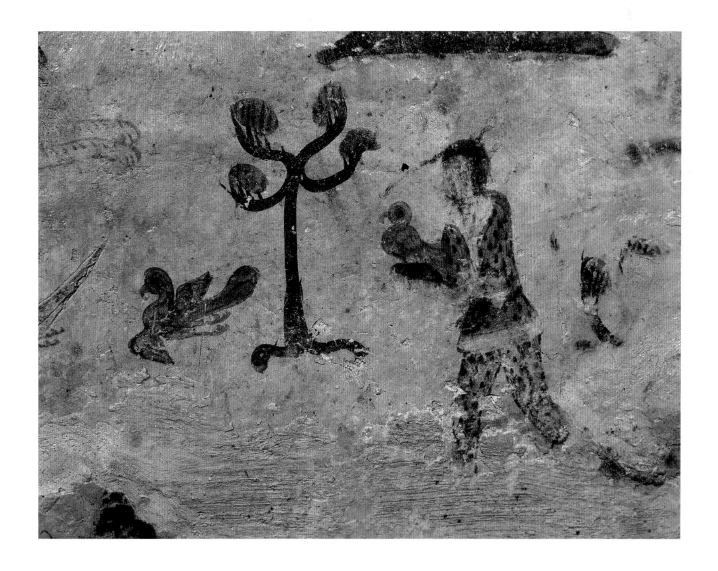

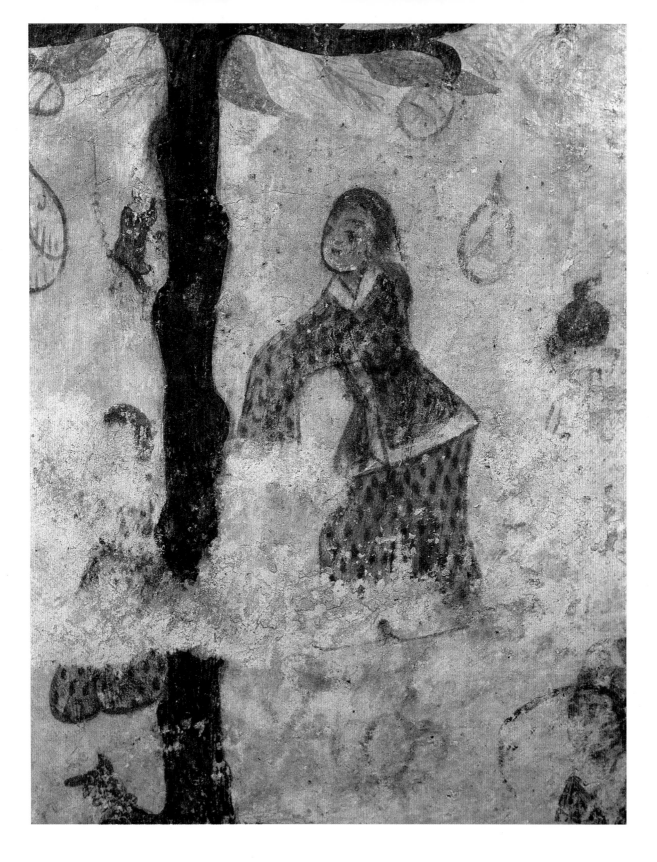

153. 戏猴人

高句丽（6世纪）

高约50、宽约30厘米

1970年吉林省集安市洞沟古墓群长川墓区长川1号墓出土。原址保存。墓向233°。前室北壁百戏图局部。戏猴者为男装女性，穿绿色长袖短花衣，花裤。仰脸微侧，双手正待接回树上的猕猴。

（撰文：傅佳欣、赵昕、林世香　摄影：苏楠、谷德平）

Dancer with a Monkey

Koguryo (6th c. CE)

Height ca. 50 cm; Width ca. 30 cm

Unearthed from Tomb No.1 of Changchuan at the Changchuan Cemetery of Donggou Tomb Cluster in Ji'an, Jilin, in 1970. Preserved on the original site.

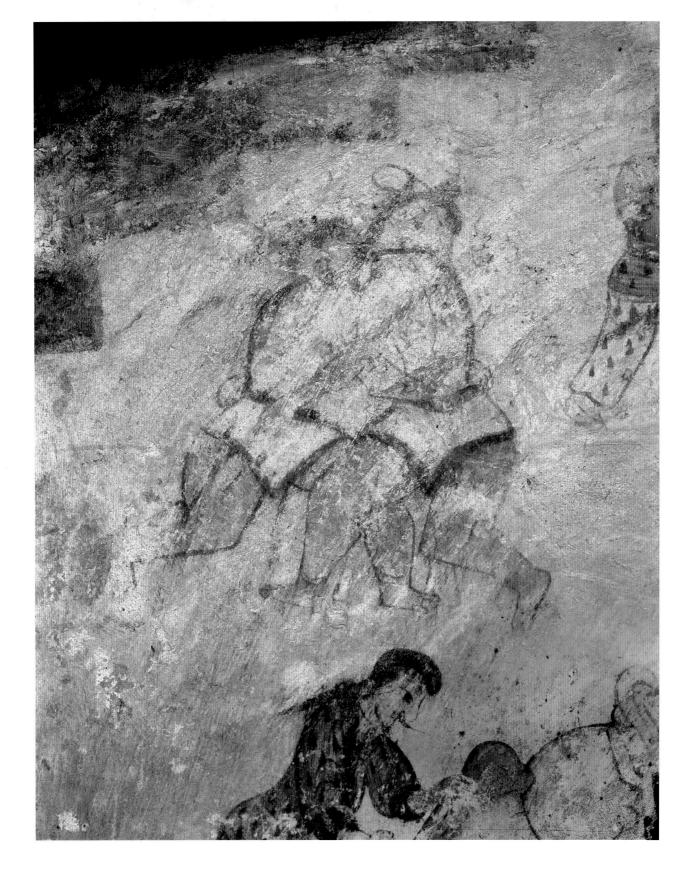

154. 角抵图

高句丽（6世纪）

高约60、宽约40厘米

1970年吉林省集安市洞沟古墓群长川墓区长川1号墓出土。原址保存。墓向233°。前室北壁左上角百戏游玩场景局部。两裸身力士相搏。

（撰文：傅佳欣、赵昕、林世香　摄影：苏楠、谷德平）

Wrestling Scene

Koguryo (6th c. CE)

Height ca. 40 cm; Width ca. 60 cm

Unearthed from Tomb No.1 of Changchuan at the Changchuan Cemetery of Donggou Tomb Cluster in Ji'an, Jilin, in 1970. Preserved on the original site.

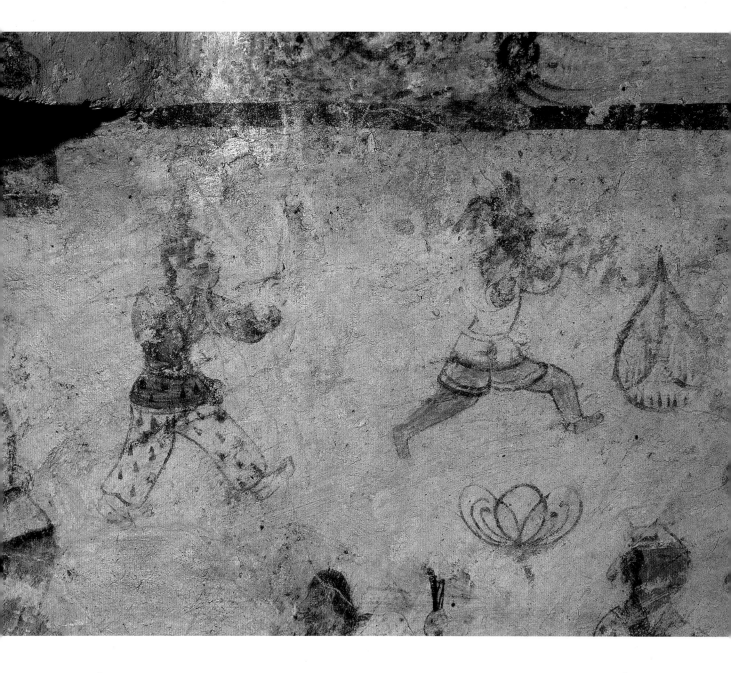

155.追逐图

高句丽（6世纪）

高约30、宽约40厘米

1970年吉林省集安市洞沟古墓群长川墓区长川1号墓出土。原址保存。

墓向233°。前室北壁左上百戏局部。二人相逐，似自由搏击游戏。追者左手握小棒顶物而行，逸者着短衣短裤，正跨步疾奔。

（撰文：傅佳欣、赵昕、林世香　摄影：谷德平）

Chasing Game

Koguryo (6th c. CE)

Height ca. 30 cm; Width ca. 40 cm

Unearthed from Tomb No.1 of Changchuan at the Changchuan Cemetery of Donggou Tomb Cluster in Ji'an, Jilin, in 1970. Preserved on the original site.

156. 猎豕图

高句丽（6世纪）

高约40、宽约50厘米

1970年吉林省集安市洞沟古墓群长川墓区长川1号墓出土。原址保存。

墓向233°。前室北壁左侧狩猎场景局部，一猎人手执长矛蓄势于胸前，对准后臀中箭奔来的野猪头部。猎者戴头饰，着红短衣，束腰。

（撰文：傅佳欣、赵昕、林世香　摄影：谷德平）

Hunting Boar

Koguryo (6th c. CE)

Height ca. 40 cm; Width ca. 50 cm

Unearthed from Tomb No.1 of Changchuan at the Changchuan Cemetery of Donggou Tomb Cluster in Ji'an, Jilin, in 1970. Preserved on the original site.

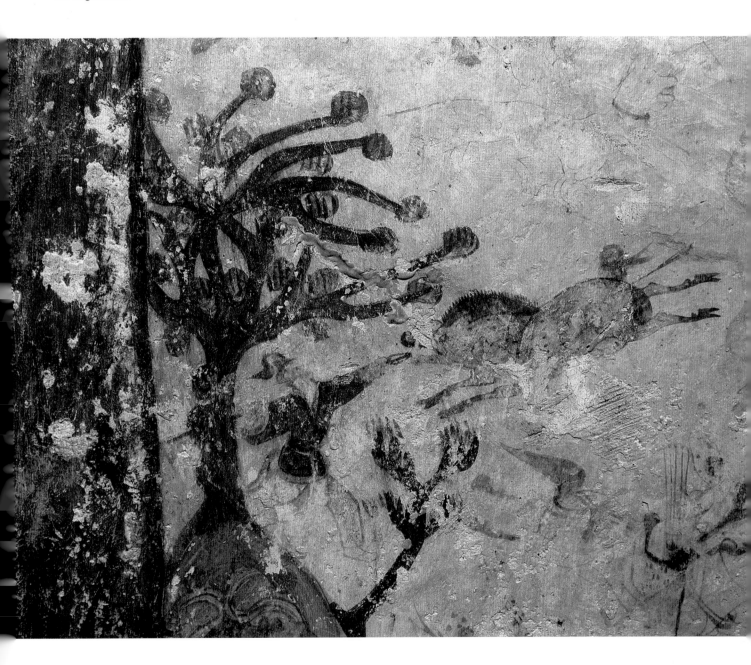

157. 舞蹈图

高句丽（6世纪）

高约40、宽约40厘米

1970年吉林省集安市洞沟古墓群长川墓区长川1号墓出土。原址保存。

墓向233°。前室南壁家居图中的观舞场景，三男子均戴折风弁，穿短衣肥裤，袖手，正躬身观看舞蹈。舞蹈为群舞，可见末后一舞女：着花短衣，肥裤，作翘臀甩袖动作。

<div align="right">（撰文：傅佳欣、赵昕、林世香　摄影：谷德平）</div>

Dancing

Koguryo (6th c. CE)

Height ca. 40 cm; Width ca. 40 cm

Unearthed from Tomb No.1 of Changchuan at the Changchuan Cemetery of Donggou Tomb Cluster in Ji'an, Jilin, in 1970. Preserved on the original site.

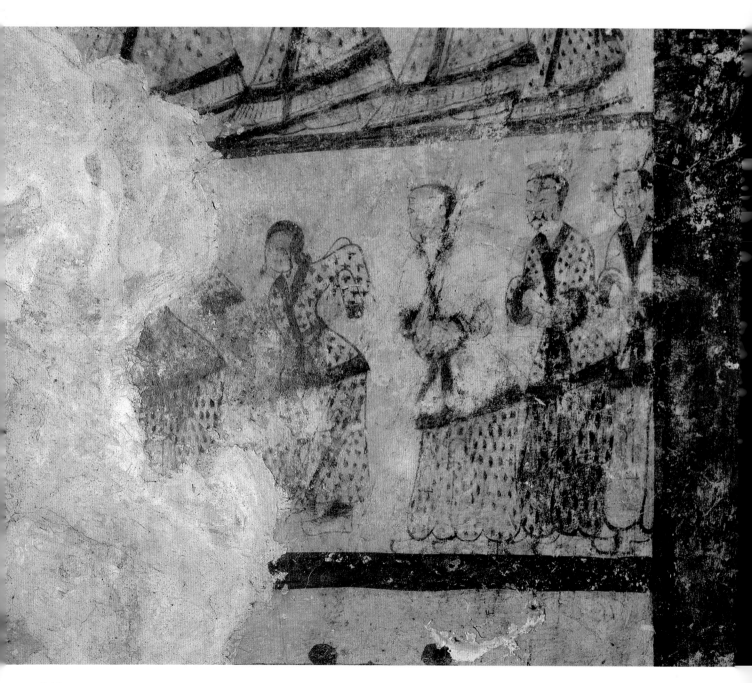

158. 菩萨像

高句丽（6世纪）

高约60、宽约140厘米

1970年吉林省集安市洞沟古墓群长川墓区长川1号墓出土。原址保存。

墓向233°。前室北藻井绘四尊菩萨立像，菩萨均有短髭，脚踏莲台，头后有背光，菩萨间绘祥云。两侧为莲花化生。

（撰文：傅佳欣、赵昕、林世香　摄影：苏楠、谷德平）

Bodhisattvas

Koguryo (6th c. CE)

Height ca. 60 cm; Width ca. 140 cm

Unearthed from Tomb No.1 of Changchuan at the Changchuan Cemetery of Donggou Tomb Cluster in Ji'an, Jilin, in 1970. Preserved on the original site.

159. 前室藻井（北侧）

高句丽（6世纪）

藻井高140厘米，下宽237厘米

1970年吉林省集安市洞沟古墓群长川墓区长川1号墓出土。原址保存。

墓向233°。佛、道题材画面。梁枋绘青龙，此四神布局与传统意义上的方位神不同，大概因墓道西向，因背向墓室设计之故。一层藻井绘四尊菩萨立像，菩萨有短髭，宽衣褒带，脚踏莲台，头后有背光。菩萨两侧为化生，二层绘飞天，抹角石绘托梁力士。

（撰文：傅佳欣、赵昕、林世香　摄影：谷德平）

North Side of the Caisson in the Front Chamber

Koguryo (6th c. CE)

Height 140 cm, Bottom width 237 cm

Unearthed from Tomb No.1 of Changchuan at the Changchuan Cemetery of Donggou Tomb Cluster in Ji'an, Jilin, in 1970. Preserved on the original site.

160.莲花化生图

高句丽（6世纪）

高约30、宽约40厘米

1970年吉林省集安市洞沟古墓群长川墓区长川1号墓出土。原址保存。

墓向233°。前室藻井东北壁侧视八瓣莲花花蕊处，绘两个童子头像，均有背光。

（撰文：傅佳欣、赵昕、林世香　摄影：苏楠、谷德平）

Upapaduka (Birth by Transformation) in Lotus

Koguryo (6th c. CE)

Height ca. 30 cm; Width ca. 40 cm

Unearthed from Tomb No.1 of Changchuan at the Changchuan Cemetery of Donggou Tomb Cluster in Ji'an, Jilin, in 1970. Preserved on the original site.

161. 力士图

高句丽（6世纪）

高约30、宽约40厘米

1970年吉林省集安市洞沟古墓群长川墓区长川1号墓出土。原址保存。

墓向233°。前室藻井抹角石托梁力士之一。肥头大耳，短髭，龇牙睁目，坐姿，赤膊，体毛浓重。手脚叉开，分别托梁和撑地。

<div align="right">（撰文：傅佳欣、赵昕、林世香　摄影：苏楠、谷德平）</div>

Guardian Dvarapala

Koguryo (6th c. CE)

Height ca. 30 cm; Width ca. 40 cm

Unearthed from Tomb No.1 of Changchuan at the Changchuan Cemetery of Donggou Tomb Cluster in Ji'an, Jilin, in 1970. Preserved on the original site.

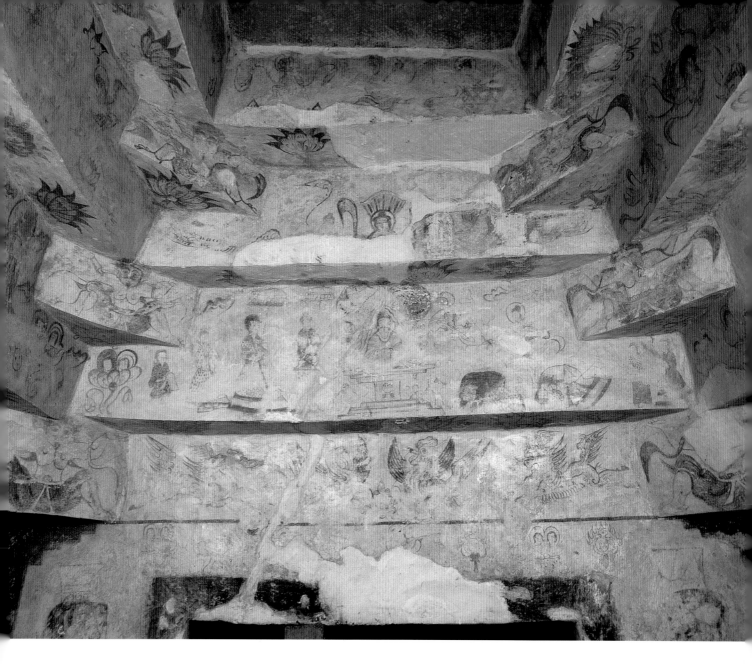

162.前室藻井（东侧）

高句丽（6世纪）

藻井高140厘米，下宽237厘米

1970年吉林省集安市洞沟古墓群长川墓区长川1号墓出土。原址保存。

墓向233°。佛、道题材。梁枋绘朱雀和狮子、瑞兽，一层藻井东壁绘礼佛图：男女二人跪在佛前行叩礼。佛像结跏趺坐于须弥座上，座下两侧各有一护法狮子，佛后有俗家男女执伞恭侍。两边绘世俗人物各二，似等待主人礼毕。二层绘化生及莲花，抹角为托梁力士。

（撰文：傅佳欣、赵昕、林世香　摄影：苏楠、谷德平）

East Side of the Caisson Ceiling in the Front Chamber

Koguryo (6th c. CE)

Height 140 cm; Bottom width 237 cm

Unearthed from Tomb No.1 of Changchuan at the Changchuan Cemetery of Donggou Tomb Cluster in Ji'an, Jilin, in 1970. Preserved on the original site.

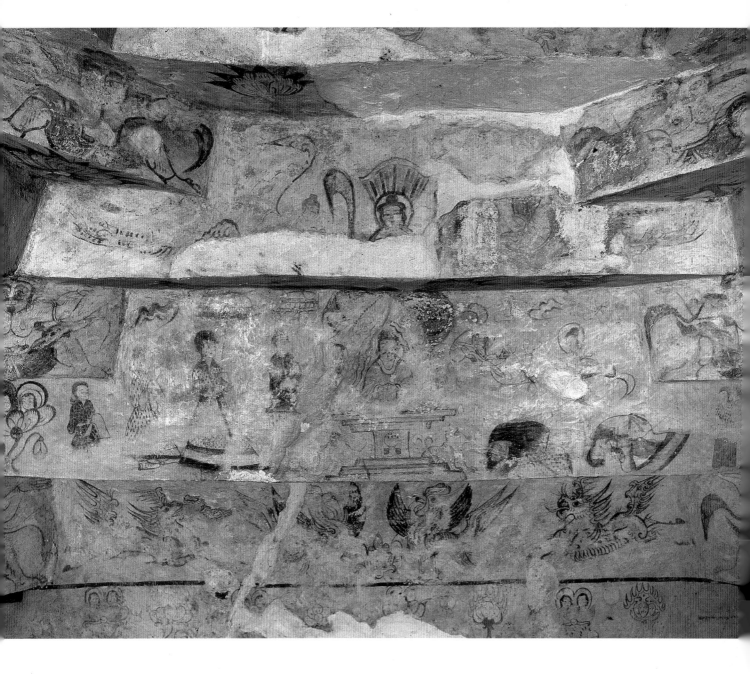

163.礼佛图

高句丽（6世纪）

高约80、宽约130厘米

1970年吉林省集安市洞沟古墓群长川墓区长川1号墓出土。原址保存。

墓向233°。前室藻井东壁第一层绘礼佛图：男女二人跪在佛前行叩礼。其跪姿如《三国志·高句丽传》所记"跪拜申一脚"。佛像结跏趺坐于须弥座上，座下两侧各有一护法狮子，佛像之后有世俗男女执伞侍立。两边又绘世俗人物各二。

<div style="text-align: right">（撰文：傅佳欣、赵昕、林世香　摄影：谷德平）</div>

Worshiping Buddha

Koguryo (6th c. CE)

Height ca. 80 cm; Width ca. 130 cm

Unearthed from Tomb No.1 of Changchuan at the Changchuan Cemetery of Donggou Tomb Cluster in Ji'an, Jilin, in 1970. Preserved on the original site.

164.神兽图

高句丽（6世纪）

高约40、宽约50厘米

1970年吉林省集安市洞沟古墓群长川墓区长川1号墓出土。原址保存。

墓向233°。前室东梁枋右侧神兽。兽身蹄足，张口吐舌，背有长棘，飞驰状。

<div align="right">（撰文：傅佳欣、赵昕、林世香　摄影：谷德平）</div>

Mythical Animal

Koguryo (6th c. CE)

Height ca. 40 cm; Width ca. 50 cm

Unearthed from Tomb No.1 of Changchuan at the Changchuan Cemetery of Donggou Tomb Cluster in Ji'an, Jilin, in 1970. Preserved on the original site.

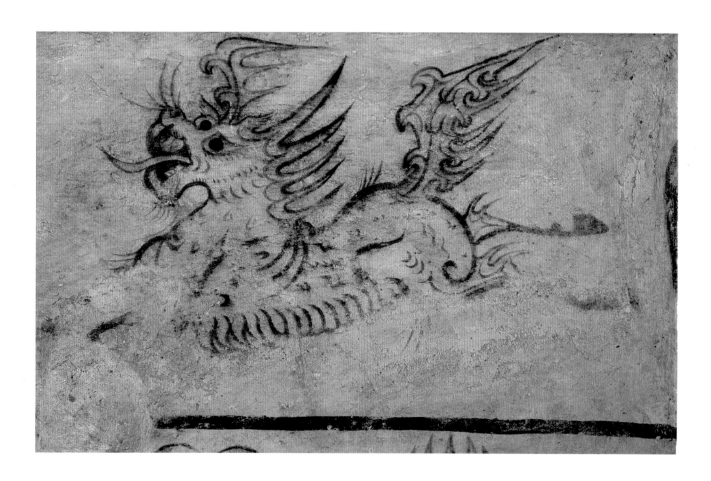

165. 墓室北壁壁画

高句丽（7世纪）

高192、宽420厘米

1938年发现，1962年吉林省集安市洞沟古墓群禹山墓区中部五盔坟4号墓出土。原址保存。

墓向150°，因并列五座封土墓之一得名。位于墓室北壁，绘四神之玄武。画面直接绘在墓室石壁上。中间为龟蛇缠绕，两头相向。环周地纹为花叶组成的网状莲花火焰，其中四个网状单元中有人物图像，其余单元中为莲叶、莲花。两隅为怪兽托龙顶梁。梁枋绘缠绕纠结的蟠龙。色彩艳丽。

<div style="text-align: right">（撰文：傅佳欣、赵昕、林世香　摄影：苏楠、谷德平）</div>

Mural on the North Wall of the Tomb Chamber

Koguryo (7th c. CE)

Height 192 cm; Width 420 cm

Discovered in 1938, unearthed from Wukuifen Tomb No.4 at the Yushan Cemetery of Donggou Tomb Cluster in Ji'an, Jilin, in 1962. Preserved on the original site.

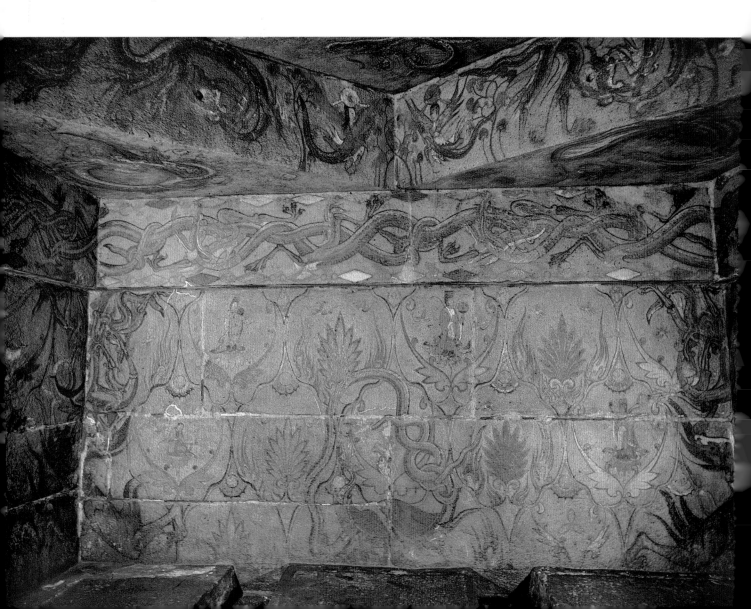

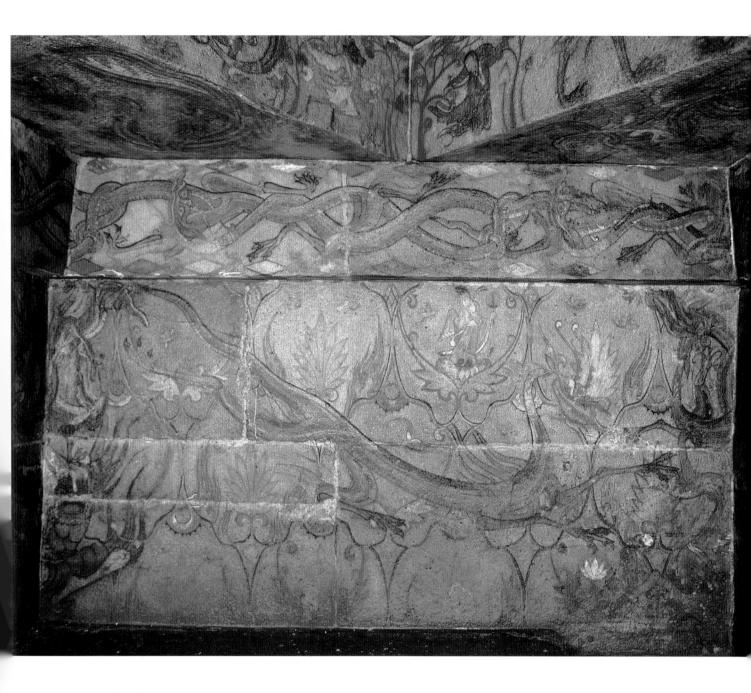

166.青龙图

高句丽（7世纪）

高192、宽368厘米

1938年发现，1962年吉林省集安市洞沟古墓群禹山墓区中部五盔坟4号墓出土。原址保存。

墓向150°。位于墓室东壁，为四神之青龙。张口吐舌飞腾向南，龙身有五色，以墨线勾成网状鳞片，颈部有彩色结环，细角，三趾。地纹为连续的莲花火焰网状，共14个单元，其中一个单元绘官服人物。其余为莲叶或莲花。两隅绘怪兽托龙顶梁。

（撰文：傅佳欣、赵昕、林世香　摄影：谷德平）

Green Dragon (East Wall)

Koguryo (7th c. CE)

Height 192 cm; Width 368 cm

Discovered in 1938, unearthed from Wukuifen Tomb No.4 at the Yushan Cemetery of Donggou Tomb Cluster in Ji'an, Jilin, in 1962. Preserved on the original site.

167.朱雀图

高句丽（7世纪）

高192、宽420厘米

1938年发现，1962年吉林省集安市洞沟古墓群禹山墓区中部五盔坟4号墓出土。原址保存。

墓向150°。位于墓室南壁，为四神之朱雀。因墓门偏东，故朱雀图像偏西。昂首向墓道方向，红色为主色，黄喙红胜，双翅展开，尾部较长。地纹亦为连续的莲花火焰网状，两个单元中有人物。两隅绘怪兽托龙顶梁。

<div align="right">（撰文：傅佳欣、赵昕、林世香　摄影：谷德平）</div>

Scarlet Bird (South Wall)

Koguryo (7th c. CE)

Height 192 cm; Width 420 cm

Discovered in 1938, unearthed from Wukuifen Tomb No.4 at the Yushan Cemetery of Donggou Tomb Cluster in Ji'an, Jilin, in 1962. Preserved on the original site.

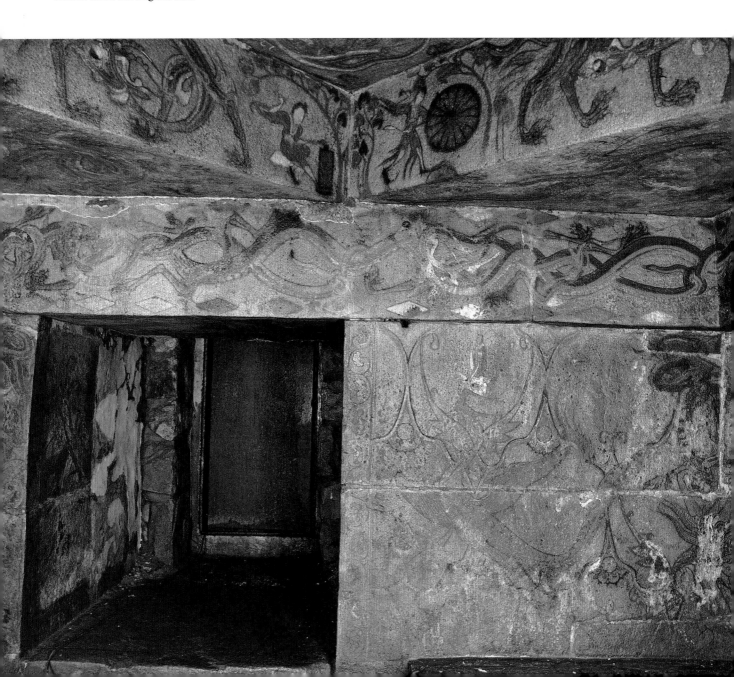

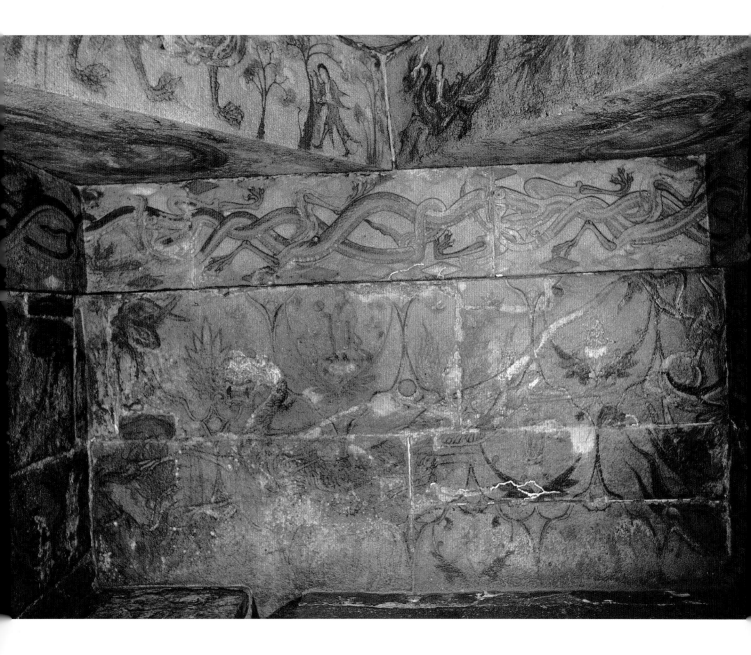

168.白虎图

高句丽（7世纪）

高192、宽368厘米

1938年发现，1962年吉林省集安市洞沟古墓群禹山墓区中部五盔坟4号墓出土。原址保存。

墓向150°。位于墓室西壁，为四神之白虎。虎身修长，头向南。躯干、腿和爪与龙相同，睁目张口，奔驰状斜贯整壁。地纹为莲花火焰网状单元，似龟甲状排列三层。其中三个单元中有人物，余皆莲叶或莲花。两隅为怪兽托龙顶梁。梁枋绘蟠龙。

（撰文：傅佳欣、赵昕、林世香　摄影：苏楠、谷德平）

White Tiger (West Wall)

Koguryo (7th c. CE)

Height 192 cm; Width 368 cm

Discovered in 1938, unearthed from Wukuifen Tomb No.4 at the Yushan Cemetery of Donggou Tomb Cluster in Ji'an, Jilin, in 1962. Preserved on the original site.

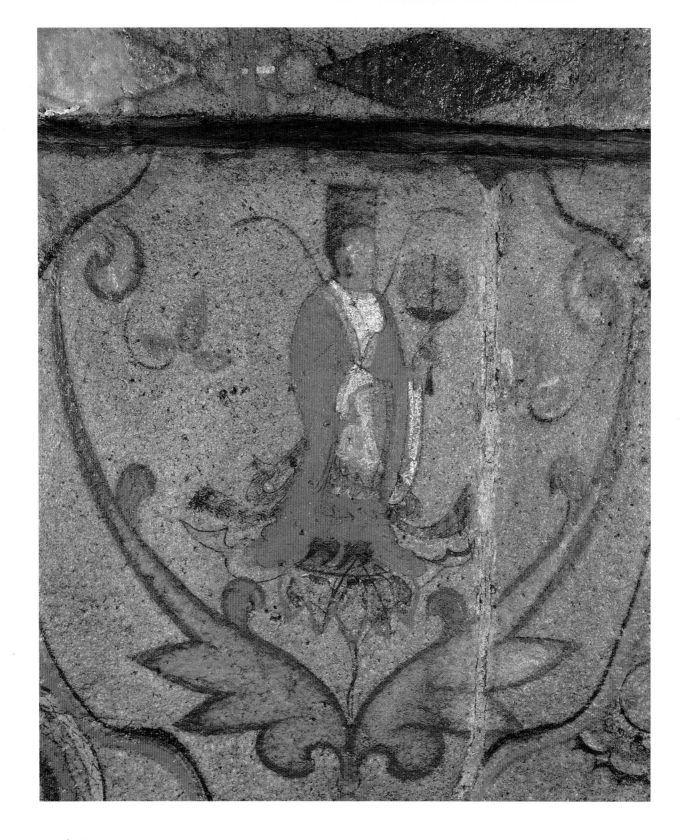

169. 官服仙人

高句丽（7世纪）

高约60、宽约50厘米

1938年发现，1962年吉林省集安市洞沟古墓群禹山墓区中部五盔坟4号墓出土。原址保存。

墓向150°。为北壁东数第二人，红袍官服人物。头戴乌纱冠，背后有对称的两条弯羽翅，着斜领宽袖红袍，左手执团扇，腰系带，登黑履，立于莲台上。

（撰文：傅佳欣、赵昕、林世香　摄影：谷德平）

Immortal in Official's Attire

Koguryo (7th c. CE)

Height ca. 60 cm; Width ca. 50 cm

Discovered in 1938, unearthed from Wukuifen Tomb No.4 at the Yushan Cemetery of Donggou Tomb Cluster in Ji'an, Jilin, in 1962. Preserved on the original site.

170. 执扇仙人

高句丽（7世纪）

高约50、宽约40厘米

1938年发现，1962年吉林省集安市洞沟古墓群禹山墓区中部五盔坟4号墓出土。
原址保存。

墓向150°。为北壁西数第二人，绿袍官服人物。头戴乌纱冠，俯首低视，着绿
色宽袖长袍，左手执团扇，右手推姿似说法，足登宽勾履，立于莲台上。

（撰文：傅佳欣、赵昕、林世香　摄影：谷德平）

Immortal Holding a Fan

Koguryo (7th c. CE)

Height ca. 50 cm; Width ca. 40 cm

Discovered in 1938, unearthed from Wu-kuifen Tomb No.4 at the Yushan Cemetery of Donggou Tomb Cluster in Ji'an, Jilin, in 1962. Preserved on the original site.

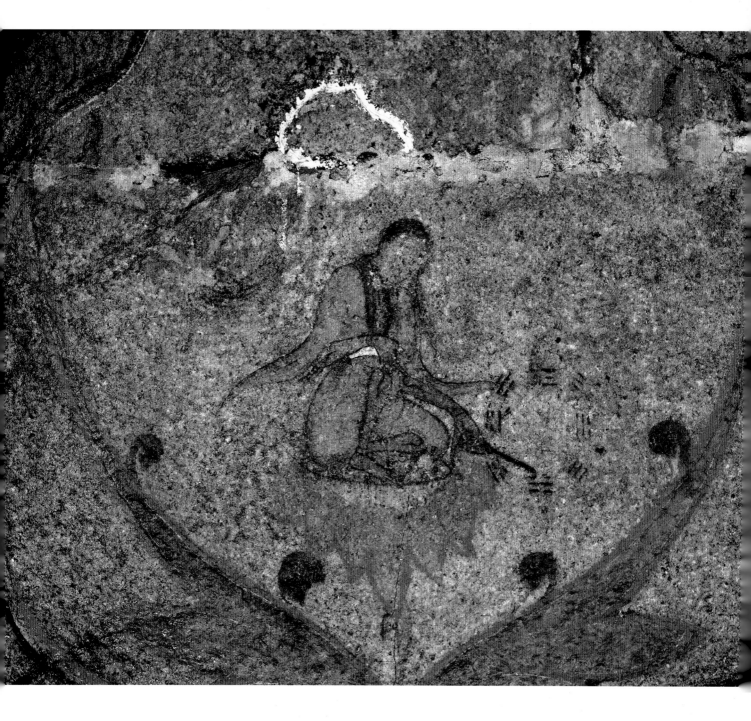

171. 卜卦仙人

高句丽（7世纪）

高约30、宽约20厘米

1938年发现，1962年吉林省集安市洞沟古墓群禹山墓区中部五盔坟4号墓出土。原址保存。

墓向150°。为北壁西数第一人，绿袍盘坐人物。披发低首，跣足，坐于莲台上，正在推演八卦。

（撰文：傅佳欣、赵昕、林世香　摄影：苏楠、谷德平）

Immortal in Divination

Koguryo (7th c. CE)

Height ca. 30 cm; Width ca. 20 cm

Discovered in 1938, unearthed from Wukuifen Tomb No.4 at the Yushan Cemetery of Donggou Tomb Cluster in Ji'an, Jilin, in 1962. Preserved on the original site.

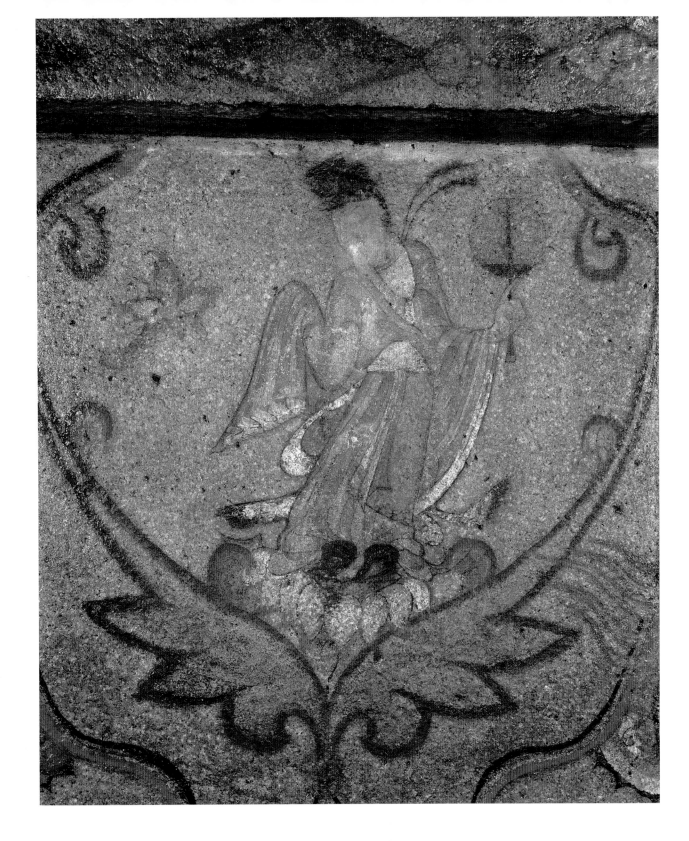

172. 仙人

高句丽（7世纪）

高约50、宽约60厘米

1938年发现，1962年吉林省集安市洞沟古墓群禹山墓区中部五盔坟4号墓出土。原址保存。

墓向150°。为东壁唯一的人物。头戴乌纱笼冠，着暗红、赭色拼条宽袖长袍，足登宽勾履，背插两羽尾，左手执扇，右手弯举藏于袖中，回身俯首，立于莲台上。

（撰文：傅佳欣、赵昕、林世香　摄影：苏楠、谷德平）

Immortal

Koguryo (7th c. CE)

Height ca. 50 cm; Width ca. 60 cm

Discovered in 1938, unearthed from Wukuifen Tomb No.4 at the Yushan Cemetery of Donggou Tomb Cluster in Ji'an, Jilin, in 1962. Preserved on the original site.

173.诵经仙人

高句丽（7世纪）

高约30、宽约20厘米

1938年发现，1962年吉林省集安市洞沟古墓群禹山墓区中部五盔坟4号墓出土。原址保存。

墓向150°。为北数第一人，赭袍跪坐诵经人物。着白领赭色长袍，束白带，右手执书，左手抚膝，跪坐于莲台上低首诵经。

（撰文：傅佳欣、赵昕、林世香　摄影：谷德平）

Immortal Chanting Scriptures

Koguryo (7th c. CE)

Height ca. 30 cm; Width ca. 20 cm

Discovered in 1938, unearthed from Wukuifen Tomb No.4 at the Yushan Cemetery of Donggou Tomb Cluster in Ji'an, Jilin, in 1962. Preserved on the original site.

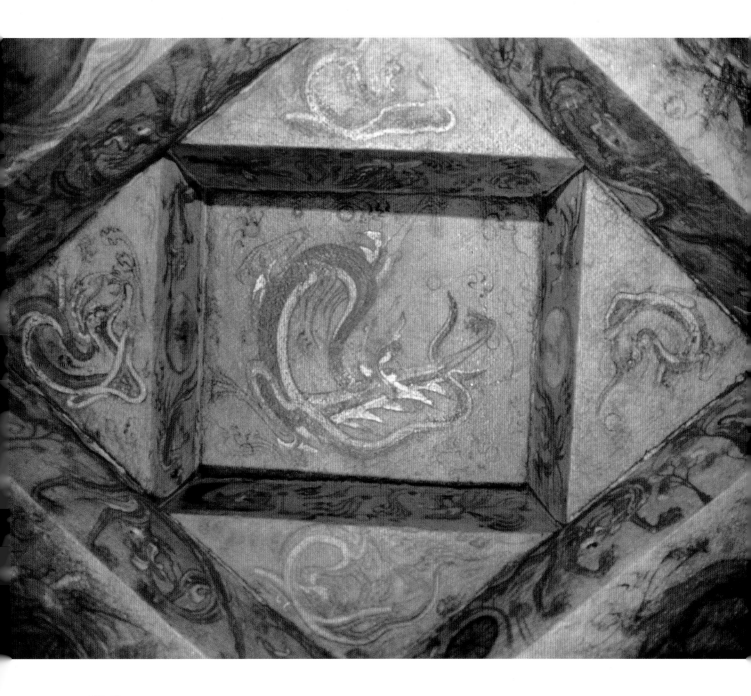

174.藻井

高句丽（7世纪）

高约140、宽约140厘米

1938年发现，1962年吉林省集安市洞沟古墓群禹山墓区中部五盔坟4号墓出土。原址保存。

墓向150°。为藻井盖顶石仰视。绘飞腾的蟠龙和流云、星斗。

<div align="right">（撰文：傅佳欣、赵昕、林世香　摄影：苏楠、谷德平）</div>

Caisson Ceiling

Koguryo (7th c. CE)

Height ca. 140 cm; Width ca. 140 cm

Discovered in 1938, unearthed from Wukuifen Tomb No.4 at the Yushan Cemetery of Donggou Tomb Cluster in Ji'an, Jilin, in 1962. Preserved on the original site.

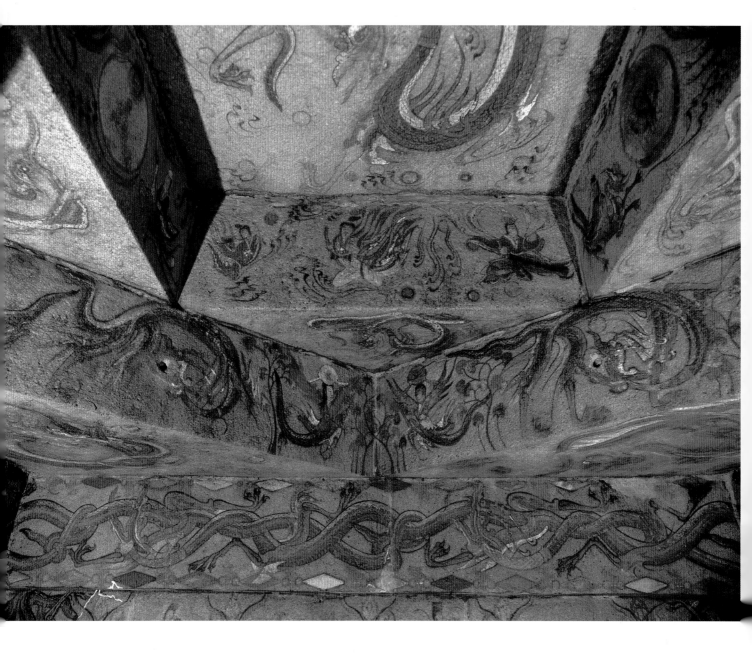

175.藻井（北侧）

高句丽（7世纪）

藻井高172厘米，下宽380厘米

1938年发现，1962年吉林省集安市洞沟古墓群禹山墓区中部五盔坟4号墓出土。原址保存。

墓向150°。位于藻井北面，抹角石、叠涩石、盖顶石合为藻井。砌石表面均有色彩艳丽的壁画。梁枋绘纠缠的蟠龙，砌石立面绘神仙、先贤、行龙，底面绘盘龙，其布局严谨，题材丰富，线条流畅，色彩新鲜依旧，堪称高句丽晚期壁画的巅峰之作。

（撰文：傅佳欣、赵昕、林世香　摄影：苏楠、谷德平）

North Side of the Caisson Ceiling

Koguryo (7th c. CE)

Height 172 cm; Bottom width 380 cm

Discovered in 1938, unearthed from Wukuifen Tomb No.4 at the Yushan Cemetery of Donggou Tomb Cluster in Ji'an, Jilin, in 1962. Preserved on the original site.

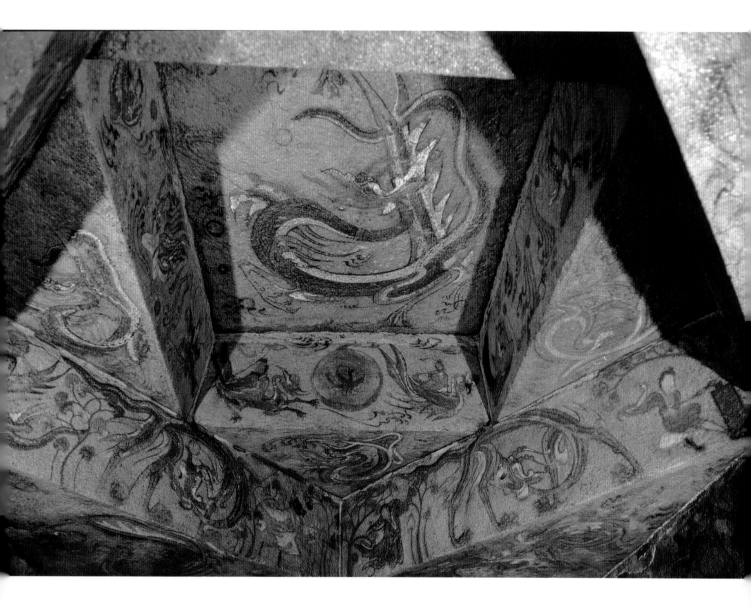

176. 藻井（东侧）

高句丽（7世纪）

藻井高172厘米，下宽360厘米

1938年发现，1962年吉林省集安市洞沟古墓群禹山墓区中部五盔坟4号墓出土。原址保存。

墓向150°。位于藻井东面。砌石表面均有色彩艳丽的壁画。梁枋绘纠缠的蟠龙，砌石立面绘神仙、先贤、行龙。

（撰文：傅佳欣、赵昕、林世香　摄影：苏楠、谷德平）

East Side of the Caisson Ceiling

Koguryo (7th c. CE)

Height 172 cm; Bottom width 360 cm

Discovered in 1938, unearthed from Wukuifen Tomb No.4 at the Yushan Cemetery of Donggou Tomb Cluster in Ji'an, Jilin, in 1962. Preserved on the original site.

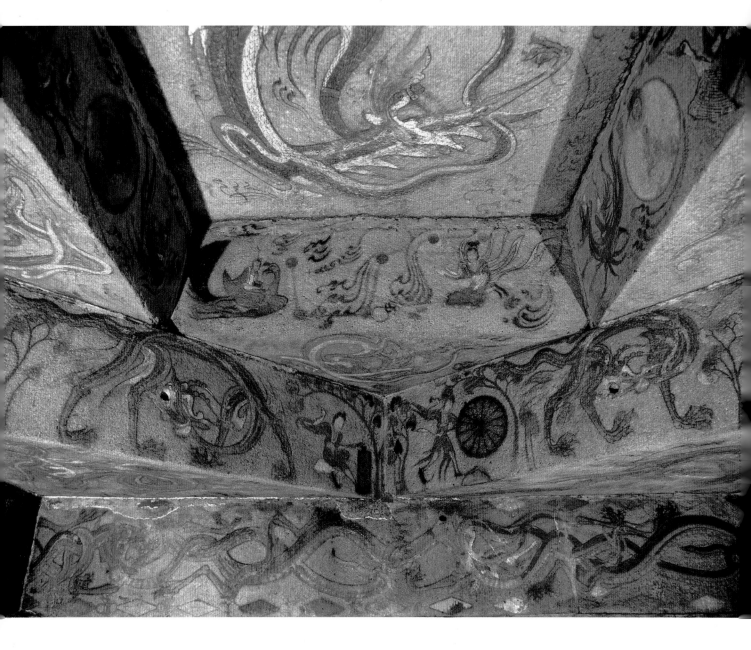

177.藻井（南侧）

高句丽（7世纪）

藻井高172厘米，下宽380厘米

1938年发现，1962年吉林省集安市洞沟古墓群禹山墓区中部五盔坟4号墓出土。原址保存。

墓向150°。位于藻井南面。砌石表面均有色彩艳丽的壁画。梁枋绘纠缠的蟠龙，砌石立面绘神仙、先贤、行龙。色彩艳丽。

（撰文：傅佳欣、赵昕、林世香　摄影：苏楠、谷德平）

South Side of the Caisson Ceiling

Koguryo (7th c. CE)

Height 172 cm; Bottom width 380 cm

Discovered in 1938, unearthed from Wukuifen Tomb No.4 at the Yushan Cemetery of Donggou Tomb Cluster in Ji'an, Jilin, in 1962. Preserved on the original site.

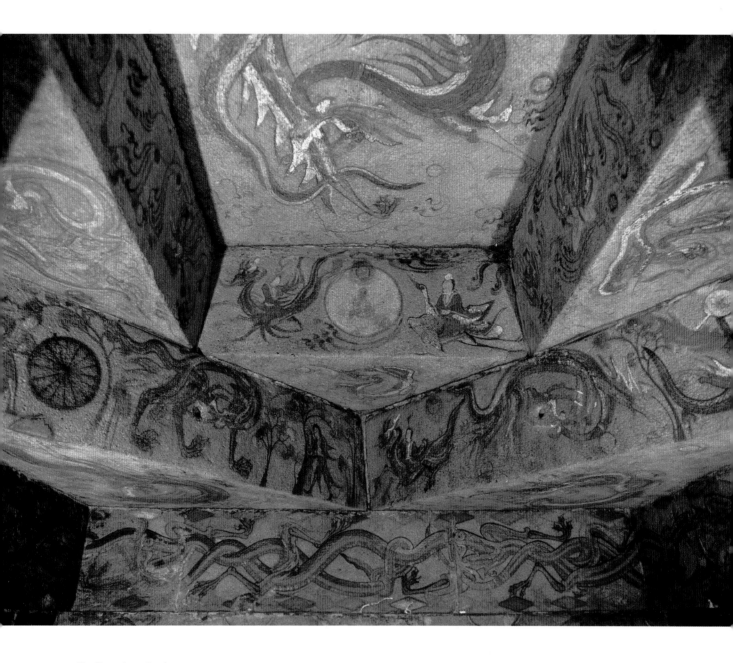

178.藻井（西侧）

高句丽（7世纪）

藻井高172厘米，下宽360厘米

1938年发现，1962年吉林省集安市洞沟古墓群禹山墓区中部五盔坟4号墓出土。原址保存。

墓向150°。位于藻井西面。砌石表面均有色彩艳丽的壁画。梁枋绘纠缠的蟠龙，砌石立面绘神仙、先贤、行龙等。

（撰文：傅佳欣、赵昕、林世香　摄影：苏楠、谷德平）

West Side of the Caisson Ceiling

Koguryo (7th c. CE)

Height 172 cm; Bottom width 360 cm

Discovered in 1938, unearthed from Wukuifen Tomb No.4 at the Yushan Cemetery of Donggou Tomb Cluster in Ji'an, Jilin, in 1962. Preserved on the original site.

179. 南抹角石上行龙

高句丽（7世纪）

高约80、宽约100厘米

1938年发现，1962年吉林省集安市洞沟古墓群禹山墓区中部五盔坟4号墓出土。原址保存。

墓向150°。为于南抹角石，为四条行龙之一。龙呈弓背回首行走状，龙身用五色，三趾，张口吐舌，口中残留凿孔，原有镶嵌物已失。

（撰文：傅佳欣、赵昕、林世香　摄影：苏楠、谷德平）

Flying Dragon on Southern Corner Stone

Koguryo (7th c. CE)

Height ca. 80 cm; Width ca. 100 cm

Discovered in 1938, unearthed from Wukuifen Tomb No.4 at the Yushan Cemetery of Donggou Tomb Cluster in Ji'an, Jilin, in 1962. Preserved on the original site.

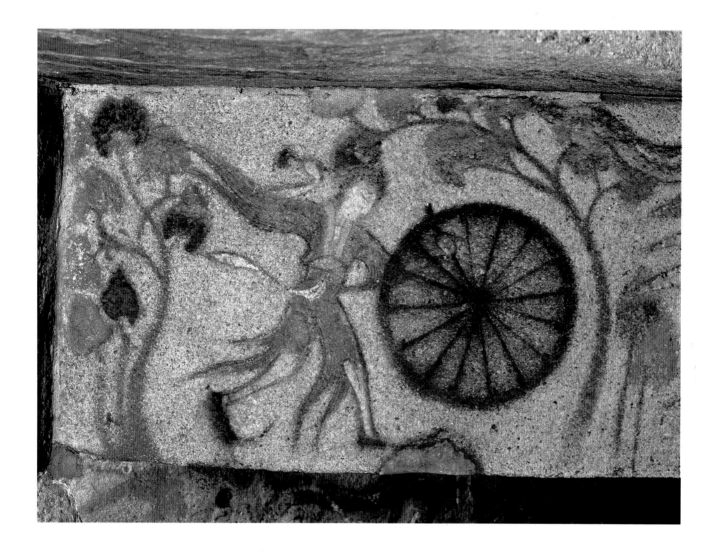

180.造车仙人

高句丽（7世纪）

高约60、宽约80厘米

1938年发现，1962年吉林省集安市洞沟古墓群禹山墓区中部五盔坟4号墓出土。原址保存。

墓向150°。位于南藻井西抹角石南端，为奚仲造车图像。又称制轮人，束发短髭，着青色羽衣，腰系白带，足穿墨色尖履，右手执锤，左手抚轮。

（撰文：傅佳欣、赵昕、林世香　摄影：苏楠、谷德平）

Cart-Making Immortal

Koguryo (7th c. CE)

Height ca. 60 cm; Width ca. 80 cm

Discovered in 1938, unearthed from Wukuifen Tomb No.4 at the Yushan Cemetery of Donggou Tomb Cluster in Ji'an, Jilin, in 1962. Preserved on the original site.

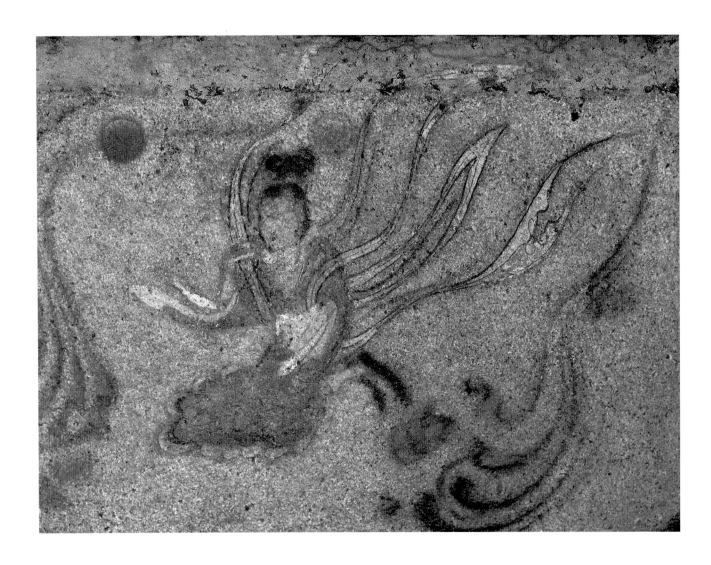

181.吹竽仙人

高句丽（7世纪）

高约60、宽约70厘米

1938年发现，1962年吉林省集安市洞沟古墓群禹山墓区中部五盔坟4号墓出土。原址保存。

墓向150°。位于南藻井西侧，为吹竽仙人图像。高髻，跪姿，着茶色长袍，黑履，绕臂身有黄色帛带向上飘起。

<div align="right">（撰文：傅佳欣、赵昕、林世香　摄影：苏楠、谷德平）</div>

Mouth-Organ-Playing Immortal

Koguryo (7th c. CE)

Height ca. 60 cm; Width ca. 70 cm

Discovered in 1938, unearthed from Wukuifen Tomb No.4 at the Yushan Cemetery of Donggou Tomb Cluster in Ji'an, Jilin, in 1962. Preserved on the original site.

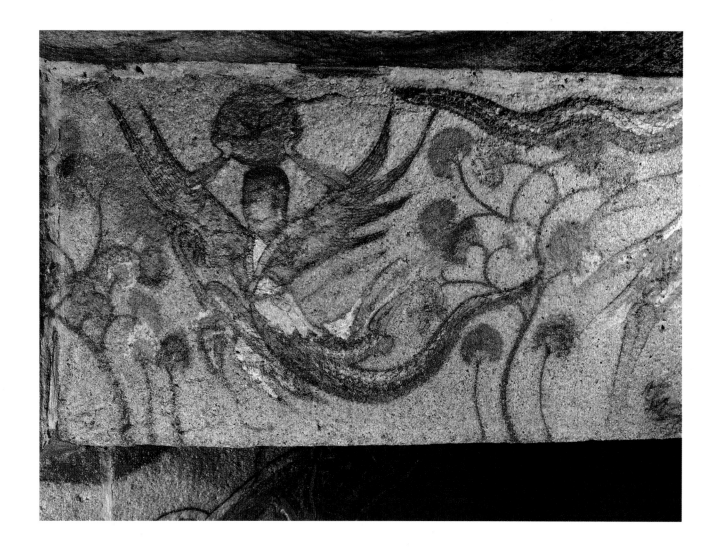

182.伏羲

高句丽（7世纪）

高约60、宽约80厘米

1938年发现，1962年吉林省集安市洞沟古墓群禹山墓区中部五盔坟4号墓出土。原址保存。

墓向150°。位于北藻井东抹角石，与西侧的女娲直角相对。人首蛇身，男相。长发短髭，着灰色羽衣，短黄裙，龙足，跨步飞行。双手至头顶捧日，日中有三足乌。

（撰文：傅佳欣、赵昕、林世香　摄影：谷德平）

Fuxi

Koguryo (7th c. CE)

Height ca. 60 cm; Width ca. 80 cm

Discovered in 1938, unearthed from Wukuifen Tomb No.4 at the Yushan Cemetery of Donggou Tomb Cluster in Ji'an, Jilin, in 1962. Preserved on the original site.

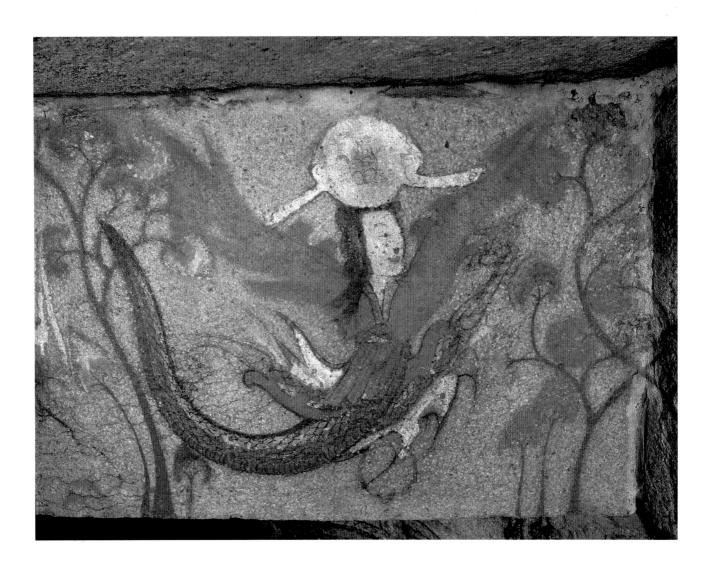

183. 女娲

高句丽（7世纪）

高约60、宽约80厘米

1938年发现，1962年吉林省集安市洞沟古墓群禹山墓区中部五盔坟4号墓出土。原址保存。

墓向150°。位于北藻井西抹角石，与东侧的伏羲相对。长发女相，人首蛇身，龙足，着红色羽衣，短灰裙，跨步飞行。双手捧月于头顶，月中有蟾蜍。

（撰文：傅佳欣、赵昕、林世香　摄影：谷德平）

Nüwa

Koguryo (7th c. CE)

Height ca. 60 cm; Width ca. 80 cm

Discovered in 1938, unearthed from Wukuifen Tomb No.4 at the Yushan Cemetery of Donggou Tomb Cluster in Ji'an, Jilin, in 1962. Preserved on the original site.

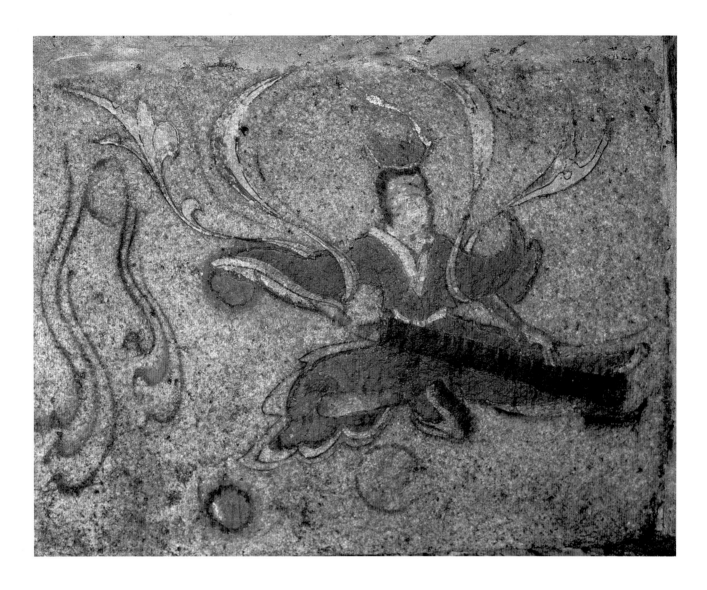

184.抚琴仙人

高句丽（7世纪）

高约60、宽约70厘米

1938年发现，1962年吉林省集安市洞沟古墓群禹山墓区中部五盔坟4号墓出土。原址保存。

墓向150°。位于北藻井东侧，为抚琴仙人图像。坐姿，头戴红色莲花冠，着赭色长袍，左腿前伸置琴于膝上，右手弹奏，左手抚弦。绕两臂有黄色帛带飘飞。

（撰文：傅佳欣、赵昕、林世香　摄影：苏楠、谷德平）

Qin-Zither-playing Immortal

Koguryo (7th c. CE)

Height ca. 60 cm; Width ca. 70 cm

Discovered in 1938, unearthed from Wukuifen Tomb No.4 at the Yushan Cemetery of Donggou Tomb Cluster in Ji'an, Jilin, in 1962. Preserved on the original site.

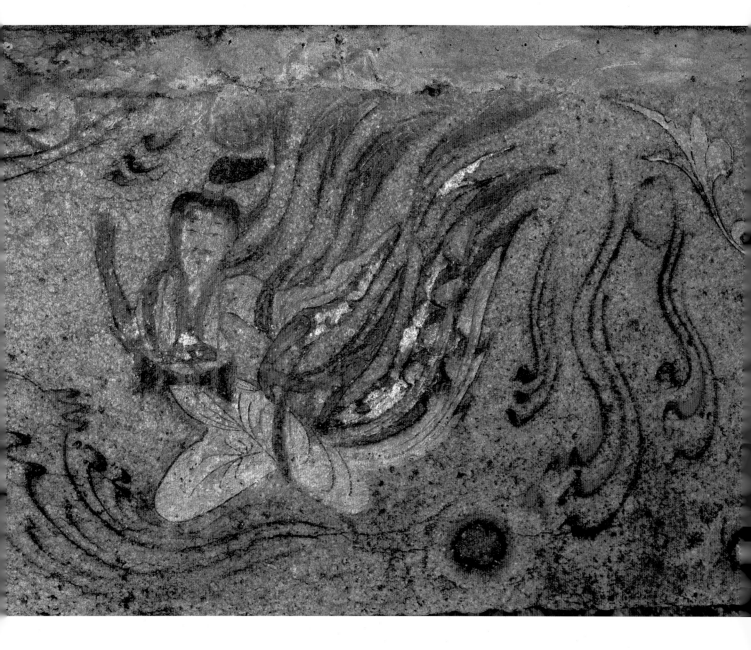

185.击鼓仙人

高句丽（7世纪）

高约50、宽约60厘米

1938年发现，1962年吉林省集安市洞沟古墓群禹山墓区中部五盔坟4号墓出土。原址保存。

墓向150°。位于北藻井二层砌石中间，为神仙图像。长发略束，短髭，右手屈臂上举，左手击胸前腰鼓，着黄色羽衣，屈腿飞翔。

<div align="right">（撰文：傅佳欣、赵昕、林世香　摄影：苏楠、谷德平）</div>

Drum-beating Immortal

Koguryo (7th c. CE)

Height ca. 50 cm; Width ca. 60 cm

Discovered in 1938, unearthed from Wukuifen Tomb No.4 at the Yushan Cemetery of Donggou Tomb Cluster in Ji'an, Jilin, in 1962. Preserved on the original site.

186. 神农氏

高句丽（7世纪）

高约70、宽约90厘米

1938年发现，1962年吉林省集安市洞沟古墓群禹山墓区中部五盔坟4号墓出土。原址保存。

墓向150°。位于东藻井南端，为神农氏图像。牛首人身，张臂奔跑状。着粉色羽衣，系白带，黑履，右手牵着一束禾穗，左手似欲攀折植物。

（撰文：傅佳欣、赵昕、林世香　摄影：苏楠、谷德平）

Shennong Shi (Farmer's Ancestor)

Koguryo (7th c. CE)

Height ca. 70 cm; Width ca. 90 cm

Discovered in 1938, unearthed from Wukuifen Tomb No.4 at the Yushan Cemetery of Donggou Tomb Cluster in Ji'an, Jilin, in 1962. Preserved on the original site.

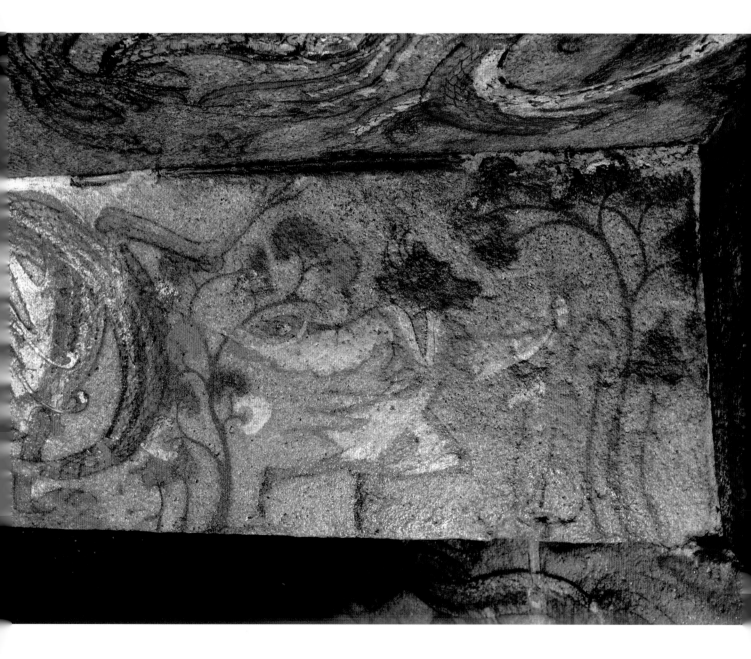

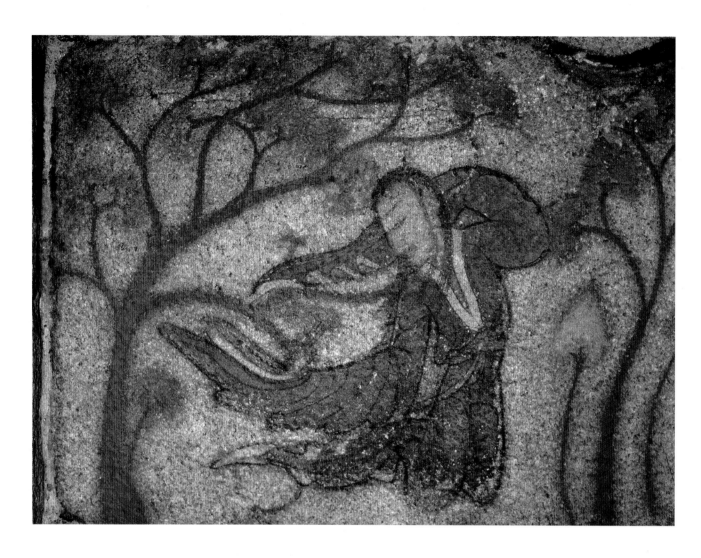

187.执火仙人

高句丽（7世纪）

高约50、宽约60厘米

1938年发现，1962年吉林省集安市洞沟古墓群禹山墓区中部五盔坟4号墓出土。原址保存。

墓向150°。为仙人图像。披长发，短髭，着青袍，左手前伸握火把，右手隐于长袖至肩后，低首俯视，屈腿飞翔。

（撰文：傅佳欣、赵昕、林世香　摄影：谷德平）

Immortal Holding a Torch

Koguryo (7th c. CE)

Height ca. 50 cm; Width ca. 60 cm

Discovered in 1938, unearthed from Wukuifen Tomb No.4 at the Yushan Cemetery of Donggou Tomb Cluster in Ji'an, Jilin, in 1962. Preserved on the original site.

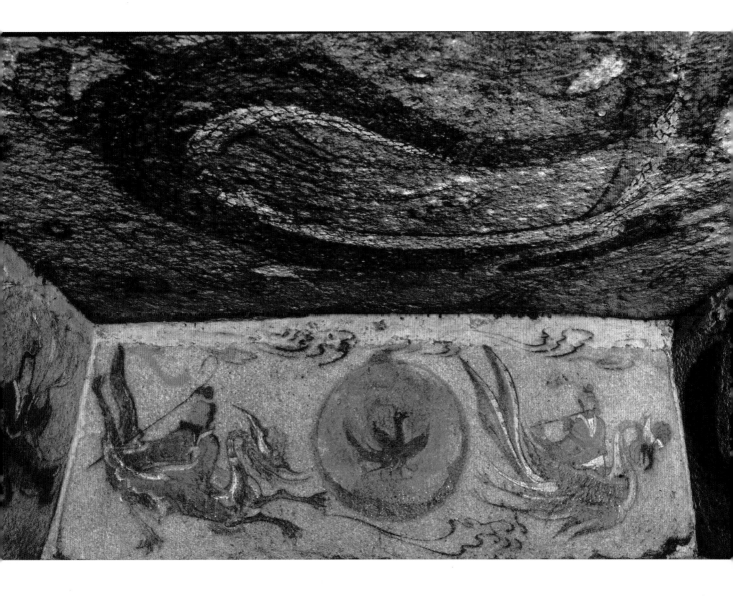

188.日神与神仙图

高句丽（7世纪）

高约80、宽约140厘米

1938年发现，1962年吉林省集安市洞沟古墓群禹山墓区中部五盔坟4号墓出土。原址保存。

墓向150°。位于二层砌石正面，为日轮与神仙图像。居中为绘有三足乌的日轮，左边仙人驭龙，束发高髻，左手执排箫正在吹奏，右手执长杆经幡。东藻井右边仙人驭凤，头有两尖耳（角？），束发，手足皆有佩环，双手执横吹。

（撰文：傅佳欣、赵昕、林世香　摄影：谷德平）

Sun God and Immortals

Koguryo (7th c. CE)

Height ca. 80 cm; Width ca. 140 cm

Discovered in 1938, unearthed from Wukuifen Tomb No.4 at the Yushan Cemetery of Donggou Tomb Cluster in Ji'an, Jilin, in 1962. Preserved on the original site.

189.蟠龙

高句丽（7世纪）

高约70、宽约120厘米

1938年发现，1962年吉林省集安市洞沟古墓群禹山墓区中部五盔坟4号墓出土。原址保存。

墓向150°。为仰视图像，四个叠涩石下方的蟠龙之一。绘在西藻井大理石下。龙身盘曲状，三趾，五色，周有云气。

<div align="right">（撰文：傅佳欣、赵昕、林世香　摄影：谷德平）</div>

Coiled Dragon

Koguryo (7th c. CE)

Height ca. 70 cm; Width ca. 120 cm

Discovered in 1938, unearthed from Wukuifen Tomb No.4 at the Yushan Cemetery of Donggou Tomb Cluster in Ji'an, Jilin, in 1962. Preserved on the original site.

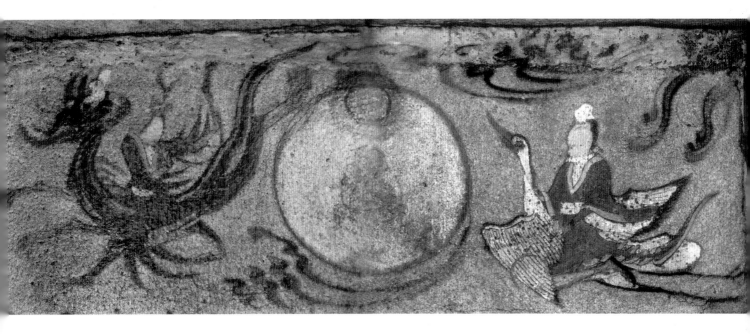

190. 月神与神仙图

高句丽（7世纪）

高约80、宽约140厘米

1938年发现，1962年吉林省集安市洞沟古墓群禹山墓区中部五盔坟4号墓出土。原址保存。

墓向150°。位于西藻井二层砌石正面，为月轮与神仙图像。居中为绘有蟾蜍的月轮，左边仙人驭龙，侧身望月，头上有双尖耳（角？），着青色羽衣，踞坐龙背吹奏胡角。右边仙人驾鹤，戴白冠，穿青色羽衣，足登黑履，向月飞翔。

（撰文：傅佳欣、赵昕、林世香　摄影：谷德平）

Moon God and Immortals

Koguryo (7th c. CE)

Height ca. 80 cm; Width ca. 140 cm

Discovered in 1938, unearthed from Wukuifen Tomb No.4 at the Yushan Cemetery of Donggou Tomb Cluster in Ji'an, Jilin, in 1962. Preserved on the original site.

191.锻铁仙人

高句丽（7世纪）

高约60、宽约70厘米

1938年发现，1962年吉林省集安市洞沟古墓群禹山墓区中部五盔坟4号墓出土。原址保存。

墓向150°。位于南藻井抹角石南端，为仙人冶铁图像。仙人束发髻，着青色羽衣，腰束白短裙，左手执锻铁钳，右手执锤，盘坐于石上正在锻铁。其前有铁砧。

（撰文：傅佳欣、赵昕、林世香　摄影：谷德平）

Iron-forging Immortal

Koguryo (7th c. CE)

Height ca. 60 cm; Width ca. 70 cm

Discovered in 1938, unearthed from Wukuifen Tomb No.4 at the Yushan Cemetery of Donggou Tomb Cluster in Ji'an, Jilin, in 1962. Preserved on the original site.

192.墓室北壁壁画

高句丽（7世纪）

高218、宽347厘米

1962年吉林省集安市洞沟古墓群禹山墓区中部五盔坟5号墓出土。原址保存。

墓向158°。此为5号墓北壁玄武图，直接绘于石壁表面。中间为玄武，龟蛇相缠，两头相视。地纹为连续的莲花火焰网状，共19个单元，莲花、火焰相隔。莲花皆侧视，十一瓣，用绿、粉、暗红、黄等色绘成。梁枋绘蟠龙，两隅绘怪兽托龙顶梁。

（撰文：傅佳欣、赵昕、林世香　摄影：谷德平）

Mural on the North Wall of the Tomb Chamber

Koguryo (7th c. CE)

Height 218 cm; Width 347 cm

Unearthed from Wukuifen Tomb No.5 at the Yushan Cemetery of Donggou Tomb Cluster in Ji'an, Jilin, in 1962. Preserved on the original site.

193. 墓室东壁壁画

高句丽（7世纪）

高218、宽356厘米

1962年吉林省集安市洞沟古墓群禹山墓区中部五盔坟5号墓出土。原址保存。

墓向158°。为青龙图像。龙身斜飞，张口向南。三趾，主体用黄、绿、红、褐等色，墨色勾勒鳞纹。地纹为连续的莲花火焰网状，共13个单元，内为莲花与火焰图案。梁枋绘蟠龙，两隅绘怪兽托龙顶梁。

（撰文：傅佳欣、赵昕、林世香　摄影：谷德平）

Mural on the East Wall of the Tomb Chamber

Koguryo (7th c. CE)

Height 218 cm; Width 356 cm

Unearthed from Wukuifen Tomb No.5 at the Yushan Cemetery of Donggou Tomb Cluster in Ji'an, Jilin, in 1962. Preserved on the original site.

194. 墓室南壁壁画

高句丽（7世纪）

高218、宽347厘米

1962年吉林省集安市洞沟古墓群禹山墓区中部五盔坟5号墓出土。原址保存。

墓向158°。为朱雀图像。因门洞中开，故墓室南壁绘两只相向的朱雀，均站立于莲台上。西侧朱雀冠如火焰，黄绿红三色尾羽，张翅欲飞。东侧朱雀与之形状略同。门额上有通壁横排的莲花火焰图案。梁枋绘蟠龙，两隅绘怪兽托龙顶梁。

<div align="right">（撰文：傅佳欣、赵昕、林世香　摄影：谷德平）</div>

Mural on the South Wall of the Tomb Chamber

Koguryo (7th c. CE)

Height 218 cm; Width 347 cm

Unearthed from Wukuifen Tomb No.5 at the Yushan Cemetery of Donggou Tomb Cluster in Ji'an, Jilin, in 1962. Preserved on the original site.

195.墓室西壁壁画

高句丽（7世纪）

高218、宽356厘米

1962年吉林省集安市洞沟古墓群禹山墓区中部五盔坟5号墓出土。原址保存。

墓向158°。为白虎图像。虎身白色，黑线虎纹，龙形三趾爪，张口睁目，飞捕形状。地纹为连续的莲花火焰网状，内绘莲花、火焰图案。梁枋绘蟠龙，两隅绘怪兽托龙顶梁。

<div style="text-align: right">（撰文：傅佳欣、赵昕、林世香　摄影：谷德平）</div>

Mural on the West Wall of the Tomb Chamber

Koguryo (7th c. CE)

Height 218 cm; Width 356 cm

Unearthed from Wukuifen Tomb No.5 at the Yushan Cemetery of Donggou Tomb Cluster in Ji'an, Jilin, in 1962. Preserved on the original site.

196.藻井壁画

高句丽（7世纪）

高约280、宽约260厘米

1962年吉林省集安市洞沟古墓群禹山墓区中部五盔坟5号墓出土。原址保存。

墓向158°。为盖顶石所绘的龙虎图。龙虎纠缠，遍及画面。虎身变形为蛇状，龙形爪，白色，唯头部可辨。龙身用五色绘成，与虎身相缠，两头相背。

（撰文：傅佳欣、赵昕、林世香　摄影：谷德平）

Caisson Ceiling

Koguryo (7th c. CE)

Height ca. 280 cm; Width ca. 260 cm

Unearthed from Wukuifen Tomb No.5 at the Yushan Cemetery of Donggou Tomb Cluster in Ji'an, Jilin, in 1962. Preserved on the original site.

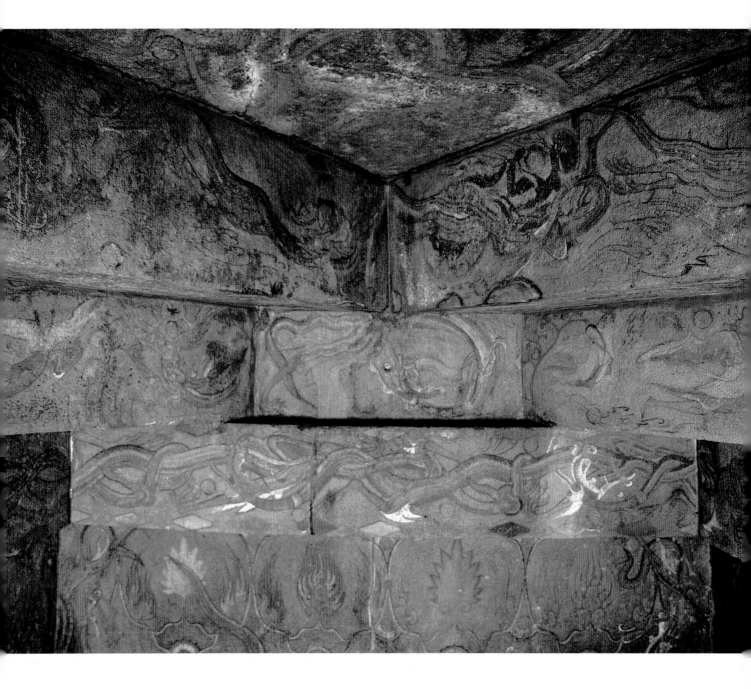

197.藻井（东侧）

高句丽（7世纪）

藻井高176厘米，下宽356厘米

1962年吉林省集安市洞沟古墓群禹山墓区中部五盔坟5号墓出土。原址保存。

墓向158°。藻井由抹角石、叠涩石、盖顶石构成。此面彩画以日神为中心，还绘有仙人、行龙等。

（撰文：傅佳欣、赵昕、林世香　摄影：谷德平）

East Side of the Caisson Ceiling

Koguryo (7th c. CE)

Height 176 cm; Bottom width 356 cm

Unearthed from Wukuifen Tomb No.5 at the Yushan Cemetery of Donggou Tomb Cluster in Ji'an, Jilin, in 1962. Preserved on the original site.

198.伏羲、女娲图

高句丽（7世纪）

高约130、宽约120厘米

1962年吉林省集安市洞沟古墓群禹山墓区中部五盔坟5号墓出土。原址保存。

墓向158°。伏羲、女娲相对图像。伏羲居东，人首蛇身，短髭，束发，着羽衣，龙爪，双手捧日于头上，日轮中绘三足乌。女娲居西，亦人首蛇身，披发，着羽衣，龙爪，双手捧月于头顶，月轮中绘蟾蜍，均作跨步飞翔姿态。两人中间和身后绘菩提树、花草。

（撰文：傅佳欣、赵昕、林世香　摄影：谷德平）

Fuxi and Nüwa

Koguryo (7th c. CE)

Height ca. 130 cm; Width ca. 120 cm

Unearthed from Wukuifen Tomb No.5 at the Yushan Cemetery of Donggou Tomb Cluster in Ji'an, Jilin, in 1962. Preserved on the original site.

199. 吹箫仙人

高句丽（7世纪）

高约70、宽约90厘米

1962年吉林省集安市洞沟古墓群禹山墓区中部五盔坟5号墓出土。原址保存。

墓向158°。位于藻井二层抹角石东端，为吹排箫的仙人图像。仙人驭龙向东，束发高髻，着绿袍，系红带，吹排箫，周围绘云气纹。

<div align="right">（撰文：傅佳欣、赵昕、林世香　摄影：谷德平）</div>

Panpipe-playing Immortal

Koguryo (7th c. CE)

Height ca. 70 cm; Width ca. 90 cm

Unearthed from Wukuifen Tomb No.5 at the Yushan Cemetery of Donggou Tomb Cluster in Ji'an, Jilin, in 1962. Preserved on the original site.

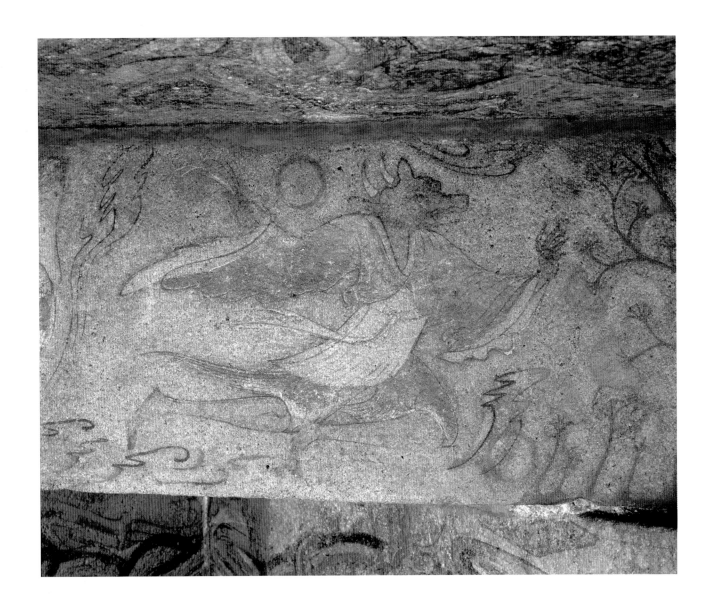

200. 神农氏

高句丽（7世纪）

高约65、宽约85厘米

1962年吉林省集安市洞沟古墓群禹山墓区中部五盔坟5号墓出土。原址保存。

墓向158°。位于藻井东抹角石南端，为神农氏图像。牛首人身，眼珠保存有镶嵌的绿松石。着褐色宽袖羽衣，绿缘，腰系绿色兜巾，黑履，左手向前张手，右手执禾穗，张臂奔跑状。

（撰文：傅佳欣、赵昕、林世香　摄影：谷德平）

Shennong Shi (Farmer's Ancestor)

Koguryo (7th c. CE)

Height ca. 65 cm; Width ca. 85 cm

Unearthed from Wukuifen Tomb No.5 at the Yushan Cemetery of Donggou Tomb Cluster in Ji'an, Jilin, in 1962. Preserved on the original site.

201.击鼓仙人

高句丽（7世纪）

高约70、宽约80厘米

1962年吉林省集安市洞沟古墓群禹山墓区中部五盔坟5号墓出土。原址保存。

墓向158°。为藻井西南的仙人图像。仙人驭龙向南，女相，束发高髻，裸上身，乳部丰隆，环臂绕飘飞的绿色帛带，着褐色长裙，侧首低俯，手击腰鼓。

<div align="right">（撰文：傅佳欣、赵昕、林世香　摄影：谷德平）</div>

Drum-beating Immortal

Koguryo (7th c. CE)

Height ca. 70 cm; Width ca. 80 cm

Unearthed from Wukuifen Tomb No.5 at the Yushan Cemetery of Donggou Tomb Cluster in Ji'an, Jilin, in 1962. Preserved on the original site.

202.驭龙仙人

高句丽（7世纪）

高约100、宽约110厘米

1962年吉林省集安市洞沟古墓群禹山墓区中部五盔坟5号墓出土。原址保存。

墓向158°。为驭龙与驾飞廉仙人图像。西侧仙人乘龙，头戴金色冕冠，右手抚龙，左手执尘尾，回首观望。东侧仙人骑飞廉，仙人头上有尖耳，戴高冠，着羽衣，背有羽翅。右手执经幡，左手执莲，仰天回首。

（撰文：傅佳欣、赵昕、林世香　摄影：谷德平）

Dragon-driving Immortal

Koguryo (7th c. CE)

Height ca. 100 cm; Width ca. 110 cm

Unearthed from Wukuifen Tomb No.5 at the Yushan Cemetery of Donggou Tomb Cluster in Ji'an, Jilin, in 1962. Preserved on the original site.

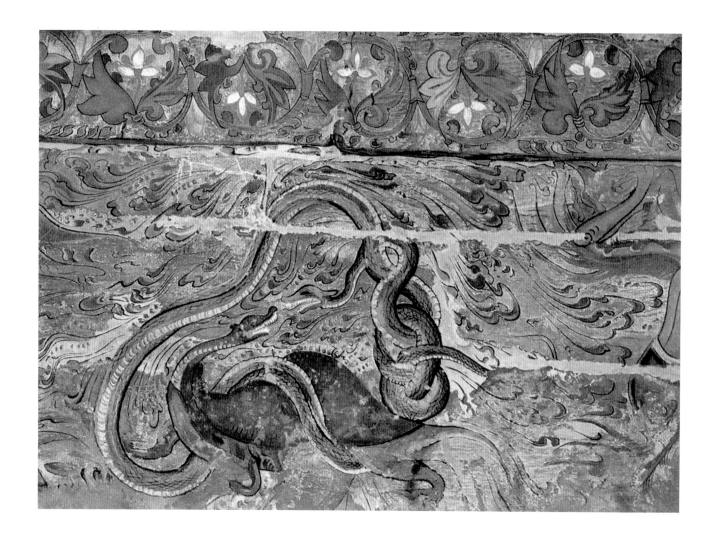

203. 玄武

高句丽（7世纪）

高约170、宽约190厘米

1938年著录。吉林省集安市洞沟古墓群禹山墓区中部四神墓。原址保存。

墓向150°。四神墓北壁玄武图。玄武为龟蛇缠绕形状，龟板整体赭色无纹，蛇有五色，两头相对。周围是流畅的云气纹样。梁枋绘连续的唐草纹。

（撰文：傅佳欣、赵昕、林世香　摄影：引自《通沟》1938年）

Sombre Warrior

Koguryo (7th c. CE)

Height ca. 170 cm; Width ca. 190 cm

Cataloged in 1938. Four-Mythical-Animal Tomb at the Yushan Cemetery of Donggou Tomb Cluster in Ji'an, Jilin. Preserved on the original site.

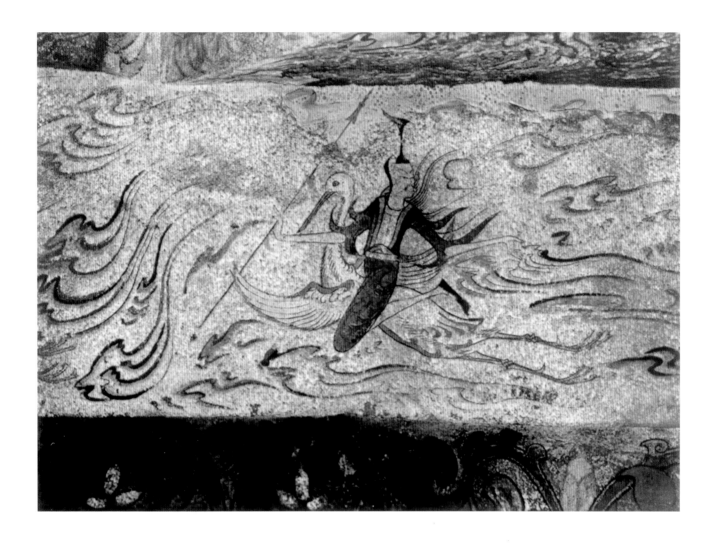

204. 驾鹤仙人

高句丽（7世纪）

高约60、宽约80厘米

1938年著录。吉林省集安市洞沟古墓群禹山墓区中部四神墓。原址保存。

墓向150°。为梁枋上驾鹤仙人。仙人骑在展翅飞翔之白鹤背上，头饰高髻，短髭，着花羽衣，墨履，右手执棨戟，左手作弹指姿态，正回首凝望。图像周围饰绘流云纹，动感极强。

（撰文：傅佳欣、赵昕、林世香　摄影：引自《通沟》1938年）

Immortal Riding on a Crane

Koguryo (7th c. CE)

Height ca. 60 cm; Width ca. 80 cm

Cataloged in 1938. Four-Mythical-Animal Tomb at the Yushan Cemetery of Donggou Tomb Cluster in Ji'an, Jilin. Preserved on the original site.

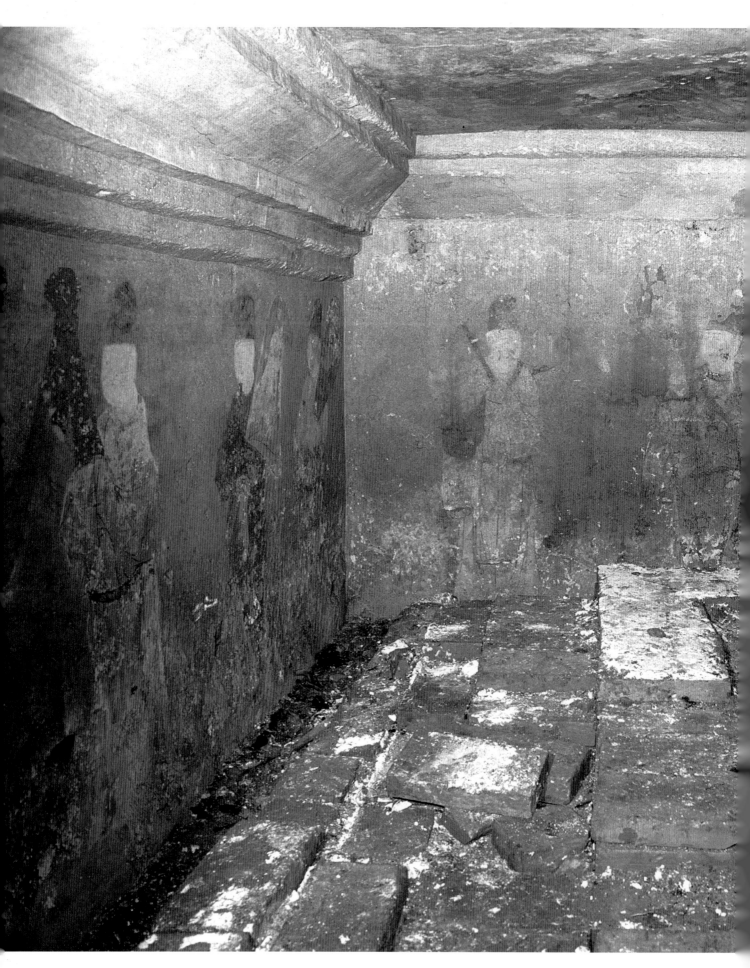

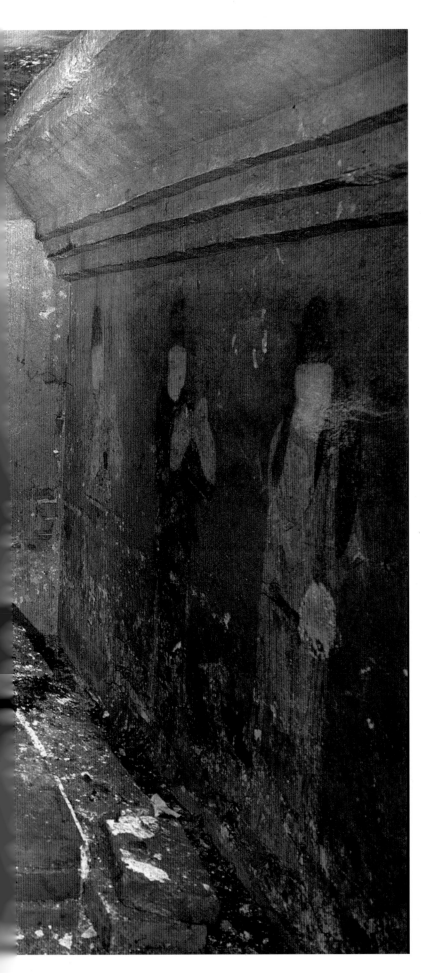

205.墓室壁画

唐·渤海（792年）

墓室南北310、东西210、壁高140厘米

1980年吉林省和龙县龙头山渤海贞孝公主墓出土。
原址保存。

墓向180°。塔墓地宫彩画。共有12个人物，分列在
甬道、墓室内，均为侍从人物。多穿唐代流行的圆
领袍服，体态丰腴，具有盛唐风韵。

（撰文：赵评春　摄影：全宗允）

Murals on the Tomb Chamber

Bohai Kingdom during Tang (792 CE)

Length 310 cm from north to south; 210 cm from east to
west; Height 140 cm

Unearthed from the Tomb of Princess Zhenxiao of
Barhae Kingdom at Mountain Longtou of Helong, Jilin,
in 1980. Preserved on the original site.

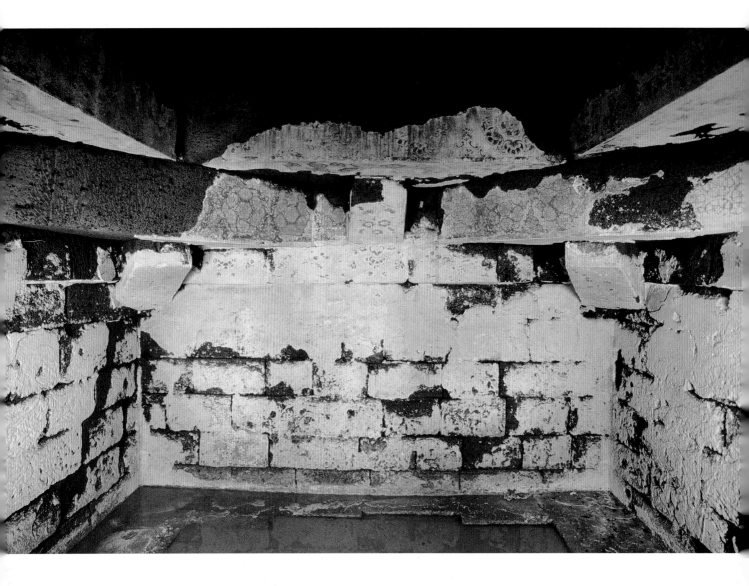

206.墓室北壁上部残存壁画

唐·渤海（698～925年）

1991年黑龙江省宁安市三陵乡三星村渤海国王陵区三陵二号墓出土。原址保存。

（撰文、摄影：赵评春）

Surviving Mural at the Top of the North Wall

Bohai Kingdom during Tang (698-925 CE)

Unearthed from the No.2 Tomb of Imperial Cemetery of Barhae Kingdom at Sanxingcun in Sanling of Ningan, Heilongjiang, in 1991. Preserved on the original site.

207.墓室南壁上部壁画花纹图案

唐·渤海（698~925年）

1991年黑龙江省宁安市三陵乡三星村渤海国王陵区三陵二号墓出土。原址保存。

（撰文、摄影：赵评春）

Designs at Top the of the South Wall

Bohai Kingdom during Tang (698-925 CE)

Unearthed from the No.2 Tomb of Imperial Cemetery of Barhae Kingdom at Sanxingcun in Sanling of Ningan, Heilongjiang, in 1991. Preserved on the original site.

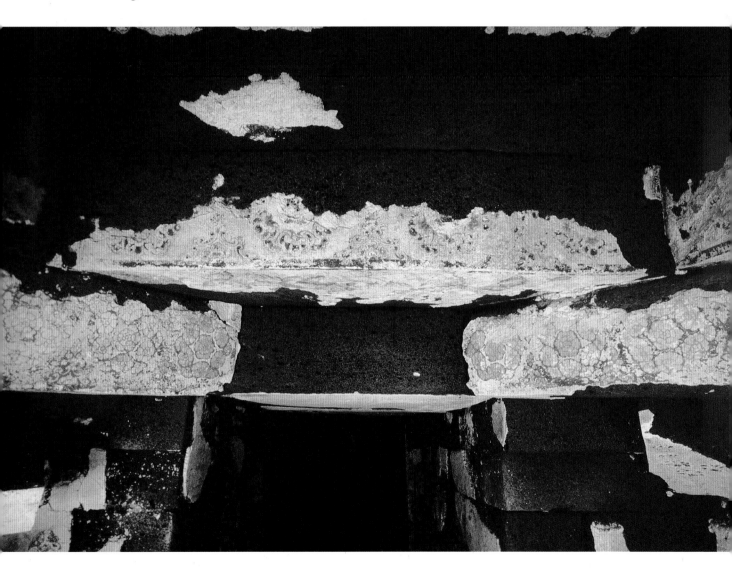

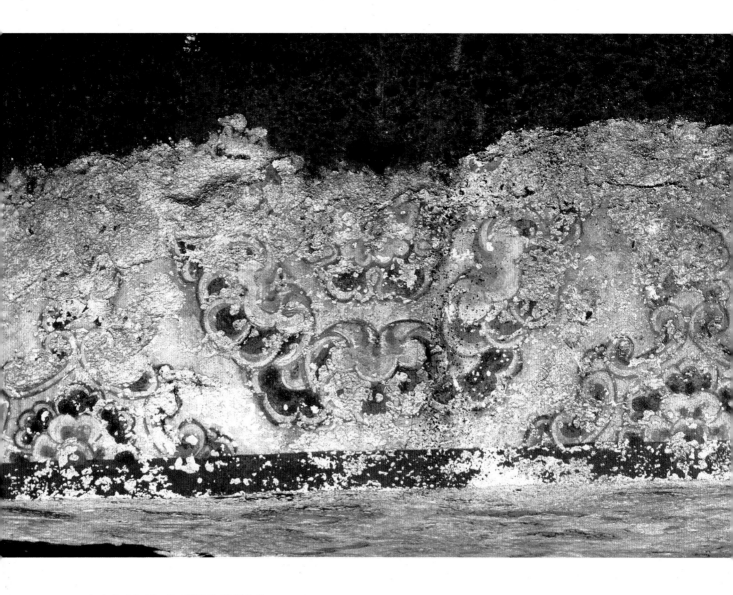

208.四方连续多彩团花图案

唐·渤海（698~925年）

1991年黑龙江省宁安市三陵乡三星村渤海国王陵区三陵二号墓出土。原址保存。

（撰文、　摄影：赵评春）

Multi-colored Medallion Designs

Bohai Kingdom during Tang (698-925 CE)

Unearthed from the No.2 Tomb of Imperial Cemetery of Barhae Kingdom at Sanxingcun in Sanling of Ningan, Heilongjiang, in 1991. Preserved on the original site.

209. 多彩朵花

唐·渤海（698～925年）

1991年黑龙江省宁安市三陵乡三星村渤海国王陵区三陵二号墓出土。原址保存。

（撰文、摄影：盖立新）

Multi-colored Flowers

Bohai Kingdom during Tang (698-925 CE)

Unearthed from the No.2 Tomb of Imperial Cemetery of Barhae Kingdom at Sanxingcun in Sanling of Ningan, Heilongjiang, in 1991.
Preserved on the original site.

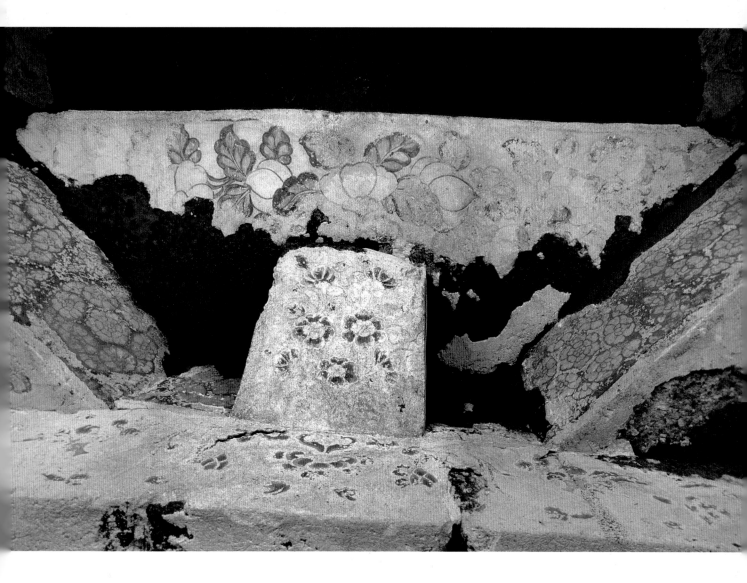

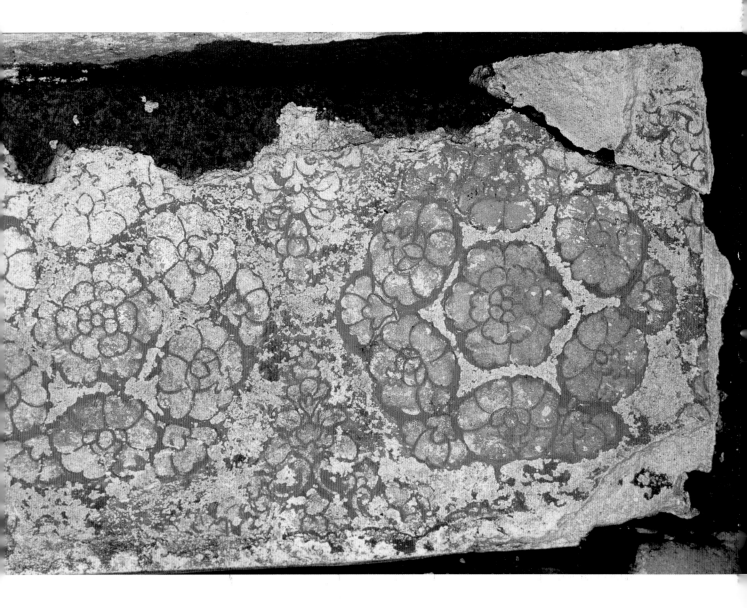

210.橙红团花图案

唐·渤海（698～925年）

1991年黑龙江省宁安市三陵乡三星村渤海国王陵区三陵二号墓出土。原址保存。

（撰文、摄影：赵评春）

Orangish Red Medallion Designs

Bohai Kingdom during Tang (698-925 CE)

Unearthed from the No.2 Tomb of Imperial Cemetery of Barhae Kingdom at Sanxingcun in Sanling of Ningan, Heilongjiang, in 1991. Preserved on the original site.